MW00824192

NEW DIRECTIONS IN LATINO AMERICAN CULTURES

A Series Edited by Licia Fiol-Matta & José Quiroga

New York Ricans from the Hip Hop Zone
by Raquel Z. Rivera

The Famous 41: Sexuality and Social Control in Mexico, 1901
edited by Robert McKee Irwin, Edward J. McCaughan, and Michele Rocío Nasser

Velvet Barrios: Popular Culture & Chicana/o Sexualities
edited by Alicia Gaspar de Alba, with a foreword by Tomás Ybarra Frausto

Tongue Ties: Logo-Eroticism in Anglo-Hispanic Literature
by Gustavo Perez-Firmat

Bilingual Games: Some Literary Investigations
edited by Doris Sommer

Jose Martí: An Introduction
by Oscar Montero

New Tendencies in Mexican Art: The 1990s
by Rubén Gallo

The Masters and the Slaves: Plantation Relations and Mestizaje in American Imaginaries
edited by Alexandra Isfahani-Hammond

The Letter of Violence: Essays on Narrative, Ethics, and Politics
by Idelber Avelar

An Intellectual History of the Caribbean
by Silvio Torres-Saillant

None of the Above: Puerto Ricans in the Global Era
edited by Frances Negrón-Muntaner

Queer Latino Testimonio, Keith Haring, and Juanito Xtravaganza: Hard Tails
by Arnaldo Cruz-Malavé

The Portable Island: Cubans at Home in the World
edited by Ruth Behar and Lucía M. Suárez

Violence without Guilt: Ethical Narratives from the Global South
by Hermann Herlinghaus

Redrawing the Nation: National Identity in Latin/o American Comics
by Héctor Fernández L'Hoeste and Juan Poblete

New Concepts in Latino American Cultures

Also Edited by Licia Fiol-Matta & José Quiroga

Ciphers of History: Latin American Readings for a Cultural Age
by Enrico Mario Santí

Cosmopolitanisms and Latin America: Against the Destiny of Place
by Jacqueline Loss

*Remembering Maternal Bodies: Melancholy in Latina and
Latin American Women's Writing*
by Benigno Trigo

The Ethics of Latin American Literary Criticism: Reading Otherwise
edited by Erin Graff Zivin

*Modernity and the Nation in Mexican Representations of Masculinity:
From Sensuality to Bloodshed*
by Héctor Domínguez-Ruvalcaba

White Negritude: Race, Writing, and Brazilian Cultural Identity
by Alexandra Isfahani-Hammond

Essays in Cuban Intellectual History
by Rafael Rojas

Mestiz@ Scripts, Digital Migrations, and the Territories of Writing
by Damián Baca

Confronting History and Modernity in Mexican Narrative
by Elisabeth Guerrero

Cuban Women Writers: Imagining a Matria
by Madeline Cámara Betancourt

Other Worlds: New Argentine Film
by Gonzalo Aguilar

Cuba in the Special Period: Culture and Ideology in the 1990s
edited by Ariana Hernandez-Reguant

Forthcoming Titles

Telling Ruins in Latin America
edited by Michael J. Lazzara and Vicky Unruh

REDRAWING THE NATION

National Identity in Latin/o American Comics

Edited by

Héctor Fernández L'Hoeste
and
Juan Poblete

First published in 2009 by
PALGRAVE MACMILLAN®
in the United States—a division of St. Martin's Press LLC,
175 Fifth Avenue, New York, NY 10010.

Where this book is distributed in the UK, Europe and the rest of the world,
this is by Palgrave Macmillan, a division of Macmillan Publishers Limited,
registered in England, company number 785998, of Houndmills,
Basingstoke, Hampshire RG21 6XS.

Palgrave Macmillan is the global academic imprint of the above companies
and has companies and representatives throughout the world.

Palgrave® and Macmillan® are registered trademarks in the United States,
the United Kingdom, Europe and other countries.

ISBN: 978–0–230–61312–6 (paperback)
ISBN: 978–0–230–61311–9 (hardcover)

Library of Congress Cataloging-in-Publication Data is available from the
Library of Congress.

A catalogue record of the book is available from the British Library.

Design by Newgen Imaging Systems (P) Ltd., Chennai, India.

First edition: November 2009

10 9 8 7 6 5 4 3 2 1

Printed in the United States of America.

Héctor dedicates this book to his son Sebastián, for the love of comics.
Juan dedicates it to his parents, Juan Poblete and Clara Garrido.

Contents

Acknowledgments ix

Introduction 1
Héctor Fernández L'Hoeste and Juan Poblete

1 Mônica Power: Comics, Society, Brazil 17
 Eva Paulino Bueno and Terry Caesar

2 *Condorito*, Chilean Popular Culture and the
 Work of Mediation 35
 Juan Poblete

3 Race and Gender in The Adventures of Kalimán,
 El Hombre Increíble 55
 Héctor Fernández L'Hoeste

4 Cuban Cartoonists: Masters of Coping 81
 John A. Lent

5 Argentina's Montoneros: Comics, Cartoons, and
 Images as Political Propaganda in the Underground
 Guerrilla Press of the 1970s 97
 Fernando Reati

6 Memín Pinguín: Líos Gordos con los Gringos 111
 Robert McKee Irwin

7 Acevedo and His Predecessors 131
 Carla Sagástegui

8 Brazilian Comics: Origin, Development, and Future Trends 151
 Waldomiro Vergueiro

9 Pavane for a Deceased Comic: Decadence, Illusions,
 and Demise of an Exuberant Narrative 171
 Armando Bartra

10 The *Fierro* Years: An Exercise in Melancholy 191
 Pablo de Santis

11 Mexican Comics: A Bastion of Imperfection 205
 Ricardo Peláez

12 Ilan Stavans's *Latino USA*: *A Cartoon History*
 (of a Cosmopolitan Intellectual) 227
 Paul Allatson

13 The Bros. Hernandez: A Latin Presence in
 Alternative U.S. Comics 251
 Ana Merino

Contributors 271

Index 273

Acknowledgments

First and foremost, we wish to thank all the artists and other parties that have contributed to this effort with images. We appreciate your support dearly. This book would not be the same without images.

We also want to acknowledge a number of people who contributed to the project through comments, inspiration, and support. These include Lauri McKain-Fernández, Micah Perks, José Quiroga, Luba Ostashevsky, Colleen Lawrie, and anonymous reviewers at Palgrave Macmillan, as well as Eva Paulino Bueno and Terry Caesar, John A. Lent, and David Foster.

Finally, we want to express our gratitude to our home institutions for supporting us during the various stages of the project: Georgia State University's College of Arts & Sciences and its Center for Latin American and Latino/a Studies; and the University of California at Santa Cruz's Committee on Research.

Introduction

Héctor Fernández L'Hoeste and Juan Poblete

As recent controversies have taught us, when it comes to matters of national, political and cultural identities, graphic narratives play very relevant roles. Given their visual impact, the fact that these cultural products may be manipulated and used for political gain has become painfully evident to many throughout the world. In November of 2005, the *New York Times* ran a story about the representation of Asian neighbors by the Japanese comics industry, a colossus with an enormous impact on Latin American comics industries, as well as in the United States.[1] The story discusses how, when it comes to the representation of Chinese and Koreans, Japanese cartoonists regularly depict their characters in a pejorative fashion, with thick black hair and narrow eyes—that is, with features exaggerating a socially constructed Asian physiognomy—whereas when it comes to Japanese characters, they favor the habitual *manga* style, with open wide eyes and Caucasian features. The story speaks to the importance of graphic narratives with respect to the way in which we see ourselves and construct others. The fact that it pertains to the Japanese industry, increasingly a model for new generations of Latin American cartoonists (as mentioned in this volume by Bartra and Peláez in their coverage of the Mexican comics industry), should give us much reason for thought. There are many equivalents for this type of situation in Latin America, given our colonial propensity to privilege foreign descent and social status. In the course of the last fifty years, much has happened in many Latin American comics industries, orienting representation towards multiple forms of graphically constructing a social and/or national identity. This book is born of the desire to chronicle some of this diversity, as well as to cover aspects of the evolution of comics and cartoons in a Latin/o American context.

In this sense, this text represents a collective effort to map out some of the complexities structuring the field of comic production, and its history and analysis in Latin/o America. It does not intend to be a full history of comics in Latin America, as all histories are, by definition, incomplete and involve, at best, fragmentary, unfinished approximations to cultural identities. Given the present state of research on the topic, a full account or

periodization of the history of comics in the continent will have to wait. Although there are more than a few excellent national histories of comics or *historietas* in Mexico, Brazil, and Argentina, most other countries only have partial accounts covering particular periods of their production and, more frequently, just an author or magazine. This is not to say that we do not endorse heartily the work of researchers like Brazilian scholar Waldomiro Vergueiro, who proposes here a summarized account of the history of comics in his home country. Nevertheless, we simply wish to point out and acknowledge that the contents of this volume are just the tip of the iceberg. Thus, an accumulation of primary research is imperative before any viable comprehensive synthesis of this cultural field is possible. This volume is an effort in that direction.

To the best of our knowledge, *Redrawing the Nation: National Identity in Latin/o American Comics* is one of the first attempts in English to cover Latin/o American comics with a fully continental scope. The representation of the continent in U.S. caricatures is covered in John J. Johnson's excellent *Latin America in Caricature*. There have also been other texts that have dealt with Latin America's graphic tradition in an expanded fashion, such as the work by communications scholar John A. Lent, a resolute pioneer in the study of comics, who writes on Cuban comics for this volume. However, in contrast to other works of this kind, we have tried to produce a volume that incorporates some of the advances in the general field of Latin American cultural studies. A pioneering effort in this direction has been David William Foster's *From Mafalda to Los Supermachos*. In contrast, throughout this volume, our contention will be that the popularity of comics in the continent can be traced back to their ability to dramatize and perform—i.e., to mediate—a lengthy historical process, the modernizing development of Latin/o America—and, in particular, the formation of its urban cultures. Comics have played a significant role in the configuration of new states and identities throughout the continent, reflecting on the implications of these changes for the millions who have come to embody the new urban majorities of the Spanish and Portuguese-speaking world. This hypothesis has two advantages: first, it provides a general organizing principle that frames the material, allowing each author to contribute gradually to its critical consideration; and second, it's broad and flexible enough to allow for a number of different analytical and empirical approaches, a variety that is well expressed in this volume.

Following Jesús Martín Barbero, one of the leading figures in the field of cultural analysis in Latin America, a key concept within our theoretical framework is mediation. Barbero defines mediation as the space where it is possible to think the relationship between production and reception, the two conventional ends of the communicational circuit, between many competing mass media (and the capitalist organization of society that they presuppose) and their corresponding publics. Mediation, as proposed in 1987, signals for Barbero a switch away from two forms of communication analysis dominant at the time: the ideological and political economy school,

represented by the work of Mattelart and Dorfman in *How to Read Donald Duck* (1972; English translation 1975) and the functionalism of those who saw the media as all powerful and direct technological shapers of society, as in Marshall McLuhan's work on media and Herbert Schiller's research on communication and cultural domination. As such, mediation is always the result of the social production of meaning under particular circumstances of elaboration and reception. For Barbero, there are three basic spaces of concrete cultural mediation for Latin American popular culture: everyday family life, social temporality, and, finally, a cultural competence based on an aesthetics grounded on repetition and recognition, i.e., a set of forms known as popular genres. Thus, mediation is the concept connecting the spaces of production and reception, and it refers more specifically to the role played by the mass-mediatization of Latin American popular cultures throughout twentieth-century modernization. Barbero has talked of "cultural matrices," in which a number of historical layers interact simultaneously, often times through the culturally specific ways of consuming/producing the messages of the mass media. Our claim here is that graphic narratives such as comics have constituted one of the important media in this connection between socio-economic modernization, cultural matrices, and mass-mediatization. Paraphrasing Carlos Monsiváis on the role of cinema during the first half of the twentieth century in Latin America, we could say that comics have provided Latin American popular readers with some of the codes, plots, and strategies that they have used to visualize their own standing in the process of continental modernization (Monsiváis, 2000: 57). In reading *historietas, pepines, paquitos, monitos,* or *muñequitos,* Latin American readers have found clues for a deciphering of their situation, characters with whom to identify, and a language with which to give form and meaning to the expression of their thoughts and feelings in their new, contemporary realities. Within this context, comics have often provided a sentimental and civic education attuned to the demands of a modern urban setting. They have frequently depicted the struggles of a heroine/hero in an unfriendly urban context while representing both the powerful and superior forces that she/he faces in this context and her/his daily life, including the subversive strategies used to cope and survive in this milieu. Along these lines, it would be possible to trace a line connecting everyday life in different historical moments with powerful images of pre-Columbian deities, colonial saints and angels, political and social powers in nineteenth-century caricatures and *grabados,* all the way to twentieth-century superheroes. However, rather than proposing a chronological timeline or suggesting historical precedents, we want to emphasize how, in the Latin/o American context, the images and their accompanying texts have been spaces of intermediation—and contact—of hegemonic domination and subversion.

Scholars like Walter Mignolo have pointed the relevance of "the question of the letter" and writing—which other authors term "the fetishism of writing"—in the context of the colonization of Amerindian peoples and territories. Mignolo argues that the ideology of the book and the letter

consists basically in taking alphabetic writing and the book, which are nothing but instruments for the preservation and communication of social knowledge, to be the basis and essence of this knowledge. In this way, the conquistadors of the sixteenth century attributed the lack of books and alphabetic writing in native cultures to an alleged lack of civilization and culture. Native orality and graphic representations were thus made into antecedents of alphabetic literacy, its prehistory, instead of being accepted as equivalent systems for the practice and conceptualization of socially relevant discourses. Colonial production of meaning denied the coexistence and equivalency of two different systems of encoding and transmitting socially relevant information—the Roman tradition of the Europeans and the ideographic or oral conventions of the Amerindians—while privileging one (alphabetic writing and its main vehicle, the book) as the only instrument for an understanding of history and truth.[2] Thus began a long history of difficult relationships and multiple forms of hybridization between popular orality and graphic representations on the one hand, and the forms of written discourses privileged by the colonial and then republican authorities in the Americas, on the other. From the construction and use of monumental and rich Baroque churches, where the people could "read" and "feel" the Catholic Church and the colonial state's grandiosity in images, to post-independence state-sponsored literacy campaigns embracing graphic imagery, discursive elements like popular oral language, the written text, and the graphic representation of reality have stimulated multiple combinations and negotiations of identity. In this context, comics are some of their most important manifestations in Latin America.

In the nineteenth century, the interaction between written and graphic text produced two distinctive discourses. First, the state and its intellectuals, both national and foreign, attempted to visually map out the new political entity by depicting everything within its territories, from monuments to landscapes, from heroes to fauna, flora, and topography. The nation produced its own cartography and thus became *ilustrada* in the double sense of the expression (graphically depicted and learned). The national iconographic traditions, together with their codes and strategies, were invented and perfected in the republican nineteenth century. They included political satire in newspapers and magazines, maps, photography, school textbooks, personal albums, etc. The second discourse in which written and graphic text interacted during this period was a late nineteenth-century development for most Latin American nations. It involved the engravings and woodcuts in massively consumed *hojas sueltas* (or penny leaflets), cheap novels, and the first massive periodical publications. While the first case came close to an official discourse of the nation-state, the second one registered the reactions to and engagements with official imagery and its representatives, along with the products of a popular imagination rich in scandals, crimes, and all kinds of extraordinary events. If the national iconography leaned towards homogeneity in the creation of a singular national public sphere, the popular one exploded into myriad ways manifesting the actual heterogeneity of the nation's constituents.

The first decades of the twentieth century witnessed precisely the multiplication of mass-produced and consumed printed material in which written and graphic text came together. By 1905, Italian Angelo Agostini had consolidated a reputation in Brazil and launched *O Tico-Tico*, a publication whose main character was "Chiquinho," a Buster Brown adaptation that would last until 1960. In this way, Agostini was situating himself ahead of a new cultural tradition that would combine literacy and graphics in a modern fashion. By 1906, "Federico Von Pilsener," the first Chilean comic strip, appeared in the magazine *Zigzag*. Some time later, in 1924, Colombian Adolfo Samper created "Mojicón," another Buster Brown imitation, reaffirming the national hegemony of Colombia's Andean interior. In Cuba, by 1927, Porter Vilá created "El Curioso Cubano," ironically, as an effort of anti-U.S. cultural resistance. In other words, in an accelerated example of transculturation, a medium strongly influenced by the U.S. cultural industry was already inspiring new means to problematize political hegemony. From the images of José Guadalupe Posada in Mexico to the creation of national icons like Dante Quinterno's *Patoruzú* in Argentina in 1931 (though the character was actually born in 1928), there is a vast range of publications that manifest the access to and representation in national culture that working people gained. *Pepín* and *Paquito*, the two Mexican magazines with extensive appeal to the general public and virtual namesakes for comic books, appeared in 1934 and 1936, respectively. National culture had finally reached the masses but it did so in a complex way, unthinkable for those early nineteenth-century *ilustrados* (enlightened) intellectuals, who dreamed of teaching political culture and language arts to the common folk. Much to their dismay, instead of the high culture book, it was film and graphic images, low popular literature and yellow journalism, muralism and radio soaps that culturally engaged the people. Visuality and multiple hybrids of written and graphic forms combined were to have a long and memorable career in the formation of modern mass national-popular cultures in the continent.

As we have mentioned earlier, Monsiváis argues that it was precisely through this sort of process, through regular theater attendance and the consumption of a nascent national cinema, that the public came into contact with *mexicanidad* and learned how to be Mexican. In the same way, it can be argued that the growing urban population in the early and mid-twentieth century, composed mainly of newly urbanized rural folks, also learned to interact with and engage its new environs via its contact with comics. *Puros cuentos*, the three-volume history of comics in Mexico by Juan Manuel Aurrecoechea and Armando Bartra, and perhaps the most detailed study of a national graphic tradition in Latin America, certainly seems to validate this contention. These new sectors of the population were composed mainly of working-class masses, eager to improve their standards of living and find better jobs in Mexico's growing cities. Thanks to the post-revolutionary implementation of import substitution industrialization (ISI) and the expanding role of the state, places like Mexico City, Guadalajara, and Monterrey attracted people from the country and brought about a profound

demographic shift. Upon arriving to the cities, comics were a readily available and affordable cultural product. Their many narratives addressed the multiple questions of the new inhabitants, empowering them to develop a new understanding of social space, adopt new cultural practices, seemingly more in touch with the new setting, and adapt old ones in order to preserve their viability. In the process, many consumers also learned how to read, quite literally, thanks to comics. While comics were not the most critical form available, they certainly managed to problematize matters pertinent to the routine of daily life in the city. Thus, comics enabled an enhanced sense of interaction between readers and new, multiple forms of Latin American modernity.

This literacy process, evident in a society like Mexico, with its longstanding muralist tradition, in which graphic illustration played a preponderant role in the consciousness of the masses, did not go unnoticed elsewhere. With the Good Neighbor Policy, the Roosevelt administration encouraged comics empires like Disney to produce benevolent (and often times still patronizing) interpretations of Latin American nationalities. *Saludos Amigos* (1942) and *The Three Caballeros* (1944), the motion pictures resulting from this effort, offered a wide assortment of characters, from Pedrito, a hapless plane meant to represent Chile's efforts to transcend physical borders, to Panchito, a gun-toting Mexican *charro* rooster. While these characters were created for animated films, in some cases they made the transition to comics, with unpredictable results for the United States' stab at the representation of Latin American countries: Zé Carioca, the festive parrot resulting from this experiment, was taken, appropriated, and further developed by Brazilians in Editora Abril, the publisher in charge of Disney titles, in an example of cultural cannibalism, somewhat comparable to the Brazilian embracement of Hollywood star Carmen Miranda. To use a concept coined by Frances Aparicio and Susana Chavez-Silverman, hegemonic tropicalizations were met with creative countertropicalizations (Aparicio and Chávez–Silverman, 1997).

By the 1950s and 1960s, with the advent of the Cold War and the Cuban Revolution, and with Latin America rapidly becoming a turf at stake in any resolution of the conflict, the future of comics was altogether clear. Thus, just as the United States engaged the Latin American population with the Disney universe and other less timid initiatives (war comics habitually sided with the U.S. Cold War perspective), promoted and backed by the Alliance for Progress and its agenda of *desarrollismo*, other sectors also became aware of the enormous communicative potential of comics. As a result, appropriation of the medium with diverse interests became the norm. To a certain extent, the portrayal of newly urbanized societies validated the U.S.-centric push towards progress. Juan Poblete's chapter on *Condorito* (1947), the popular Chilean character, sheds some light on the implications of urban migration and accelerated modernization during this period. Particularly in the beginning, thanks to its folksy meditations on urban migration and the impact of the growing infrastructure (e.g., the renowned "Panamericana"

series, centered on the continental highway project), Condorito incarnates this approach well. In other instances, assessment of U.S. influence in the process was more understated and oblique. For instance, Héctor Fernández L'Hoeste's text on *Kalimán* (1965) points out how, in order to conceal the implications of the overwhelming political and cultural influence from the neighbor to the north, this superhero's narrative is set anachronistically under British imperial rule, thus eliding any critical responsibility towards a rapidly changing Mexican society, eager to celebrate its modernity and a theoretical advancement into the industrialized world order. These are no more than two examples, yet they illustrate well how comics of this protracted period were involved in the assessment of modernity through a variety of methods.

Then again, it is important to consider that urbanization did not happen at the same time in all of Latin America. The countries with the earliest urbanizations, Argentina, Brazil, and Mexico, all benefited from this shift, giving birth to robust national comics industries. Whereas editorial cartooning is a phenomenon of the press and is present even under exclusive elite markets, comics involve a certain degree of meso-cultural development including authors, specialized agents and formats, and a significant reading public. Thus, it's only understandable that, given their urban nature, comics would emerge swiftly thanks to a shift in national demographics. Most Andean and/or Central American nations, where urbanization took place at a slower pace, did not benefit initially from this shift. By the time they were urbanized, new media were claiming greater portions of the cultural market and hindering the commercial viability of domestic comics. Thus, their comic traditions were, to a certain extent, disparate. Instead of experiencing the stages shared by other countries through a gradual, measured advancement, they simply engaged the current, most available phase of media development. Through a variety of approaches, many chronicled this moment. Between 1953 and 1968, for example, Rubén Osorio and Hernán Bartra published 190 issues of a bi-weekly comic in Peru, "in support of missions and their evangelizing work in the jungle," setting a record for the country's longest uninterrupted youth publication.[3] In 1962, on the other hand, Ernesto Franco published Colombia's most exemplary comic strip, "Copetín," based on the adventures of a street urchin, originating a belated, critical view of accelerated urbanization. Burgeoning Latin American cities, it seemed, lacked a cohesive social project and, to a large extent, revealed acute societal disparity. Fernando Reati's piece for this volume on the work of Montoneros, a subversive movement that used the work of cartoonists and scriptwriters in its propaganda efforts, also chronicles some of the medium's alternative uses within an urban context. Used for their ideological warfare, comics produced a representation of the city as an arena of political and economic conflict.

As we have mentioned, the 1960s also represent the arrival of television and, almost simultaneously, the climactic point of a golden age of comics in the major Latin American cultural scenes. The massive appearance of this

audiovisual medium marked the subsequent decline of homegrown comics industries, impacting the lifestyle of urban classes that consumed comics in their leisurely time. In Mexico, for example, Yolanda Vargas Dulche's *Lágrimas, risas y amor* (1962) and Rafael Navarro and Modesto Vásquez's *Kalimán* (1965) shared space with Eduardo del Río's *Los Supermachos* (1966–1967) and *Los Agachados* (1968–1977). Given the heightened social profile of comics, the national cultural establishment gained a new awareness of the medium. This growing consciousness sparked a subsequent wave of interest in comics throughout the Americas, stimulating the medium in countries that, given their late urbanization, did not exhibit a strong tradition. In Venezuela, idiosyncratically named characters like Bicho Bruto, Cabeza E'Ñame, and Fulanita appeared in *El Gallo Pelón* (1953). In 1957, the Peruvian daily *El Comercio* launched "Supercholo," an autochthonous response to U.S. superheroes. In 1961, the magazine *Cascabel* appeared in Bolivia, with comics like "La Maquinita" and "Rayo Justiciero," a local crack at superheroes. Eventually, these budding efforts merged with the greater Latin American comics mainstream and developed jointly along three main lines: an artisanal production at the grass-roots level; a national and industrial production, centering on content of local nature; and a transnational, industrial phase, in which the countries with more established comics industries, Argentina, Brazil, and Mexico, participated and interacted with U.S., European, and Japanese publishers. Occasionally these trends overlap, as in Mexico, with publishers like Novaro or Novedades, which targeted children with local content while simultaneously editing international titles, or Argentina, with *Billiken* and *Patoruzú*, national titles specifically targeted at children, and the concurrent marketing of the Disney universe. *Condorito*, once the result of an independent artisanal and then national effort, altered its national status (though this is not evident in the product), thanks to its acquisition by Mexican media empire Televisa; eventually, it matured into an operation with an industrial and transnational character. In Brazil, Maurício de Sousa gradually conquered the market with the help of Mônica, his main character, dating from 1963. His production eventually comprised the entire production catalog of Editora Globo, ex-Rio Grafica e Editora, one of the main Brazilian publishers during the 1960s and 1970s. Yet, during almost the same period, marked by years of military dictatorships (1964–1985), hundreds of pornographic comics with alleged pedagogic bent and explicit representations of homosexuality sold well in Brazil, authored by Carlos Zéfiro, a cartoonist with a well-guarded secret identity. Clearly, a full periodization and history of Latin American comics would require paying attention to multiple contexts and overlapping spheres and processes at the local, national, and international levels. Hence, rather than focusing on a definitive timeline for the continental development of the medium, we only hope to illustrate how comics played key roles in the consolidation of various national imaginaries.

From the 1970s on, with the onslaught of globalization and neoliberalism, the comics market in Latin America replicated the Euro-American and

Japanese segmented market structure. In other words, while national comics continued to exist and diversify, they no longer exhibited the impact or scope of their golden ages. Graphic novels and *manga* impacted the Latin American comics scene heavily. Many of the best authors and artists from Argentina, Brazil, and Mexico migrated, seeking better conditions of production elsewhere. In a sense, the parallel gain in cultural prestige provided a way out for many authors of a languishing industry. While it was plain that a massive national comics industry was no longer viable—at least in a fashion akin to its previous conception—given widespread substitution through imports and/or *maquilas*, many authors managed to maintain or increase their level of cultural prominence. Access to new technologies and the accompanying shift in worldwide communication paradigms provided new opportunities and challenges for cartoonists and publishers. New, more specialized forms of comics (erotica, alternative, etc.) intermittently appeared on the market. Quite understandably, this moment, in which drastic change brought about the possibility of acceptance of new talents, embodied some of the most distinctive production in the Western hemisphere. In 1970, after a successful stint in the magazine *Alterosa*, Brazilian cartoonist Henrique de Souza Filho (Henfil) released his best-known comics strip, "Os Fradinhos" (The Mad Monks), fully representative of a new, more aggressive style of criticism. Upon migrating to the United States for a brief stint, Henfil's open attitude to sexuality proved inconsistent with Anglo tastes. Ultimately, his premature death, having contracted AIDS from a blood transfusion (Henfil was hemophilic), was a significant loss for Brazil's comics industry. In Mexico, during the same period, new titles appeared, like *Yerba* and *Simón Simonazo*, with a candid counter-cultural vein. Eventually, projects like *El Gallito Cómics* and the El Taller del Perro collective took over in the late 1980s and 1990s, and established themselves as cornerstones of a new, alternative approach to the language of comics. In his article for this volume, Ricardo Peláez, a member of El Taller, chronicles some of his travails as Mexican cartoonist. Still, the emergence of a new generation of cultural actors, bent on developing a more selective style, did not mean that the traditional, family-oriented publication disappeared. As in previous decades, comics managed to adapt and even thrive—witness the impact of *Sensacionales*, a sub-genre tangentially covered here by Peláez—still fulfilling in some respects the same functions as in the past.

As the previous review suggests, the influence of comics on culture and identity has been significant. Gender issues, for instance, offer another good view on the way in which comics tackle many of the major problems and changes of the day in the continent. Comics are, by historical tradition, a male-oriented medium. Thus, the implications of an unfettered male view in the field (even shared by some women cartoonists) ought to be examined. In Latin America, as elsewhere, there is the convention, created by male artists, of representing women as objects to be consumed visually by male readers. While it is important to keep in mind Anne Rubenstein's reminder that, contrary to the expectations of U.S. readers, the audience for Mexican

historietas—at least within the first half of the twentieth century, the time of consolidation of national-popular regimes throughout the continent, like Argentina, Brazil, and Mexico—was neither young nor exclusively male, it is also crucial to acknowledge the prevalence of a male-oriented comics imagination. This erotic imagination is usually one-sided (strictly heterosexual mis/representation of women) and chauvinistic. Women are frequently portrayed in an objectifying fashion: big breasted, with rounded hips and lips, scantily clad, and, quite predominantly, as objects rather than subjects of action. They are often spectacularly beautiful, and in search or dire need of a male companion who can protect them. As such, comics, or at least many products within the genre, participate in what may be labeled a masculinist imagination.

In some representations of gender by men, stereotypes are mobilized but then immediately criticized and deconstructed by counter-stereotypes. Argentine comics can be a good case in point. In classics like Héctor Oesterheld's *El Eternauta* (1957), which narrates an alien invasion of Buenos Aires, men embody all possibility of action and women are relegated to eminently passive roles. By 1964, Joaquín Salvador Lavado, better known as Quino, was issuing a more humorous approach with *Mafalda*. While Mafalda, the main character, is the product of a typical Argentine, middle-class family, her actions appear framed by the sentiments and actions of her peers, Libertad and Susanita, who incarnate opposite ends of the political and societal spectrum. Honoring her namesake, Libertad is a diminutive schoolmate sponsoring progressive views. Susanita, on the other hand, is a future matron, reactionary in essence, stereotypically feminine in the mold of the 1950s, prior to the emergence of women's liberation movements. Through these clashing views, Quino uses and deconstructs gender stereotypes. While we may question *Mafalda*'s actual political subtext, it is undeniable that it constitutes a sophisticated engagement by a male author with respect to societal gender roles and expectations. Undoubtedly, its approach is more elaborate than Oesterheld's straightforward disdain for female agency.

In the late 1970s and 1980s, in collaboration with Argentine artists like Horacio Altuna and Ernesto García Seijas, prolific author Carlos Trillo produced comics like *Las Puertitas del Sr. López* (1979–1982) and *El Negro Blanco* (1987–1993). In *Las Puertitas*, señor López, a short, overweight clerk controlled by his wife, has access to an Alice-in-Wonderland type of reality. In this alternate universe he can, among other things, have multiple relationships with beautiful young women who love him unconditionally. In dictatorial Argentina, amidst a rabidly patriarchal environment of repression—witness the overthrow of Isabel Perón's government and the ensuing years of torture—women were often framed as male escapisms. Following the arrival of democracy, *El Negro Blanco* narrates the adventures of a journalist and his relationship with a group of beautiful women, who, this time around, are all professionals: Flopi, Chispa, Agatha, and doctora Caramelo. In this context, women are represented in a more deceptive light. The general frame of the story portrays them as liberated and more independent, actively

involved in a professional environment, and in open competition and some-times surpassing their male peers. Nevertheless, the female characters clearly act within the boundaries of a male imagination, embodying idealized representations of the female anatomy. In this context, women's enhanced sense of freedom contributes to the ratification of male fantasies. The character of Flopi, for instance, gained such popularity, that it eventually surfaced in the Argentine version of *Playboy*.[4]

While many of these transformations could be dismissed as cosmetic, it is evident that things have changed lately. Around the turn of the century, Argentina witnesses, perhaps more than any other place in Latin America, increased acceptance of women producing comics. Beyond cartoonists like Ana von Rebeur, María Alcobre, Patricia Breccia, and Diana Raznovich, the most renowned one—quite definitely, at the international level—is Maitena Burundarena, the daughter of an ex-cabinet member of the military regime. Her production centers on matters of gender and has gained widespread popularity throughout the continent. Regrettably, Maitena's production falls short in terms of class and race. Her narrative universe, based on vignettes that problematize aspects of daily life for women, focuses almost exclusively on the travails of the upper middle class, avoiding the implications of recent economic upheavals, and fails to incorporate other ethnicities, condoning the misperception of homogeneity in Argentine society. In this sense, regardless of the physical origin of cultural production—like Quino, Maitena may at times produce from afar—the political and cultural imaginary of her work is, for better or worse, Argentine. From this viewpoint, her work, while it grants indispensable protagonism to women, embodies well some contradictions and limitations of Latin American comics.

There are multiple equivalents to the Argentine construction of gender in other latitudes. In Brazil, characters like Maurício de Sousa's phenomenally successful *Mônica* (1963), which spawned the most massive South American comics empire, of almost Disney-like proportions, offer an upbeat take on gender, playing, to a safe degree, on the premise of Mafalda: that of a group of kids with a little girl as leader. De Sousa's Mônica, covered by Eva Paulino Bueno and Terry Caesar in this volume, embodies a feisty representation of femininity, seldom accompanied by meaningful critical insight on her surroundings. Thus, while it's an identity portrayal that simulates assertiveness, it promotes a romanticized view of gender equality, acutely missing in Brazilian reality. In Colombia, political cartoonist Vladdo has popularized *Aleida* (1997), a strip with a female protagonist, bent on rationalizing societal conundrums through the prism of gender. As a sentimental advisor, the main character, which avoids concrete allusions to national circumstances, persistently reaffirms a conflictive understanding of events, framing personal definitions within power struggles. Nevertheless, Aleida's advice for the resolution of love predicaments replicates the politics of conflict in Colombian society. In light of this structure, male authorship is ratified and seldom questioned, effectively concealed in the process.

In the U.S. Latino comics scene, more nuanced representations of identity have been apparent for some time, from Jaime and Gilbert Hernandez's *Love and Rockets* series (1981–1996)—discussed here in Ana Merino's text—with countless stories chronicling southern California's thriving mix of cultures, to more recent and innovative proposals, like Jessica Abel's *La Perdida* (2001–2005), a five-part series problematizing gender and identity at a more intimate level, and hinting at the relevance of ethnic heritage in contemporary U.S.A. The Hernandez's saga, product of L.A.'s thriving punk scene in the early 1980s, centers on the story of Palomar (authored by Gilbert), a fictional Latin American village, and the life of two punk lesbians, Maggie Chascarrillo and Hopey Glass (authored by Jaime), living in California in an ongoing serial titled *Locas*. Strong and complex female characters usually populate these accounts, an indelible sign of the Hernandez's authorship. As a result, these cartoonists have gained an almost cult-like status among female comics readers. Perhaps the most noteworthy example of recent female Latina authorship of comics, Jessica Abel's story narrates the predicaments of Carla, a Chicana who travels to Mexico in search of her roots. While her narrative meditates on the implications of a romanticized ethnic heritage, it also has the virtue of a strong female perspective, seldom explored with such acuity and depth in comics. As a Chicana in Mexico, Carla deals with questions and aspects of social reality from her own position. Lastly, there are more militant representations of gender in Latino comics, such as the inventive work of Jaime Cortez in Los Angeles, which chronicles the challenges of the gay community in today's politically charged environment, hinting at the enormous potential of the medium to educate and perhaps even transform society. While Cortez's work has yet to be evaluated critically, it does suggest new paths for the construction of identity in Latin/o American comics.

Class is another key relevant factor in comics. At the grass-roots level, the association between comics and a working-class public has centered on a group of ideas: first, the conceptualization of the medium as a form of transition between cultures of illiteracy and literacy; second, the use of comics as a tool for the awakening of social consciousness; and third, the perception of comics as a sensible vehicle for the life experiences of the working classes. The experience of Mexico, in which the depiction of the lifestyle and ambitions of the working class played a preponderant role, is highly illustrative of this complexity. A good example is the work of Gabriel Vargas Bernal and his longstanding series on *La Familia Burrón*. A somewhat different example is the work of Rius (Eduardo del Río) who, from a Marxist perspective, has produced a series of works explaining leftist ideas and worldviews to Latin American readers. Another instance of class representation and of the use of comics to, in the language of the 1960s, raise awareness or create political consciousness is the case of many Chilean comics—both from the right and left ends of the political spectrum—during Salvador Allende's Unidad Popular government. In fact, while the government relied on the titles of the national press Quimantú (a Mapuche term meaning "light of knowledge") to promote heightened social awareness through publications such as *La Firme* and the *Cuadernos de Educación Popular*, conservative sectors celebrated the

satirical portrayal of the Allende administration in "Cambalache," the cartoon supplement of *Sepa*, a weekly newsmagazine (Woll, 1976; and García). This polarized tradition produced in 1971 one of the key texts in the history of ideological analysis of mass mediated images: Ariel Dorfman and Armand Mattelart's famous *Para leer el pato Donald* (*How to Read Donald Duck*).

In terms of middle-class representation, the examples are endless. After all, comics are often a middle-class cultural form. Argentina, as is to be expected of a country with one of the largest middle classes in the continent, has been particularly adept in the generation of titles along these lines. From Breccia to Altuna, Oesterheld to Sampayo, Trillo, or Wood, be it cartoonists or scriptwriters, Argentines have mastered the concealment and privileging of middle-class values and mores, willingly or not. Mexico and Brazil also have longstanding traditions of middle-class construction, best personified in the production of Vargas Dulché and De la Parra, one of the most productive teams of the golden age of Mexican comics, and in the vast empire of Maurício de Sousa. The most renowned Latin American comics, from *Condorito* and *Kalimán* to *Mafalda* or *Mónica*, pertain to middle-class traditions of comic consumption and production. They are the comics that one still finds at the local bookstore—sometimes, in a somewhat diminished version of what they once represented for the corresponding national industry. Nowadays, showing signs of accelerated transformation, they're the titles most likely to be adapted for transnational consumption, given their credentials and established trajectory in the publishing sector.

The understanding of some comics as a potential expression of high culture is a relatively recent phenomenon, incarnated mostly by the rise of graphic novels and the acceptance of cartoonists as auteurs. Though comics tend to be less recognized as privileged forms of authorship in comparison to editorial cartoonism, eventually, some of this highly idiosyncratic production was appreciated and canonized. Initially, when this process took place, comics passed from having a mass culture appeal to giving birth and establishing new, national art forms, as in the case of the Argentines Ricardo Siri (Liniers) and Max Cachimba, for example, or the Brazilians Adão Iturrusgarai and Lourenço Mutarelli. These new actors perform within a substantially restricted cultural circuit, which, though it may not represent the numbers and financial success of previous generations, embodies significantly greater social prestige. This is a trend that, to varying degrees and taking cultural differences into consideration, replicates what has taken place in the Anglophone world, in which, after years of marginal and challenging production, authors like Chris Ware and the Bros. Hernandez have been embraced and published in consecrated staples of the cultural establishment, such as the *New York Times Magazine* or *The New Yorker*.

In contrast to its Latino counterpart, race and ethnicity are, quite probably, the least problematized aspects of Latin American comics. This should come as no surprise given the continental prevalence of nationalist discourses of *mestizaje* and miscegenation as forms of overcoming racial and ethnic differences, and the corresponding lack of a critical tradition on these subjects. In the minds of many, racial equality, viewed from a thoroughly

formal viewpoint, was already reached after the nineteenth-century fights for national emancipation or, at the very least, was a result of the waves of democratization of the first half of the twentieth century. Moreover, the cultural hegemony of a continental imaginary of class struggle and alleged racial mobility has seldom resulted in explicit efforts at engaging racial or ethnic differences from a critical perspective.

A few examples from the more ethnically diverse countries highlight the complexity of the medium with respect to race. Brazil, the country that replicates diversity in a way closest to the United States, still views itself, largely, as a racial democracy, perpetuating an acutely internalized and distorted view of racial inequality. In *Mónica*, for example, it might be possible to identify elements of racial integration, and even some incipient criticism of negatively assessed racial differences, but direct problematization is far from evident. Recent developments in Brazilian society, while hinting at a growing awareness and an increasing level of problematization, do not yet point to wider acceptance and embracement of the topic within the cultural mainstream. In Mexico, despite physical proximity to the United States, where race has been part of wide social struggles since at least the 1950s, things do not fare much better. The recent polemic on Memín Pinguín illustrates easily the difference in attitudes towards race between the United States and Latin America (see Robert McKee-Irwin's chapter in this volume). When the Mexican postal service issued a stamp in commemoration of Memín, a black infant known as the darling of the comics scene of the 1960s, the character's corporeal features, with grotesquely exaggerated lips and anatomical proportions, and surrounded by romanticized poverty, generated an uproar among African-American groups in the United States. In Mexico, the reaction was viewed largely as an ethnocentric excess of the so-called "minorities" of the North, blatantly disregarding the imagery's meaning within the neighbor's culture. In the United States, even supposedly progressive sectors viewed the controversy as a ratification of the backwardness of a Latin American nation. Memín is just the tip of the iceberg. Other titles by Yolanda Vargas Dulché and Guillermo de la Parra, such as "Fuego," with interracial love stories set in the colonial Caribbean, much along the lines of Jean Rhys' *Wide Sargasso Sea* (1966), and "Almas de niño," with misleading narratives based on the worldview of children, so common in the context of Latin American's literary boom, propose, according to critics Bartra and Monsiváis, moralizing melodramas where class differences reign supreme. Race, it seems, is seldom the focus of analytical interest.

In Peru (a country covered in this volume by Carla Sagástegui)—to name a South American country in which racial politics nevertheless play a key role— while comics have not managed to transcend national borders, the problematization of internal race issues has been mixed. Prior to the massification of the medium in the 1940s, magazines like *Palomilla*, with 40 editions of twenty thousand issues, in the course of three years, introduced life in the indigenous-dominated Andes to urban children, replicating the previously mentioned view-from-the-city. It included characters like Demetrio Peralta, a robber from Puno, with a firm critique against exploitation, and Pedrito, a student of

Native American descent, whose account narrates his journey from the country to the provincial capital and, eventually, Lima, facing discrimination and injustice at every turn, as well as some solidarity by the poor.[5] In 1952, the press of the Peruvian capital held contests to replace foreign content. Among the winners was a comic by Rubén Osorio, published between 1953 and 1956, in which the main character was the leader of a peasant revolt with a magical chain. Though the character was evidently of Amerindian descent, the narrative only foregrounded class struggle, effectively erasing the problematization of race. Recent stabs at race in Peru have been more straightforward. The news daily *La República*, for example, published "Los achorados," a comic strip chronicling the life of a Peruvian black family, by Alfredo Marcos.[6]

In contrast, in the United States, in an environment in which matters of race regularly trump readings of class, representation by Latino authors has given preponderance to ethnic identity. "La Cucaracha," by Lalo Alcaraz (whose work is discussed here by Paul Allatson) and the previously mentioned *Love and Rockets*, are two great examples. Alcaraz often mocks Anglo culture for its lack of inclusiveness and the Hernandez, while adding class and gender criticism, make sure that race and ethnicity remain as the core themes of their production. Strongly influenced by U.S. culture in matters of race and ethnicity, Puerto Rico also reflects some of these tendencies, though in a more problematic fashion. "Turey el Taíno," a popular aboriginal character created by Ricardo Álvarez-Rivón, published by the news daily *El Nuevo Día* with the support of the Instituto de Cultura Puertorriqueña, suggests a contradictory defense of Spanish as well as a sanitized identity based on a symbolic claim of indigenity—given that Tainos disappeared shortly after the arrival of Europeans to the Antilles—as a measure of resistance to the influence of English. Paradoxically, while the strip familiarizes its readership with some Taino vocabulary—effectively resurrecting it—Turey supposedly stands for the defense of the Spanish language and the legacy of conquistadors, in resistance to the English-based colonizing tradition.

These are, to come to the point, some of the nuances affecting the context of Latin/o American comics. This cultural production—which owes a great deal of its popularity to its ability to dramatize and perform the modernizing development of the continent, and thus to help in the configuration of the identities of the new urban majorities of the Spanish and Portuguese-speaking world—is now, at the beginning of the twenty-first century, presented with a very favorable scenario for at least some of its forms.

Globalizing cultural processes have meant a further segmentation of national markets and the re-territorializing emergence of transnational segments of consumers and circulation networks. In other words, they have involved a fragmentation and a re-aggregation of what had so far been mostly constituted as national markets and spheres. The old and new mass media, having participated actively in this process, have also spread globally a series of discourses on difference that have presented a challenge to homogenous national imaginaries in Latin/o America. New identity-based micro-politics have expanded and joined the sphere of formal traditional

macro-politics. Citizenship is increasingly connected not just to its formal political and civic forms but also to its cultural and consumption based ones. In this scenario, Latin/o American comics present some significant strength and are also faced with crucial challenges.

On the one hand, like many contemporary audiovisual genres, they propose a symbiotic relationship between image and text. Contrary to the learned tradition of the book, which, as we have seen, validated an opposition between writing and image in the continent's history, the narrative practice of comics depends on a bridging between written and visual texts. As graphic reproduction technologies have become both much more sophisticated and economically feasible, they have also democratized access to their creative possibilities, producing the conditions for a multiplication of smaller, horizontal markets. These attributes indicate some of the current and future cultural potential of the medium. On the other, if comics are to continue to perform their historic role of representing and contributing to the modernizing and democratizing processes of Latin/o American societies, they will have to evolve from a certain predominance of the patriarchal *criollo* imaginary to a further diversification of the variety of producers (artists, writers, business people), consumers, and cultural and political perspectives animating their narratives.

Notes

1 Norimitsu Onishi. "Ugly Images of Asian Rivals Become Best Sellers in Japan." *The New York Times*. November 19, 2005. Section A, Page 1, Column 1.

2 Walter Mignolo. *The Darker Side of The Renaissance: Literacy, Territoriality, and Colonization*. Ann Arbor: University of Michigan Press, pp. 1–25.

3 Mario Lucioni. "La historieta peruana 2." *Revista Latinoamericana de Estudios de la Historieta*, v. 2.8., p. 210.

4 Héctor Fernández L'Hoeste. "Flopi Bach: A Benevolent Misogyny?" *International Journal of Comic Art* 7.1 (Spring/Summer 2005): 206–229.

5 Mario Lucioni. "La historieta peruana 1." *Revista Latinoamericana de Estudios de la Historieta*, v. 1.4, p. 264.

6 Mario Lucioni. "La historieta peruana 2." *Revista Latinoamericana de Estudios de la Historieta*, v. 2.8, p. 216.

Works Cited

Aparicio, Frances R. and Susana Chávez Silverman. *Tropicalizations. Transcultural Representations of Latinidad*. Hanover: Dartmouth College, 1997.

García, Mauricio. "Apuntes sobre la historieta chilena. 20 dibujantes y la U.P." Visited June 2008. http://www.ergocomics.cl/sitio/index.php?idele=20030907194130/.

Monsiváis, Carlos. *Aires de familia. Cultura y sociedad en América Latina*. Barcelona: Anagrama, 2000.

Woll, Allen L. "The Comic Book in a Socialist Society: Allende's Chile 1970–1973." *Journal of Popular Culture* (Spring 1976): 1039–1045.

Mônica Power: Comics, Society, Brazil

Eva Paulino Bueno and Terry Caesar

What is a comic strip once it outgrows the pages of a daily newspaper and becomes the basis for political programs as well as merchandise, magazines, videos, and theme parks? Americans will be reminded of Walt Disney, although the Disney Corporation has no declared political agenda or aspiration beyond that of protecting its own reputation as a producer of "family" entertainment. Brazilians, however, will be reminded of Maurício de Sousa Produções—MSP—the company associated with the Turma da Mônica characters. The MSP is and is not another version of Disney.

Maurício's corporation resembles Disney, first of all, because it remains the product of one man, who established the company in several stages, until it became one which not only produces bimonthly magazines, but also oversees the distribution of merchandise, the production of animated films, and the establishment of theme parks. Until recently, there were two of these parks, one in the Shopping Eldorado in São Paulo, and another in the Cittá América, in Rio de Janeiro. The latter was closed this past January 17, 2004, but in a letter in the Turma da Mônica site Maurício says that he plans to open it again "in the future." Placed inside a big shopping area, the Shopping Eldorado, the first park has nothing of the size or scale of Disneyland or Disney World, and yet it functions in similar ways, first and foremost to market the MSP Company. In this as in so many other ways, especially to an American, to study Maurício de Sousa's corporation appears like considering a more modest version of the Disney Corporation, albeit on a different time scale. However, appearances are deceiving.

Consider the difference in ambition between the two businesses. Simply put, a business is not a corporation. The Maurício de Sousa Company retains to this day its original roots in comic strips. The Disney Corporation has grown far beyond its—or rather, Walt Disney's—original roots in live animation. A corporation, that is, seeks continually to extend its organizational and economic domain, while a business is content to stay within one. The

most striking difference of all—for the purpose of the following discussion—follows from this difference.

From the very outset, comic strips in print were mere offshoots of Walt Disney's imaginative investment in animated cartoons for the screen. Mickey Mouse, for example, was a cartoon—"Steamboat Mickey"—in 1924, before he became a strip. (In 1931; soon followed, and "then supplanted," according to Pierre Couperie's standard history of comics, by Donald Duck [73].) The MSP, however, did not start geared toward animated films. Indeed, the summarized "history" of the company given in the Turma da Mônica website says that, from the time Mônica was released, in 1970, to 1980, the company worked exclusively with print comics. However, with the arrival of the animated Japanese comics, and the realization that the company did not have animated comics for television, MSP lost markets.

Facing so many obstacles, Maurício "parou com o desenho animado e concentrou-se somente nas histórias em quadrinhos e seu merchandising"—"stopped working on animated comics and concentrated only on the stories and their merchandising," waiting for a "normalization of situation." The policy seems to continue to this day, since Maurício promises, in the pages of the commemorative issue of Mônica's fortieth birthday, that, after many years, the first feature-length project, the "Cine Gibi da Turma da Mônica," will be released in July 2004. According to information given by the New York office of MSP, in 2007, MSP released a full length film, "Mônica's Gang in Time Travel." After that, we will have perhaps one film a year. We are analyzing the possibilities for four new ones."

In spite of this recent turn to films, to study the work originating with Maurício de Sousa is to study comic strips and magazines. Our interest is in his most popular one, "Mônica" who, unlike other Maurício de Sousa characters who began as strips in the newspapers from 1959 to 1970, already appeared as a separate magazine with her name in 1970. To this day, the strips—published in about 100 daily newspapers in Brazil—are used as a way either to introduce new characters, or to "test" them with the public. If they are well received, some will have their own magazines later. And all the characters, old and new, will become part of the Mônica universe, which, despite its similarity to the universe created by Walt Disney for his set of anthropomorphic animals, is profoundly different.

Each offers an imagination of innocence, though not in the same way or for the same reasons. In his study of Disney, Robert Giroux states at one point the following: "Stripped of the historical and social constructions that give it meaning, innocence in the Disney universe becomes an atemporal, ahistorical, apolitical, and atheoretical space where children share a common bond free of the problems and conflicts of adult society" (31). We will argue that De Sousa proposes no comparable project. His world depends to this day upon social constructions peculiar to Brazil, and his childhood versions of these constructions do not need to be purged of history or politics before they are born. Mônica and her gang are comic book characters. But they have never been designed to become Disney characters, not even at

the present time, when the MSP has come to resemble a nascent form of the Disney Corporation.

Only the characters Chico Bento, Papa-Capim, and Pelezinho, according to Moacir Cirne, initially respond to the "brasilidade comprometida com a realidade cultural do país"—"Brazilianness engaged with the cultural reality of the country" (56). Alas though, these too are found lacking, since Chico Bento suffers from either the "re-duplicating drawing" or "the plots themselves" (56). Papa-Capim (the little Indian) is defective because he has not appeared in "the first team" of Maurício's characters. It is, however, when he speaks about the character Pelezinho that Cirne clarifies some important points concerning his reservations for the whole of Maurício de Sousa's enterprise. The text is worth quoting at length:

> E Pelezinho? Como o Pelé da vida real—que nos maravilhou a todos com seu futebol mágico—estamos diante de um "negro de alma branca." Por certo, não é por aí que conseguiremos superar o racismo existente no Brasil. Ao contrário, apenas o reforçaremos. (56)
>
> And Pelezinho? Just as the real-life Pelé—who enchanted all of us with his magical soccer—we are dealing with a "Black with White soul." Evidently, this is not the way we will be able to overcome the existing racism in Brazil. On the contrary, we'll just reinforce it.

It is important that we understand the assumptions of this critique. Basically, with respect to Disney, Maurício is damned if he is and damned if he isn't. On the one hand, his cartoon universe can be understood in exactly the ways Giroux characterizes Disney. On the other hand, even when it cannot be understood this way, Maurício's difference from Disney restores "cultural reality" in the worst way. Or to put the matter otherwise, where there are signs of an identifiable nation in Maurício's texts, for Cirne they are the wrong signs, for the wrong reasons.

What is a nation? Insofar as Brazil is concerned, the question is as old as the country itself. In the following discussion, our assumption will be that the Mônica strip cannot pose the question directly. This is not so much because, as a business comparable to the Disney Corporation, the MSP is engaged in representing its own world (distinctive characters, special nuances among them, particular aesthetic surfaces) as a "product" peculiar to itself. Mônica cannot directly embrace the question of national identity because as a comic expressly designed for children, Mônica proposes no challenge to the issues at stake in the construction of a people.

In their influential critique, *Empire*, Michael Hardt and Antonio Negri make a distinction insofar as a nation-state is concerned between a multitude and a people. In part, the distinction is one of tolerable differences; in a people, internal differences are eclipsed, "through the representation of the whole population by a hegemonic group, race, or class" (104). Our thesis will be that in the cartoons before us, internal differences have not entirely been eclipsed. (The MSP product even tolerates bits of risqué humor.) While its construction of childhood is indisputably implicated in issues of

representation (how could it not be?), the representation lacks the systematic sponsorship of a hegemonic group. In the final section of this discussion, we will make a distinction between the special, ideologically-driven category of MSP products, "Comics for a Cause," and the Mônica strip as it regularly continues to appear, apart from any "cause." For the most part, as a cartoon, Mônica is a singular specific instance of what we generally take to be a presiding truth about popular culture. John Fiske expresses it succinctly: "Popular culture is made from within and below, not imposed from without or above...There is always an element of popular culture that lies outside social control that escapes or opposes hegemonic forces" (2).

What Cirne takes to be, precisely, an imposition, we take to be an emergence. He misses a uniquely Brazilian dimension in Maurício's response to Disney because his formula for cultural dependency is based not only on a top-down model that fails to countenance the quite astonishing proliferation of comic strips, magazines, and serials generated under the auspices of the MSP. In addition, Cirne's formula misses entirely the specifically Brazilian valence in this proliferation, which we will attempt to explain in the next section, and then situate in historical terms after that.

A Star Is Born: Mônica and Her Gang

When Maurício de Sousa first sold the stories of a little blue dog, Bidu, and his owner Franjinha to the São Paulo newspaper *Folha da Manhã* in 1959, he was not actually inventing anything new, or breaking any ground. Indeed, the history of Brazilian comic strips is as long as the history of the genre in Western countries: on January 30, 1869, the first Brazilian serialized, drawn story was published. Its name was "As Aventuras do Nhô Quim"—"The Adventures of Mistah Quim"—and its author, the Italian Angelo Agostini. The character, Mistah Quim (whose name is a diminutive of Joaquim) is a simple man of the countryside. His adventures and surprises comprise the bulk of the stories.

This inaugural character as well as the fact that a foreigner was responsible for the beginning of the genre in Brazil can be said to accompany the story of comics in the country. Ninety years after the publication of "The Adventures of Mistah Quim," Maurício de Sousa's career begins and will therefore function as a kind of synthesizer of these two currents: the deeply Brazilian themes—embodied in the man from the countryside—and the foreign influences, as we have discussed above. It must be pointed out, however, that between Agostini and De Sousa, the history of Brazilian comics has featured an enormous amount of artists, each experimenting with different themes, different techniques, and different styles.[1]

What makes Maurício de Sousa's work special, and deserving of a separate discussion? Several factors solicit our attention. One of them is that Maurício de Sousa is the creator of not just one or even of a group of characters. He has created a series of different characters living in different places (some even "live" in a cemetery—the main character is Penadinho, a little ghost)

or different times (one of his most beloved characters is a dinosaur called Horácio). The number of characters increases any time Maurício (as he is called even by his employees) either imagines a new character, or receives a "suggestion" from a real-life person or situation that makes its way into the set of characters in the magazine. Another factor that makes De Sousa's work especially interesting in the Brazilian comic context is that, unlike other creators, De Sousa has managed to create and maintain the uninterrupted publication of his magazines since 1970, when the first *Mônica e sua Turma* was published. In 2003, Maurício de Sousa was called "o homem de um bilhão de revistinhas"—the man of one billion magazines.

In fact, the website of the corporation—an award-winning one—provides the most accessible testimony to the strip's distinctive authority as well as its vast scope. There are three categories: Sunday pages, comic strips, and serialized stories. The first of these gives a total of 337 examples of standard three-row panels (one or two panels in the first and last rows), divided into four main characters: Mônica herself, Cebolinha—"Chives"—called Jimmy Five in English, Cascão (Smudge, in English), and Magali, or Muggy, in English. This second category also contains over 300 examples, in the standard three-panel format for daily strips. The third category of serialized stories provides eight examples, followed by links to a dozen or more, under the umbrella of some nine characters, including, in addition to the "gang," new ones such as Billy, Tina, and Pitheco.

There is much more to the site: book publishing, sticker albums, an animation series, and a list of over a hundred examples of industries from toys to food products making use of the De Sousa Corporation licensing agreements. Most striking, however, is yet another category, derived wholly from the person of Maurício de Sousa himself, the Instituto Cultural. Under his name and image, there are over 150 stories, vignettes, and reflections, many with pictures of Maurício and his children, each written in the form of a personalized message, detailing various trips, thoughts, and whimsies. Each one testifies to the sole and enduring creative authority of one man, Maurício de Sousa, beaming over the comic-strip universe he has created throughout his life and the life he has made over into the comic-strip universe.

Nonetheless, the contrast with Disney is striking. How to explain it? We can suggest that the De Sousa world can remain as it is—still recognizably derived from its original comic characters—because it continues to be rooted in one spot. This spot has a name. Except for Chico Bento, who lives on a farm, all of Maurício's foundational characters live in the neighborhood called Limoeiro. The name of the neighborhood evokes a number of things in Brazilian culture: a folkloric song "Meu limão, meu limoeiro," which was popular in the 1960s, as well as the name of a small town in the state of Pernambuco. Furthermore, since "limoeiro" is the lemon tree, and this, in turn, evokes the ever-popular summer drink, "limonada," what we have is a name for the idyllic space of childhood itself.

Limoeiro is then, not so different from the Buenos Aires neighborhood of the character Mafalda created by the Argentine Quino in the sense that

it is a childhood space within the larger national space.[2] Just as Mafalda's neighborhood reflects Argentinian concerns at the time the cartoon was published, the space of Limoeiro reflects Brazilian concerns and situations. Take a story published in the *Almanaque do Chico Bento* 82, "Pra quando crescer"—"For When They Grow," a wordless narrative covering only two pages, illustrating the *caipira* Chico Bento leaving his home with a hammock and planning to spend the afternoon relaxing.[3] But wherever he goes, all the trees have been cut. He is visibly frustrated and sad. Instead of getting angry, he goes back home, returns to the place where the forest once was, and plants little trees. A thought balloon shows him as a grown man beside his wife, looking on as two children—obviously theirs—enjoy the grown trees, playing in a hammock.

How to read such a story? We prefer to comprehend it not so much as an example of bourgeois ideology—environmentalism doing duty for a more searching consideration of the ravages of capitalism—as an example of commonplace or venerable sentiments (about nature in this case) that saturate the magazines. These sentiments have more to do with traditional folklore than ideology. In his discussion of the formation of the National-Popular, David Forgacs emphasizes at one point that popular masses, excluded from high culture and "official" conceptions of the world, "process instead the unelaborated and unsystematic conceptions of folklore and common sense." In order to be hegemonized, these "strata," he continues, "must be addressed through a medium adapted to their different cultural positions" (186).

The MSP magazines provide just such a medium. However, children provide no such strata, which is why a strictly ideological reading of the cultural productions that have been designed for them is bound to seem heavy-handed. Perhaps there are no "children-as-such." Instead, there are only the cultural positions that await them. Nonetheless, the De Sousa productions neither align themselves with these positions so seamlessly nor adjust themselves to these positions so ideologically.

And what of Limoeiro? Consider a story from a 2004 magazine, "A noite das garotas"—"The Girls' Night," in which, at a certain point, the girls decide to camp inside the house. Mônica immediately dons a little handkerchief, starts sweeping the floor and impersonating the boss and the maid at the same time. The dialogue:

> — "Ó das Dores! O que me trouxe pro jantar?"
> — "Tem sardinha, vatapá, macarrão e caviar!"

> — "Hey, das Dores! What did you bring me for dinner?"
> — "There are sardines, vatapá, spaghetti and caviar!"

That is, in a Brazilian household, there must be a maid. Since, in this case the "maid" is sweeping the floor at the same time she is talking about the food she has brought, two things are implied: the maid not only cleans, but she also buys and cooks the food. Moreover, since "Vatapá" is a specialty of the Northeast of Brazil, this maid, (Maria) das Dores, is most likely an

immigrant from the Northeast, a very common event in the big cities of the Southeast, such as São Paulo and Rio de Janeiro.

Das Dores is, then, a very accurate representation of how many maids in Brazil take care of household chores. But how to argue that this representation, in turn, is not itself a justification of the institution of maids? (Much less of Brazil's class or racial system.) We recall Cirne's objection to Pelezinho, based on the assumption that a simple allusion to Pelé brings down upon the cartoon character's head the whole institution of racism. Once again, we would caution that registration of some portion of the social system does not immediately convert into an apology for it. More to our present emphasis here, registration of a maid merely functions as an example of the national imaginary, nothing more, especially since this imaginary is recreated by children for children within the more immediate social space of Limoeiro, which is at once suburban, familiar, and utopic.

Compare this to "The Girls' Night," a final, less subtle story from the *Almanaque do Cascão 79*. In "Ao gosto do freguês"—"According to the Customer's Taste," Cascão—the eternally dirty boy—discovers that his little piggy bank is empty, and "ainda falta meio mês pra receber minha mesada"—"it is still half a month away from my next allowance." Although this is a fairly common problem faced by children of other countries, the way Cascão solves his problem seems to us as much part of the Brazilian national imaginary as the institution of maids from the Northeast: he fills an old bag with things he finds in his house and then goes to the street to sell them. If we consider the actual social conditions of street vendors in urban Brazil, who are not working simply to fill up their piggy banks, we can understand the function of a different, more ideal social space, where "the street" exists to console rather than to structure the inadequacies of the home. "Limoeiro" is the name we would give both to the genealogy of this story as well as to its own peculiar operation.

It is, we would again contend, beneath ideology, or, at most, prior to it—as we can see if we compare this last story to the eternal search for profit by the character Manolito of *Mafalda*. Manolito, we recall, works with his father in his grocery store, and has a fixed idea about his future as a businessman. He works and saves, and calls Mafalda's baby brother "unproductive," because the baby does not work. But Manolito works out of a bourgeois need to "grow" professionally, to inhabit his father's business as fully as possible. His goals for the future are grandiose, because he believes he has a future in which his ability to sell and to save makes sense. That is, he has a system, and so the humor that attends his project makes satiric fun of it.

What we note in the Brazilian instance is precisely a lack of satire. Cascão, in such contrast, is more markedly a child, whose immediate need to get some money is its own end result. He has no project, and his need, if rather inescapably implicated in capitalist economy, is not subjected to any systematic comprehension. Indeed, as the reader learns at the end of in "Ao gosto do freguês," the money Cascão makes after so much wheeling and dealing is quickly spent when it rains and he has to buy an umbrella. Once more,

nature finally becomes a more decisive force than culture. Thus, the comic deflation here is folkloric in character, rather than ideological in any strict or exacting sense.

Limoeiro marks the difference. There is nothing quite like this space in *Mafalda*, and there is certainly nothing like this space in Disney, whose project, from the very outset, was designed to appropriate other imaginative spaces, other cultural narratives, and other means of production. Jack Zipes notes how—to take a single example—with "Snow White," Disney became successful at "[making] his signature into a trademark for the most acceptable type of fairy tale in the twentieth century" (34). How did he succeed? By transforming the story into "something peculiarly American" (36). (Snow White becomes an orphan, the Prince ceases to play a negligible role, the dwarfs are individualized, and so on.) In contrast, De Sousa to this day continues through the strip to tell the same Brazilian fantasy story of Mônica and her friends, rooted in the same space (filled with ghosts, maids, and umbrellas), lovingly revisited and recounted most recently for a very special anniversary.

A Forty-Year-Old Little Girl in the Land of Cannibalism

The 2004 special issue for the commemoration of the fortieth anniversary of the creation of Mônica provides a most clarifying look into not only the history of the creation of the character and her gang, but also into the mechanics of the production of the magazines. The preface to the magazine, signed by Maurício de Sousa himself, says, "Forty years ago, a small group and I worked in the project of the *Revista da Mônica*. I never ever entertained the possibility that it might not work." In the following paragraphs, De Sousa gives an upbeat history of how he "put the characters in the world" so that they could "tell funny stories and sometimes teach something." De Sousa says that in these 40 years he and his group "have been able to put together a cultural phenomenon unique in the world, with its own philosophy, original drawing style, and a lot of personal satisfaction for me and for everyone who works with me." It is abundantly clear, from this preface, that De Sousa is the head of the organization that produces the magazines and other artifacts, and that his is a paternalistic company. It is not surprising that the main character, Mônica herself, has been modeled after his own eldest daughter. But she was not the first character ever created by Maurício.

According to Maurício de Sousa's biography posted in the site of the Turma da Mônica, when he first came to São Paulo from the town of Mogi das Cruzes, he tried to sell his drawings to some newspapers, but was not successful. Instead, he took a test to be a police reporter in the newspaper *Folha da Manhã* (Morning Paper), was approved, and became a reporter in 1954. In 1959, he showed some of his drawings to some journalists in the same newspaper. The rest, as it is said, is history: the newspaper lost a reporter and gained a cartoonist, who contributed strips featuring the adventures of a

boy called Franjinha and his dog Bidu. After these two characters, De Sousa created others such as Cebolinha, Piteco, Chico Bento, Penadinho, Horácio, Raposão, Astronauta. By the end of the 60s, these characters appeared in about 200 newspapers, thanks to the company that De Sousa created to make sure the strips were properly distributed. After the strips in the newspapers, the text states as follows,

> chegou o tempo das revistas de banca. Foi em 1970, quando *Mônica* foi lançada já com tiragem de 200 mil exemplares. Foi seguida, dois anos depois, pela revista *Cebolinha* e nos anos seguintes pelas publicações do *Chico Bento*, *Cascão*, *Magali*, *Pelezinho* e outras.
>
> It was time for the magazines to be sold separately. It was in 1970, when *Mônica* was issued with an initial run of 200,000. It was followed, two years later, by the publication of *Cebolinha*, and in subsequent years by *Chico Bento*, *Cascão*, *Magali*, *Pelezinho*, and others.

Each one of these characters has special characteristics. Cebolinha (Jimmy Five) is the boy who cannot pronounce the sound of "r" and is always getting in fights with the strong Mônica over the control of the neighborhood. Chico Bento is the country boy, the *caipira*, who speaks a kind of hillbilly Portuguese; Cascão (Smudge) is Cebolinha's best friend, and the character who does not like to shower ("cascão" means "dirty crust"); Magali (Muggy) is Mônica's best friend, who likes to eat all the time; Pelezinho is the soccer player named, of course, after Pelé.

The most ostensibly Brazilian aspect of the adventures of all these characters—besides the occasional cart pushed by an ice-cream vendor—is that each appears in Portuguese, uttering common idioms, popular sayings, characteristically national jokes (even some off-color ones, such as the one involving a female ant and a male elephant, Rita and Jotalhão). But there is more: the presence in recent decades of international popular culture icons and films, which intermingle with the Brazilian characters, in a sometimes disconcerting flattening cultural location as well as in time and space.

Take, for example, the case of the story published in the special issue commemorating the fortieth anniversary of the magazine. In the opening image, which takes two-thirds of the page, we see Mônica—or, rather, we recognize her by the characteristic big front teeth and furrow of black hair—wearing night-vision goggles, earphones, and a black wet-suit, coming down from a cord, speaking in code, "echo para echo Charlie echo Delta! Afirmativo?"— "Echo to Echo Charlie Echo Delta! Do you read me?" Starting from the fact that Mônica's outfit is completely different from her usual little red dress, and continuing both with the big-city setting represented by the skyscrapers in the background and with the "spy-speak" that Mônica is employing here, the reader knows that the contact to be made is not with anything Limoeiro represents, but with the spy movies and TV shows that children watch in Brazil.

Because the name "Charlie" appears in Mônica's speech, the reference is to "Charlie's Angels," a U.S. show regularly presented in the afternoon

in Brazilian television; the extra-magazine reference can be presumed to be almost global in nature. As this specific story progresses, it turns out that the members of the "Turma da Mônica" are in São Paulo to visit the studios of the Maurício de Sousa Produções. They themselves are soon back to their usual outfits and proceed to visit the studios and present the artists to the reader.[4] Similarly, one can find international figures such as Michael Jackson (called "Maicou"), or direct mention to films, such as in the "Horacic Park" adventure, (in which the "Brazilian" dinosaur Horácio defeats the Tyrannosaurus Rex without losing his characteristic kindness), "Coelhada nas Estrelas"—"Rabbit Hit in The Stars" (a parody of Star Wars), "Batmenino Eternamente"—"Eternally Batboy"—and "Comandante Gancho"—"Captain Hook."

We can of course explain the presence of these icons through popular culture itself. Not only is Mônica part of it; it is part of Mônica. Moreover, popular culture is global; no longer can Limoeiro either contain or prevent it. In Brazil, from the 7,000 existing TV sets in 1950, now just about every household in the country has at least one set.[5] A substantial percentage of Brazilian TV time is occupied by what is called the "enlatados"— the "canned stuff"—that comes from U.S. television, usually re-runs of old shows such as "Bonanza," "Zorro," "McGiver," as well as "Charlie's Angels." Direct broadcasts of the Oscar ceremonies or the Miss Universe pageant have been possible for years, and the existence of cable networks in recent years has changed the nature of television viewing even more. On the basis of television alone, it is not surprising, therefore, that the Turma da Mônica stories would reflect this massive presence of international—read usually "American"—popular culture.

Therefore, it is more surprising that despite this presence the imaginative space of the characteristic MSP "product" continues to function under the sign of Limoeiro. We see this even in the universes of the characters who are not strictly related to Mônica and her Gang (and who are thus free from global pop reach), such as the little Brazilian Indian "Papa Capim," who lives in a tribe, and not in a city. Another example: "Penadinho," and his cemetery-dwelling friends. There are also the characters that live in pre-history, and even the characters that live in the dinosaur age, including Horácio, a lettuce eater. All these characters, no matter where and when they are set, live in a community governed by the same laws of the neighborhood under which Limoeiro functions—benign daily misunderstandings on the order of perhaps the most enduring action that occurs in the Mônica strip: Mônica comes upon Jimmy Five tying together the ears of her little blue rabbit, Samson, and proceeds to beat him up.

Waldomiro Vergueiro argues otherwise on this point. For him,

> Apesar do seu feito poder ser considerado uma vitória para os quadrinhos brasileiros, é também necessário reconhecer que, a fim de se tornar um grupo de personagens com características universais, A Turma da Mônica deixou o meio ambiente brasileiro quase que completamente de fora de suas histórias.[6]

Although [Maurício's] important feat can be considered a victory for Brazilian cartoons, it is also necessary to recognize that, in his effort to create a group of characters with universal characteristics, the Turma da Mônica left the environment of Brazil almost completely out of its stories.

According to Vergueiro,

> Maurício também salientou esse mesmo aspecto, em entrevista que concedeu ao Núcleo de Pesquisas de Histórias em Quadrinhos da USP, em março de 2005...nessa entrevista Maurício salientou que, na realidade, para criar seus personagens, ele analisou o mercado e verificou a tipologia dos personagens que faziam sucesso na época. Desta forma, foi criando personagens que pudessem concorrer com eles. Para concorrer com a Luluzinha, criou a Mônica; para o Brucutu, criou Piteco; para o Gasparzinho, criou o Penadinho, e assim por diante.[7]
>
> Maurício also stressed this same aspect in an interview given to the Núcleo de Pesquisas de Histórias de Quadrinhos of the University of São Paulo in March of 2005...in this interview Maurício said that, actually, to create his characters, he analyzed the market and checked the typology of the characters that were successful at the time. This way, he started creating characters that could compete with them. To compete with Lulu, he created Mônica; [to compete] with Brucutu, he created Piteco; with Casper, he created Penadinho, and so on.

In other words, for Vergueiro, the whole MSP project is a response to international pop culture. On the contrary, we would argue that the presence of the global prototypes in Maurício's stories become merely another dimension of a specific Brazilian model of cultural production, and we can see this particularly when specific allusions are made to cultural products that have not yet been assimilated inside the country. How to do so? Or rather, we will argue, how not to do so, according to the pattern established by intellectuals in the 1920s, who recognized and embraced what they called "cannibalism." Cannibalism, in turn, established an available model for appropriation of all manner of foreign influences and cultural forms during subsequent decades.

Transmutation, or a Game of Marbles

In an interesting discussion of EPCOT's Magic Eye Theatre fifteen-minute 3-D Michael Jackson production, "Captain E/O," Ramona Fernandez mentions how fitting its theme of transmutation is to the whole Disney enterprise. In fact, she contends, E/O, in his white spacesuit, cape, and white gloves "appropriates Mickey's persona in "The Sorcerer's Apprentice" segment of *Fantasia* (1940) and, by extension, appropriates the persona of Walt himself" (246–247). Precisely. Disney—the man, the corporation, the production process—proceeds to this day through transmuting whatever it touches. So the comic strips turn into animated cartoons, which become feature films that are transformed into television series, which metamorphosed into theme

parks, computer software, and model cities. And so the world's narratives are Disneyfied, from *Snow White and the Seven Dwarfs* to *The Little Mermaid*, *The Hunchback of Notre Dame*, and *Mulan*.

Transmutation may constitute the fateful theme of any comic strip that grows to sufficient size, commodifies itself, and seeks entry—if only by default—into the larger global stage of cultural production. Once in that world, the story and its transformations become available for further appropriations that may be quite different from the original. In the case of Maurício's response to Disney, we can take, for example, the serialized story that appears in the "Turma da Mônica" home page, titled "Mônica, a sereia"—"Mônica, the Mermaid," dated 1996. Any attempt to read Disney's "The Little Mermaid" in this story is frustrated. Mônica finds a little mermaid crying by the side of a river, and exchanges places with her so that the mermaid can go after her true love, a young boy she saw on the margins of the river. Soon Mônica is bored with her experience as a mermaid, and her friend Magali informs her that the mermaid is after Mônica's own love interest, Renatinho. When Jimmy Five and Smudge find out that Mônica is now a mermaid and therefore cannot leave the river, they begin teasing her.

To make things worse, a man appears with a net, catches Mônica, and puts her in an aquarium in order to sell her. The friends try to prevent it, but the only one who can do anything is the original mermaid. As soon as Mônica is back to her own self, she punishes the greedy man and finds a way of throwing Jimmy Five into the river, in order to make him pay for teasing her while she was a mermaid. If we recall the Disney story, many cute creatures surround the little mermaid, while she pursues her dream of becoming a girl and marrying her true love. Is there an American text here—the little mermaid akin to so many immigrants who come to the United States and have to lose their national and cultural characteristics in order to become part of the nation? If so, in the Brazilian version, neither the girl nor the mermaid ever truly becomes the other. Instead, the main victory obtained by the joint effort of the mermaid and the children is the defeat of the man who wanted to sell Mônica.

But the peculiar MSP transmutations are not done only with Disney's material. Another of the serialized stories, "Lendas do folklore"—"Folkloric Legends," which also appears in the web section of serialized stories—makes a clear reference to the comparisons between the more "scary" stories children are familiar with through television, and Brazilian folkloric tales. The story depicts Smudge, Magali, and Mônica sitting in front of the television and some character in the show declaring "I want your blood!" At the same time there is thunder while Jimmy Five suddenly enters the house. The kids are startled by the thunder. He is afraid neither of the thunder nor of the content of the story. In fact, Jimmy Five is not afraid of anything: when Mônica brings in a book of Brazilian folk tales, he proceeds to mock each one of the characters while Smudge and Magali continue to be scared.

In the end, Mônica grows tired of Jimmy Five's lack of respect for the tales, and hits him with her blue rabbit Sansão, while Smudge concludes that

Jimmy Five is only afraid of the Legend of the Blue Rabbit. In other words, the whole universe of the folkloric—founded on fear and sustained by superstition—is simply banished. Mônica and her friends never really leave their known universe. Not only does a periphery of creatures again fail to acquire a dimension of distinctiveness, they also lack Disney-driven "cuteness." In addition, this particular "legend" becomes a species of comic mockery; the older, rural-based culture survives within a newer, urban culture, but its power has been transformed through television.

As Anne Rubenstein notes in her history of Mexican *historietas*, control of comic strips in Brazil, unlike Uruguay, Venezuela, Colombia, and Peru (and more like Argentina, Chile, and Mexico), did not mean control of foreign imports (169). Brazil possessed a comic book industry of its own. More important, appropriation of the outside in all its many guises could take place according to a theoretical formula. In the 1920s, with the explosion in the literary scene of the "Cannibalist Manifesto," the nature of the inevitable appropriation—or cannibalization—of outside models was clearly not only admitted, but also advocated by the Brazilian intelligentsia of the time. This process, according to the members of the group "Pau Brasil"—"Brazilwood," which included most of those behind the "Cannibalist Manifesto"—was in fact nothing new to Brazilian culture, which had been at once constituted and recreated as such since the beginning of European colonization.

However, these ideas did not arrive in Brazil "unmediated," and they did not become disseminated "intact" either. In other words, just as the stories based on classic literature of Western culture become "translated" in the pages of the *Turma da Mônica* stories, the theories—scientific, philosophical, aesthetic—that reached Brazil already arrived changed. Or, as Roberto Schwarz argues, in his well-known essay "As idéias fora do lugar"— "Misplaced Ideas":

> In the process of reproducing its social order, Brazil unceasingly affirms and reaffirms European ideas, always improperly. In their quality of being improper, they will be material and a problem for literature. The writer may well not know this, nor does he need to, in order to use them. But he will be off-key unless he feels, notes and develops –or wholly avoids—this aspect. (29)

The writer, in the case of the stories of the "Turma da Mônica" is Maurício de Sousa. Take his particular reading of "Romeo and Juliet," issued in 1996 and published as a serialized story on the home page (available in Portuguese as well as in English). Here, befitting a story for children, the characters Mônicapuleto and Cebolinha Romeu Montéquio get married, but never die. Instead, Mônicapuleto becomes very upset with Shakespeare upon reading the end of the story, and decides to "pay a little visit" to Prince Xaveco, who had expelled Romeu from the city. She beats him up with her infallible blue rabbit, and he consents to allow Romeu to stay in town, and return to his bride. Romeu, however, is more interested in a game of marbles that he played with the other boys.

What we have in this story is a "translation" of the classic Romeo and Juliet into the economy of Limoeiro, even though the existence of Shakespeare, and the end of the original drama, are both mentioned (albeit challenged and finally changed). With the child-aged characters playing the main roles and determining, in the end, that the story should have a happy ending more to the taste of the young readers, what we do not have is a Disney version, in which the venerable narrative is repossessed wholesale, subjected to an ideological overhaul, and returned to a putative film or video audience consisting of adults as well as children. The refusal of this version, in turn, becomes a prior condition for the new version to become something else.

MÔNICA POWER

One of the more infamous pronouncements ever made about Disney, or rather Disneyland (which is usually understood by critics of Disney to be its best and truest fruition) occurs in Jean Baudrillard's celebrated theoretical discussion, "Simulacra and Simulations." Baudrillard makes the following statement: "Disneyland is there to conceal the fact that it is the 'real' country, all of 'real' America, which is Disneyland" (172). Of course any fantasy construct of childhood—that of Mônica and her gang no less than that of Mickey and his friends—must necessarily enter into a contract with the actual world, whereby real problems are admitted only very selectively. Nonetheless, our argument has been that the nature of this contract is finally quite different when we compare MSP to Disney.

To answer the question with which we began: Mônica and her gang may have outgrown the pages of a daily newspaper, yet imaginatively they still remain inside those pages. Furthermore, even if the cartoon has only the slightest ideological nuance, it still possesses a recognizable social character, which we have termed, after its original suburban neighborhood, Limoeiro. What would happen (we might ask) if the idealized character of Limoeiro were to be not only expanded to global scale but extended into the actual social world of poverty and crime, or electricity problems and health risks?

As it happens, we do have an example of this extension: the highly visible campaigns associated with the MSP-sponsored "Comics for a Cause." The subjects of the campaigns include vaccination, road etiquette, cardiac health, smoking, and child pornography. These campaigns are always developed in partnership with Brazilian governmental and even international institutions. The one for cardiac health—to take one example—was the result of a 1987 visit to Maurício de Sousa by Beatriz Campagne, director of the project Heart Power, sponsored by the American Heart Association. The campaign developed in two sectors: with the children, explaining the dangers of smoking and the need for exercise and a healthy diet; and with training physicians, supervised by medical school professors.

The background of the stories always features *Turma da Mônica* characters. In "Healthy Maternity," we accompany Mônica as she helps her cousin Rebeca accept her future little brother, and, in the process, discloses the need

for special food and care for the expecting mother. In another story, "The 'A to Z' Care of the Baby," Cebolinha and Cascão "interview" Mônica's mother about their friend's early childhood. The original intent of the boys is to find out why Mônica became so strong. By the end they learn about the importance of mother's milk, proper hygiene, and vaccination. And so on. All of the stories are eminently practical in nature. In effect, they reveal at least two things about the cartoon universe: how close it has always been to actual lived social life and how distant it has been from overt ideological design.

One story is especially compelling in this regard: the "Manual sobre as Doenças Cardíacas"—"Manual on Cardiac Illnesses"—which can be seen as the most surprising story. Its opening page shows the baby nursing at the mother's breast. The balloon with the mother's words has the following text:

> Hello there! This manual is designed to help orient the parents of children with heart disease, from the baby's first days of life until adolescence. Did you know that good nutrition is fundamental for the growth and development of a child with heart disease? And that it also makes recuperation from surgery easier and it helps protect the child from infections? Interested in learning more? Then turn the page, because we have a lot to talk about, ok?

In colorful pages sprinkled with images of Mônica and her pals in their early childhood, the story covers the basic care for children with heart disease. The language is not the same used in the cartoons; this is an informational brochure that was distributed throughout Brazil, and its immediate readership is comprised of young parents who may be trying to come to terms with the difficult reality of the need of special care for ill children.

Ideology? The word can be invoked if one likes. Certainly, none other of the MSP products contains such pointed, specific social reference as each of these "Comics." However, we would prefer to see the manuals differently. Viewed within the context of the whole Maurício project, each of the "Comics for a Cause" becomes readable as an example of what can only be called utopian representation. In other words, they demonstrate, real social problems **can** be solved. Cultural production **can** be made to serve the ends of the people, especially people who require the rudiments of instruction about basic matters of public health. Questions of class **can** be at least momentarily set aside, while notions of hegemony seem idle when set beside infected children.

Our theoretical orientation points to a classic article on popular culture, Frederic Jameson's "Reification and Utopia in Mass Culture." Jameson tries to isolate the "utopian" moment in the study of popular culture, and to emphasize its necessary operation within some larger and more strictly (or harshly) ideological framework: "works of mass culture cannot be ideological without one and the same time being implicitly utopian...they cannot manipulate unless they offer some genuine shred of content as a fantasy bridge to the public about to be so manipulated...such works cannot manage anxieties about the social order unless they have first revived them and given them some rudimentary expression" (144).

Thus, the "Comics for a Cause," which appear to be at variance with the rest of the MSP enterprise, instead become continuous with it. Exactly in Jameson's terms, each of these texts strives to provide the "content" without which the "fantasy" of the Mônica cartoon cannot in some way function. One can disagree about the degree of ideological "manipulation" involved in the cartoon, but not, we believe, fail to grant its thorough, consistent utopian character, whether the social ground is conceived of as an imaginary Limoeiro or as the actual Brazil. Indeed, to the considerable degree that this character is the product of one man, Maurício de Sousa, we can understand something more: the optimism of the MSP project, from its very outset; Maurício writes in the preface to the fortieth anniversary issue of Mônica that he never contemplated the possibility that the project might fail.

We propose a final comparison with Disney: such optimism, we feel, can be most fully appreciated by being distinguished from what can only be termed as Disney's cynicism. It is one thing to educate children and their parents as citizens. It is quite another to appeal to them as consumers. "Disney's view of children as consumers has little to do with innocence," writes Giroux, "and a great deal to do with corporate greed and the realization that behind the vocabulary of family fun and wholesome entertainment is the opportunity for teaching children that critical thinking and civic action in society are less important to them than the role of passive consumers" (158). On the other hand, De Sousa can give over the universe of Mônica and her gang to society because he appears to conceive of it in utopian terms, as worthy of education rather than simple exploitation.

There is nothing in the history of Disney like "Comics for a Cause." The Disney Corporation does not conceive of itself as having an educational purpose. Moreover, unlike MSP, Disney does not ultimately concede the society in which babies are born or children have serious illnesses to have a separate existence at all—at least according to the effective rationale of its business practice. To conceive of it as having a separate existence would be to imagine extending to it some utopian comprehension. Instead, as Baudrillard emphasizes, the "Disney imaginary" is "meant to be an infantile world, in order to make us believe that the adults are elsewhere, in the 'real' world" (172).

In the MSP imaginary, on the other hand, adults are here with their children; their presence, together, is perhaps the most important reason why the difference between fantasy and reality holds in the world of Mônica and her gang, and is not subject to some species of Disney reversal. Aside from this difference, the MSP can act to intervene in a quite identifiably Brazilian reality, and attempt to lend practical assistance to some of the nation's ills. The "Comics for a Cause" are comics. However, in addition, they have the inestimable virtue of demonstrating to us that comic strips do not have to purchase their peculiar power—"Mônica's power"—at the expense of the actual social world. Instead, they remain accountable to this world.

Notes

The authors would like to thank MSP for its initial help in the project. Permission to reprint certain images was given and then subsequently withdrawn. Our readers are free to make what they will of this fact. It has not influenced our discussion or prompted us to revise it.

1 Moacy Cirne writes that, in fact, the beginning of the serialized story can be pushed back to 1867 and 1868, when the same Agostini already published some work that can be considered a precursor to the cartoon as we understand it (16).
2 See Héctor Fernandez L'Hoeste's discussion of Mafalda in *Imagination beyond Nation*.
3 "Caipira" is a term originated from a cultural group residing especially in the interior or the state of São Paulo and in the south of the state of Minas Gerais. Because the "caipiras" are usually rural people without easy access to formal education, the term ended up become synonymous with "hillbilly," "uneducated," "ignorant." Maurício de Sousa was raised in the interior of São Paulo, and his character Chico Bento reveals his fondness and understanding of the philosophy and moral stance of the "caipira." For a thorough discussion on "caipiras," see Antonio Cândido's *Os parceiros do Rio Bonito*.
4 *Mônica 40 anos. Edição comemorativa*. 2004. The pages of this magazine are not numbered.
5 The number is given at the site called *História da TV*, http://www.tudosobretv.com.br/historv/tv60.htm#, checked on July 9, 2005.
6 Vergueiro, "A odisséia dos quadrinhos infantis brasileiros: Parte 2: O predomínio de Maurício de Sousa e a Turma da Mônica." *Revista Agaquê*: http://www.eca.usp.br/agaque/agaque/indiceagaque.htm.
7 Personal communication of June 27, 2005.

Works Cited

Bueno, Eva Paulino, and Terry Caesar. *Imagination beyond Nation, Essays on Latin American Popular Culture*. Pittsburgh: University of Pittsburgh Press, 1999.

Cândido, Antonio. *Os parceiros do Rio Bonito; Estudo sobre o caipira paulista e a transformação dos seus meios de vida*. Rio de Janeiro: José Olympio, 1964.

Cirne, Moacy. *História e Crítica dos Quadrinhos Brasileiros*. Rio de Janeiro: Ed. Europa, FUNARTE, 1990.

Couperie, Peter. *A History of the Comic Strip*. New York: Crown Corporation, 1968.

De Sousa, Maurício. *Navegando nas letras*. Rio de Janeiro: Editora Globo, 1999.

Dorfman, Ariel. *The Empire's Old Clothes*. New York: Pantheon Books, 1983.

Dorfman, Ariel and Mattelart, Armand. *How to Read Donald Duck. Imperialist Ideology in the Disney Comic*. London: International General, 1975.

Fernandez, Ramona. "Pachuco Mickey." In Bells, Haas, and Sills, eds.

Fernàndez L'Hoeste, Héctor. "From Mafalda to Boogie. The City in Argentine Humor." In: Eva Paulino Bueno and Terry Caesar, eds., *Imagination beyond Nation, Essays on Latin American Popular Culture*. Pittsburgh: University of Pittsburgh Press, 1999.

Fiske, John. *Reading the Popular*. London: Unwin Highman, 1989.

Forgacs, David. "National, Popular: Genealogy of a Concept." In: Simon During, ed. *The Cultural Studies Reader*. New York: Rutledge, 1993.

Giroux, Robert. *The Mouse That Roared. Disney and the End of Innocence*. Lanham, Maryland: Rowman & Littlefield, 1999.

Hardt, Michael and Antonio Negri. *Empire*. Cambridge: Harvard University Press, 2000.

Jameson, Fredric. "Reification and Utopia in Mass Culture." *Social Text* 1 (1979): 130–141.

L'Hoeste Fernandez, Héctor. "From Mafalda to Boogie. The City in Argentine Humor."

Rubenstein, Anne. *Bad Language, Naked Ladies, & Other Threats to the Nation. Political History of Comic Books in Mexico*. Durham: Duke University Press, 1998.

Schwarz, Roberto. "As idéias fora do lugar." *Ao vencedor as batatas; forma literária e processo social nos inícios do romance brasileiro*. São Paulo: Duas Cidades, 1977: 13–28. English translation: Misplaced Ideas. Essays on Brazilian Culture. Edited and with an Introduction by John Gledson. London: Verso, 1992.

Vergueiro, Waldomiro. "A odisséia dos quadrinhos infantis brasileiros: Parte 2: O predomínio de Maurício de Sousa e a Turma da Mônica." *Revista Agaquê* 2.2 (October 1999) at http://www.eca.usp.br/agaque/agaque/indiceagaque.htm (July 9, 2005).

Zipes, Jack. "Breaking the Disney Spell." In Elizabeth Bell, Lynda Haas, and Laura Sells, eds., http://www.Mônica.com.br/index.htm—February 2005, 21–42.

Condorito, Chilean Popular Culture and the Work of Mediation

Juan Poblete

This chapter will focus on *Condorito*, one of the most successful and internationally renowned Latin American comics. It will attempt to provide an analytical overview of the development of this comic strip from its national origins to its later international and transnational production, distribution, and consumption. It will link *Condorito* with its roots in Chilean popular culture and will contend that *Condorito* also exemplifies the transition from individual authorship to the process of industrial creation of a successful product in/for the market. Throughout the chapter, my major contention will be that the popularity of *Condorito* owes a great deal to its ability to dramatize and perform a *longue durée* historical process: the modernizing development of Latin America and, in particular, the formation of its urban cultures. This "popularity" of *Condorito* represents a crucial point at the intersection of two meanings of "lo popular." In *Condorito*, "popular" is both "of the people", i.e., referring to the cultural ways of the poor who have historically accounted for the vast majority of Latin Americans, and "enjoying a degree of popularity" within mass mediated urban culture. An important hypothesis here will be that *Condorito* is one of the cultural spaces where that historical intertwining occurs successfully.

This appeal rests partly on *Condorito*'s setting. Pelotillehue, the fictional town where the comics' action takes place, is in fact endowed with the capacity of permanently absorbing modernity while keeping its perfect balance of rural and urban life. In Pelotillehue, things are always changing while nothing really changes. As such, it represents the perfect blend of tradition and modernity that has remained so elusive and challenging in the continent's history. In a more specific sense, *Condorito* holds the promise of a perfectly balanced national-popular culture, wherein *lo popular* has been constituted as the hegemonic national force. In his world, the elements and sensibilities of an older but fundamental popular-agrarian substratum of Chilean culture

interact functionally with a newer mass-mediated urban stratum. This utopian strand manifests in Condorito himself: always and simultaneously in search of employment and adventure, working on and off in various jobs while enjoying a very active life of friendship with an extended cast of secondary characters in bars, the practice of sports, the courting of women, Condorito embodies the ideals of a longstanding model of popular masculinity in Latin America. Within this model, some friends are pals forever, enemies are annoying but eventually non-threatening or neutralizable, while women are divided into beautiful, young, and conquerable, or old, ugly, and aggressive. Condorito's ability to survive, if not succeed, to confront the powerful with the weak's lateral resources of tactics (mostly, but not exclusively, wit and humor), are of course an important part of the character's cross-class popular appeal. Enrique Lafourcade has called him "la expresión mas rica del hombre medio chileno" (the most accomplished expression of the regular Chilean citizen"), where *medio* can be both average and middle-class. In Communist writer Volodia Teitelboim's words: "[Condorito] is the symbol of the shrewdness, warmth and vivaciousness of the *hombre del pueblo* [working-class man]. He is the archetypical funny Chilean, who confronts all adversities in life with grace and humor. That is why it's one the greatest creations of the national spirit."[1] Always popular, Condorito embodies in truly exemplary a fashion the process through which *lo popular* becomes mass-produced and consumed, while modernization takes the form of a constant "mediation" between longstanding residual cultural elements and newer ones, brought in and developed by the mass-mediatization of Latin American societies.[2]

Created in 1949 by a young artist, René Ríos Boettiger (1913–2000), better known as Pepo, *Condorito* has had at least three clearly discernible periods. Kenneth Macfarlane and Jorge Montealegre have divided the history of *Condorito* in three stages. The original one is from its beginning, in 1949, to about issue number 50. It is, despite the help provided by a series of collaborators, mostly controlled by Pepo's own personal artistic impulse. The second transitional period is marked by the disappearance of some characters (Chuleta and Titi Caco) and the incorporation or transformation of others (Condorito stops smoking; Yayita becomes more sophisticated). The third stage is a phase of universalization, which starts with issue number 84. According to Macfarlane and Montealegre, at this point, Condorito stops being specifically and exclusively Chilean and himself (always representing the same clever *roto chileno*) Instead, it acquires, not so much the ability of interpreting other characters, such as doctors, policemen, Robin Hood, Batman, Tarzan, etc. (something he had done before), as the tendency to mostly do so.

First Stage: The Origins

Condorito sees the light on August 3, 1949 in a vignette published by Pepo in *Okey*, a magazine owned by the Zig Zag publishing company. In 1955,

given the success of the character, Pepo compiles the first traditional anthology with 96 pages of these sporadic one-page jokes, published since 1949. From that point on, until 1961, Condorito will appear periodically, in the magazine, and yearly, as a compilation. By 1962, these editions become biannual. In 1968, three are published; in 1975, four. In 1980 and 1981, six issues are published each year. By 1982, *Condorito* appears nine times a year and, by 1983, it becomes biweekly. In the process, the publication has switched ownership three times: from Zig Zag to Andina and, finally, to Televisa, the Mexican transnational multimedia company. Moreover, *Condorito* appears in a monthly "Golden Book" and a collector's bimonthly edition, as well as in some attempts to branch out some of its characters independently, such as Coné (Condorito's nephew), in additional publications. If the strip's modus operandi and even some of its cast members and basic narratives (Coné does not seem to have parents; Condorito is eternally dating Yayita) resemble those of Disney's Donald Duck stories, it is not by accident. Pepo told many times of how, after seeing Chile's second-class (mis)representation as Pedrito, a little airplane incapable of going over the Andes in Disney's *Saludos Amigos* (1942) documentary, he decided to create a truly national alternative. (Ulibarri, 48) The anecdote, repeated countless times, is nothing but innocent.

As part of the interwar effort to neutralize Nazism in the 1930s, the U.S. administration presided over by Franklin Delano Roosevelt created the Office of the Coordinator of Inter-American Affairs within the motion picture section of the State Department. "Its declared purpose "was to 'show the truth about the American way' and, to that effect, it hired Hollywood studios to engender propaganda geared to fulfill the promise of the Good Neighbor policy (Roosevelt's name for the US's Pan-American policy)" (Piedra, 148). One of those Hollywood studios was Disney's. Julianne Burton adds the following seeming paradox: "while Disney's South American project was (...) built upon a self-conscious disposition formulated at high levels of national government to represent Latin being, culture, and experience with authenticity and respect for intraregional as well as interregional variations," in a series of educational documentaries and a trilogy of films, which include *South of the Border with Disney* (1941), *Saludos Amigos* (1943) and *The Three Caballeros* (1945), it ended up representing—through a highly developed refashioning—a complete ideological metropolitan repackaging of diverse raw material. In *The Three Caballeros*, this effort reached, through a particular kind of return of the repressed, the status of a full-blown "allegory of first world colonialism." Burton concludes: "Disney's gift of intercultural understanding turns out to be the act of packaging Latin America for enhanced North American consumption" (Burton, 1994:133–146).

In this sense, it would be a mistake to consider Pepo's re-telling of the origins of Condorito as simply an anecdote, which could or couldn't have happened. There is a certain historical necessity in the story, also manifested in the origins of other Latin American cartoon figures. Simply put, in the midst of early mass-mediatization of Latin American societies, any national

creation was likely to be the reactive or negative result of a visual and techno-logical scape (in Arjun Appadurai's sense of a dominant configuration) con-stituted by the hegemonic forms. But it surely was not just that. At the very least, the following question must be asked: if, despite Disney's explicit task of producing a more realistic and positive representation of Latin American culture in all its specificity, his studio ended up reproducing many of the cul-tural stereotypes that constitute the colonial imaginary, i.e., if in spite of their efforts, the Disney team expressed a political unconscious that always already framed what they could accomplish, what then is the content of the political unconscious manifested by Pepo's gesture, what cultural imaginary, with its mix of utopian and dominant perception and desires, is thus receiving its expression in the creation of Condorito? In its original form, as published in *Okey*, Condorito emerged in the middle of a historically complex visual con-text. Along with the mostly U.S. syndicated comic strips, such as Mandrake, Flash Gordon, Zoltan, or Alias the Rocket, there are multiple adventures by the Italian Emilio Salgari, hybrid drawing-photo stories, and classic *foto-novelas* (both American and local). Within this palimpsest, which already reveals multiple historical layers, some of which date back in their popularity to at least the late nineteenth and the early twentieth century, Condorito adds another form of interaction between the visual and the written. Latin America has endured a long history of interfaces, which, connecting word and image, make the former available to a broader section of the always par-tially alphabetized population. This history includes, in the specific case of Chile, the *hojas sueltas* (popular urban broadsheets) of the late nineteenth century, along with what later became *la prensa amarilla*, the sensationalist press focusing on crimes and tragedies, which nevertheless expressed often times a not so hidden political critique of the status quo. As Osvaldo Sunkel (1985) and Jesús Martín Barbero (1987) have shown, those stories may seemingly be exclusively about innocent or tragic love affairs between hope-ful and hopeless people, but are in fact also the repositories of a popular way of seeing the world and thus embody the seeds of political criticism. From this viewpoint, the hierarchical fairy tale-like component of many of those love or tragic affairs, with their violence and emotions going from one end of the social spectrum to its opposite, expresses both the political resignifica-tion of social differences (utopian energy) and its rather melancholic accep-tance (ideological energy). Carlos Monsiváis has usefully suggested—for the case of Mexican popular culture—the term re-signation, expressing both utopian and ideological components. In that effort, *Condorito* will trans-form one of the key components of the popular appeal of those stories, the serialization based on a careful mixing of general summary and suspense. *Condorito* will turn the summaries into a permanent basic situation (the *roto* or working-class Chilean in Pelotillehue) and use the serialization to become a franchise. Instead of proper suspense, Condorito will pack a punch per page, relying on its last drawing, which comments and culminates the pre-vious frames in some humorous fashion. Though through different means, Pepo found in *Condorito* the same balance between expectation and surprise

present too in the aforementioned historical popular forms. In the process, he carefully developed predictability and familiarity, along with the hope of a truly unexpected ending. This formula, as we will see, going well beyond the limits of narrative structures and into the ideological territory, characterizes all popular genres and became one of the central components of *Condorito*'s success. Within it, changes were always couched in the context of persistence; transformation was always a new form of the old life.

At first, *Condorito*'s humor was based mostly on his endless capacity to lose and fail. Indeed, the one-page story appeared always towards the end of *Okey* and its red tone page was in marked contrast with the predominant black and white context of other stories, containing oversized heroes such as Robin Hood, Mandrake, Flash Gordon, etc. In 1970, a special issue celebrating 20 years of publication reproduced the first seven stories of Condorito in *Okey* with the following added prologue: "This one that you see here was Condorito's first cartoon story, published in 1949. In order to remember that past, we reproduce here the first seven adventures of our popular character. He started undeniably as a 'roto fatal' (working-class guy with bad luck)" (number 32, 1970). The *roto fatal* expression alludes simultaneously to his social standing and to its quality as a likable loser. Its very first story is clearly symptomatic of such qualities and social position: after a week of hunger, the penniless Condorito steals a hen. Unable to kill the animal—he lacks the guts or is too compassionate—Condorito is caught by a policeman who, after putting him in jail, proceeds to cook and eat the bird. A phrase is thus born as the characteristic punch line defining this first epoch *Condorito* and its implicit philosophy: "Exijo una explicación" ("I demand an explanation"). The other six original jokes presented Condorito in the following situations: finding refuge atop a building to escape the wrath of his oversized client; locked up as a mad man unable to extract an aching tooth; fantasizing about his rich future, only to discover mentally that rich people lead too complicated a life; holding up a passerby, only to be held up by what turned out to be a robber; risking his life by using a lion's disguise in a poor circus in order to earn some money (the menacing tiger turns out to be just another "roto" who asks him "Oye ñato, ¿cuánto te pagaron a vos? ("Hey buddy, how much did you get paid?") (number 32, 1970). The last story of this initial seven completes the psychological make-up of Condorito: not only is he a *roto fatal* but he is a good-hearted one too: he eats the lunch of a hungry boy and then, full of guilt, takes him to a restaurant to eat. Unable to pay, Condorito is beaten up and ends doing the dishes, but is able to say: "Me quedan 517 platos que lavar pero mi conciencia está tranquila" ("I still have 517 dishes to do, but my conscience is clear" (number 32, 1970).

Second and Third Stages: From Decent Loser to Successful Cultural Mediator

In at least in one occasion, Condorito emerged from the inside of *Okey*, spreading its two-page story across the front and the back covers of the

magazine. Without exaggerating, it can be said that this 1952 story, in its own narrative structure and in its newly acquired formal independence from its previous graphic context (from the last pages to the front and back covers), somehow clearly announces the psychosocial mechanism that, from this point on, will be involved in *Condorito*'s enduring popular success.[3] As if to celebrate the occasion, in this story Condorito has successfully convinced his customers (he is a tailor here) to wear some extravagant clothes that conceal his many mistakes. Thus, although unable to sew properly, he is capable of turning his limitations into accomplishments. The means for this achievement is what Condorito, who stands next to an overdeveloped muscular aide—himself holding a big hammer—calls in the punch line his "moderno método de persuasión" (modern method of persuasion). Underperforming his tailor duties due perhaps to his limited education, Condorito—who calls himself "el modisto atómico" (the atomic tailor), and is living in a competitive and difficult modern world of business (his shop is called "Sastrería El Último Grito de la Moda" [The Latest in Fashion Tailor Shop])—survives by convincing his clients that he is delivering something else or more than the ridiculous outfits he sews.

Overcoming the limitations of his first phase as a "roto fatal," Condorito will now turn into a somehow mostly accomplished "survivor," in the midst of social changes that will force the cartoon to combine the moral/immoral axis, typical of the first period, with the modern/traditional one, which will characterize his adventures from then on. In that sense, *Condorito* will come to exemplify what E.P. Thompson once called a popular moral economy, one that presents itself as an alternative/response to the capitalist dominant one (Thompson, 1971). In this subalternized world, close relationships of kinship, friendships, and the like, still predominate over distant ones, based on professional or social standing. This utopian content, which is the means of re-signation to and of the world Latin Americans lived in their newly modernizing countries in the late 1950s and 1960s, is at the very heart of Condorito's enduring popular appeal and extraordinary continental success.

Thus, *Condorito* demands to be considered as both a nationalist reaction to the increasing internationalization of the cultural industry and as the expression of a cultural imaginary that is itself constituted by mass mediated forms of communication (including the comic strip). The content of these mediations is mediation itself: they reflect on the *longue durée* process of modernization of Latin American societies.

From the 1940s to the 1960s, José María Arguedas, the bilingual and bicultural Peruvian writer, would develop one of the most powerful novelistic representations of such a process, as it affected Native American and mestizo populations in his country. His effort intended to provide an answer to questions posited to the national imaginary by the massive migration of Indians and mestizos to urban spaces in Peru: What kinds of transcultural processes could produce a modern Peruvian national culture? What were the respective roles of whites, Indians and mestizos in such a national culture? Was one integrated national culture possible or desirable

in a multicultural and plurilingual society? The process demanded a hermeneutics that could make sense of the popular experience of the city for national culture. Arguedas' *El Zorro de arriba y el zorro de abajo*, left unfinished by the author's suicide, seems to be the high point of the author's attempt to address those issues and marks, within the literary sphere, the limit of such an experiential record. A number of theoretical approaches, such as transculturation (Ángel Rama, 1982), heterogeneity (A. Cornejo Polar, 1977), and hybridity (N. García Canclini, 1989), have been proposed to analyze the complexities of this experience of modernity in Latin America. Martín Barbero, dealing more directly with the role played by the mass mediatization of Latin American popular cultures in such modernization, has talked of "cultural matrices," in which a number of historical layers interact simultaneously, often times through the culturally specific ways of consuming/producing the messages of the mass media (Martín Barbero, 1987). John B. Thompson has highlighted more generally how, despite the relative loss of its normative authority, tradition ("As sets of assumptions, beliefs and patterns of behaviour handed down form the past") has not so much vanished, with the disappearance of many of the direct physical social interactions that once grounded it, as transformed its way of social circulation, "loosing their moorings" only to be "re-embedded in new contexts and re-moored" (Thompson 1995:187). The mass media have thereby played a crucial role in mediating new roles of/for tradition for the growing urban populations in need of affiliation, hermeneutic codes, and identities. Comics, of course, have contributed to this effort.

In this context, Pelotillehue, Condorito's famed community, may be contemplated as an archetypal space where such transition is always in permanent process of development, attesting to its nature as long-term epochal change. In Pelotillehue, Chileans have learned to live in the city as well as to enjoy the nostalgic reconstruction of a simpler past life of local moorings. From this perspective, Pelotillehue is, simultaneously, a place and a globalized non-place. It is a place, insofar it has all the characteristics of a small Latin American town of the 1950s and 1960s. There we find conventional forms of popular sociability, such as bars, soccer teams, and cheap restaurants, along with new mass means of transportation and communication media, such as TV sets, radios, taxies and movie theaters; along with the closely knit neighborhood, the gossip of comadres and compadres; the cars and motorcycles together with oxen and carts; the *huasos* (Chilean cowboys) along with the new businessmen. Pelotillehue is also a non-place, in Marc Auge's coinage, insofar it operates as a globalized space specialized on a particular function shared by many other concrete locations (Augé, 1995): in this case, to make possible the always-in-process transition between traditional and modernized societies. This de-localized quality has allowed a very successful transnational traveling of Condorito and Pelotillehue. Condorito and its cast of characters and situations can travel without much difficulty because in some strong sense, they never move, because they were and always are in a non-place. This deterritorialization functions as a reterritorialization of

the Latin American social imaginaries that the mass media, including the comic, perform in the continent. Such reterritorialization operates as mediation between the Latin American populations and the forms of modernity that they themselves produce, enjoy, and suffer. In this function, later comic heroes, such as Inodoro Pereyra, created in 1974 by Argentine artist Roberto Fontanarrosa, accompany Condorito and Pelotillehue. Like Condorito in Pelotillehue, Inodoro, a traditional Argentine gaucho, lives in the middle of a pampa that is both fully localized and highly deterritorialized, functioning simultaneously as a historically grounded space and as a non-space where the main result of the modernization process is lived out. In this pampa, nineteenth-century Argentine history, with its confrontation between white huincas and Native Americans, coexists with late twentieth century transnational companies, in search of natural resources, while the main figures of Argentine history parade to Inodoro's rancho to engage in one-to-one conversations that allow this comic strip to deploy its game of contemporary cultural criticism. Despite this deterritorialized pampa and unlike *Condorito*, *Inodoro Pereyra* has traveled less well due, perhaps, to its higher degree of sophistication and its reliance on a heavily vernacular gaucho Spanish.

Thus far, I have been using a concept that requires further specification. Jesús Martín Barbero defines mediation as the space where it is possible to think the relationship between production and reception, between competing mass media (and the capitalist organization of society they presuppose) and their publics. Mediation, as developed in 1987, signals in Martín Barbero a switch away from two forms of communication analysis dominant at the time: the ideological and political economy school, represented by the work of Mattelart and Dorfman on *How to Read Donald Duck*, and the functionalism of those who saw the media as all powerful and direct technological shapers of society, as in the paradigmatic work of Marshall McLuhan. The concept of mediation alludes to processes rather than to structures, relationships rather than separate agents, interactions much more than unidirectional flows. As such, mediation is always the result of the social production of meaning under particular circumstances of elaboration and reception. For Martín Barbero, there are three basic realms of concrete cultural mediation for Latin American popular culture: everyday family life, social temporality (where the time of social capitalist production connects with everyday life in the form of work schedules and free time), and, finally, a cultural competence based on an aesthetics grounded on repetition and recognition, i.e., a set of forms known as genres. His ideas will allow here an analysis of some of the locations and situations where the particular forms of mediation embodied by *Condorito* take place.

REPRESENTING PLACES AND PEOPLE: THE COUNTRYSIDE

What is most noticeable about the representation of the countryside is that it is a space defined mostly from the city, shaped by an urban perception. This does not mean that it is simply a city-identified sensibility, but

rather a view affected by urban experience. In this sense, a story called "The Revenge" and published in number 23, 1968 is particularly interesting. In it, Condorito is a poor countryman who sets out to the city in order to sell his turkeys ("Coman, coman, mis pavitos, que pronto emprenderemos el viaje pa' la capital" [Eat, eat, my little turkeys, 'cause soon we'll set out for the capital]). He doesn't know what a train is and sleeps right by the tracks. When the train comes, it kills his turkeys and Condorito swears revenge. He decides to go to the city to get to know it. In the city, he comes across a street vendor who is selling toy trains. Condorito breaks through the circle of bystanders and stomps on the trains saying: "Don't you know that these bugs are assassins? That is why you have to kill them while they are young and small." It is as if, in this story, Condorito were retracing his origins as a *roto*. His common sense, energies, and revenge are all honest but misplaced. The contact with the new urban environment is a rough and often times violent one. It is a learning experience and it demands some initial sacrifices. But Condorito is a quick learner, whose attraction for a population who can still recall or trace their origins to the countryside resides precisely in his later ability to "cope" and "survive" in the city. In "Analfabeto" ("Illiterate"), from number 26, 1969, Condorito is again a peasant and takes the train to Pelotillehue. Worried that his unfriendly and urban reading seatmate will know that he is illiterate, Condorito buys the newspaper and begins to look at it upside down. Because of the way Condorito is holding the newspaper, we see the upside down picture of a ship in the middle of the sea. So, when the city man, thinking that he is going to have an easy laugh at the expense of an ignorant peasant, asks Condorito if there is any news, the latter replies: "No sir, no news other than this ship that went belly up, overturned!"

Playing on the double meaning of "burro" (donkey and stupid) in Spanish, "Qué burro!" (number 28, 1969) will continue this process, where it is the socially underprivileged character who often has the last say. Condorito, a country man taking a pile of wood on the back of a donkey, stumbles upon a construction site where a road is being built by an intricate team of workers and modern machinery. Approaching the engineer in charge, Condorito tells him of the way roads are built in the countryside: you just let a donkey go its way freely and it always finds the best, shortest, and easiest way. Interesting, says the engineer, and what do you do when there is no donkey available? Well, then we hire an engineer, Condorito replies quickly. As it is obvious here, the countryside knowledge is not only presented as a legitimate way of informing a practice, but also as capable of comparing favorably and, in fact, outdoing the urban knowledge of the expert. This reversal of roles, in which the world is momentarily turned upside down, is not only one of the narrative mechanisms of many jokes in general, but also a culturally specific popular way of dealing with well established cultural hierarchies.

It is pertinent to point out here that it is no coincidence that these peasant jokes became particularly popular towards the end of the 1960s, since a major agrarian reform was taking place in Chile at the time. During the government of Eduardo Frei (1964–1970), his "Revolution in Liberty" found one

of its cornerstones in the massive mobilization of peasants and the "assault upon the Hacienda system" (Loveman 1988:268), which, for centuries, kept them under tight societal control. The resulting social energies accumulated in processes such as this would eventually lead to the popular radicalization of the Chilean political development as manifested in the election of Salvador Allende and the forces of Unidad Popular to power in 1970.

One of the clearest manifestations of this mediational role—between tradition and modernity, between rural and urban societies—performed by *Condorito* in Chilean and Latin American culture is found in another means of communication, different yet not unrelated in its cultural significance. The Pan American highway built with U.S. support during the 1940s and 1950s, and significantly improved in the 1960s, connects 16,000 miles of the Western Hemisphere, providing not just an international link between countries, but also an intra-national one, connecting once remote areas with main metropolitan centers. In its long process of construction, with an always unfinished status (to this day, it's under construction); in its nature, as a piece of modernity going through the countryside, thus connecting the old and the new; in its seriality and basic repetitive pattern, the Pan American highway has invited a full series of jokes in which *Condorito* manifests many of its fundamental generative procedures. It is frequently a full page and, most often, a central double page with a single drawing in which Condorito, who is perennially in charge of painting the white lines dividing the lanes, confronts all kinds of difficulties (cows, rivers, policemen, phone lines, etc.) or simply displays his wit to perform, in his own fashion, what he considers his fundamental duty.

Figure 2.1 (number 97, volume 25) shows what could be considered an excellent graphic representation of this article's main argument. In it, we see Condorito performing a delicate act of mediation while trying to extend the reach of modernity over the remnants of a previous historical form. An old fashioned bridge appears damaged, yet somehow, the line of the highway can still be supported by it. This continuity is made possible by a logical trick in the drawing: the line demarcating the lanes has become continuous. In most other occasions though, the joke will hinge on the paradoxically continuous nature of the discontinuous dotted line. In two other examples selected (figures 2.2 and 2.3), Condorito uses two opposing forms of knowledge to perform, in his way, the task of painting the dotted line. In figure 2.2, Condorito mediates between the temporality of labor, with the mechanical and repetitive nature of the task at hand, and his own desire to turn work into recreation, through the anticipation of a happy end with the use of the popular oral game of "Loves me, loves me not." In figure 2.3, in contrast, tired of the same interminable and disheartening job, Condorito uses a learned written expression to similar effect. The same display of resourcefulness uniting the country and modernity, as evident in the Pan American highway, is found in figure 2.4. In it, Condorito, though having run out of paint, manages to paint the dotted line with milk from a cow (number 115, volume 26).

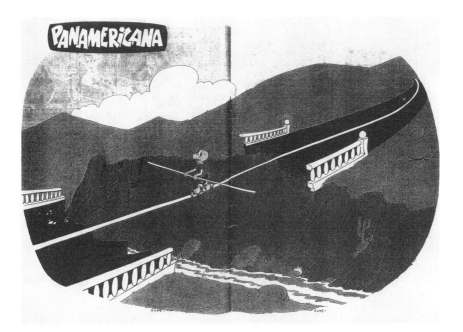

Figure 2.1 The difficult task of mediation.

Representing Places and People: The City

The jokes on peasants arriving to the city are one way of entering the city-scape in Condorito's adventures. A fairly representative example of this strand is "Perdido" (Lost) republished in volume 43, 1992 in a selection of classic countryside jokes ("Chistes de campo"). Condorito, arriving in *la capital* in the company of a friend, goes to the hotel where they will stay. He decides to take a look around, while his friend warns him to not get lost since "the city is very big." Three months later, Condorito shows up back at the hotel, where his friend says: "How could you have gotten lost, don't you know that asking questions you can get to Rome? (That is, you can get anywhere you want.) Condorito replies dryly: "And where do you think I am coming from?" Within this perspective, the city is both the place of always-desired destination for a peasant ("at last in the capital!") and the space where his daily life know-how is inoperative. Getting to Rome and back though, Condorito seems to have begun mastering the art of city traveling. This is apparent in another sample of classic "chistes de campo" (jokes from the country), this one from a *"Condorito de Oro"* of July 2002. "Avispado" (Street-smart) begins with the standard "We are now in the capital, nephew," which Condorito, in typical countryside attire, says to Coné at the train station. They catch a taxi, whose driver thinks, "With this fool I am going to make up for a bad day." "How much will you charge us?"

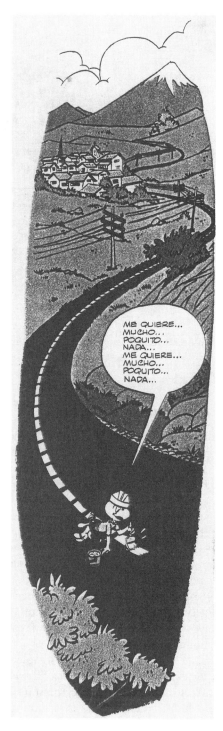

Figure 2.2 Connecting forms of labor and knowledge.

Figure 2.3 Connecting high and low.

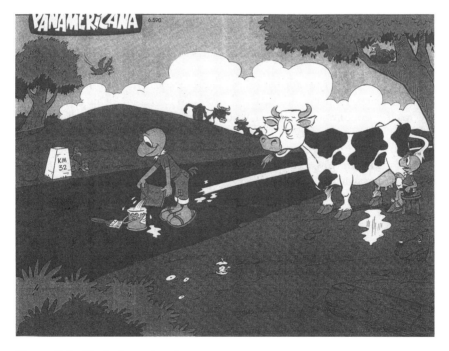

Figure 2.4 Deploying cultural resources.

asks Condorito. The driver replies, "One thousand pesos for you; the kid goes free." Quickly, Condorito states "Then take the kid; here is the address. I am going on the subway." Consequently, although the city will continue to be the space where country people get lost or do the wrong thing, it has also become the place where a certain experience of living in the modern world can be deployed to the peasant's advantage.

Although Martín Rivas—the eponymous hero of Chilean author Alberto Blest Gana's 1862 text, considered Chile's most characteristic, canonical novel of the period—was not properly a peasant, he shares his provincial origins with Condorito. They both start as newcomers to the city and suffer a long process of education, which will transform them into the quintessential survivors. Yet, while Martín Rivas joins the upper classes, Condorito stays closer to his origins. Nevertheless, both will come to be seen as embodying a fundamental process in Chilean history: the successful integration into a modernity that uses their previously acquired strong provincial moral grounding to shape their trajectories in the urban context. From this viewpoint, *Martín Rivas* and *Condorito* exemplify what could be called an archetypal historical situation: the confrontation with modernity itself, as embodied in the always challenging and often threatening city life. Seen in this light, we can identify with their adventures, as they allow us to vicariously perform our sense of foreignness while simultaneously confirming our qualified belonging to the city. In the case of Condorito, of course, its own anthropomorphic process highlights this relative foreignness, along with its relative integration. Condorito's appearance, halfway between a condor (one of Chile's national symbols)[4] and a human, allows the character to perform an implicit critique, a defamiliarization or, at least, a performatic deployment of many of the social codes constituting modern life.

The process of transformation of Chilean society, from an agrarian to an urban one, is nicely summarized in "Na'que ver" (Nothing to do with it), itself a contemporary urban youth expression referring to things "out of place" or "inappropriate." Condorito, who lives in the city and dresses accordingly, is invited to go a *fiesta criolla* (a Creole traditional celebration) in a countryside town called Tragullón. For that purpose, he buys a traditional *huaso* attire. The party, "typically Chilean" he has been told, will have all the elements defining tradition in the customary agrarian sense: rodeos, *cueca* dancing, empanadas, and red wine. Yet, when he arrives at the party, everybody is dressed in typically modern urban fashion and is dancing the Charleston and mambo, and drinking dry martini, frappé mint, or whisky.[5] Things have come full circle and Condorito seems to have closed the loop. Now the *huaso* attire no longer represents tradition and it is perceived as an out of place ("na'que ver") costume. *Chilenidad*—Chileanness—has evolved into ever more complex ways of life that incorporate the full impact of American international culture. Thus, new symbols will have to be elaborated to signify it in this context. *Condorito*, a 50 year-old comic strip, has become one of them.

Another key aspect of city life conceived as mediation is, in general terms, Condorito's relationship with technology and mass mediated modern culture. In two classic jokes about vacuum cleaners, we see the "discourse of modernity" being undone by the specificity of the local situation. "Aspiradoras" (vacuum cleaners) were, in the late 1960s and early 1970s, a coveted new domestic appliance. They were also famously unable to deliver what they promised: an effective liberation from the chore of sweeping with a broom, a real satisfaction to the aspiration to modernity. In "Aspiradora vendo" (Vacuum Cleaner for Sale, number 25, 1968. Figure 2.5), Condorito, who is a case-carrying door-to-door salesman, proceeds energetically to dump dust, ashes, and other residues on the floor of the old woman's house. When, in a rare pause of his long and stereotypical speech, he asks where he could plug the machine in, the woman says, "I would happily do it if only I had electricity at home." In "La aspiradora" (The Vacuum Cleaner, number 31, 1970), Condorito is the homeowner being pitched a vacuum cleaner by a self-possessed salesman with a fully prepared speech, which ends with the winning line, "And besides, this machine pays for itself!" "Great," says Condorito, "I am interested in one, just bring it over when it has finished paying for itself." What we witness here is not so much the critique of modern technology, as the deconstruction of the "discourse of modernity," embodied in the discourse of advertising and marketing. In "Oh! Los Avisos" (Ah! The Commercials), Condorito tries to comfortably listen to a soccer game on the radio while sipping coffee. In the process, he has to endure the repeated interruptions of the soccer broadcasting by an increasingly outrageous series of commercials. The story ends when Condorito complains about insomnia and the broadcaster responds, "Do you suffer from insomnia? Kill yourself, but do it with the right brand of gun!" (number 30, 1970). This encroachment of mass mediated discourse on daily life is also thematized in "De película" ("Like in The Movies" figure 2.6), in which a romantic evening at

Figure 2.5 Modernity's multiple temporalities.

Figure 2.6 Formatting reality.

the beach, with Condorito and Yayita, his girlfriend, watching the sunset, ends with the last rays of light spelling out the word "FIN" ("The End"), equating direct experience of an event in nature with its mediated representation as a broadcast spectacle (number 28, 1969).

CONCLUSION

Left-leaning and highly sophisticated comic productions, such as *Mafalda* and *Inodoro Pereyra* in Argentina, and *La Familia Burrón* and *Los Supermachos* in Mexico, have all received some serious scholarly consideration. By comparison, *Condorito* has been mostly ignored, not just in Latin America in general, but also specifically, in Chile. This could be seen as a natural result of the higher degree of development of the long standing Argentine and Mexican comic industries. Nevertheless, it can also be attributed to a less natural phenomenon: the predilection of contemporary academe to analyze overtly critical forms of popular culture, relegating many of the equally if not more popular forms, that by comparison seem apolitical, to a secondary status.

According to Jorge Montealegre, undoubtedly the critic who has paid more sustained attention to *Condorito*, the three key components of *Condorito*'s enduring success are: the "humor blanco," that is, its PG-rated humor void of any real sex, violence, or politics; the simplicity of its jokes, which can be understood by kids and grownups alike; and, finally, its ability to skirt or

elude political contingency.[6] Having found this formula, which the Disney Corporation used to create an international empire, Pepo stuck to it through more than 30 years of direct involvement with the production of the comic. Like the Disney formula, which has been analyzed as fully political and neocolonial in the classic readings of Dorfman and Mattelart, as well as the expression of a new and emerging global culture of viewers and readers, conceived as mental teenagers and interested mostly on grand visual spectacles and adventures (Moretti and Ortiz), *Condorito* invites multiple readings and its non-political stand is in itself a political position full of invested social energies, commentary, and meanings. The 1999 special issue celebrating 50 years of publication overtly expressed a version of this formula:

> The flexibility of the character makes it possible to recreate countless situations. This makes the reader accept Condorito as a universal character. Condorito doesn't have political or religious ideas and adapts itself easily to all kinds of people of all ages (...) *Condorito* is an extraordinary occurrence in graphic humor, capable of crossing borders, reaching all kinds of publics, of all ages and belonging to any social class. *Condorito*'s success is the result of its simple content, light humor and its capacity to communicate with regular people. (*Condorito 50 años de humor*, no page number)

In this chapter I have tried to show how this "successful simplicity" is, in fact, the result of *Condorito*'s extraordinary ability to represent a complex and long process in the history of modern Latin America. Far from simply being elementary and light-hearted entertainment, *Condorito* represents a sustained engagement with the experiential side of modernization as urbanization for the people of a continent who have moved from being mostly rural to mostly urban in the series' lifespan. *Condorito*'s capacity to travel across national borders, its ability to interpellate a Latin America-wide readership is the result of a series of factors including: the non-place nature of Pelotillehue, the use of a historically deep Latin American popular culture matrix featuring the underdog, the weak, the poor and the working-class characters as resourceful, clever and often times successful, the repeated and fundamental contrast between the countryside people and mores and their urban counterparts, the use of everyday situations conceived of as challenges and potential sources of knowledge for newly acculturated urban populations, etc. A final factor is Condorito's mode of production. *Condorito* exemplifies, first, the transition from individual authorship to the process of industrial creation of a successful product in/for the national market and, secondly, the transition from the national sphere to that of transnational production for the international market. While normally a naturalized reflex of cultural criticism would be to present such a trajectory as one of decadence and corruption, in important ways this change and immersion into the cultural industry can be seen as having at least complex ideological effects: what used to be the result of a singular inspired author has been for a long while partly produced by the anonymous contribution of an extensive number of individual collaborators and then further reworked by teams of professionals. As of

1999, a team of eight scriptwriters began the production process of some-times creating and often times reviewing the scripts and jokes submitted by a vast network of anonymous contributors, who are paid upon acceptance of their material. Then, the jokes are sent to an editorial committee, which has the final say. Once approved, the stories are further developed by four scriptwriters into a series of narrative vignettes to be developed visually by a team of graphic artists. Everything is then recorded in a film to be adapted and used by the various subsidiaries of Televisa productions in the differ-ent Latin American countries. The Chilean version, it has been said, has been stripped of many local linguistic marks because its excess production is sent to Bolivia and Peru. The language and structure of the Venezuelan, Mexican, and Colombian editions of the comic are adapted separately for their specific national consumption.[7] Does this change in authorship close the loop in *Condorito's* popular roots by extending the social base from which the comic draws its effectiveness and representativeness, or does it presents us with another market-tested "external" production for popular consumption? As in the punch lines in Condorito's jokes, these questions, along with *Condorito's* full and extended trajectory of success, will continue to demand an explanation for a long time.

NOTES

1 Quoted in "Condorito como bajado del escudo," unattributed article in *El Mercurio*, February, 12, 1999, p. C16.
2 For further considerations on these two meanings of "lo popular" see Aman (1991:9, note 2) and Martín Barbero (1987).
3 *Okey*, IV, number 201.
4 On Condorito and the condor image in Chilean history, see Montealegre (1999).
5 The undated story is included in number 115, 26 (1975) and is part of a special supplement of huaso jokes that are called "recuerdos de antaño" (Memories of yesteryear).
6 Quoted by Marietta Santi, "Condorito, un cincuentón interesante," *Las Ultimas Noticias, February 21, 1999.*
7 See Marietta Santi, "Condorito, un cincuentón interesante," *Las Ultimas Noticias, February 21, 1999.*

WORKS CITED

Aman, Kenneth and Cristián Parker. *Popular Culture in Chile. Resistance and Survival.* Boulder, CO: Westview Press, 1991.
Burton, Julianne. "'Surprise Package': Looking Southward with Disney." In Smoodin (1994), pp. 131–147.
Dorfman, Ariel and Armand Mattelart. *How to Read Donald Duck. Imperialist Ideology in the Disney Comic.* New York: International General, 1975. (Original Spanish version 1971)
Martín Barbero, Jesús. *De los Medios a las mediaciones: comunicación, cultura y hege-monía.* México: Gustavo Gili, 1987. There is an English version: Martín Barbero,

Jesús. *Communication, Culture and Hegemony: From the Media to Mediations.* London: Sage, 1993.

Montealegre, Jorge. "Humor gráfico de Chile. El Cóndor pasa." *Patrimonio Cultural*, number 16, 1999, pp.12–13.

Smoodin, Eric. *Disney Discourse. Producing the Magic Kingdom.* New York and London: Routledge, 1994.

Sunkel, Osvaldo. 1985. *Razón y pasión en la prensa popular.* Santiago: Ilet, 1996.

Thompson, E.P. "The Moral Economy of the English Crowd in the Eighteenth Century," reproduced in *Customs in Common. Studies in Traditional Popular Culture.* New York: New Press, 1993, pp. 185–258.

Thompson, John B. *The Media and Modernity. A Social Theory of the Media.* Stanford, CA: Stanford University Press, 1995.

Race and Gender in The Adventures of Kalimán, *El Hombre Increíble*

Héctor Fernández L'Hoeste

In recent years, in a manner akin to Edward Said's *Orientalism*, not a few authors in the field of Latin American cultural studies have explored the concept of Latin Americanism, albeit from different perspectives. Yet, in light of the events of September 11, 2001, Said's work has gained new stature, for the Orient has become crucially important to the redefinition of world struggles embodied by contemporary globalization. To the United States, in particular, today's Orient represents a defining space and critical moment, as the stalemates in Palestine, Iraq, and Afghanistan will determine, to a great extent, how it is viewed as world power and builder of consensus among the international community of the twenty-first century. Thus far, the balance seems ominous.

 In this light, Said's work, which provides a rich theoretical framework with which to problematize the relation between East and West, gains relevance and importance. Being his most lucid piece of scholarly production, *Orientalism* points out how the Orient was an object of European (and U.S.) discourse. Along these lines, the text plays a key role in the recognition of the forms of production of alterity. It establishes the importance of the negative construction of the non-European others in order to sustain and empower Western identity. In an analogous fashion, Latin American authors have argued that the theoretical configuration of Latin Americanism has played a significant role in the consolidation of U.S. identity. In this context, Latin Americanism reproduces a style of thought that, like Orientalism itself, conceals a formidable structure of cultural domination. Implicit in the use of this mindset are many risks; specifically for formerly and currently colonized people, the dangers and temptations of assimilating and reproducing this way of thinking among themselves and applying it onto others.[1]

In the following text, I contend that one of the most lucrative and endur-
ing figures in the world of Mexican comics, a character successfully marketed
across many Latin American nations, the superhero Kalimán, is a very illus-
trative example of this practice, in which its creators—by way of consent—
enact the structures of domination that sustain Mexican and Latin American
society; in particular, views of race and gender that contribute to the suste-
nance and diffusion of a conformist male, Caucasian imaginary, much to the
benefit of the societal and political establishment. Though *Kalimán* has an
extensive tradition in terms of publication, for the purposes of this text I will
refer mostly to the events of the character's original saga, narrated in the first
numbers of the comic book series and periodically redistributed in an effort
to maintain and increase its readership.

KALIMÁN, OR HOW TO BE WHITE
AND PASS FOR ORIENTAL

In Mexico, starting with the cultural and political hegemony of the Mexican
Revolutionary Party (PRM) during the early twentieth century, the intel-
lectuals of the Revolution manipulated the discourse of national identity
at will. Their hope was to implement a version of official culture that,
while more inclusive than that ousted by the Revolution—the policies of
late nineteenth century dictator Porfirio Díaz, while managing to stabilize
the Mexican economy and spur industrial development, were remarkably
Eurocentric and sponsored a whitened sense of identity—allowed them the
time and space to put into practice a new, functional project of nation.
In order to accomplish this object and appease the masses taking over
the Mexican capital city as the result of incursions by populist leaders like
Pancho Villa and Emiliano Zapata, key thinkers such as José Vasconcelos,
Secretary of Education for the Revolution and author of *La raza cósmica*
and *Indología*, as well as his colleagues at Mexico City's athenaeum, contrib-
uted greatly to the superficial idealization and romantization of the Aztec
past. Through these mechanisms, they managed to offer to the Mexican
public, in an official fashion, the idea that the new government embraced
Amerindian descent and viewed the heightened political profile of the
mixed-breed masses with good eyes.

Nonetheless, while government culture celebrated *mestizaje* (racial mix-
ing) and emphasized the glorious, indigenous past of all Mexicans, it con-
tributed little to the living conditions of millions of citizens of indigenous
and mixed descent. The result of its policies is keenly evident in contem-
porary Mexico. Like many Latin American countries, Mexico remains a
divided society, caught between a triumphal discourse of racial harmony
and the appalling reality of poverty resulting mostly from class and race
boundaries. Within this equation, racial identity is second to class status; at
times, it is even disguised as an issue of class. After all, the Spanish colonial
system was based on the caste system, in which racial status was equated

with class status, practically erasing the problematization of the former in Latin American society. The end result becomes immediately apparent, since class is the main cultural currency in most versions of identity promulgated by Latin American establishments. In consequence, race was relegated to a lower, second-tier rung. Such portrayals of identity, which tend to privilege class over race—as opposed to the United States, where things tend to work in the opposite direction—serve the interests of the national above all and pretend to take lesser notice of lines of distinction according to ethnicity, sponsoring misguided adherence to governmental schemes in which nation and state become synonymous. Thus, as an exemplar of an effective, nationalist exercise of the Latin American construction of identity, Mexico clearly stands as a very enthusiastic proponent.

Such a task wasn't accomplished casually. Aside from the omnipresent influence of the Mexican state in the national media, education and history were appropriated and revised to ratify the dictates of the intellectual elite. To this day, history texts used nationwide are provided free of charge by the federal government. School texts are the result of a periodic contest managed by the administration in power, in which political censorship and cultural interests play a crucial role. Additionally, many Mexican newspapers, as well as radio and TV networks, receive generous subsidies from the government in the form of consistent, guaranteed advertising, creating a wealth of concerns and links between the regime and media. The ascent to power of Vicente Fox, the candidate of a leading political opposition party and the corresponding change in government, with its likely abandonment of press subvention and financial support, did not entail total abandonment of this practice. The reshuffling of investment in advertising, more oriented towards publications aligned with the interests of the new group in power, explains partially the dismal situation of the Mexican media at the beginning of the new millennium. A number of main newspapers even declared bankruptcy. Thus, Mexican identity—or at least the version resultant from this interaction—turns to be as much a case of governmental schemes as it is a matter of its people articulating compatible narratives.

The case of Kalimán, *el Hombre Increíble,* an adventure character created by Mexican Rafael Navarro Huerta and Cuban expatriate Modesto Vásquez González, members of the creative team at Radio Cadena Nacional (RCN), during the early 1960s, is particularly pertinent to this situation. Kalimán is, quite probably, the most popular and profitable superhero in Mexico and Latin America, with the possible exception of El Santo, Mexico's beloved wrestler. Having debuted in 1965, a year marked by the thriving expansion of the Mexican economy and the exultant discourse of a government proclaiming passage to the industrialized world, *Kalimán* sold weekly for 26 consecutive years. Since 1998, distribution has resumed in the hands of a local publishing house, which has re-edited many earlier issues, including the character's original narrative, and published new editions in color.

Additionally, the story of Kalimán was broadcast as a radio series since 1963, a fact that contributed greatly to the character's popularity throughout the subcontinent. In this respect, Mexico and Colombia, with their corresponding locally produced versions, stood as the greatest markets. In 1970, a film version was produced with Jeff Cooper, a U.S. actor, in the title role. In due course, the movie spawned several sequels, with mixed results.

As his name suggests, Kalimán's context is not particularly Latin American. The name alludes to the character's identity as the fifth man within the dynasty of the goddess Kali. Originally from a remote, subterranean civilization known as the Kingdom of Agharta, Kalimán is a cultured, rational individual who uses his impressive physical and mental powers to assist fellow human beings in distress. As a boy, Kalimán was removed from home and faced all sorts of adventures, culminating in his maturing as a refined individual, cognizant of martial arts, Oriental philosophies, linguistic proficiency, remarkable erudition, and Western know-how. After many hardships, he returned to Kalimantán, his home province, and unmasked the greedy counselor responsible for his exile. The comic series then chronicles the numerous adventures that follow the hero, as he abdicates his throne and distributes his wealth among his subjects.

Another significant aspect of Kalimán's proposal is that the character's story is set in a time in which imperial power was synonymous with British rule. This is particularly handy, since *Kalimán* is a product of the 1960s, when the United States promoted a benign image throughout Latin America—at least in comparison with the early twenty-first century—given conjectural efforts by the Kennedy administration and its Alliance for Progress. At the time, the United States was equated—and celebrated—as a paradigm of modernity. The Mexican government certainly did what it could to promote good ties with its neighbor to the north, regardless of its increasing involvement with non-aligned nations across the globe. Mexico feigned distinct sovereignty, only to pay closely attention to the dictates emanating from Washington. Thus, it is only understandable that the adventures of Kalimán are set in a way in which U.S. presence is largely missing—regardless of its actual truth—avoiding the possibility of political conflict, an outcome closely watched by the Mexican cultural establishment.

Kalimán's values and abilities, though a tad esoteric, are wide-ranging. To begin with, Kalimán never kills. He respects life, human and non-human, above all. Fittingly, he is also able to communicate with animals, practices telepathy and telekinesis, transforms his physique at will, and even feigns *actus mortis* (a simulation of death), in a veritable celebration of the many ramifications of life. Additionally, in a fashion similar to Batman, Kalimán is usually accompanied by a younger, less experienced sidekick: an Egyptian boy called Solín, who propitiates dangerous situations constantly, given the desperate nature of his many clumsy attempts to assist his mentor and companion. Like his master, Solín is of noble origin: he's a direct descendant of pharaohs. He has also decided to forsake a life of comfort, distributed his wealth among his subjects, and embraced adventure, hoping to bring good

and justice to humankind. As would be expected, both characters combine mystical altruism with an egalitarian agenda, proper of the background of their creators, who, as middle-class Mexicans and sons of the Revolution, were undoubtedly concerned with issues of class. In this way, Kalimán's behavior departs from the Dark Knight's, who, as U.S. hero, fails to relinquish his fortune. It is only sensible; Bruce Wayne's wealth provides a persona that fits well in the asphalt jungle that is Gotham. Kalimán's turf, on the other hand, is seldom urban. In addition, within the context of Mexican society, in which class disparities are blatant, hypothetical disdain for wealth suits a superhero best, as it alleviates class resentment and social tensions, promoting a traditionalist spirit.

Kalimán's most puzzling contradiction stems from a different circumstance. When it comes to physical appearance, there is a particularly conflicting detail: although the entire context of his origin and background is Oriental, inexplicably, his physique is that of an individual of Caucasian descent. A reader could easily argue that this claim is subjective, prone to the interpretation of color in the comic's imagery, given that most of *Kalimán*'s production has been edited favoring sepia tones. Yet, a more conscientious reading of the text points to the contrary. Kalimán's race is not fortuitous. Though this is a scarcely mentioned or noticeable aspect within the narrative, it is formulated on enough occasions as to be noticed by careful readers: in particular, during the hero's travels through Africa, where he's clearly differentiated as a white giant. The first number of the comic series, which chronicles his origin, as well as his adventures in Africa at the hands of a tribe of pygmies, is irrefutable evidence of this aspect.[2] An even more observant critic could argue that whiteness is subjective and that, to a tribal African culture, a restrictive interpretation of alterity may append elements of whiteness to other groups, such as persons of Indian descent. However, African nations are relatively familiar with populations of Indian descent. As fellow subjects of the British Empire, people of the Indian subcontinent migrated to Africa a long time ago and eventually became staples of the societal and political establishment of many ex-colonies. In any case, the fact that Kalimán is perceived as white passes unnoticed and unquestioned to most of *Kalimán*'s readership— including thousands of Latino followers in the United States, a context that tends to problematize race to a greater extent than Latin America. This is merely understandable since, within the plot, racial incongruities and ethnic anachronisms abound in an altogether suspicious fashion, almost as though they served an ulterior agenda.

Kalimán's race, as well as much of the context of his adventures, are remarkable examples of the way in which the Mexican media constructed alterity, positing a Caucasian as an ultimate other within a stereotypically Oriental setting. In a fashion diametrically opposed to the metropolis, which relied on the construction of non-European others to legitimate its sense of identity and power, the creators of Kalimán proposed a distinctively Oriental, Caucasian superhero as a non-Mexican, non-Amerindian other. In

other words, Mexico's dependable other is best embodied by a Caucasian of non-European descent, never mind the inconsistency. Hence, the strategies described by Said in his identification of the Western construction of alterity apply just as well in this Mexican case. As it would be expected, Kalimán illustrates many of the structures of domination prevailing within Mexican and Latin American society. A critical reader may, in the representation of this superhero and the pedagogic intent of his virtuous behavior, recognize many of the incongruities of this order. For one, the identification of the main role with a Caucasian character reproduces the social arrangement favored by most Latin American nations, according to which lighter-skinned descendants of Spanish conquistadors are usually better educated and enjoy a higher social profile, as well as a more favorable economic status. This aspect, patently visible in a wide spectrum of Mexican cultural products, forms part of conventional wisdom. On the other hand, the Caucasian superhero is disguised as the superlative other, thanks to his portrayal amidst an exotic setting. Within this reading, ethnic interpretation ratifies the prejudiced dictates of Vasconcelos, in which theoretically "pure" ethnicities were seen as decadent and aberrant, and only *mestizaje*—the racial mixing proper of the majority of the Mexican population—granted a shot at a new, improved *Übermensch* (i.e., a superman). After all, Vasconcelos writes about "*una raza total, una raza que en su sangre misma sea síntesis del hombre en todos los varios y profundos aspectos del hombre,*" (a total race, one whose blood synthesizes man in all his profound and deep aspects) in a brazenly racist manner.[3] Amidst this scenario (of forcible miscegenation), a Caucasian alternative was to assimilate ethnic traits proper of the aboriginal groups of conquered nations, virtually, a description of the cultural process put into operation by the Revolution, in which an openly Eurocentric culture was superficially enhanced with Aztec makeup. Thus, though Kalimán's physique is that of a white man, culturally, his behavior and values owe more to his Oriental upbringing. These two approaches are, we will come to see, within this Mexican case, mutually complementary.

In the spirit of many great, illustrated characters—Tintin stands as a great example—Kalimán's saga is marked by its ethnographic disposition. The hero's original narrative, for instance, depicts his travels throughout India, Nepal, Tibet, Mongolia, Zanzibar, Kenya, and the Indian Ocean, as well as his encounters with Mongols, Tartars, Chinese and Malaysian pirates, Turkish slave-hunters, Tibetan monks, Zulu and Watusi warriors, British subjects—in their customary imperial role—and even pygmies. Representation incorporates the habitual scenarios, characters, and clichés. Kalimán's homeland, for example, though situated in the realm of Kalimantán near the province of Katmandu—the capital of Nepal—is suggestively Oriental in its context. Considering India's context prior to partition, in which Muslim and Hindu communities were mixed, this heterogeneity could be excused. Then again, Muslim is not always synonymous with Oriental, and vice versa. Yet, Ali and Krishna, the two hunters that raise the boy Kali far from his parents, are a

distinct indication of the intimate intermingling of cultures, a bold assertion in itself. Their names exemplify the two main groups of the Indian subcontinent. The village of Janil Bará, where young Kali is auctioned as slave, is, despite its proximity to the Himalayas, a veritable collage of cultures, camel-riding Arab traders included. Additionally, part of the dialogue by Abul Pashá, Kalimán's father, incorporates expressions like "¡*Gloria de Alá*!" (By the glory of Allah!). Close to his death, Pashá even commends his son's fortune to Allah, authenticating the perception of a Muslim background.[4] On the other hand, Kalimán's attire includes a turban that might associate him with the Sikh community. His physique, though Caucasian, is usually interpreted along these lines: when Brenda Drake, daughter of the governor of Zanzibar, first looks at him, she takes him for a Hindu prince. In all, Kalimán is a mishmash of ethnic markers, facilitating the reader's confusion and the re-affirmation of many stereotypes.

Aside from the hero's parents and subjects, as well as his spiritual mentors—replicating the paternalistic disposition of the colonial Mexican order, in which family and religion played a vital regulating role—non-European types are often portrayed in a negative light, as thugs, thieves, and tyrants, or simply as noble savages. Mongols and Tartars are no less than brutish beasts; Chinese and Malaysian pirates are ruthless, incult types; and enemies easily manipulate African warriors and pygmies, given their almost childish nature. In contrast, his British friends, Sir Thomas Drake, governor of Zanzibar, and his daughter Brenda, who promptly becomes Kaliman's first love, are depicted as honorable, refined, and well intentioned. As mentioned, such a biased portrayal, fairly common in Mexican media, does not represent a novelty. As anyone who has flipped through enough TV channels knows well, Mexican soap operas are packed with melodramas whose stars, in marked contrast to the average Mexican population, are tall, blond, and blue-eyed. Kalimán isn't blonde, but he's definitely blue-eyed. Yet, most of these soaps are set in a traditionally Mexican context. Kalimán's popularity, instead, is anchored on the colorful nature of his epic, which takes place at the other end of the world. This element, as well as the fact that the character was targeted—from its inception—at a working-class public, sets the hero in a different light.

Kalimán's identity, though concealed by his environs, also includes components of codes familiar to its audience. For example, his physique could be explained by the fact that his exact origin is unknown (though his divine nature is openly insinuated). Like Moses, Kalimán first appears as a crying baby, concealed in a basket rescued by fishermen and taken to the region's rulers, who quickly decide to adopt him. Echoing the signature of a traitor (though Judas received thirty pieces of silver), the greedy Turkish merchant who sells the boy Kali at the slave market is paid ten golden coins to reveal the child's fate: he has been sold to Mongols. A governing Judeo-Christian premise, it seems, tints most of the narrative. Later on, amidst a contest deciding a land issue between Mongols and Tartars, young Kali must face

an enormous giant (whom he promptly defeats). Though veiled, Biblical overtones are certainly evident. Hence, Kalimán's remarkable abilities are, to a certain extent, justified by his condition, vaguely rooted in a Judeo-Christian context.

Mexican culture is adept at religious syncretism, as evidenced in the cult of Juan Diego, the Indian peasant venerated by the populace, and the celebration of the Virgin of Guadalupe, the patron saint of Mexico, modeled on Tonantzin, the Aztec goddess. The façades of Mexican colonial churches frequently display the image of the sun, the foremost Aztec god, in an attempt to appease Amerindian sensibility during colonial times. Consequently, to the readership, amidst an Asian setting, the inclusion of ingredients pertaining to Judeo-Christian mythology does not appear very out of place. Despite their society's overall homogeneity in terms of construction of identity, Mexicans are accustomed to an enforced sense of cultural heterogeneity, precisely because of the cultural agenda of many administrations of the past century, which preached and glorified racial mixture. In this way, they are raised within a cultural matrix that organizes society along official dictates, whatever we understand them to be.

Within this order, contrary to all evidence, *mestizaje* is enshrined as the most virtuous way of national identity. Hence, it's only logical that Kalimán operates within these coordinates. Through him, Mexico legitimates its role as part of the Western world. In other words, when his creators envisioned the hero, they were—unconsciously or not—proclaiming the fact that Mexicans could also be Orientalists. They could share the prepotent, arrogant attitude of the European (and U.S.) gaze and partake in its benefits. In this way, Mexico ratified its Western condition. As a product of 1960s culture, *Kalimán* is typical of its times, when, thanks to the celebration of the Olympics and the so-called Mexican economic miracle (during this decade, Mexico's economic expansion was phenomenal, averaging a high annual rate of per capita growth), the government's main concern was to be perceived as a worthy partner for the industrialized world, notwithstanding political (the massacre at Tlatelolco; the crushing of the student movement) and cultural (the demise of the Mexican *Nueva Ola* and its accompanying counterculture) repression. Additionally, *Kalimán* was admittedly created as an alternative to what conservative Mexican sectors identified as the increased vulgarization of their culture. This process was most visible in the film industry of the 1960s, which, after the end of the Golden Age of Mexican cinema, resorted to a hectic pace of production that inevitably brought about a decline in the quality of product. Within this decade, the number of "B" movies soared, with poor scripts, raunchy themes, improvised sets, bad acting, and careless editing. In contrast, *Kalimán* represented an attempt to produce for the masses with concern for a higher quality and, regressively, a return to a nobler, more honorable role model—above all, within the traditionally moralizing scope of the middle class. *Kalimán* was the outcome of a style commonly identified as *violencia blanca* (white violence, notwithstanding the pun), exempt of profanities, sex, and brutality, yet particularly

supportive of oligarchic and patriarchal structures. Its only competition of importance, the Mexican wrestlers' cinema circuit, an equally idiosyncratic cultural product, though willing to echo the puritan spirit—and, at times, even the Orientalism—of heroes like Kalimán, failed dazzlingly, given the technical limitations of the period.

According to Said, "Orientalism is a style of thought based upon an onto-logical and epistemological distinction made between 'the Orient' and (most of the time) 'the Occident.'"[5] With *Kalimán*, the Mexican comic book indus-try contributes to this process, in which the European/Caucasian is portrayed in a positive light and the foreigner is framed as barbarian. Nevertheless, it does so with a twist: advocating *mestizaje*—or at least *mestizaje* as inter-preted by the white, ruling classes of Mexico and much of Latin America. Therefore, just as "Orientalism embodies a Western style for dominating, restructuring, and having authority over the Orient," it also depicts lucidly the mechanics of Mexican and Latin American identity.[6] In other words, it personifies the structures of domination favored by Latin American ruling classes, based largely on consent and shared prejudice. In Latin America, when it comes to race, the lower and middle classes are expected to embrace and sanction the views of the rich. Within this context, Kalimán's physical appearance is less relevant (thus, its public disregards the evidence). After all, like most of Latin America, Mexico is a thoroughly class-oriented society. Racism is rampant, but it is consistently trumped by class discrimination.

Kalimán clearly embodies the perspective of its creators. As middle-class Mexicans producing cultural artifacts for the working class, his creators believed in and supported the idea of a Caucasian whose *mestizaje* resided in name, culture, and behavior; not in the actual physical appearance, but in the appropriation and use of a culturally mixed background. It is characteristic, for example, to find Caucasian Mexicans with indigenous names; a favorite one, Cuauhtémoc, the name of the last Aztec monarch, comes immediately to mind. Tenoch, for instance, was the name of a main character in Alfonso Cuarón's hit motion picture *Y tu mama también* (And Your Mother Too, 2001), which traces an allegorical journey from the central mega-city to the peripheral countryside, where the presence of the state apparatus is null. Yet, a more fitting example would be a film like Antonio Serrano's *Sexo, pudor y lágrimas* (Sex, Shame, and Tears, 1999), a hapless comedy about the life of yuppies in the capital city, in which Mexicans of Indian descent are conspic-uously absent or white-washed. Such is the way upper middle-class Mexicans favor seeing themselves: Indians by culture, yet not by skin color. As a social segment, they're willing to participate in national mythology and reassert their Aztec roots, only as long as their racial superiority remains unques-tioned. This mindset, product of years of indoctrination and social condi-tioning, is internalized to such an extent that, upon traveling abroad—in particular, to the United States—many white Latin Americans are enraged by the fact that they're not treated as (what they deem as) equals. Within this perspective, race fails to be a social construct, but remains a matter of pig-mentation, thus the misapprehension of exclusion by Anglos.

At any rate, within this layout, it is easy to see how Kaliman's rivals ratify my argument. In the gallery of Kalimán's opponents, even the only two Caucasian foes, who insinuate a distance from the Orientalist perspective, address this inclination. Upon a visit to London, where he has traveled to see friends, Kalimán confronts *Conde Bartok* (Count Bartok), a vampire. In another episode, during a stay in Africa, he falls in love with Shiba Tak, the evil *Bruja Blanca* (White Witch), a white woman whom, having survived the plane accident in which her parents perish, is raised by gorillas. Both narratives are clear allusions to characters in the Western tradition of alterity: Dracula and Tarzan. In both occasions, contact with far-away lands involves danger and risks to the power structure of the empire. Correspondingly, London is visibly constructed as a place of affection, since most of Kalimán's friends are linked, in one or another way, to British imperial designs. Despite his wardrobe and origin, the fact that Kalimán fights and overcomes both evils—thus, siding with the metropolis—frames him as a champion of the colonial order. Other evil-doers—to use a term in vogue—include Karma, a bald-headed mate from the Lama monastery; Kardo, an alien with an inexplicable penchant for Turkish clothing; Omar, a merciless Bedouin involved in narco-trafficking; and the *Araña Negra* (Black Spider), whose presence is vaguely reminiscent of The Shadow, the North American radio personality. Still, though this latter character incorporates elements of the U.S. tradition, his context and accomplices are all well situated in Africa or the Orient. Jointly, his enemies validate the idea that evil comes from remote places located beyond the industrialized world; individually, they're not as ethnically and culturally divergent as Kalimán. In a sense, Kalimán is constantly ambivalent: while he personifies—and benefits from—a culturally mixed identity, he always maintains the paradigmatic nature of Western civilization. In a certain way, he incarnates a *mestizo* bent on the supremacy of specific racial archetypes.

Next To "Them," Mexican Machismo Looks Great

In "El Santo's Strange Career," Anne Rubenstein proposes a critique of one of the most popular Mexican cultural icons, the wrestler El Santo.[7] In it, she traces El Santo's journey from working-class hero to middle-class pop celebrity. Much of what she states with respect to the depiction of this character in earlier comic strips still applies to the current version, re-launched in 2005 under the name of *El Hijo del Santo* (El Santo's son), who, in emulating the cult status of his progenitor, is giving continuity to the myth of the benevolent Mexican wrestler. Rubenstein's critique centers on El Santo's personification of the virtuous Mexican man, as opposed to the stereotypical macho. However, in the process of acting out the role of the counter-macho—and this is Rubenstein's contention—El Santo validates a conservative, exploitive order that is no less oppressive than that sponsored by Mexican machos. A critique along this same vein can be put

forward in the case of Kalimán, though substantiated in a more insidious fashion. While my previous criticism has thus far dealt with the context of *Kalimán* in a flexible chronological order, a detailed tracking of the narrative might prove more suitable to a critique of its representation of gender.

Kalimán is, quite clearly, a man of the Orient. While he is the result of Mexican imagination, the reality of his original saga is set amorphously in a time proper of the British empire, in which the colonial system is preponderant. In this context, Kalimán's acting of manhood is contrasted with that of tyrants and ruffians with a penchant for harems and corporal brutality. Therefore, when it comes to matters of gender, Kalimán appears to be a more noble-hearted, sensitive version of a man. His sense of decency and decorum, it would seem, is tinted by the communal respect ubiquitous in romanticized colonialism. For this reason, colonialism, in its authentication of stereotypical views with respect to the British and their Oriental outposts, plays a substantial role in the justification of *Kalimán*'s representation of gender, justifying the formality of the hero's demeanor and rationalizing his rectitude in terms of class. In *Kalimán*, class markers abound, yet they often have to do with more than just class. That's why, when Kalimán is rescued from the ocean by the British governor of Zanzibar, his daughter immediately interprets Kalimán's gentle deportment as a symptom of aristocratic origin. Class, in the British as well as in the Mexican and Latin American context, colors gender. Consequently, a transition from one to another, while plausible, is likely to pass unnoticed.

On the whole, Kalimán's depiction of gender is supported by a relatively straightforward set of considerations. For one, a predictable aspect of Kalimán is that, like most superheroes, he is remarkably monogamous, regardless of his reputation as a ladies' man. To cut a long story short, Kalimán is an astoundingly chaste heterosexual. As a champion of good, he behaves in a gallant fashion, never taking advantage of his romantic conquests, usually set amid the predicaments of a damsel in distress. His flirtations with the opposite sex are the customary result of interested women. Seldom does Kalimán venture a thought or inkling as to his preference in matters of the heart. This behavior, while probably unusual in the context of Mexican machismo, is sustained in terms of "Oriental" gentlemanliness, based on the hypothetical distance and circumspection between genders in the East. In this way, Kalimán replicates attitudes and behaviors that stand in marked contrast to those exhibited by his rivals, who tend to embody even more exaggerated and distorted representations of Oriental manhood.

Then again, the plot of the story does an excellent job at rationalizing these differences in such a manner that they pass unnoticed and unquestioned. For one, Kalimán's adoptive parents, the rajah Abul Pashá and princess Amejrá Pushim, bequeath their son a lot more than just high social stature. Partially thanks to them, Kalimán perpetuates conduct and

values that, in the context of the Raj, the British rule of the Indian subcontinent (1757–1947), appear unquestionably pro-Western. Their behavior, founded on a faithful and idealized perception of marriage, frames much of our hero's conduct with respect to the opposite sex. The apple, it could be said, does not fall far from the tree. In other words, Orientalism, while justifying the excesses of villains, also serves to validate and regulate gender according to conservative Western standards sanctioned in the adventures of Kalimán. The enlightened hero sponsors morals that, while appearing more progressive than the vitiated depictions of Oriental constructions of gender, still manage to frame a resilient patriarchal order. In this sense, a particularly good example of the story's rendering of gender is Kalimán's father refusal to have more wives, in spite of his inability to procreate a son with princess Amejrá, thus condoning a monogamous relationship amid a context where it noticeably passes for anomalous. For this couple, love trumps everything: the people's demands of lineage and even the occasional surfacing of lust. Instead, Abul Pashá chooses to embrace the wild prophecies of a sage from the mountains, who predicts the arrival of great joy. Quite fittingly, the rajah's noble intentions are rewarded by an occurrence of pseudo-divine origin: a baby's appearance (Kalimán) in a basket at a nearby river.

Kalimán's sense of decency, it could be said, aside from pertaining to a speculative family tradition, can be attributed to its time of conception. After all, despite the sexual revolution—or precisely because of it—Latin American cultural products of the 1950s and 1960s habitually upheld an ersatz puritanical air, trying to cling to society's vanishing grasp of the normative. Therefore, rather than disclose its manipulation of alterity, *Kalimán* becomes the suitable vehicle for the advancement of male virtue, enthusiastically embracing the tangential benefits of misrepresentation. Next to the narrative's prejudiced portrayals of Oriental manhood, Mexican males, whatever their behavior, come out looking great. In addition, just in case readers are willing to contemplate a model worthy of emulation, the comic book suggests its protagonist as archetype. To ascertain some contrast, the recommended vision of gender relies just as heavily on a theory of women, who, like men, are pictured without ambivalence, in an extreme fashion: they're either pristine or downright sinful, no in-betweens. Kalimán's romantic interests tend to be virgin-like maidens, very attuned to traditional Mexican and Latin American gender sensibilities. Reading *Kalimán*, it is real easy to understand what being a "good" guy or girl is all about. As a result, sexuality is drastically repressed, melodrama is heightened, and, above all, thanks to a misdirected understanding of Oriental spirituality, bodily needs are relegated to oblivion. Kalimán's ability to prioritize mind over body takes good care of this latter aspect.

A theory of women does not necessarily imply their presence: omission, in many cases, can play an equally important role. An alternative cornerstone of gender in *Kalimán* is the almost absolute absence of females in its early narrative. This deficiency becomes a trademark of Kalimán's initial sagas, in

which women fail to play any significant role. In *Kalimán*, female characters tend to follow two patterns of behavior. First, when they tend to appear, they are generally viewed as idealized, submissive objects of affection. Things happen to them; they don't ever make things happen. Hence, the world of Kalimán, the child and youngster, is exempted from any actions of heterosexual connotation. Next, there are a few women who are unmistakably portrayed as glamorous objects of desire or deceitful vamps; i.e., if these women act, nothing good ever tends to emerge. Misogyny, translated from *malinchismo*, seems to be the course of the day.[8]

Men, on the other hand, are the engines of action in the story and their resourcefulness—both in good and evil—is limitless. Returned to the river by the evil vizier Sarak, who wishes to take over Abul Pashá's lands, Kalimán is rescued, first, by a massive eagle, and second, by the hunters Ali and Krishna. If one man appears to be recklessly wicked, soon others appear who are diametrically bent on rectifying his misdeeds. Time after time, Manichaeism rules the development of actions, facilitating a reductive understanding of the text. This aspect is, to a fair extent, a shared characteristic with comic book creations of the 1950s and 1960s, influenced by the Cold War. Disney characters are an exceptionally good example, as suggested by the work of Dorfman and Mattelart.[9] *El Eternauta*, the masterpiece of Argentine scriptwriter Héctor G. Oesterheld and, quite probably, one of the best examples of canonical Latin American production, also embraces this logic, excluding women as well as evincing the sexism preponderant in "progressive" Latin American sectors of the time.

By the same token, Kalimán's upbringing in the forest at the hands of a pair of hunters, aside from lacking any female presence, borders the homoerotic. Western superheroes favor tights and snug outfits. (Kalimán will eventually adopt this style.) During his childhood, Kalimán and his mentors, Ali and Krishna, saunter around the jungle scantily clad in trunks, bare-chested and sweaty. Men, it seems, must grow in exclusively masculine environments, in close contact with nature, incarnated by the animals and vegetation of the jungle, but not in the presence of the opposite sex. Even the animals that befriend and protect our hero, such as a wolf and tiger, are males, an aspect made clear by the Spanish language's handling of gender. The only exception to this rule is the interlude of Kalimán's failed escape from Mongols, when he's protected by a doe, which provides him with milk and warmth amid the severity of a mountainous climate. Consequently, it is clear that the animal plays a motherly role. Viewed from an emotional perspective, Kalimán's relationship with the animal is, to say the least, a bit idiosyncratic. Seemingly, in order to be protected and sheltered, Kalimán must grow in a world free from the noxious influence of vexing females, yet mammal equivalents are admissible. Aside from his mother, Kalimán's first acknowledged encounter with women is past the age of eight, when, after the demise of Ali and Krishna, and his subsequent rearing by animals, female slaves are being auctioned in the village of Janil Bará. Though

Kalimán immediately unleashes a diatribe on the injustice of slavery, his words do not acknowledge this first instance.

Beyond this circumstance, Kalimán's adolescence remains unmistakably masculine. In the world of Mongols, in which he lives up to the age of fifteen, women are seen as commodities, so their presence is tangential at best. When Tartars, the sworn enemies of Mongols, kidnap him and the daughter of a rival leader almost seduces him, he pays little attention to her charms and instead prefers to escape. Virtue, it seems, must not be distracted by more earthly affairs. Kalimán then lives in a Lama monastery, another setting uninhabited by women, where he masters the powers of the mind and body, learning many languages and martial arts, as well as finding out that he comes from a long line of champions of good (thus hinting at reincarnation). Once again, the monastic experience endorses the exclusion of women to a radical extent. By the age of sixteen, once his apprenticeship is finished, he falls in the hands of Chinese pirates (another exclusively male scenario), who dupe him into espousing their war against Malays for two belligerent years. For all his intellectual prowess, it is amazing how Kalimán's good heart sets him up to undertake the worst of deeds, as when he pillages and murders for Mongols and Malays. When it comes to narrative perversions, apparently, heroes are just as likely to be fooled. In the process, he suffers a shipwreck, only to be rescued by a tall ship commandeered by Sir Thomas Drake. Once again, Kalimán becomes an object of desire, since Brenda, Drake's daughter, befriends him. As mentioned previously, when it comes to love and our hero, who never displays any assertive qualities with respect to the matter, women are consistently portrayed as famished suitors, in a fashion altogether reminiscent of demonization. While Kalimán's behavior is justified as a consequence of his superior condition, it also ratifies a virtuous construction of Mexican masculinity, analogous to El Santo's. This time around, though, Kalimán response will be less aloof. Finally, it appears, the hero has been smitten by love. Nonetheless, this first passion at the age of eighteen is framed in such an upright, proper way that it legitimates a very conventional interpretation of physical love. The relationship is embellished emphatically with airs of chastity, along the lines of morality paraded in El Santo's dalliances with disadvantaged ladies.

As stated previously, omission becomes particularly critical in matters of female representation. The fact that women fail to appear on a regular basis within the narrative underlines the normalcy of a predominantly male world. From this point of view, readers can relate this quality to the remote corners of the planet illustrated in the plot or use it to substantiate their support of an unchanging gender order. Thus, omission becomes an aspect of justification. Since women do not figure largely as part of the social equation of the worlds depicted in *Kalimán*, their presence—or lack of it—passes for the most part unnoticed in the Mexican context. To put it briefly, *Kalimán* is not a cultural product that endorses the acknowledgement of

women. A society and time that are blind to women have a tendency to pro-
duce cultural artifacts that replicate blindness, regardless of the object of
representation. Some do it in a mechanic, straightforward fashion. *Kalimán*
does it in a more evocative style, encouraged by the inherent exoticism of
the Orientalist gaze.

Finally, the thread of the story reveals that, aside from his relationship
with women, Kalimán can appropriate gender in a more effective, colo-
nial fashion, replicating the dominant gaze of the empire. When the ship
finally arrives in Africa, Kalimán, who has gained Governors Drake's con-
fidence thanks to his prodigious display of skills, thwarts an attempt on the
Englishman's life, instantly becoming the enemy of an Arab slave trader
named Abel Zalim. The Arab then kidnaps Brenda and, during Kalimán's
daring rescue attempt, she dies. Kalimán runs after Zalim, who has escaped
into the heart of the continent, and, through this persecution, encounters
Zulus, Watusis, and the occasional tribe of pygmies. Far from being a dark,
remote place, Africa seems to be the ideal testing ground to publicize the
hero's many skills. Africa is not only the hunting ground of the European,
but also the playground for his close subordinate, the brainchild of a pair
of Mexican authors who imagine and portray the location along the set of
clichés promoted in colonial narratives.

To come to the point, the continent is feminized. When Kalimán ventures
into the jungle on a horse, the gaze of a curvaceous woman holding a jar on
her head frames his departure.[10] What is the theoretically male reader sup-
posed to look at in this moment? Is it at the silhouette of a departing hero
or at the sensuous anatomy of a woman who, in the act of looking, frames
Kalimán's pose as a dominant force and re-orients the reader's gaze towards
him? Comics are a privileged medium in that they manage to conflate many
representations into one. While Kalimán departs in search of Abel Zalim, it
is Africa that he embraces as a land of adventure, with an attitude detached
from the air of circumstance that affects his experiences near India. In sum-
mary, at this point, Africa becomes the object of conquest for the colonial
hero that is Kalimán. (At the end of travails in Africa, Kalimán even has
time to visit—with the flair of an astonished tourist, a manner he never
exhibits elsewhere—the Upper Nile and Victoria Falls.) Through his actions,
Kalimán comes to represent the very process that has engendered him: the
penchant of the subordinate mind for reproducing the dominant order, the
rule of empire. Just as Kalimán embraces a womanly Africa, the Mexican
authors have resorted, unwillingly or not, to recreating a version of gender
along the dictates of Western interests, in which male supremacy is condi-
tioned by the weal of the metropolis.

The final episodes of Kalimán's original saga narrate the hero's return to
his land in search of his stolen kingdom. Thus, once Kalimán has achieved
renown in Africa, he is to be celebrated by its inhabitants. An image at this
point of the story depicts faces representative of diverse African ethnicities
crying out his name. The graphic frames the many faces with an outline of

the Indian subcontinent, in an effort to encapsulate the population of both places in one succinct stroke. The faces, in accordance with the rest of the narrative, are all male. If the image is meant to condense the Orient, incorporating Africa, it does so at the expense of women, who do not seem to matter much in either place according to *Kalimán*. The hero then returns to his home province, unmasks the tyrant (his mother is sacrificed in the process), distributes his wealth among his subjects, and then flees to the mountains to conclude his training at the monastery. From then on, many adventures follow, which make the bulk of the character's production, consequently affected by his prior history.

At this point it's imperative to bear in mind that Kalimán will soon embrace the company of Solín, in a manner all too suspiciously similar to the relationship between Batman and Robin. While I will not venture any ideas with respect to the nature of this relationship, which stands out for its affectionate undertones, I will certainly point out that the adoption of this setup—that of an older, mature superhero faithfully accompanied by a younger sidekick—signals the influence of the U.S. cultural industry. Thus, *Kalimán* works at various levels: it not only involves a representation of colonialism, replicating the thoroughly internalized colonial mindset, but also hints at the mechanics of colonialism within a more contemporary practice of culture. Comics might be the product of the metropolis, yet, within a critical exercise of transculturation, they do not necessarily imply the reproduction of the medium along the lines of metropolitan prerogatives. To a great extent, *Kalimán* isn't a product along the lines of critical exercise.

Like El Santo, *Kalimán* is strongly influenced by its rise as a cultural product amid the prosperity of the Mexican economy of the 1960s. Juan Manuel Aurrecoechea and Armando Bartra have discussed the significance of comics in the urbanization of Mexicans, guiding the population amid the change in mores brought about by an all-encompassing modernity.[11] Mexicans learned to be Mexicans not only by going to the cinema, as Carlos Monsiváis points correctly, but also by reading comics. Up until the 1960s, the Mexican reading public still took many cues from comics, conceived with unabashed pedagogic intent. In this sense, comics not only taught the people how to read, but also how to implement new spatial and social relations, chiefly among them, revised constructs of gender. If gender roles from the country ceased to prevail in the city, new ones had to be devised, in order to maintain gender orthodoxy within a rapidly changing nation. Thus, in the context of its representation of a male hero in an international setting—paying little attention to the slightly anachronistic circumstances of the story, which justified the celebration of Victorian tradition, more in line with Mexican Catholic sentiment—*Kalimán* provided key outlines for the acting of masculinity in a new environment.

In this way, *Kalimán* worked at different levels. To begin with, it proposed a chivalric construction of manliness, which, despite its Oriental

stature, could be emulated by Mexicans. It thus proposed a model to fol-
low, along the lines of the paternal spirit of the political revolution. At the
same time, it validated the idea that Mexican males, while lagging in some
aspects in matters of egalitarianism, were not as abusive as guys in other
latitudes, particularly when these men were depicted along the set of stereo-
types promoted by an imperial gaze. Next to this team of thugs, Mexican
charros did not fare badly. It was only a matter of siding with the good
guys, like Kalimán. Thus, as a springboard for the construction and reaf-
firmation of identity, Orientalism proved extremely useful for the team of
creators behind *Kalimán*. While I sincerely doubt that Navarro Huerta and
Vásquez González had greater designs in mind, what I wish to point out is
that, as talented members of the Mexican middle class, they managed to put
forward a product in which they put to work all they knew, consciously or
subconsciously, of their identity in terms of race and gender (beyond Vásquez
González's Cuban origin). Ethnic bias and nationalism, firmly entrenched
in their generation, contributed to their promotion of views in which cer-
tain segments of society, while pretending to work in harmony with oth-
ers, wielded power and applied it indiscriminately to their own benefit, at
times with the consent of others, at times with blatant disregard. Within
this mindset, the British empire retained much of its prominence as a cen-
ter of power and civilization, and distant corners of the world supplied an
ideal canvas to problematize aspects that, when discussed too close to home,
proved uncomfortable.

CODA

Kalimán, I argue, is a superb example of the way in which hegemony
is exercised, not only by ruling, foreign bodies, but also by a local
order, which chooses to disguise itself as exotic. It takes the idea behind
European hegemony—its superiority in comparison to all non-European
peoples and cultures—and reconfigures it to its advantage, in line with
the locally endorsed perception. Just as the Oriental is, according to
Said, "*contained* and *represented* by dominating frameworks," so is this
character's audience.[12] Just as Orientalism works as a style to dominate,
restructure, and impose authority over the Orient, to gain in strength
and identity by setting oneself against an other, it can be appropriated
by third parties and used in the implementation and regulation of their
societies. To consume and enjoy *Kalimán* is, at the very least, to share
a prejudiced context, one in which, like Europe setting itself against the
Orient, Mexico theoretically validates its ways against racial convention
and gender equality, and towards social egalitarianism. As such, *Kalimán*
is a particularly useful case to argue the significance of Latin American
graphic art as a cultural product. If we read closely, concealed in it, we
are able to recognize many of the codes and values of contemporary Latin
American society.

Figure 3.1 By the glory of Allah!

Figure 3.2 May Allah protect you...

Figure 3.3 He shall be my husband!

Figure 3.4 How handsome.

Figure 3.5 Leaving the village...

Figure 3.6 You will die, white giant!

Figure 3.7 Kalimán's blue eyes.

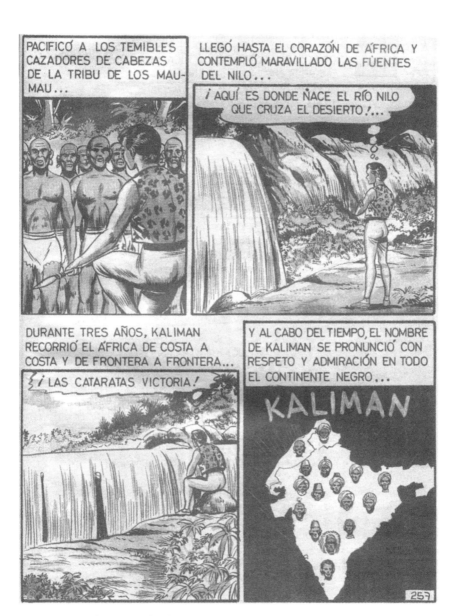

Figure 3.8 The name of Kalimán.

Notes

1 Edward Said, *Orientalism* (New York: Vintage Books, 1979): 25.
2 Leopoldo Zea Salas, *La leyenda de Kalimán, el hombre increíble* (Querétaro, Mexico: Litográfica y Editora del Bajío, 1995): 246, 248.
3 José Vasconcelos, "Indología," in *Hispanoamérica en su literatura*, edited by Nicholson B. Adams (New York: W.W. Norton, 1993): 216.
4 Zea Salas, *La leyenda de Kalimán*: 12, 83.
5 Said, *Orientalism*: 2.
6 Said, *Orientalism*: 3.
7 Anne Rubenstein, "El Santo's Strange Career," in *The Mexico Reader*, edited by Gilbert Joseph and Timothy Henderson (Durham and London: Duke University Press, 2002): 570–578.
8 The *Malinche* was an Amerindian princess who served as Hernán Cortés's translator and eventually became his lover, giving birth to the first mestizo, according to popular mythology. To this day, her actions, interpreted as betrayal, color politics of gender in Mexico.
9 Ariel Dorfman and Armand Mattelart, *How to Read Donald Duck: Imperialist Ideology in the Disney Comic* (New York: International General, 1984).
10 Zea Salas, *La leyenda de Kalimán*: 225.
11 Juan Manuel Aurrecoechea and Armando Bartra, *Puros cuentos. Historia de la historieta en México* (México, Conaculta-Grijalbo, 1988). For a more recent account along these lines, see the article in the June 2005 issue of *Hoja por hoja*, available at http://www.hojaporhoja.com.mx/. June 24, 2006.
12 Said, *Orientalism*: 40.

Works Cited

Aurrecoechea, Juan Manuel and Armando Bartra, *Puros cuentos. Historia de la histo-rieta en México*. México, DF: Conaculta-Grijalbo, 1988.

Dorfman, Ariel and Armand Mattelart. *How to Read Donald Duck: Imperialist Ideology in the Disney Comic*. New York: International General, 1984.

Rubenstein, Anne. "El Santo's Strange Career." In *The Mexico Reader*. Edited by Gilbert Joseph and Timothy Henderson. Durham, NC, and London: Duke University Press, 2002.

Said, Edward. *Orientalism*. New York: Vintage Books, 1979.

Vasconcelos, José. "Indología." In *Hispanoamérica en su literatura*. Edited by Nicholson B. Adams, John E. Keller, John M. Fein, and Elizabeth R. Daniel. New York: W.W. Norton, 1993.

Zea Salas, Leopoldo. *La leyenda de Kalimán, el hombre increíble*. Querétaro, Mexico: Litográfica y Editora del Bajío, 1995.

Cuban Cartoonists: Masters of Coping

John A. Lent

I believe that man will not merely endure; he will prevail.

William Faulkner, Stockholm, Sweden, December 10, 1950

Though the American novelist drawled those words in another context—the fears of that Cold-War, nuclear era that humans would blow themselves to smithereens— they work rather well in describing the indomitable spirit and the will to survive of Cuban cartoonists. Staving off the abrupt change of the political system in 1959, the more than 40-year U.S. economic embargo, and the loss of support of Comecon countries and the collapse of the Soviet Union in 1990–1991, Cuban cartoonists not only endure, but prevail, capturing hundreds of international awards, organizing and sponsoring activities (seminars, training programs, festivals, cartoon museum) to unite and promote the profession in the region, and winning worldwide recognition and respect.

The Cuban cartoonists have learned to make do with the barest of materials, sometimes obtainable from friends abroad, at other times invented, using whatever is at hand, including what nature has endowed, and to find outlets besides those that require scarce newsprint and celluloid, putting their cartoons on television, murals, or bulletin boards and entering national and international festivals/competitions.

Living in these uncertain circumstances, cartoonists occasionally are tempted to leave Cuba in search of opportunities abroad. At crucial times, such as the beginning of the Revolution, the Mariel Boatlift of 1980, and the Período Especial (Special Period) of the early 1990s, a number did leave, settling in the United States, Mexico, Spain, Brazil, Chile, and elsewhere. The stories of those who stayed and those who left are equally fascinating and equally full of hardship and deprivation.

THE REVOLUTION

Unlike the rest of the Caribbean, Cuba had a strong comic art tradition, full of humor periodicals, comic strips, political cartoons, and some animation. Much of this continued during the Revolution's formative years, as editorial cartoons appeared in the dailies *Hoy* (Today), *El Mundo* (The World), *Revolución*, and *La Tarde* (The Afternoon). What began to change was the dominant ideology, and with it, the infrastructure of mass media, and thus cartooning. For those with short memories, Cuba before 1959 was ruled by a string of United States-supported dictators, the most recent of whom was Fulgencio Batista. The degree of freedom journalists (and likely cartoonists) had under Batista depended on how much they benefited from *botella*, an unofficial system of paying publishers and journalists for favorable coverage.

After Fidel Castro came to power, the mass media were reorganized into a tighter infrastructure to better serve the goals of the Revolution (see Lent, 1985, 1988). Long-standing newspapers and magazines were closed, replaced by others under branches of the Communist Party, and broadcasting and film were formally structured under the Instituto Cubano de Radio y Televisión (ICRT) and the Instituto Cubano del Arte e Industria Cinematográficas (ICAIC). The latter was created three months into the Revolution, and by December 1959, ICAIC had an animation department. Another three animation departments were created, the most productive being that of ICRT, which, from 1970 to 1990, made 900 animated works (Castillo, 1998).

Humor was to be part of the Revolution in other domains: evidenced by the appearance of many comic strips and gag cartoons in dailies and magazines and the creation of humor magazines, comic books, and a number of professional activities and organizations. In 1961, *Palante* (Forward) appeared as a humor weekly, later followed by *Melaíto* in Santa Clara and *Dedeté* in Havana. Throughout the 1960s and 1970s, cartooning was strengthened with the launching of the Museo del Humor and a biennial international cartoon festival, both in San Antonio de los Baños in 1979, children's magazines such as *Pionero*, *Pásalo*, and *Zunzún*, and professional support organizations such as the Unión de Periodistas de Cuba's (UPEC) Humorists Section and the Unión de Escritores y Artistas de Cuba's (UNEAC) Visual Arts Section (Lent, 1991: 26–27).[1] Later, in 1985, comic books for adults came into being when UPEC's publishing arm, Editorial Pablo de la Torriente, issued the weekly *El Muñe*, monthly *Cómicos*, and less frequent *Pablo*.

When the Revolution came, many cartoonists welcomed it, some of who had already contributed to the revolutionary struggle. Among them were Marcos Behemaras, Virgilio Martínez Gaínza, Santiago Armada Suárez (Chago), René de la Nuez, and Adigio Benítez. Some reflected with fondness on the days leading up to and shortly after the Revolution, De la Nuez (1998) telling of placing subtle pro-Fidel symbols in his "El Loquito" (The Nut) comic strip before 1959, and heeding Fidel's personal requests on what

to target after he assumed power, and Benítez (Castañeda, 1988: 6) proclaiming, "My intention with caricature was naturally to contribute to the people's struggle in favor of socialist ideas, against tyranny and for peace ... in their struggle for freedom, for the revolution."

Obviously, not all cartoonists agreed with the Revolution's goals and some left Cuba, among them Lorenzo Fresquet, Silvio Fontanillas, and Antonio Prohías. All were staunchly anti-Communist. Fresquet and Fontanillas ended up in Miami, drawing for Spanish-language newspapers in the 1960s and 1970s (Díaz, 1999). Prohías was the most noted of the three, both in Cuba and the United States, serving as president of the Association of Cuban Cartoonists until he was asked by pro-Fidel forces to resign in 1959. For years, he drew highly popular strips such as "La Oveja Negra" (The Black Sheep) and "El Hombre Siniestro" (The Sinister Man) and award-winning editorial cartoons for *El Mundo, Información*, and *Zig Zag*.[2]

Prohías said that because of his anti-Castro cartoons, he was accused of working for the U.S. Central Intelligence Agency; subsequently, he lost his publishing venues and left Cuba on May 1, 1960, after 100,000 Cubans protested and wanted to put him to the wall ("Spy vs. Spy," 1998: 26). Francisco Blanco (2001) talked about Prohías' stance concerning the change of government in 1959:

> We were very good friends ... When the Revolution triumphed, Prohías had close links with the Batista regime. I was a fighter against the government of Batista through the unions. Prohías said it was Communism and he could not stand it. He was a capitalist and could not live in this system. My revolution was to fight against Batista. Prohías prepared for me to replace him [on *El Mundo*, which Blanco did].

In New York, Prohías accepted a factory job ironing sweaters and drew some editorial cartoons for two Spanish-language newspapers. Different versions have been given about how he convinced *Mad Magazine* to use his works; his daughter, Marta Prohías Pizarro (Díaz, 1999), said he threatened to rip up his portfolio of drawings when *Mad* suggested he take them elsewhere. Gradually, *Mad* published Prohías' "Spy vs. Spy" strip, never thinking his tenure would last 29 years until he retired in 1990. The genesis for "Spy vs. Spy," described by Dean (1998: 8) as "[T]wo generic spies outwitting each other with seductive ruses and Rube Goldberg-esque devices," was "El Hombre Siniestro," although the latter was more cruel. Pizarro (1999) described one "El Hombre Siniestro" strip: "El Siniestro opens a beauty shop and calls it the 'Venus de Milo Beauty Shop.' An ugly woman walks by the shop and thinks that if she goes in, she'll walk out beautiful. You see her walk in [and in the last panel you see her] come out of the shop without any arms." Blanco (2001), claiming he knew "the real history of 'Spy vs. Spy,'" told me:

> In the 1950s, Prohías had a section in *Bohemia* [a popular magazine] called "El Hombre Siniestro," like Dracula. It was only one character. When Prohías

got to the United States, he realized the struggle of the two superpowers. He created two characters from one—one black, one white. "Spy vs. Spy" had the same characteristic as "El Hombre Siniestro." In the latter, the character had a candy belt (he put a lot of candy around his belt); when he'd meet a little girl, he'd give her the poisoned candy and she'd die. I used to tell Prohías the strip was too cruel. Prohías would say, "You don't know human beings."

The departure of Prohías and others in the early days of the Revolution spawned what Tomás Rodríguez Zayas (Tomy) (1998) called a new generation of cartoonists, "humble peasants," most of who came out of the military. Tomy told of his own experience at the time:

> That group found some open spaces as a lot of established cartoonists left the country. It gave me, as a 20 year old, the opportunity to become art editor of *Dedeté*. It marketed me. I was very lucky. When I started with *Dedeté*, I got in touch with many cartoonists and won awards abroad. I travelled and got to know other countries. It made me understand a very important thing: that I could have worked in those countries. But something happened to me: I could make money abroad, but I would never have social recognition as here...Another element is my roots. All my peasant family lives in the same place I came from. And, although I live in Havana, every year I go two or three times to visit them. And, in another country, I would miss those things.[3]

The Mariel Boatlift and Cartoonists

Another exodus of cartoonists occurred in 1980 during the Mariel Boatlift, when Castro allowed at least 188,000 Cubans to move to the United States. As Díaz (1999) pointed out, the Marielitos (and the cartoonists among them) were different from the first wave of wealthy, white-skinned immigrants. Poorer, dark-skinned, and disenfranchised, this group had a different picture of Batista's Cuba—it was not the paradise the Miami exiles of the 1950s-60s made it out to be. Díaz (1999) said the Mariel cartoonists were also unlike their predecessors, as they were younger, minor artists who did not consider Fidel as the enemy, who understood the Revolution to be a consequence of U.S. policy, and who actually benefited in ways from the Revolution. She said they were more like immigrants than exiles, and left Cuba because of constraints and with hopes of a better life.

Among the Mariel cartoonists was Hernán Henríquez, member of the first groups of animators at ICAIC in 1959. He said his ICAIC position had been great, but there was no "way to improve my private life" (Zagury, 1999a). But, the situation did not change that much for the better in the United States, where he became a timer for Klasky Csupo:

> In Cuba, I had a salary, and I didn't have to pay the house rent, the doctor, or the school. People didn't really work for the money; they worked for a position in society. So if money is not that important, you can explore ideas the way you want...[In the U.S.] [o]ne becomes a slave to consumption, and has to find

money to buy things; that's when your creativity disappears. It's harder to be creative this way. (Zagury, 1999a)

Others grew disenchanted with their United States experience, mainly because their opportunities to draw for Spanish-language periodicals were very limited. They also found that, being suspected by the first wave of immigrants as Castro agents sent to infiltrate the Miami Cuban community, they had to prove themselves with rabidly anti-Castro works. Then, when the Miami community was altered in 1993, with an influx of other Latin Americans and different issues, even the outlets for their anti-Castro cartoons dried up. José Varela, who published a minor, short-lived weekly strip on manners while in Cuba, went eight years without getting a cartoon published in the United States, because his work was not anti-Castro. He became exclusive political cartoonist for *El Nuevo Herald* when the demographics of the community changed in 1993. Varela described the plight of "Cuban cartoonists in exile" as living "in obscurity. With a few exceptions, they live without recognition in the land of their birth, and live unknown to the large English speaking community. They have been exploited and been, in a sense, the victims of their own political zeal" (Díaz, 1999). Trying to get to the root of the problems afflicting these cartoonists, he identified the rigidity of "old-timers" in the face of change, leading to isolation from the new community of Hispanics in Miami and the U.S. cartoonist community, "the lack of unity, petty jealousies, inabilities to find outlets for their work…limited funding, changing policies at newspapers and other publications" (Díaz, 1999).

Período Especial

At no time was cartooning in graver danger than the 1990s, when Cuba suffered its most severe economic crisis since the triumph of the Revolution, brought on by the persisting U.S. embargo, the denunciation of the commercial agreement between Comecon countries and Cuba, and the fall of socialism in East Europe. Everything was in scarce supply, and available money was used for necessities such as food, fuel, and medicine, with paper, celluloid, and other materials that sustain a healthy cultural milieu relegated to a lower priority.

Publishing was one of the first fields to be affected. In 1991, only four percent of the paper normally imported could be obtained, and much of it was set aside for publication of textbooks (Mogno, 2003: 236). Book publishers favored almost without exception manuscripts with educational value; they also were forced to reduce first edition press runs from 100,000 to 10,000 (Coro Antich, 1991). Cartoonist Gustavo Rodríguez said in an economic slump, comics are the first to be abandoned, because the government, which owns the book industry, does not respect the medium (Rodríguez, 1998). Cartoonists wishing to collect their works in anthologies or other book forms faced a hopeless ambition. Veteran cartoonist Manuel Lamar (Lillo),

whose very popular characters were featured in 23 books (one selling more than 210,000 copies), had three books of cartoons he had worked on for two years languishing in his house when I visited him in May 1991. He wanted me to take the drawings to the United States and find a publisher (Lillo, 1991). Ares, whose two previous books of cartoons sold out in 50,000 and 100,000 editions, had two other books "in press" but they could not be published for lack of paper (Hernández Guerrero, 1991).

Another consequence of the shortage of paper and other printing materials was the closing or reduction in frequency and size of newspapers and magazines. Sixteen of 17 daily newspapers were converted to weeklies, leaving one daily, *Granma*, considerably reduced in size, and at least one half of all other periodicals were closed.

Humor magazines and comic books were similarly affected. Both *Palante* and *Dedeté* were closed in November 1990, and *Melaíto* in Santa Clara faced the same circumstance throughout the 1990s, not resuming until 1999 and then only as part of a local newspaper on a monthly, not weekly, basis (Delgado, 2000; Glez Reyes, 2000). *Palante* was out of existence for three months, resuming in February 1991, as a monthly using very small print (Rodríguez, 1998). Before Período Especial, *Palante* had a circulation of 250,000; by 1998, it could climb only to 50,000. *Dedeté* was not even that fortunate; as late as 1998, its young editor Alen Lauzán (1998) was still "trying to bring it back" as a separate periodical. For much of the Período Especial, *Dedeté* appeared once a week as the last page of the daily *Juventud Rebelde* (Rebel Youth). In 1998, for a brief time, *Dedeté* was published separately in an eight-page format every 45 days. A later editor, Gustavo Rodríguez (2001), said this arrangement was on a very irregular basis, before *Dedeté* was demoted to the back page again. In February 2001, the roller coaster ride continued and *Dedeté* became an eight-page tabloid still again, but also retained its weekly back page of *Juventud Rebelde* status.

Comic strips and comic books were scarce during Período Especial. Limited in number, size, and frequency, newspapers seldom used cartoons or strips; comic books either stopped, or, like humor magazines, reduced format, number of pages, or frequency of publication. The children's *Zunzún* magazine, on six or seven occasions, appeared as two pages in *Juventud Rebelde* (Hernández, 2001), before returning to a separate magazine format at the end of the 1990s. Editorial Pablo de la Torriente, which had opened up the field of comic books in the late 1980s, with *Cómicos*, *Pablo*, *El Muñe*, *Juventud Técnica*, and others, should have closed, according to Mogno (2003: 236).

> And effectively they did, but as another unbelievable witness of the tenacity, courage, and determination of the Cuban people not to surrender, in the first years, which were the hardest, they found ways of continuing to publish, even though very irregularly, and in very poor print quality. They survived with acrobatic adaptations to absurd formats, by exploiting other magazines' paper chipping, or by taking advantage of even small quantities of paper, which occasionally arrived thanks to foreign friends.[4]

Animation production was drastically curtailed during Período Especial: of four studios, only ICAIC still made animated cartoons by 2000. The largest studio, ICRT Animación, has not produced anything after 1990, because of the "economics of Período Especial and the replacement of cinematographic technology with computers and video" (Castillo, 1998). ICRT did not have the budget to upgrade the technology (Castillo, 1998; Jaime, 1998). Additionally, the animation industry was plagued with problems of film importation restrictions and in the early 1990s, by frequent interruptions in the delivery of electricity (Mogno, 2003: 236).

When I was in Havana in May 1991, a severe point of Período Especial, I was struck by the determination of some cartoonists to find ways out of the economic morass. A then 29-year old Ares (Hernández Guerrero, 1991) said,

> We are facing serious difficulties related with the publication deficit. This is becoming a limitation for the cartoonist who creates to see his work published. [But], we must not confuse difficulties with crises since Cuban humor is getting stronger every day. Lately, as a matter of fact, there is an interesting phenomenon taking place in the Cuban cartoon scene, and this is the transition from humor making to painting and vice versa. This creates artwork that is sometimes placed in nobody's land.

Others, perhaps still determined, were not as upbeat. José Polo Madero (1991) saw the situation as an equalizing agent in that, "At this time, every cartoonist is equal; the professional is equal to the amateur, as we are all dead." Lillo (1991) lamented, "I get up now in the morning and say what am I going to do today. Then I have nothing to do; there is no work for me now." Both Polo and Lillo left Cuba shortly after.

But, publishers and cartoonists already in 1991 were looking for solutions, which came in ingenious ways of continuing to work, including improvising materials and finding new outlets. Tomy drew on his peasant roots to create his own materials out of nature's bounty, as he had done as a child. He (Tomy, 1998) said, "I had no materials so I invented them—juices from plants, tree saps to get some colors, and terra cotta (mud). My childhood years were like that. That's why Período Especial did not hurt me so much." In San Antonio de los Baños, Francisco Villamil (1998) continued to work, cutting out and pasting paper drawings together, while his fellow townmate, Angel Boligán (1991), participated in international and local exhibitions and created a mural newspaper in the window of an optical shop. Called *El Cartún: El Período Especial de Humor y Opinión*, the display featured local cartoonists' works and was changed monthly. Tomy (1998), who himself worked with materials "not very common" with cartoonists (oil painting, acrylic, wood), felt Período Especial had redeeming value in that it encouraged graphic experimentation:

> That forced us to invent, to use other materials. And, I think far from hurting graphic art, it enriched us, because a lot of cartoonists had to deal with other

materials. I have done woodcut engraving; Manuel and Torres, ceramics. There is no space to publish, so we do this and get into national and international competitions. That forced us with the few materials we could get to produce quality work that could compete—linoleum engraving, working scenery for theater plays, wall paintings/murals with political cartoons. Villamil uses cut-out paper. Airbrush has been very economic for me. I mixed printing inks and could print with minimum of effort. Some cartoonists changed to animation (Tomy, 1998).

Similarly in animation, much improvisation occurred during Período Especial. As Coelho (1998) wrote, what Cuban animators lacked in resources and technology, was compensated for with improvisation and creativity. Juan Padrón (2001) delighted in telling how ICAIC had kept outdated equipment, such as a 1928 camera, in use:

> Usually, it takes an engineer to reassemble a camera like the one from Mexico [given to ICAIC in 1995 or 1996 in exchange for animation work done for the Mexicans]. But Cubans love doing this—putting difficult stuff together to defeat imperialism. These [two cameras] are like museum pieces but very efficient…We go to Panama, rent a stereotype, bring it here, see how it works, take it back, and then make our own. We have to live this way. That's why you see 1940s and 1950s American cars running everywhere. The Germans came here and were surprised we were fixing cameras they no longer use.

Besides fashioning equipment and materials to continue their work, cartoonists found different outlets, sometimes with help from publishers. As already mentioned, many entered their works in national and international competitions, not only with the view of getting exposure, but also with the hope of winning needed cash awards. Cuban cartoonists collectively have been awarded a phenomenally large number of such awards since the Revolution. Other cartoonists strayed into animation (Tomy had his cartoons used in documentaries and newsreels directed by Santiago Álvarez), illustration, advertising, painting, or creating pottery and other objects for the opened-up tourist industry. Probably most successful has been Manuel Hernández (2001), who draws humorous paintings on ceramics and sells them from his workshop and a gallery at the resort beach Varadero. During Período Especial, Garrincha (Rodríguez, 2001) drew on pottery and greeting cards for projects able to obtain necessary license permits; Martínez (1998) sold humor sculptures and paintings he created to tourists and, like other cartoonists, caricatured patrons at the zoo and other interest points. Julio Antonio Ferrer Guerra (1998), while waiting for a break to enter comics, lived by selling his paintings to tourists. Because he works in color, and color comics do not exist in Cuba, he was looking for outlets in Mexico.

A few cartoonists were able to remain in Cuba and draw for Spanish or Italian comics publishers. Orestes Suárez was hired by Eura Editore, a Rome publisher, in 1993, and received a big boost to his career the following year, when Milan publisher Sergio Bonelli visited Cuba and saw Suárez's work

at a competition. Suárez has worked for Bonelli since then, drawing one of the several versions of "Mr. No." Suárez said the most exciting aspect of doing comic books in Cuba is "staying alive" (Suárez, 2001). Still other cartoonists seemed to strive at reinventing cartoons and comics, mixing comic art techniques and forms with painting, so "to be adept with other art forms" (Rodríguez, 1998; Ares, 1991), and as a "way to gain respect for cartooning" (Boligán, 1991). One of the country's two women cartoonists, Alicia de la Campa (1993) called her work "survival art," a type of decorative, sometimes abstract way of drawing. Alen Lauzán, whose cartoons had a Toporesque flavor, said that, with limited outlets, painting-like cartoons stood even less chance of finding publication (Lauzán, 1998). His cartoons, and those of Ares with a surrealistic tinge, found publication in *Dedeté* while Lauzán was editor.

A danger of cartoonists drifting into these areas was that it left a void when Cuban comics tried to revive themselves. *Mi Barrio*, started in 1996 as a bimonthly, found it difficult to attract authors devoted to comics, especially once they received higher fees in advertising or illustration. Garrincha (Rodríguez, 2001) told the effect doing pottery and greeting cards for two years had on him: he felt he was losing his cartooning skills. A possible larger impact is that fewer cartoonists committed to drawing comics, or "losing their inspiration" as Pérez (2001) said, can be perceived as an indication of their insignificance. Pérez (2001) said such a perception already existed:

> In fact, at the moment, comic strips have a problem, not from higher levels, but from the middle ranks with their prejudices about comics. There is a very general opinion that comic strips are an easy way of reading, and to promote comic strips is to promote that type of reading.

Well into Período Especial, *Palante* tried to keep interest alive in cartooning and provide outlets for cartoonists, by devoting two pages each issue to 12 comic strips (Delgado, 2000) and by establishing "Palante Televisión" and a printed tourist edition. *Palante* editor Rosendo Gutiérrez (1998) said the weekly 15-minute (later 30-minute) television show lasted for one and a half years in 1995–1996, and consisted of interviews with cartoonists, information about their lives, and a selection of their cartoons. Earlier in 1994–1995, *Palante* experimented with two printed editions, one of which featured cartoons of an international slant and aimed at the tourist market. Gutiérrez (1998) said only six issues appeared, because it "cost us more for the price of the paper than what we received per issue."

In the late 1990s, underground fanzines circulated among artists and intellectuals, but painters, not cartoonists, brought out most of them. Lasting only an issue or two, they were underground in theme and mode of production and distribution.

ICAIC animation also found new ways to survive, becoming like many Asian counterparts, an overseas producer (in this case, for Spanish animation), or seeking foreign partners for domestic cartoons. Director of ICAIC

Animación Norma Martínez Pineda (2001) explained, "We get money this way to make Cuban films. Part of our money comes from the state. In 2000, 70 percent of our animation production was for foreign clients, 30 percent was domestic. We plan to reverse that ratio next year." She based her prediction on the expected expansion of ICAIC to a larger building with more animators and an animation school. Usually ICAIC produces an average of 130–140 minutes yearly for Spanish clients and 30–40 minutes of domestic animation. Every four or five years, the studio makes a feature-length work, usually a version of Padrón's *Vampiros* series. Besides Spain, ICAIC has produced for French, Mexican, and Canadian studios (Padrón, 2000, 2001). Padrón (2000) said Spain prefers working with Cuban animators because they share a common culture and language: "The Spanish prefer to come here and pay more than they would have to pay in Asia or Turkey because of these common traits. But, as we do this work for Spanish television, it means we can't do enough Cuban films." ICAIC also seeks foreign partners in making domestic works. The latest *Vampiros* feature animation received one-third of its budget from a Spanish television station and Canal Plus (Padrón, 2000); the Spanish also supported production of 104 episodes adapted from Argentinean cartoonist Quino's "Mafalda" strips in 1994 and six one-half hour television episodes of Padrón's "Elpidio Valdés."

But, as Villamil said of cartoonists during Período Especial—that a whole generation of work went unknown for lack of resources or outlets—the same applies to animation. When ICRT Animación closed, a number of its staff of 150 went to ICAIC, but others ended up in non-animation drawing or left for Ecuador, Chile, Venezuela, and elsewhere.

Print cartoonists were forced to leave Cuba as well, mainly for economic reasons. Artists such as Ajubel (Alberto Morales), Carlucho (Carlos Villar), Lillo, Boligán, Simanca, Lauzán, Polo, among others, now live outside Cuba. In most cases, they left reluctantly or after exhausting as many possibilities as possible of earning a living in Cuba. Osmani Simanca (2002) said he had lived as most Cubans, as standby, ready to hop to the United States, because "in the early 1990s, no one knew what was happening in Cuba." Simanca went to live in Salvador, Brazil, in 1994, but changed his mind and returned to Cuba before finally deciding to live with his Brazilian wife in her homeland. Boligán went to Mexico in 1992 supposedly for a 15-day stay to draw a wall painting in Cancun. When offered an opportunity to exhibit his works in Mexico City, he decided to stay. "I stayed for professional reasons," he said, adding, "There are all kinds of magazines and newspapers there. Mexico is more open professionally" (Boligán, 1998). He thought other Cuban cartoonists also left for more "opportunities and invitations" elsewhere. Describing his 1990–1991 efforts at the aforementioned *El Cartún* in San Antonio de los Baños, Boligán (1998) said, "It was the only thing I could do there as there was no space. I resisted till the last consequences."

Some left Cuba when the worsening economic situation coupled with continuing political constraints made life too difficult. Boligán talked about

the sense of freedom he felt in Mexico; Garrincha (1998) and Miriam (1998) mentioned the "grey area" between what the Cuban Communist Party wants and what Cuban editors are left to comprehend or decide. Stating editors receive "tremendous...pressure from the party," Garrincha called the grey area a place where "silly concepts have been applied and bad decisions made." Miriam, using a baseball analogy appropriate to the subject of her comic strip, said the "editor and party own the bat, glove, and baseballs"; she said *Palante*, for which she has worked since 1968, used more political satire 30 years before than it did in 1998. René de la Nuez (1998) also believed he had more freedom in his early cartoonist days of the 1950s and 1960s. He blamed the restrictive state of Cuba on "bureaucratic machinery without humor."

Lest these references to cartoonists leaving Cuba be construed as their admitting defeat, and therefore negating the opening assertions that Cuban cartoonists will endure, let it be remembered that most artists remained in Cuba, and that through their clever work and coping abilities, continued the profession's long tradition in the country. They may have been down, but they will be coming up again. Mogno (2003: 237) put it well:

> The history of Cuba teaches that one must forbear the premature use of the expression 'the end'; like a phoenix, anything (and everything) in Cuba seems to be able to regenerate from its own ashes. It would not be imprudent, however, to speak of a stalled moment both for comics and animated cartoons.

Modes of Production: A Comparison

Comparatively, how do the cartoonists inside and outside Cuba function in terms of modes of production—e.g., how do they use their cartoons to depict the other (Fidel and the Cuban government in the case of those who left; the United States and its government with those who stayed), how do they maintain their sense of creativity, how do they perceive each other?

The way Fidel and the Cuban government were depicted usually depended on the time period about which one is talking and the country to which the cartoonists moved. Those who moved to the United States in the first exodus were highly critical, either because they were against communism, felt they were forced to leave Cuba, or had become part of the rabidly anti-Fidel community of Miami. The second group in the 1980s did not have the same strong convictions but knew they had to bash Fidel if they were to find outlets for their drawings in the U.S. Spanish-language press. By the time of the latest migration, the pressure to criticize Fidel had lessened considerably as the older generation Miami community died off or was diluted by émigrés from other parts of Latin America. Of course, a few cartoonists went in other directions, where they did not feel it necessary to deal with their homeland's issues at all—e.g., Prohías with "Spy vs. Spy" or Henríquez, who worked for an American animation studio.

Cartoonists who moved to other countries have, for the most part, been part of the new guard and have not seen a need to criticize their homeland. They have either taken up issues of their new places of residence as subject matter or dealt with more universal themes, or have drawn apolitical cartoons in a strictly humorous vein.

In Cuba itself, the overarching goal of cartoonists does not appear to be to attack the United States. At times when relations have been exceptionally strained, such as the González kidnapping case, or during the early days of the Revolution, Cuban cartoonists have targeted Uncle Sam. Normally, however, comic strips and cartoons are politically non-descript, taking on the funny, mundane, or grotesque aspects of human endeavor. Thus, Miriam uses baseball as the subject of her strip, Ares experiments with unusual characters (some fat; some grotesque), and Padrón satirizes an assortment of unrelated characters, events, and time periods in his latest "Vampiros."

Cartoonists' ability to use their creativity also varies according to where they are. Most of those who arrived in the United States haven't had time to be very creative, as they have had to work a number of jobs, mostly unrelated to their cartooning skills, just to survive. As Henríquez quoted earlier said, they have become "slave(s) to consumption," and when that happens, creativity disappears in the rush to produce more at a faster pace so as to also consume more. Because of the limited number of Spanish-language outlets, and the resulting competitiveness, some cartoonists rarely, if ever, had their cartoons published. José Varela, for example, said that eight years elapsed before his first cartoon was published in the United States. Exiles responding to Mercedes Díaz's (2005) interviews, reported "living in obscurity," experiencing a sense of profound loneliness, or feeling they did not serve a greater good or purpose since arriving in the United States. Some who left Cuba for Spain or other parts of Latin America fared better, particularly Ajubel and Boligán, but still felt somewhat out of place in their new environs.

The point might be made and supported that though those who remained behind suffer economic deprivation and generally lack art supplies and traditional places to publish, their creative juices continue to flow. This may stem from several factors, among which are, first, knowing their own culture and the manner in which things function, they find unique ways to cope with shortages and continue their creativity, if only discovering ways to survive as cartoonists; second, many retain jobs that at least minimally allow them to survive, at the same time providing time for other creative pursuits, such as entering international competitions, etc.; and third, they have support from family and friends both in Cuba and abroad.

Ironically, considerable help is provided Cuba-bound cartoonists by successful, new guard, cartoonist émigrés. Unlike those who left earlier, this group of cartoonists has maintained links with Cuba and they help, in various capacities, those who did not leave. Through her interviews, Díaz (2005) found that the new generation of cartoonists abroad has compassion for fellow artists in Cuba. For example, they do not seek publication in

Cuban periodicals, because, by doing so, they would deny Cuba-based cartoonists much needed space and remuneration. Díaz (2005) heard of other ways those abroad were helpful: sending in art materials, serving as financial conduits to bypass the U.S.-induced and sustained economic embargo, providing exchange venues and publication outlets, and helping those in Cuba to assess more carefully whether to emigrate.

Although, or perhaps better yet, because both those who left and those who stayed struggle—either just to exist and/or to continue their creative work—they respect each other; there is no sense of jealousy or betrayal on either side, only cooperation.

Notes

1 Cartoonist Francisco Blanco (2001) and comics writer Manolo Pérez (2001) both described 1964–1967 as a rich time for periodicals and comic strips. Mogno (2003) mentions many of these works. Luis Castillo (1998) and David Jaime (1998) talked about Cuban animation's heyday of the 1970s.

2 Prohias said his editorial cartoons were effective because he had friends in government who provided him tips ("Mad Magazine's . . . ," 1970: 48).

3 Apparently, Tomy had second thoughts in the late 1990s when he went to Brazil to live. He stayed three months and returned, after which his success was even more phenomenal.

4 Lazaro Fernández (1998) said even though there was a scarcity of materials, there was "always a friend available who gives us some of this, some of that. We get materials from many places."

Works Cited

Acebo. Interview with John A. Lent, Havana, Cuba, June 26, 1998.

Blanco, Francisco. Interview with John A. Lent, Havana, Cuba, March 31, 2001.

Boligán, Angel. Interview with John A. Lent, San Antonio de los Baños, May 24, 1991.

———. Interview with John A. Lent, San Antonio de los Baños, June 22, 1998.

Campa, Alicia de la. Interview with John A. Lent, Havana, Cuba, June 26, 1998.

Castañeda, Mireya. "Adigio Benítez: An Artist Who Lives Silently in His World." *Granma Weekly Review.* January 31, 1998: 6.

Castillo, Luis. Interview with John A. Lent, Havana, Cuba, June 22, 1998.

Coelho, Cesar. "The Havana Connection." *Animation World Magazine.* February 1998.

Coro Antich, Arnaldo. Interview with John A. Lent, Havana, Cuba, May 21, 1991.

Dean, Michael. " 'Spy vs. Spy' Creator Antonio Prohías Dies." *Comics Buyer's Guide.* March 20, 1998: 8.

Delgado, José. Interview with John A. Lent, Havana, Cuba, February 15, 2000.

Díaz, Mercedes. "From Exile to Obscurity: Profiles of Cuban Political Cartoonists in Exile in the United States (A Working Paper)." Paper for John A. Lent's "Comic Art and Animation" class, Temple University, 1999.

———. "Drawing in 'Cuban': Examining the Life and Work of Expatriate Cuban Cartoonists." Ph.D. dissertation, Temple University, 2005.

Fernández, Lázaro. Interview with John A. Lent, Havana, Cuba, June 22, 1998.

Ferrer Guerra, Julio Antonio. Interview with John A. Lent, Havana, Cuba, June 22, 1998.

Glez Reyes, Rolando. Interview with John A. Lent, Santa Clara, Cuba, February 20, 2000.

Gutiérrez, Rosendo. Interview with John A. Lent, Havana, Cuba, June 27, 1998.

Hernández, Manuel. Interview with John A. Lent, Havana, Cuba, April 4, 2001.

Hernández, Roberto. Interview with John A. Lent, San Antonio de los Baños, April 1, 2001.

Hernández Guerrero, Aristides Esteban (Ares). Interview with John A. Lent, Havana, Cuba, May 23, 1991.

Jaime, David. Interview with John A. Lent, Havana, Cuba, June 22, 1998.

Lamar, Manuel (Lillo). Interview with John A. Lent, Havana, Cuba, May 23, 1991.

Lauzán, Alen. Interview with John A. Lent, Havana, Cuba, June 24, 1998.

Lent, John A. "Cuban Mass Media after 25 Years of Revolution." *Journalism Quarterly*. Autumn 1985: 609–615, 704.

———. "Cuban Films and the Revolution." *Caribbean Studies*. 20 (1988): 3/4, pp. 59–68.

———. "Lively Cartooning in the Land of Castro." *Comics Journal*. September 1991: 25–29.

———. "Cuba's Comic Art Tradition." *Studies in Latin American Popular Culture*. 14 (1995): 225–244.

———. "Cuba's Tomy: An Expert in Coping." *FECO News*. No. 30 (2000): 8–9.

———. "Vampires, Lice and a Dose of History: Juan Padrón and Cuban Animation." *Animation World Magazine*. February 2002: 22–26.

———. "Cuban Political, Social Commentary Cartoons." In *Cartooning in Latin America*, edited by John A. Lent, pp. 193–215. Cresskill, NJ: Hampton Press, 2005.

Lent, John A. and José E. Polo Madero. "The Shrink with Pen and Ink: Cuban Cartoonist/Psychiatrist Ares." *WittyWorld*. Winter/Spring 1992: 33–36.

"*Mad Magazine*'s Prohías." *Cartoonist PROfiles*. November 1970: 48–55.

Martínez, Jorge (Lloyy). Interview with John A. Lent, Havana, Cuba, June 26, 1998.

Martínez Pineda, Norma. Interview with John A. Lent, Havana, Cuba, April 3, 2001.

Méndez, Pedro. Interview with John A. Lent, Santa Clara, Cuba, February 20, 2000.

Miriam. Interview with John A. Lent, Havana, Cuba, June 26, 1998.

Mogno, Dario. "Parallel Lives: A History of Comics and Animated Cartoons in Cuba." In *Cartooning in Latin America*, edited by John A. Lent, pp. 217–238. Cresskill, NJ: Hampton Press, 2005.

Nuez, René de la. Interview with John A. Lent, Havana, Cuba, June 25, 1998.

Padrón, Juan. Interview with John A. Lent, Havana, Cuba, February 14, 2000.

———. Interview with John A. Lent, Havana, Cuba, April 3, 2001.

Pérez, Manolo. Interviews with John A. Lent, Havana, Cuba, April 1, 2001.

———. Interviews with John A. Lent, Havana, Cuba, April 1, 2001.

Pizarro, Marta Prohías. Interview with Mercedes Díaz, Miami, Florida, April 1, 1999.

Polo Madera, José. Interview with John A. Lent, Havana, Cuba, May 22, 1991.

Rodríguez, Gustavo (Garrincha). Interviews with John A. Lent, Havana, Cuba, June 23 and 25, 1998.

———. Interviews with John A. Lent, Havana, Cuba, June 23, 25, April 1 and 2, 2001.

Simanca, Osmani. Interviews with John A. Lent, Salvador, Brazil, July 31 and August 5, 2001.

"*Spy vs. Spy* Creator Antonio Prohías Dies." *Comics Journal.* April: 26–27, 1998.

Suárez Lemus, Orestes. Interview with John A. Lent, Havana, Cuba, March 30, 2001.

Tomy, Tomás Rodríguez Zayas. Interview with John A. Lent, Havana, Cuba, June 25, 1998.

Villamil, Francisco. Interview with John A. Lent, San Antonio de los Baños, June 23, 1998.

Vrielynck, R. 1985. "Breve Reseña Histórica del Dibujo Animado Cubano." *Plateau.* Winter: 4–12.

Zagury, Léa. "A Chat with Hernán Henríquez." *Animation World Magazine.* April 1999a.

———. "Latin American Animation in Havana." *Animation World Magazine.* April 1999b.

Argentina's Montoneros: Comics, Cartoons, and Images as Political Propaganda in the Underground Guerrilla Press of the 1970s

Fernando Reati

Any Argentine citizen brave enough in the mid-1970s to have in his or her possession one of the underground publications of the left-wing guerrilla organization Montoneros couldn't but have noticed with some surprise that among the communiqués, editorials, messages from the leadership, photos of fallen comrades, and other habitual staples of the revolutionary press, there were numerous comics, cartoons, and visual icons that visually reinforced the ideological message. This was after all the so-called Dirty War, the bloody period of State terror when the armed forces violently suppressed any form of dissent—guerrilla groups but also intellectuals, labor and student activists, members of church and human-rights groups—through the abduction, torture, and death of some 30,000 individuals in secret detention camps. Considering the dangerous nature of the guerrilla struggle and the daily brush with death that the activists experienced while producing this press, it is significant that Montoneros managed to create in such an environment what is possibly the richest and more sophisticated apparatus of visual rhetoric for agitation purposes among similar revolutionary movements in Latin America, and that comics, cartoons, and other graphic imagery played so prominent a role in its agitation efforts.

Montoneros, an organization of Peronist-populist background, had evolved over just a decade into a radical, militaristic opposition group that would eventually be crushed at the end of the 1970s by the dictatorship that had overthrown the elected government of Isabel Perón in 1976. Montoneros was founded in 1968 by a small group of Peronist youth of Catholic background. Its vaguely populist-nationalist brand of socialism was based on Perón's so-called 'third way' position (supposedly equidistant from capitalism and communism), and soon the group became a central

actor in the Argentine political scene until it was violently suppressed by the military. In the brief 1973–1974 democratic interlude after Perón returned from exile, the organization fully participated in parliamentary politics and Montonero-leaning activists held seats in Congress and even a few governorships and ministerial positions. However, after Perón's sudden death in 1974, the Peronist administration was promptly taken over by the right-wing faction of the movement led by his wife Isabel, and Montoneros decided to all but quit parliamentary politics and return to the armed struggle that had made it popular in 1968–1973. At this point, military sources estimated its supporters to number 70,000 with some 7,000 bearing arms (Weathers 1), although independent studies suggest the guerrilla threat was greatly exaggerated by the military in order to justify the bloody coup of 1976.[1] What is beyond dispute is that after the brief 1973–74 truce, Montoneros was not only willing but also capable of waging a serious armed opposition to the government, as exemplified by the more than 500 guerrilla operations that took place in 1975 alone (Anzorena 348).

It is in this context that Montoneros developed a sophisticated press that made a conscious use of visual rhetoric, producing a surprisingly large number of underground newspapers, magazines, newsletters, and bulletins. Some titles were intended for nationwide distribution while others aimed at specific regional groups or supporters abroad: *Evita Montonera*; *El Montonero*; *Peronismo Auténtico*; *Estrella Federal*; *Boletín del Ejército Montonero*; *El Descamisado*; *Boletín del Movimiento Peronista Montonero*; *Noticias de la Resistencia*; *Boletín Zonal del Partido Montonero*; *Boletín de la Resistencia*; *Vencer: Revista Internacional del Movimiento Peronista Montonero*. Among these, *Evita Montonera* was the most sophisticated, longest-running and most widely distributed publication, first appearing in December 1974 and continuing uninterrupted through issue no. 25 in August 1979. It is clear that during its brief existence, Montoneros advertised its political agenda through an impressive array of sophisticated underground and semi-underground publications, and that this vast effort evidenced a unique awareness as to the importance of visual political propaganda through graffiti, drawings, cartoons, comics, symbols, and photos. Rhetorical persuasion replaced ideological conviction as a source of legitimacy, and the reliance on verbal and visual rhetorical devices increased as the group gradually turned away from political action and more towards the armed struggle. It is at this juncture that a complex apparatus of visual rhetoric made of emblems, stars, photos, symmetric slogans, and iconic figures, along with comic strips, cartoons, and drawings, provided the Montonero followers with a sense of identity through the repetition of certain basic imagery that compensated for an increasingly empty political discourse.

How to explain Montoneros' obsession with visual agitation to the detriment of a sounder ideological message? It is clear that there were serious political limitations to Montoneros' agenda due in part to its Peronist-populist background, which made the group disregard a more ideological approach to politics and prefer instead an emotional appeal to the sentiments

of the Peronist populace. Sigal and Verón describe how throughout 30 years of undisputed leadership, Perón conceived of his political project as something that remained outside the conventional parameters of capitalism and communism (49). The young militants of the Peronist left inherited this distrust for traditional ideologies and were thus unable to develop an alternative thought of their own (James 275). As a result, Montoneros attempted not to contradict the supposedly non-ideological enunciation mechanisms of the Peronist movement, but rather to adopt them and control them from within, thus searching for legitimacy in sources other than ordinary ideological action (Sigal and Verón 21). Lacking a political message, Montoneros' armed actions were eventually conceived of as expressive non-verbal acts of dubious military or political value but with a strong propaganda effect.

At the same time, the group's strong reliance on visual rhetoric as a source of legitimacy must be viewed within Argentina's rich tradition of comics, cartoons, and graphic art, much of it socially oriented and politically motivated. Argentina arguably possesses the longest and most varied history of graphic art, cartoons, and comics in Latin America, as Judith Gociol and Diego Rosemberg show in their *La historieta argentina: Una historia*. Gociol and Rosemberg point out that Argentina was among the first countries in the world to reproduce *Yellow Kid*—originally published in *The New York World* in 1893 and possibly the first comic strip ever produced—and that shortly after a number of locally produced cartoons saw their way into Argentine magazines and newspapers. Interestingly enough, the earliest Argentine comics were created by graphic artists whose training was in the sort of political caricature and social satire that was then in vogue in local magazines such as *Caras y Caretas*, *PBT*, and *El Hogar* (Gociol and Rosemberg 20). This points out to an early intersection between politics and graphic humor in Argentina that would continue for decades to come. The new art form became immediately popular and, by the 1910s, the children's magazine *Billiken* was already selling half a million copies a week and exporting tens of thousands more to the Spanish-speaking world, while *El Tony* (another classic outlet for Argentine comics) started with ten thousand copies in 1928 and was soon putting out 300,000 copies a week (Gociol and Rosemberg 21, 23). Many of these stories were attuned to an Argentine taste by adopting local themes and portraying indigenous characters, i.e. gauchos and Indians from the pampas as opposed to cowboys and Sioux. Such was the case with *Patoruzú*, an immensely popular strip about a naïve but noble Patagonian Indian, which first appeared in 1936 and soon turned into a national icon. Even *Patoruzú* was not devoid of a heavy ideological sub-text: "[The strip became] a sounding board for prejudices against different immigrant groups and for the prevailing nationalism of the period" (Gociol and Rosemberg 26).

In subsequent decades, Argentine comics and cartoons continued to be intricately connected to social and political mores. Graphic humor, even in its most innocent form, often served as a tool to gauge the state of the Argentine psyche at a given time. The 1930s and 1940s saw the birth of

"Don Fulgencio," "Ramona," "Avivato," and "Cicuta," all one-sided characters who reproduced easily identifiable national traits—the ignorant but good-hearted maid, the likable con artist who takes advantage of others, and so on—drawing from and helping reinforce a paradigmatic set of Argentine social stereotypes (Gociol and Rosemberg 31). The Argentine comic came of age in the late 1950s when renowned author Héctor Germán Oesterheld chose Buenos Aires as the setting for the alien invasion that is at the center of his *El Eternauta* (more on this later); many of Oesterheld's other 1960s stories—*Sherlock Time*, *Sargento Kirk*, *Mort Cinder* and *Ernie Pike*—also betrayed a definite Argentine sensibility and spoke about the present even when set in distant lands and times. But it is in the 1970s that national reality and cartoons intersected with an urgency never seen before, as Argentina transitioned from the 1966–1973 military dictatorship to the constitutional government of Juan Domingo Perón (1973–74) and Isabel Perón (1974–76), and then back to military rule after the bloody 1976 coup. In 1972, while students and workers were demanding in the streets that Perón be allowed to return from exile, two important magazines specializing in graphic humor appeared and became immediately popular for their irreverent style: *Hortensia*, the first outlet to originate not in Buenos Aires but in the interior of the country (two of its strips—Roberto Fontanarrosa's *Boogie, el Aceitoso* and *Inodoro Pereyra*—became instant hits with their witty humor and indirect jabs at the national idiosyncrasy); and *Satiricón*, which lampooned Argentina's cultural habits through scatological humor and a fresh attitude towards sex and taboo topics. Of course, much of this tradition was lost during the 1976–83 period of State terror, when there was little room for humor or any kind of criticism aimed at the military dictatorship. And yet, even under the widespread fear of State terror a new magazine appeared in 1978—*Humor Registrado*—which managed to poke fun at the regime by skillfully pushing the limits of what was permissible under the strict censorship of the time.

This is the context in which Montoneros' ample use of cartoons and graphic art can be understood as part of the group's arsenal of visual propaganda tools. The comics and cartoons used by Montoneros to convey its political message fall under two main categories: the political cartoon that lampoons the enemy in a rather dry and humorless way; and the imitation of a well-known popular comic strip or graphic humor character in order to gain from its already established reputation among the public. Whereas the first type of political lampoon is to be expected, it is the second option that illustrates Montoneros' profound awareness of the importance of visual messages as political propaganda. The most elaborate example of this is perhaps the publication of a Montonero version of the popular strip *Clemente* in various issues of the underground newsletter *Noticias de la Resistencia*. *Clemente* was an immensely popular daily strip by Caloi (Carlos Loiseau) that first appeared in the newspaper *Clarín* in 1973 coinciding with the end of the 1966–73 military dictatorship. The strip featured an armless bird with zebra-like stripes that almost invariably commented on current events

and contemporary life in Buenos Aires. *Clemente* thus falls within the tradition of *Peanuts* in the United States or *Mafalda* in Argentina, in that it offered mild social criticism through the portrayal of the quirks and obsessions of ordinary citizens. With his witty remarks, down to earth language filled with Argentine colloquialisms, and fanatical love for Boca Juniors (the soccer team regarded as the favorite of working-class Argentines), Clemente promptly gained the hearts of millions of readers. His popularity peaked during the 1978 World Soccer Cup, held in Buenos Aires just two years after the 1976 military coup, when the regime attempted to take advantage of the games by showcasing Argentina as a democratic country and by denying international press reports about human rights abuses. José María Muñoz, a well-known sports commentator and regime sympathizer, called on soccer fans to refrain from the time-honored Argentine tradition of raining confetti and ticker tape on players because it made the host country look untidy, which prompted the strip's character to engage in a personal campaign against Muñoz. From the pages of the newspaper, Clemente encouraged fans to pay no heed to Muñoz' advice and to inundate the stadiums with ticker tape, something most readers correctly interpreted as a subtle attack on the military junta's repressive ideology:

> Throughout the sports event, Caloi's character confronted José María Muñoz, the most famous soccer commentator at the time. It was an unusual and uneven fight: an ink drawing arguing with a flesh and bone man. Whereas Clemente represented the oppressed people of Argentina, Muñoz—renamed by the character Murióz [a pun with "murió" or "he died"]—embodied the dictatorship's message that a clean image of the country could be attained by simply not throwing ticker tape in the stadiums. "How can we not throw ticker tape when we Argentines always throw ticker tape!" screamed Clemente. And people understood this with an astounding accuracy and threw more ticker tape than ever. (Gociol and Rosemberg 578)

Drawing from *Clemente*'s immense popularity, Montoneros ran a version of the strip adequately renamed *Clemente (historias prohibidas)* (forbidden stories) for no less than thirteen issues of the underground monthly *Noticias* between May 1977 and September/October 1978, coinciding with some of the bloodiest years of military repression. In the September 1977 issue, Clemente is dressed in gaucho garb and recites verses in the tradition of the stanzas that any reader would immediately recognize as reminiscent of José Hernández' *Martín Fierro*, Argentina's famous nineteenth-century gaucho epic. Clemente's verses include pointed jokes at the leaders of the military junta, with a funny stanza that characteristically uses humor for political purposes: "En el cielo las estreyas / en el campo las espinas / y en la gorra de Videla / la escupida e' mi madrina" ("There are stars in the sky / thorns on earth / and all over [general] Videla's cap / there is my godmother's spit"). Not coincidentally, at the conclusion of the strip Clemente states what may well summarize Montoneros' philosophy on graphic humor: "La cultura popular es un arma como cualquier otra" ("Popular culture is a weapon just

like any other"). A subsequent strip in the October 1977 issue of *Noticias* is equally effective in its combination of humor and political propaganda. In it, Clemente calls the police on the phone to denounce a robbery in progress and tells the officer that it is the nation itself that is being mugged. He says the thieves are a skinny guy with big ears (an obvious reference to then Minister of Economy Martínez de Hoz), and another guy with a moustache and a green cap (in reference to Videla). This prompts the angry police officer to hang up on Clemente, who then laughs heartily about the success of his prank. (See figure 5.1) Other strips portray Clemente in various situations involving soldiers, the police, striking workers, the unemployed, the World Soccer Cup, and so on. It is clear that the Montonero *Clemente* intended to elicit the readers' sympathy by explicitly alluding to symbols of Argentine popular culture. Thus, in the December 1977 issue of *Noticias* the character is caught by the police in the act of spray painting slogans on a wall, and when the officer accuses him of being a "B.D.S.M." (a delinquent subversive Montonero) Clemente responds he is just a "C.A.B.J." (a fan of Club Atlético Boca Juniors). In the next frame, after he's been roughed up by the police officer, Clemente summarizes his contempt for his tormentor by referring to him as a fan of River Plate, the rival soccer team normally favored by the upper class in Argentina: "Botón y encima gayina…" ("He is a cop and a fan of River Plate on top of that…"). (See figure 5.1.)

The attempt to elicit sympathy by linking Montonero symbols and ideas to well-known visual icons of Argentine popular culture is once again evident in the reproduction on at least a few occasions of the acclaimed *Mafalda* strip. Published between 1964 and 1973 by renowned Argentine graphic

Figure 5.1 "Clemente," "Historias prohibidas."

humorist Quino, *Mafalda* was immensely popular for its description of middle-class social mores and its attacks on the status quo through the not-so-innocent eyes of a little girl who observes critically the world of the adults around her. The little girl's worries about world peace and the arms race, the Vietnam War and the Chinese Cultural Revolution, the hippies and the Beatles, made the strip a typical by-product of the 1960s. And yet, it should be also remembered that *Mafalda* appeared "during a time of military dictatorship [1966–73] in which there was considerable official censorship of social commentary and a general climate of repression" (Foster 20). This infused any new reading of the strip after the 1976 military coup with renewed significance. By no coincidence, when asked years later if he could envision a grown-up Mafalda, Quino responded by imagining for her a fate similar to that of so many other young Argentines who grew up inquisitive and critical of the world in the late 1960s and early 1970s: "Probably she would've never reached adulthood because she would now be counted among the disappeared. I mean, she probably would've been a disappeared person" (quoted in Gociol and Rosemberg 180). It was precisely the anti-authoritarian and left-of-center message of the strip—however mild by late 1970s standards—that made *Mafalda* useful to the Montonero propagandists who recreated it. Two strips featuring the popular girl appeared in issue #3 of *Boletín de la Resistencia* (1977), a crude regional Montonero newsletter in suburban Buenos Aires. In one of them, Mafalda is at the beach philosophically musing about how inevitable it is for sand to slip through one's fingers and leave nothing behind but a few grains; upon this, her father screams "Stop talking about wages!" in a not so subtle reference to the consequences of the dictatorship's economic policy. In the other strip, Mafalda overhears a conversation between two adults who wonder what the government might do to try to remain strong; then she notices a police van passing by and she thinks to herself, "Well, at least there goes a bottle-full of vitamins." It is significant that while the technical quality of the reproduced strips was less than optimal, there seemed to be no attempt on the part of the guerrilla propagandists to turn their character into a Montonero Mafalda (as was the case with the Montonero Clemente) perhaps because the strip's original social commentary was still relevant in 1977 and didn't need to be adapted to the new context.

Another popular graphic icon that Montoneros undertook to reinterpret for propaganda purposes was the country's official mascot for the 1978 World Soccer Cup. When Argentina hosted the games while under military rule, many human rights activists considered it a drawback because it would allow the junta to gain much needed international recognition; others, however, saw the presence of international journalists and foreign soccer fans as an opportunity to advertise the plight of the victims of State terror. During the competition, Montoneros intensified its propaganda efforts and attempted to capitalize on the games in many different ways, by broadcasting anti-government messages from underground TV and radio stations, holding clandestine press conferences with foreign journalists, and blanketing soccer

stadiums with thousands of leaflets. The most creative propaganda tool was perhaps the transformation of the national soccer mascot "el gauchito"—a little gaucho boy dressed in the national team's shirt, donning a gaucho hat, a horsewhip in one hand and a soccer ball under the foot—into a Montonero "gauchito." Montoneros proceeded to inundate the city with leaflets and stickers where the "gauchito" was accompanied by anti-government slogans: "Kick Videla. The people will win this game"; "Argentina World Champ. The people support the national team but repudiate Videla and Martínez de Hoz"; "Argentina 78—Dictatorship 0. We shall win." Furthermore, the "gauchito" underwent a not so subtle physical transformation, where the gaucho hat was replaced by a bandana with the word "Monto," the horse-whip was replaced by a Montonero spear, and the soccer ball under his foot turned into a lit bomb. (See figure 5.2.) It is difficult to judge how effective this visual tool was in the Montonero propaganda war, or how many people actually became familiar with it. Its significance lies in the skillful manipulation of a highly coded graphic icon invested of multiple layers of meaning by the ordinary citizens who were its intended audience, something akin to what was done with the *Clemente* and *Mafalda* comic strip characters.

Perhaps the most intriguing graphic tool in the Montonero visual arsenal was an unsigned strip that appeared under the title *Camote* in six consecutive issues of the monthly *Evita Montonera*. The high value assigned to graphic art by the editors of *Evita Montonera* can be judged by the fact that two full pages—with an average of six frames per page—were used for each installment of the strip, except for the first installment which ran for a total of four pages. This represented a great commitment of space and effort on the part of the Montonero propaganda strategists at a time when the guerrilla press was under severe stress to survive, with scores of activists being abducted and killed every day. *Camote* tells the story of a young activist who goes into hiding after a shootout with the police. When Anselmo, an

Figure 5.2 The Montonero "Gauchito."

old-time Peronist, gives him refuge in his humble home, Camote falls in love with his daughter. Later on, Anselmo is ambushed and killed by right-wing thugs at the service of union bosses, and it is now Camote's turn to return the favor and avenge his death by participating in the killing of the thugs' leader. At the end of the six installments, Camote must leave and says farewell to Anselmo's daughter because new duties await him in the service of the revolution; however, they both utter a "See you soon" that seems to promise that one day they will be reunited once the fight is over. This relatively simple plot is supported by illustrations in the style of Argentine graphic artist Ricardo Carpani, whose posters and drawings depicting working-class figures and revolutionary motifs were favored by militant groups in the 1970s.[2] Carpani's style was reminiscent of traditional Soviet poster art and some of his general aesthetics can be discerned in *Camote*: contrasting volumes, well defined lines and proletarian motifs in the midst of a somber but heroic atmosphere. (See figure 5.3.)

Figure 5.3 "Camote" (*Evita Montonera* 8, p. 22).

In *Camote*'s themes, we find echoes of another reputed Argentine artist, Héctor Germán Oesterheld, whose own ideological transformation into a Montonero activist illustrates the group's view on militant art. Oesterheld owed his reputation to the large number of unique characters he created from the 1950s through his disappearance at the hands of the military in 1977. His most famous comic was *El Eternauta* (a play on words meaning "space/time traveler"), which appeared in weekly installments from 1957 to 1959 with illustrations by Francisco Solano López. The story was based on a universal science-fiction premise—evil aliens blanket Buenos Aires with a poisonous snowfall and a handful of survivors are left to organize the armed resistance against the galactic invaders—and yet it was uniquely Argentine in setting and subplots. With subtle allusions to contemporary political events and an eerie premonition of the tragic events that took place twenty years later under State terror, the story attained an enduring popularity and became "the greatest science-fiction adventure ever written in the Southern part of the world and the best Argentine comic of all times" (García and Ostuni 125). After a courageous but ultimately failed resistance against the powerful alien invaders, the main protagonist is caught in a time warp and spends the rest of eternity jumping from one dimension to another looking for his missing wife and daughter. It is the protagonist's fate, as well as the notion that ordinary citizens can come together to fight heroically against a superior enemy, that prompted many to see in *El Eternauta* a foreshadowing of State terror, and even a sinister premonition of the author's own disappearance along with his four daughters and a son-in-law, all of them Montonero activists.

While the 1957–59 version of *El Eternauta* might have been an intuitive depiction of the universal battle between David and Goliath—with ordinary Argentines fighting an alien Goliath—a second version written by Oesterheld a decade later was less subtle and more openly political. In this version, written in 1969 for the magazine *Gente* and illustrated by Alberto Breccia, the characters and setting are the same but the ideological content has dramatically shifted: the mortal snowfall that previously affected all of Earth now only affects Latin America, and the planet's superpowers ally themselves with the alien invaders and leave the Third World countries to fend for themselves. This shift in emphasis clearly resulted from a changing political climate in Argentina—1969 witnessed a popular uprising against General Onganía's rule as well as the first embryonic urban guerrilla actions—and points to Oesterheld's growing sympathy for the left-wing faction of the Peronist movement. As Juan Sasturain notes, now "Oesterheld breathes a different air, that of an Argentina in upheaval at the end of the 1960s, and he changes the framework in which he outlines the same struggle" (quoted in Gociol and Rosemberg 463). Oesterheld's ideological transformation is further illustrated by the publication of his *¡Guerra de los Antartes!* ("The Antartes War!") in *Noticias*, a Montonero-leaning newspaper, in 1974.[3] This story is related to *El Eternauta* in that it revisits the topic of an invasion by outside forces, but its depiction of a fictional post-revolutionary Argentina

evidences the author's growing preoccupation with the political uses of art. Oesterheld's shift from independent middle-class artist to committed Montonero activist is completed by the publication of a third version of *El Eternauta* in the magazine *Skorpio*, just a few months after the 1976 military coup and with illustrations by Solano López. Set in a post-apocalyptic Buenos Aires in the year 2100, it betrays a certain messianic tone (Gociol and Rosemberg 464) and clearly identifiable Montonero ideologemes such as the belief in individual heroism, a willingness to sacrifice oneself for the cause, and a fascination with death: "The Eternauta becomes now something akin to the paradigm of the perfect revolutionary...[The protagonist] organizes the survivors in military fashion, he prepares them physically and psychologically for combat and to give up their lives in pursuit of an ideal" (García and Ostuni 140).

By the time Oesterheld was abducted by the military in April 1977 and taken to a secret detention center where he was last seen alive in 1978, his ideological journey was complete and his art—along with his life—had been placed at the service of his revolutionary ideals. Some of this unlimited dedication to the struggle, coupled with a deep belief in self-sacrifice and the inevitability of death, transpires in *Camote*'s plot and makes it a perfect illustration of the Montonero ideology. The strip betrays the same fixation with violence—both repressive and revolutionary—and the fetishistic cult of guns that appear repeatedly elsewhere in *Evita Montonera*. The six *Camote* installments include no less than four violent scenes: the shootout with the police when Camote saves the life of a comrade; Anselmo's beating by right-wing thugs; Anselmo's torture and death at the hands of the thugs some time later; and Camote's heroic participation in the revenge execution of the thugs' leader. Camote's thoughts in the midst of a gun battle are typical of the gradual replacement of political discourse by military prowess: "¡Qué música, ése es el 38 de Mario!" ("Like music to the ears: that's Mario's 38 revolver!"). Another common Montonero ideologeme is the delay of sexual gratification by the militant who must dedicate his life (and sexual energies) to the revolution, as evidenced when Camote falls in love with Anselmo's daughter and yet he chooses to postpone a relationship. This reminds us of Susan Sontag's suggestion in her study of Leni Riefenstahl's films under Nazism, that authoritarian ideologies require the channeling of a person's sexual energy into the superior goals of the group: "The fascist ideal is to transform sexual energy into a 'spiritual' force, for the benefit of the community. The erotic (that is, women) is always present as a temptation, with the most admirable response being a heroic repression of the sexual impulse." (93) A third and fundamental rhetorical construct that plays a crucial role in *Camote*—as well as in the overall Montonero experience and not surprisingly in the different versions of Oesterheld's *El Eternauta*—is a glorified view of martyrdom and death. The strip is filled with examples: the first time Anselmo is beaten by thugs, he scolds his wife for crying; when he is murdered later on, he heroically shouts "Long Live Perón!" The notion of martyrdom resulted from a rhetorical as much as an ideological need since

the organization's message was enunciated through each sacrifice, death becoming the expressive act by which the message was sent to the people: "A death that says a lot, or rather says it all," reads a characteristic eulogy to a dead comrade in *Evita Montonera* #12 (22). It is then no surprise that *Camote* became one more tool in a graphic arsenal that conveyed the message that heroism—interpreted as one's willingness to die—was the keystone of the Montonero struggle.

The re-semanticized comics and cartoons in the Montonero press show the extent to which emotionally loaded visual imagery and graphic symbols became an important source of legitimacy in the battle for rhetorical predominance. This is why the Montonero press became filled with emblems, stars, and iconic figures laid out in symmetric and predictable patterns that provided a sense of identity through hypnotic repetition. This coincides with what Sontag in her study of Riefenstahl's cinema terms "fascist aesthetics," i.e. an aesthetics proper to fascist art that is characterized by rigidity, symmetry, and repetition: "The rendering of movement in grandiose and rigid patterns [...] (Art Nouveau could never be a fascist style; it is, rather, the prototype of that art which fascism defines as decadent; the fascist style at its best is Art Deco, with its sharp lines and blunt massing of material, its petrified eroticism)" (91–92, 94).

Images and words can undoubtedly have a profound effect on reality. Yet, as with the proverbial sorcerer's apprentice, those who rely too much on images and words may sometimes fall prey to their own incantations. The way in which Montoneros resorted to a vast array of visual rhetorical devices in order to advance its revolutionary goals may be a tragic but illuminating example of this. Due to its own distrust for ideology and to the very nature of a guerrilla struggle that forced it to fight in conditions where the production and distribution of agitation material was difficult and dangerous, Montoneros became obsessed with ensuring that the organization remained highly visible among the people. Its dilemma was how to maintain a high public profile while simultaneously avoiding physical exposure to the enemy, which was crucial when confronted with fierce military repression after the brief 1973–74 interlude. The very first issue of *Evita Montonera* in 1974 put it succinctly: "We must *hide* our structures and functioning from the enemy. But we must make our *presence* ever more overwhelming" (the italics are mine; 12). Consequently, the flood of verbal and visual messages and the intensive use of rhetorical persuasion techniques became central aspects of the Montonero struggle. An internal document of February 1977, titled "Let's Win the Information Battle" and signed by a "National Secretariat for Propaganda and Indoctrination," shows the extent to which the group was fully aware of the role played by rhetorical persuasion. This is why it created a "Propaganda and Indoctrination" section in 1976 immediately after the military coup (*Evita Montonera* #13, 8), and why it emphasized the need to keep a steady flow of information in order to make the organization's message accessible to the people under the difficult circumstances of State

terror: "*Evita Montonera* must play a role in the propaganda battle against the censorship and misinformation imposed upon us by the enemy" (*Evita Montonera* #13, 3). The overwhelming flow of Montonero newspapers, magazines, documents, communiqués, graffiti, and flyers, coupled with the predominant use of visual rhetorical tools such as comics, cartoons, icons, emblems, graphics, and photos, attest to this awareness.

The question is not only what role rhetoric—particularly visual rhetoric—played in the Montonero project, but also whether it managed to persuade its intended audience. In a sense, Montoneros' rhetoric clearly succeeded in influencing behavior among its followers, to the point that thousands of activists ended up fighting under the banners of the organization and giving their lives for it. And yet, the larger audience—Argentine society—remained for the most part indifferent and even hostile to an organization that had become increasingly isolated from the people due to is own growing militarist tendencies and distrust of ideology. Instead of questioning its own political errors, Montoneros reacted to this isolation with a renewed barrage of rhetoric, and the communication channels between the organization and the people eroded even further. A certain sense of frustration in this respect can be perceived in the *Evita Montonera* of May 1976, just two months after the coup: "What good is it to inflict [on the enemy] more than 80 casualties if the masses will ignore it?" (19). In 1978, after suffering thousands of casualties of their own, *Evita Montonera* editorialized about "our forces having had to pay a necessary historical price," and about "capitalizing on the prestige obtained with the heroism of our shed blood" (*Evita Montonera* #22, 5). This language was consistent with the group's view of martyrdom, where each death was a rhetorical act and part of a message addressed to the people. This view was nowhere better expressed than in the calculating words of Montoneros' top commander Mario Firmenich towards the end: "We did our war calculations and we were prepared to endure a number of human losses of no less than 1,500 units in the first year" (quoted in Anzorena 357). Trapped into this obsessive preoccupation with visibility and presence but unable to reach its goals Montoneros resorted to every rhetorical and visual device it could muster, including the numerous images, cartoons, comics, emblems and all sorts of graphic icons that made its press unique. Never before in the history of guerrilla organizations had rhetorical devices been so instrumental and political action been as dependent on iconic words and images as with Montoneros, but also never before had the immense power and at the same time potential delusion of words and symbols been so clear. With an extreme trust in rhetoric coupled with a naive belief in historical inevitability, Montoneros created a verbal and visual reality of its own. But reality is neither a text nor an image (or at least not only that), just like human beings are not simply its signs: after thousands of deaths and the crushing defeat of the organization, it became clear that Montoneros, like the sorcerer's apprentice, had in the end believed too much in its own rhetoric and fallen prey to its own incantations.

NOTES

All translations from Spanish sources are mine. My special gratitude goes to Roberto Baschetti (Argentina) and Richard Gillespie (Great Britain) who in the mid-1980s gave me access to Montonero documents virtually unavailable elsewhere. Being caught in the possession of guerrilla propaganda—magazines, leaflets, stickers, posters—was in the 1970s tantamount to certain death at the hands of the military; thus, it was with great personal risk that these professional historians gathered collections of guerrilla documents during such a perilous time.

1 Around 1975, some sources spoke of even higher numbers, such as 250,000 sympathizers with 25,000 of those armed (Johnson 15). However, more careful researchers later concluded that, at their peak, Montoneros could not have had more than 2,000 guerrillas, with perhaps 400 fully armed (Frontalini and Caiati 72). German sociologist Peter Waldmann estimates there were 1,000 Montonero cadres active in 1975 (quoted in Gasparini 92).

2 Born in 1930, Ricardo Carpani became well known for his mural art and posters of political content commissioned by unions and human rights groups. He went into exile from 1974 to 1984, after which he returned to Argentina.

3 A first and incomplete version of the story had appeared in the magazine *2001* in 1970–1971. Oesterheld's ideological transformation is also evidenced by his choice of Ernesto Che Guevara and Eva Perón as the two key historical figures for a series of biographies commissioned by Editorial Jorge Alvarez in 1968 (García and Ostuni 133).

WORKS CITED

Anzorena, Oscar R. *Tiempo de violencia y utopía (1966–1976)*. Buenos Aires: Editorial Contrapunto, 1988.

Foster, David William. "Mafalda: From Hearth to Plaza." In *Buenos Aires: Perspectives on the City and Cultural Production*. Gainesville: University Press of Florida, 1998. 17–33.

Frontalini, Daniel and María Cristina Caiati. *El mito de la Guerra Sucia*. Buenos Aires: CELS, 1984.

García, Fernando and Hernán Ostuni. "*El Eternauta.*" *Revista Latinoamericana de Estudios sobre la Historieta* 2, 7 (2002): 125–152.

Gasparini, Juan. *Montoneros: Final de cuentas*. Buenos Aires: Puntosur Editores, 1988.

Gociol, Judith and Diego Rosemberg. *La historieta argentina: Una historia*. Buenos Aires: Ediciones de la Flor, 2000.

Sigal, Silvia and Eliseo Verón. *Perón o Muerte: Los fundamentos discursivos del fenómeno peronista*. Buenos Aires: Hyspamérica, 1988.

Sontag, Susan. "Fascinating Fascism." *Under the Sign of Saturn*. Farrar Straus and Giroux, 1975. 73–105.

Weathers, Bynum. *Guerrilla Warfare in Argentina and Colombia, 1974–1982*. Maxwell Air Force Base, Ala: Air University Library, 1982.

Memín Pinguín: Líos Gordos con los Gringos

Robert McKee Irwin

One of Mexico's most beloved comic book characters is a little mischievous but good-hearted black boy named Memín. Comic book historians Juan Manuel Aurrecoechea and Armando Bartra write that it "ha sido y sigue siendo uno de los mayores *best sellers* de la historieta mexicana" [has been and still is one of the biggest best sellers of Mexican comic books] (393).[1] Conceived in the 1940s by the prolific popular writer Yolanda Vargas Dulché (1926–1999) and illustrated by Alberto Cabrera, Memín was originally the protagonist of the comic strip *Almas de niño*, a regular feature of the *Pepín* comic book. Teaming with illustrator Sixto Valencia, Vargas Dulché launched Memín in his own comic book in the 1960s. He would remain enormously popular well into the 1980s, and continues to be published weekly, making its run one of the longest in Mexican comic book history. Mexico has historically been the world's largest per capita consumer of comics (Hinds and Tatum 6)—indeed critics claim that "Mexico and Japan have become the world's only comic-book cultures" (Hinds and Tatum 7)—but in the last few decades, the genre has lost much of its readership. However, the release of a series of postage stamps in the summer of 2005 commemorating the classic comic stirred up an enormous controversy in North America that revived Memín's popularity and had all of Mexico rallying to his defense (figure 6.1). This text surveys the range of ideas presented in the often strident debate on *Memín Pinguín* and offers an evaluation of its ultimate significations with regard to race in Mexico.

The Controversy of 2005

Just weeks after Mexican president Vicente Fox made the gaffe of stating that Mexican immigrants in the United States were only doing the work that no one else, "not even blacks" wanted to do, the release of a postage stamp

Figure 6.1 Memín Pinguín stamps.

of a little black bald boy with huge lips, bug eyes, protruding ears, and a
hefty mother dressed in housedress and bandana incited outrage among
African American political activists in the United States. The Reverends
Jesse Jackson and Al Sharpton were appalled that Mexicans were celebrat-
ing what looked to them like Little Black Sambo and Aunt Jemima, rac-
ist icons that had long been obliterated from visual culture in the United
States. The Bush White House joined in, condemning the Memín stamps
as "offensive" ("Califica la Casa Blanca..."). Mexicans, themselves shocked
that the United States, the country (aside from South Africa) best known
worldwide for a history of overt racism, dared to accuse Mexicans of rac-
ism, rallied to Memín's defense. The high pitched dialogue resembled a
juvenile shouting match, much like those described by José Vasconcelos
in his autobiographical *Ulises criollo*, in which he recalled his youth on the
Texas-Coahuila border: "Sin motivo y sólo por el grito de *greasers* o de
gringos, solían producirse choques sangrientos" [Without any motive and
only because of someone shouting "greasers" or "gringos," bloody clashes
would occur] (226), only instead of shouting racial epithets at each other,
now each side stridently accused the other of racism.

U.S. commentators (who weighed in vociferously via newspapers and
blogs) could not believe that Mexicans were honoring the representation of
an Afro-Mexican who was made to look like a monkey. For African American
journalist Leonard Pitts, Jr., Memín "is a black boy with swollen lips, simian
features and a propensity for ineptness and trouble. In other words, he is a
classic pickaninny." For Kenneth Brooks, he is "a grotesque comic figure
that assaults our sense of human dignity." Blogger Michelle Malkin writes
sarcastically, "It seems racism against black Americans is unacceptable except
when it's endorsed by the untouchable Mexican government" in a column
entitled, "So...Mexican Racism Is OK?" African Americans cannot believe
that Mexicans have not paid attention to the civil rights movement in the
United States. Pitts adds, "While *Memin Pinguin* [*sic*] is such an obvious
affront that even the White House felt compelled to denounce it, a spokes-
man for [Vicente] Fox told Reuters he couldn't understand what all the fuss
was about...Our friends down south need to get out more often."

Mexicans responded vocally, pointing out that the United States could learn a great deal about racial relations by studying Mexican history. Historian Enrique Krauze points out that slaves were freed early in Mexican history, and Mexicans of color have risen to positions unimaginable in the United States, with both indigenous (Benito Juárez) and black Mexicans (Vicente Guerrero) serving as president, and achieving status of national hero ("The Pride"). Afro-Mexicans hold a prominent place in Mexican culture: "En México hay un 'Cristo negro', se sigue escuchando a 'Toña la Negra', y aún se tararea 'La negrita cucurumbé'" [In Mexico, there is a "black Christ," we continue listening to [the singer] "Toña la Negra," and we still hum [the children's song by the popular artist Cri Cri] "La negrita cucurumbé"] ("Los ancestros").

What in the United States might be interpreted as a product of tensions between African Americans and "Hispanic" Americans after the latter recently overtook the former as the nation's largest "racial" minority does not translate well to Mexico. Mexico never knew the racial segregation of the United States, and consequently never needed to experience the violence of the civil rights movement. Mexico, in fact, has a history of promoting itself as a "racial democracy": the ideology of "mestizaje" identifies Mexico as a mixed race country, an attitude glorified in the national holiday known as El Día de la Raza, which celebrates Mexico's multiracial diversity.

However, Mexico's antiracist propaganda masks racial hierarchies that indeed sustain subtle but relentless structures of discrimination against darker skinned Mexicans. Some of these subtleties are better understood by Mexican American intellectuals, who are well versed in both Mexican history and U.S. civil rights discourse, many of whom weighed in on the *Memín Pinguín* controversy. For commentator Elizabeth Martínez, "The stamp represents a hardcore, all-too-familiar racist stereotype," while journalist Cristóbal Cavazos sees Memín as product of "the nationalist and racial illusions that the Mexican establishment propagates." Their arrogant responses, echoing those of Afro-Americans, reflect a typical *gringo* notion of international relations that places unquestioned U.S. specific values at the center of any debate. Renowned Chicano scholar Rodolfo Acuña complains of "the gap between civil rights conscious Mexicans in the United States and Mexican officials who defend" Memín, and charges that "Mexicans just don't know their own history." Martínez agrees: "We would do well, then, to talk to Mexicans about their racism," adding "with a certain effort not to sound superior." Whether or not they "sound" superior, it is clear that these commentators believe themselves superior, and are driven, in a gesture that mimics colonialism, to bring underdeveloped Mexicans up to speed with regard to contemporary protocol on race representation.

This attitude is by no means limited to Mexican Americans. Journalist Susan Ferriss expresses her annoyance that the burgeoning Afro-Mexican "black-pride movement" has not garnered widespread attention in Mexico: "it appears that the Mexican media and public are still not listening," implying that US media, where she publishes, is savvier. The U.S.-based leftist

legal advocacy group, the Equal Justice Society, responded by writing a letter of protest to president Fox in which they vow "to educate ourselves about Mexicans of African heritage and the intellectual, cultural, creative and economic wealth that is generated by these people whose contributions to humanity are too often obliterated by the kind of derogatory stereotypes represented in the Memin Pinguin [*sic*] stamps" and to meet with (presumably ignorant) Mexican officials to pass on their knowledge to them.

Mexicans, far from agreeing that they could learn from U.S. civil rights discourse, insisted that they treated blacks better than in the United States, often assuming their own patronizing and self righteous attitudes. Renowned writer Elena Poniatowska commented, "En nuestro país la imagen de los negros despierta una simpatía enorme, que se refleja no sólo en personajes como Memín Pinguín, sino en canciones populares. Hasta Cri Cri creó su negrito sandía. En México, a diferencia de lo que sucede en Estados Unidos, nuestro trato hacia los negros ha sido más cariñoso" [In our country the image of blacks awakens an enormous sympathy, which is reflected not only in characters like Memín Pinguín, but in popular songs. Even Cri Cri created his little black watermelon man. In Mexico, in contrast with what occurs in the United States, our treatment toward blacks has been more affectionate] (quoted in Palapa, Montaño and Mateos).

The cartoonist who has been drawing Memín for the past 40-odd years, Sixto Valencia insists, "Everyone here knows he's this funny little kid. And nice. And generous. Oh, and black, too. Why such an uproar now?" (quoted in Campbell). Valencia argues in fact that "Memín Pinguín actually took on racism several times, he hardly perpetuated it" (quoted in Campbell), complaining that "Jesse Jackson...y sus derivados que se quejaron, nunca han leído un solo número de Memín..., pues sus argumentos son blancos" [Jesse Jackson...and his followers who complained have never read a single issue of Memín..., therefore their arguments are empty] (quoted in Palapa, Montaño and Mateos). The ignorance lies, then, on the U.S. side and not the Mexican side.

In fact, a perusal of U.S. commentaries on Memín quickly uncovers multiple errors, signaling that many of *Memín*'s loudest critics have never even seen the comic book. *The Berkeley Daily Planet*'s reporter erroneously claims that "the number of newspapers carrying the 50-year-old comic strip has declined steadily from the early 1960s" (Vincent), when Memín in fact has never appeared as a newspaper strip, but as a standalone comic book. Callimachus of the Done With Mirrors blog refers to Memín's creator Yolanda Vargas Dulché as "Yolanda Carlos Dulche." And blogger Kenneth Brooks of Ethicalego, who apparently knows Memín only from the postage stamp and an early description on Wikipedia, complains that Memín is contrasted with other characters, his buddies, who are drawn "as handsome boys with good looks and a demeanor that suggests wealth and intelligence." While there is no doubt that the Memín character is more of a caricature than his sidekicks, and that he plays a clown to their role of straight men, only one of them is from a wealthy family, while the other two, each raised by a single parent, are

clearly very poor, no better off economically than Memín. In fact, Ernestillo appears to be the poorest of the four friends, Memín himself noting in one episode, upon observing Ernestillo's miserable bed: "¡Ah, Jijo! Mi cama es mucho más blandita y cómoda que la suya. Pasará muchos fríos en la noche." [Wow! My bed is much softer and more comfortable than his. He must get cold a lot at night] (Vargas Dulché and Valencia, No. 7: 8). Brooks refers to these three kids as Memín's "better friends," undoubtedly an awkward translation of "mejores amigos" [best friends]. Brooks' ignorance of context and language do not stop him from advocating intervention: "Does Mexico enjoy a special place in the international community so its internal affairs are untouchable? . . . Our government can and should deny President Fox the close economic ties he wants until he recalls those postage stamps."

Mexicans' response has been not only to rally to Memín's defense in countless blogs, newspapers and other public forums, but also to buy something many had forgotten about for years: *Memín* comic books. Following the controversy, reports began to surface about the sale of the rights to the *Memín* stories with the idea of reviving them in the form of a *telenovela* or animated film, and about a merchandising campaign that already includes calendars, posters, CDs and cell phone images, and may well be expanded to include dolls, board games, watches, snacks, and so on. Briefblog, a Mexican marketing blog observed at summer's end, "Memín se convirtió de la noche a la mañana en un producto solicitadísimo" [Overnight Memín became a highly sought after product] (Live U4).

Nonetheless, some Mexicans have reacted to the controversy not by defending *Memín*, but by pointing out the general problem of invisibility faced by Afro-Mexicans in national cultural production, and the issue of racial stereotyping. Afro-Mexican pop singer Johnny Laboriel concurred with Memín's critics that the caricature is offensive, while La Asociación México Negro[2] issued a statement declaring "Memín Pinguín rewards, celebrates, typifies, and cements the distorted, mocking, stereotypical and limited vision of black people in general" (quoted in Peters). Others, such as Mexican historian and anthropologist Claudio Lomnitz agree, but argue that "[t]he ruckus completely overshadowed the original subject of debate; Mexican racism replaced immigration as the issue of the day."

MEXICO'S COMIC HERO

There is no doubt that Memín resembles Little Black Sambo (figure 6.2). It also cannot be denied that he is the *historieta*'s only character who is not meant to be realistic. In one episode, he states quite clearly that he was "born black and bald," and in fact Memín never grows one hair on his head (Vargas Dulché and Valencia, No. 197: 5). With his exaggerated lips and eyes, he is meant to be something of a little monkey, and in fact in another episode, when Memín and his buddies are invited on a trip to Africa, he gets kidnapped by an ape who mistakes him for her son (figure 6.3: Vargas Dulché and Valencia, No. 208–209). His widowed mother, Doña Eufrosina

Figure 6.2 Page 5 of MP, number 197, story by Yolanda Vargas Dulché, illustrations by Sixto Valencia, reprinted courtesy of Manelick de la Parra Vargas, Grupo Editorial Vid.

does indeed look a lot like Aunt Jemima, as well. However, it should be noted that Memín's creator, Yolanda Vargas Dulché claims to have based her protagonist not on any racist representation from U.S. culture, but on the Afro-Cuban children who captivated her imagination on a trip to Cuba. Memín's Mexicanness in fact is given an Afro-Cuban tint on occasion, for example when in one installment he becomes delirious from not eating and begins singing and dancing to the tune of the Cuban classic, "El manisero" [Peanut Vendor] (Vargas Dulché and Valencia No. 206: 27–28). And Memín's "Má'Linda," as he calls her, may indeed be a stereotypical "Mammy" figure, but it is quite possible that her visual rendering draws less from U.S. icons such as Aunt Jemima than from well-known Afro-Caribbean ones, such as Mamá Inés. This latter figure is most readily associated with a classic Cuban rumba song made popular first by Rita Montaner and later by Bola de Nieve

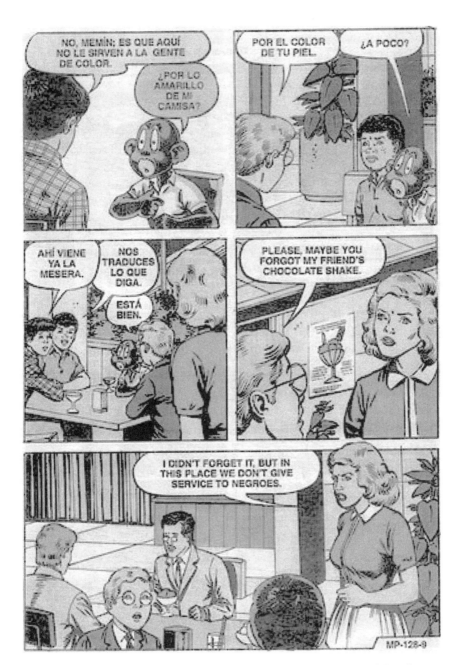

Figure 6.3 Page 9 of MP, number 209, story by Yolanda Vargas Dulché, illustrations by Sixto Valencia, reprinted courtesy of Manelick de la Parra Vargas, Grupo Editorial Vid.

("Ay, Mamá Inés"): Mamá Inés is a hefty Afro-Cuban woman who wears a typical *bata cubana*, a kerchief on her head, drinks coffee and smokes cigars. In addition to being a celebrated icon of Afro-Cuban femininity, she has been appropriated by coffee companies in Puerto Rico and the Dominican Republic who continue to feature her likeness on their products. Indeed, Eufrosina speaks with a notably Cuban accent (Lomnitz).

"Pinguín" means "little mischief maker" in Mexican Spanish. Memín is a good-hearted little boy, devoted to his mother and his friends, but has a knack for getting into trouble. He is at times lazy and a joker, but is always the protagonist of the action, and readers are encouraged to sympathize and even identify with him for being good, but not perfect, and in fact notice-ably different from those around him (figure 6.4). Memín meets up with bad luck, injustice and mistreatment, but always comes out okay, and in fact learns many important moral lessons through his misadventures.

Other major recurring characters of the comic include Memín's three best friends, Carlangas, Ernestillo, and Ricardo, their parents, a chubby boy named Trifón, and the boys' schoolteacher. With the exception of Trifón, whose most distinctive physical feature (his heaviness) is visually exaggerated for comic effect, the other lighter skinned characters (none of whom, signifi-cantly, is indigenous looking) are drawn with a relative verisimilitude.

However, each has its own story. Carlangas is a tough kid, son of a single mother who is forced to work in a dancehall, offering company (or worse) to clients. Ernestillo is a star student, but poor (to the point of going shoe-less) and often neglected by his widowed alcoholic father. Ricardo's family is wealthy, but his father believes that it is good for his son to attend public school. Richness and physical comfort do not mean a happy family life, however, as his parents decide to divorce, and his father takes up with his secretary. Authority figures such as the boys' teacher and the parish priest, along with Memín's own Má'Linda, a loving single mother who makes a liv-ing taking in laundry, are upstanding citizens and role models, who provide moral guidance to the sometimes imprudent youngsters.

Memín Pinguín is, then, both comic and melodramatic. Its thirty-two page episodes always continue from one issue to the next, like a soap opera. Its author, Vargas Dulché, in fact, had a long career writing not only comic books, but also *telenovelas* and romantic novels, well known for their beloved, usually impoverished, protagonists. She claimed that she drew on her own experience as a young girl growing up in poverty for many of her plotlines (Rubenstein).

Memín Pinguín in fact followed patterns typical of the Mexican comic book industry. Its initial incarnation, *Almas de niño*, was published in the 1940s in the *Pepín* comic book, along with many similar comics. When *Memín* came out on its own in the 1960s, it shared the market with com-ics of multiple genres, including romance (e.g. Vargas Dulché's own long running *Lágrimas, risas y amor*), adventure (the hugely popular *Kalimán*, whose protagonist was something of an Oriental superhero created by Modesto Vásquez González and Rafael Cutberto Navarro), and humorous

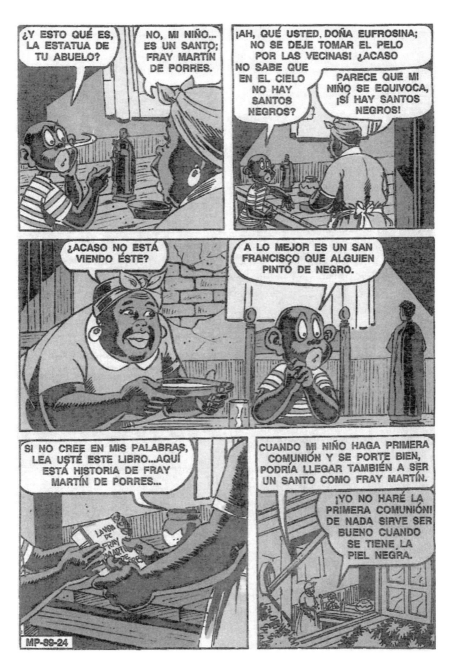

Figure 6.4 Page 30 of MP, number 247, story by Yolanda Vargas Dulché, illustrations by Sixto Valencia, reprinted courtesy of Manelick de la Parra Vargas, Grupo Editorial Vid.

family melodrama (Gabriel Vargas's *La familia Burrón*, the tragicomic saga of a lower middle-class Mexican family).

Many of these comics were enormously successful in Mexico, where they were (and are) read not only by children, but by adults, many of whom, semiliterate, had little access to or comfort with books and newspapers. In addition, many of the biggest firms of Mexico's comic industry exported their comics, often in translation. *Memín*, thus, was not only a Mexican phenomenon, as it traveled to multiple parts of Latin America, and also to countries like Italy, Iran, Japan, Indonesia, and the Philippines. In the latter country, it is said that it was admired so much for its moral teachings that *Memín* became required reading in grade schools ("Aparecerá . . . ").

MEMÍN AND RACE

While the visual representation of Memín is indeed reminiscent of racial caricatures that have been denounced in the United States and elsewhere, the content of the comic book was often unequivocally antiracist, at least on the surface. One memorable episode that addresses the theme of race was inspired by the Venezuelan poet Andrés Eloy Blanco's poem, "Píntame angelitos negros" (Paint black angels for me). The poem, which refers to the Eurocentric aesthetic of religious art that represents heaven as terrain of only whites, begs painters to also paint black angels on their frescoes. It later became a hit song ("Angelitos negros"), often sung by Afro-Latin American artists such as Mexican Toña la Negra or Cuban Celia Cruz, and also a popular Mexican movie (again titled *Angelitos negros*) starring Pedro Infante, loosely based on the Hollywood hit *Imitation of Life*. In this episode, Memín is told that blacks are not admitted to heaven as evidenced by the fact that angels are never represented as black. Memín then decides to rebel by being bad. Since he won't get into heaven anyway, it makes no sense to be good. Of course, his attempts at badness go awry—when his mother asks him how his day has gone, he replies, "Me fui de parranda con algunos amigos, pero acabaron de pleito y sacaron cuchillos y la cosa acabó con la policía" [I went to party with some friends, but it ended in fighting and they pulled out knives and it all ended with the police], which regular readers, familiar with the innocence of these little boys, know to be utterly ridiculous; the narrator comments, "Eufrosina se mordió los labios para no reírse ante aquella actitud de hombre de mundo que su hijo tomaba" [Eufrosina bit her lips to hold in her laughter at that worldly attitude that her son assumed], and Ma'Linda thinks to herself, "¡Pobrecito mi niño, quiere ser malo y no puede!" [My poor boy—he wants to be bad, but he just can't!] (Vargas Dulché and Valencia, No. 89: 23). Memín's badness falters irreparably when his buddy Trifón falls dangerously ill and his noble heart calls him to action. Meanwhile, his mother brings home a statuette of Afro-Peruvian saint Martín de Porres to show Memín that blacks not only get into heaven, but can be made saints, and the parish priest allows Memín's friends, who are concerned that Memín will get into serious trouble, to color in some

of the angels in the religious art decorating the church. Memín of course realizes that he must go back to trying as best he can to be a good boy (figure 6.5:Vargas Dulché and Valencia, No. 89–90).

A particularly well-remembered storyline entitled "Líos gordos" [Big fat problems] located racism outside of Mexico. On a trip to Texas with a local soccer team, Memín and his friends are refused service in a diner because Memín is black (figure 6.6). His buddies, Carlos, Ricardo, and Ernesto, rise to his defense, and all four end up in a scuffle that lands them in jail. They obtain their revenge on the soccer field by beating the U.S. team (Vargas Dulché and Valencia, No. 128). Here the lesson is that racism is wrong, and that the overt segregation practiced in the United States in the 1960s, when the comic was originally written, was indefensible. This memorable episode led one commentator to write, "Memín Pinguín a racist? To the contrary: He didn't even know discrimination! He only found out when he got to the United States." (Judith Amador Tello, quoted in Siegel). Here, the *gringos* are overtly racist while the Mexicans accept racial difference without prejudice. This position, the same one reiterated by most Mexicans responding to the stamp controversy, purports that in mixed-race Mexico racism in fact does not exist and that Mexicans, like Memín's friends, take the antiracist high road—indeed this message replicates state propaganda on race. Despite Mexico's inferior position with regard to economic development, technology, education, etc., Mexico is portrayed as morally superior to the United States for its lack of institutionalized racism.

However, racism is not an attitude limited to *gringos* in *Memín*. Memín suffers racist invective from Mexicans, as well, although Mexican racists are always portrayed as in the wrong. When Ernestillo's father calls Memín an "espantoso...negro del demonio" [frightening...demonic negro] and an "engendro del infierno" [creature from hell], it is only because he is in a state of alcoholic confusion (Vargas Dulché and Valencia No. 6: 12). In another sequence, the friends and their parents visit the ranch of Don Heriberto, a good friend of Carlangas's father, with whom his mother has reunited. When invited to lunch, Eufrosina offers humbly to help in the kitchen, where she feels she belongs, but Heriberto insists that she join everyone at the table. But, in the middle of lunch, Heriberto's snobby son arrives with his blonde girlfriend and exclaims irately, "¡Quién permitió a este negro, sentarse a nuestra mesa?...¡Lárgate!...Los negros no deben mezclarse con nosotros..." [Who let this black boy sit at our table?...Get out of here!...Blacks should not mix with us...] (Vargas Dulché and Valencia No. 299: 21). However, justice is served when later on, at a bullfight, Memín so charms the blonde girlfriend that she gives him a big kiss, right in front of her livid boyfriend (*Ibid*: 29).

Other adventures treat the race theme more playfully. For a while, a wealthy elderly white lady who is also blind mistakes Memín for her grandson. He ends up living in her mansion for a time in the role of the rich white boy (Vargas Dulché and Valencia, No. 189–197). However, in another episode, when Memín is first invited to his rich blonde friend's house, he

Figure 6.5 Page 24 of *Memín Pinguín* (MP), number 89, story by Yolanda Vargas Dulché, illustrations by Sixto Valencia, reprinted courtesy of Manelick de la Parra Vargas, Grupo Editorial Vid.

Figure 6.6 Page 9 of MP, number 128, story by Yolanda Vargas Dulché, illustrations by Sixto Valencia, reprinted courtesy of Manelick de la Parra Vargas, Grupo Editorial Vid.

frightens Ricardo's mother ("¡Qué horror! ¡Un mico!" [Horrors! A monkey!], she shrieks when she sees him for the first time: quoted in Camacho Hurtado 121). The mother turns out to be an uptight snob, while Ricardo's more liberal and generous father welcomes Memín into the household.[3]

RECEPTION AND INTERPRETATION

Certainly it is no surprise that many Mexicans recall *Memín* as antiracist. Mexican readers note that Memín looks different from most Mexicans, and yet they love him because they identify with him for other reasons: his optimism in the face of poverty, his struggles in school, his innocent confrontations with major social problems among adults (alcoholism, spousal abuse, adultery, and, indeed, *racism*), his bad luck, his generally tough life. He is especially lovable because despite suffering universal ills, he always exhibits a sense of humor, loyalty to his friends, an innate honesty, respect for authority, and above all an enormous love and devotion for his mother. While young readers in the 1960s, 1970s, and 1980s may have fantasized about being Kalimán or meeting up with Rarotonga, the Jungle Queen (protagonist of another popular Mexican comic authored by Vargas Dulché), they identified with and learned lessons of life with Memín.

Of course, there was no institutionalized criticism, formal or informal (i.e. in academia or in popular journals) of comics during Memín's heyday. It is only recently that the power of popular culture in promoting ideologies and shaping values has been taken seriously among intellectuals. Mexico's National Museum of Popular Culture (now called National Museum of Popular and Indigenous Cultures) in Coyoacán, founded in 1983, gave space to a major exhibition on the history of comics in Mexico that has to date resulted in the publication of three large illustrated volumes tracing the history of Mexican *historietas* from 1874 to 1950 (Aurrecoechea and Bartra) and a CD ROM-based catalogue of twentieth century Mexican comics (Aurrecoechea) that includes an introduction providing a critical history of the genre (Bartra). U.S.-based historians took up the theme in the early 1990s, writing their own history of *la historieta mexicana*, focusing on the 1960s and 1970s (Hinds and Tatum). It seems that, like so many phenomena of popular culture, it was only once it was in decline that intellectuals understood its importance and began treating it with a paternalistic nostalgia.

In fact, as Carlos Monsiváis points out, the study of comics is made all the more difficult by "el desdén que se expresa en la ausencia de colecciones de [la historieta mexicana] en las bibliotecas públicas" [the disdain expressed in the absence of Mexican comics from public library collections] (*En los ochenta años* 11), which explains the dearth of criticism on the so called "golden age" of Mexican comics of the 1930s, 1940s, and 1950s, "considerada así por ser el único momento en que el país entero lee historietas" [so considered for being the only time in which the entire country was reading comics] (Monsiváis 4).

Historians have located *Memín Pinguín* in a genealogy of Mexican comics centered on the adventures of poor urban kids, dating back to a strip called *Macaco y Chamuco: aventuras de dos insoportables gemelos* in 1912, and identifying the Buckwheat character ("Farina" in Spanish) of *Our Gang* (both the comic strip and the film were exported to Mexico from the United States) as a partial inspiration for Memín. Memín also had Mexican precursors in film, such as the boy actor known as "Toño el Negro," who appeared in 1930s films such as *Madre querida* and *El derecho y el deber*, both directed by Juan Orol (Aurrecoechea and Bartra 373–376).

The filmic connection is particularly relevant since these two massively popular genres of national cultural production, whose histories coincided in producing their greatest social impact in the second quarter of the twentieth century, used similar narrative strategies to reach their audiences. Mexican audiences, as they entered cultural modernity by voraciously consuming both movies and comics, responded eagerly to the emotional appeal of melodrama, a prominent narrative genre for each of them. Writes Carlos Monsiváis of the first era of Memín Pinguín (when he appeared under the title *Almas de niño*):

> Despite its obvious atrociousness, *Almas de niño* consecrates a method and establishes the real solution for Mexican comics; if it is not possible to compete with the North Americans in terms of artistic or technical resources, the best defense lies in excess, melodrama's lack of limits…That orgy of purified feelings contrasts with the unpolluted and aseptic universe of U.S. comic strips and transmits to readers a conviction: don't be afraid of tears, nor of exaltation, nor of suffering. They are not your grief, but your reward (quoted in Aurrecoechea and Bartra 389).

While contemporary critics have made note of "el racista recurso de extremar la estilización grotesca de los personajes étnicamente 'exóticos'" [the racist recourse of carrying the grotesque stylization of ethnically "exotic" characters to the extreme] (Aurrecoechea and Bartra 391), typified in *Almas de niño* and *Memín*, this style of representation, innocent as it may have appeared in the 1940s or even early 1960s, was surely raising some eyebrows by the peak of *Memín*'s circulation in the 1980s.

Nonetheless, no study concerned itself, except in passing, with this issue until 1999, when Colombian Eusebio Camacho Hurtado included a brief but biting critique of *Memín Pinguín*, the comic book's title in Colombia, in his study *El negro en el contexto social*, affirming that "la simbolización que se hace del negro en los citados personajes penetra en el subconsciente de sus lectores y se refleja en la conciencia social de éstos, mediante prejuicios que afectan tanto a negros como blancos, y el resultado de estos efectos psicológicos será el rechazo a los rasgos negroides" [the symbolization that is made of blacks in the above mentioned characters penetrates the subconscious of readers and is reflected in their social consciousness in the form of prejudices that affect both blacks and whites, and the result of these psychological effects is the rejection of negroid traits] (99). A few years later, U.S.-based

critic Marco Polo Hernández Cuevas wrote, "*Memín*...enseñaba al mestizo a burlarse del negro como si fuera el Otro. *Memín* fue un medio más para enseñar al mestizo a renegar a todo aquello, dentro y fuera de él, que no fuera blanco" [*Memín*...taught the *mestizo* to mock the black as if he were the Other. *Memín* was one more means of teaching the *mestizo* to deny all that, whether within or outside himself, was not white] (57).

Indeed, Afro-Mexicans, particularly males, are largely invisible in Mexican cultural production. Although the Afro-Mexican female occasionally appears, usually in a hypersexualized role, exemplified in the witchy seductress who is the protagonist of Xavier Villaurrutia's opera, *La mulata de Córdoba*, male characters are especially rare. One may recall el Aguilucho and other shadowy figures of Mexico City's illicit underbelly in Fernández de Lizardi's *El Periquillo Sarniento* from the early 1800s, but more often the rare blacks appearing in Mexican cultural production are portrayed as not belonging to Mexican culture, and indeed are often identified as Cuban. In Mexican golden age cinema, in particular, Afro-Latin American music is frequently exoticized and de-Mexicanized. Something similar occurs in the long popular children's songs of Cri Cri (Francisco Gabilondo Soler).

Mexican Memín

If Afro-Mexicans are few and far between in these roles of loose women, outlaws and children, they are utterly nonexistent as adult males, roles that would allow them, according to patriarchal models of the era of *Memín Pinguín*'s creation (1940s) and greatest commercial success (1960s-1980s), to be protagonists in national culture. *Memín*'s difference, then, was apparent to Mexican readers, and in the end it is impossible not to judge the *historieta* racist.

However, the particularly nationalist tone of Mexicans' defense of *Memín* suggests that such a reading has not been the norm. *Memín*, to Mexican readers, was Mexican, without any doubt, just as much as any of his friends, even if on his civics test, he struggles to recall the year of Mexico's *grito de independencia* ("¡Ah, qué rebruto soy! Eso sí lo sabo [*sic*]...en el año 1810, por el curita pelón Hidalgo" [Ah, how stupid I am! I do know that...in 1810 by the bald little priest, Hidalgo] (Vargas Dulché and Valencia No. 8: 8)) and cannot remember the exact name of Mexico's president (*Ibid*: 9). In fact, if there is any character whose Mexicanness is called into doubt, it would be Ricardo, who looks very *gringuito*, and in fact appears to have been a copy of the U.S. comic protagonist Richie Rich. *Memín*'s difference, then, is most significant. He is Mexican: he lives in a very Mexican-looking *barrio*, he tells Mexican-style jokes, and his daily life is filled with details recognizable to Mexican readers from their own surroundings. And yet he does not look like any popular version of the Mexican male. He allows readers who similarly do not see themselves in Mexico's best known archetypes and icons, Mexicans who are not as good looking as the movies star models of Mexicanness, who don't quite fit the stereotypes of *charro*, *pelado*, or *caifán*, who are in some

way a little bit different (but still utterly Mexican), to nonetheless identify with this funny little black boy *as Mexicans*. An editorial of the Mexican newspaper *El Universal* states, "Los críticos estadounidenses ignoran que Memín no es un mero dibujo, sino el reflejo de un niño de color, travieso e hiperactivo, que se abre paso en la sociedad pese a su propia circunstancia de pobreza" [U.S. critics ignore that Memín is not a mere drawing, but the reflection of a mischievous and hyperactive boy of color who finds a place for himself in society despite his circumstance of poverty] ("*Memín*: un conflicto de historieta").

For many Mexicans, Memín was an icon through which they learned to accept a Mexican identity of difference. Online columnist Jules Siegel is correct in observing that difference, when affectionately poked fun at in Mexico, is evidence of its being embraced. "Calling a man homosexual or saying that his mother is a whore is insulting. Saying that he is black...is, at worst, crude...This is a country where everyone has a nickname and it isn't usually flattering. If you are fat, you will be called Gordo or Gorda. If you are skinny, you might be known as Flaca or Flaco. Worse, among some crowds, you could be called Calaca...Your friends love your skinniness because they love you." Memín—short, dark skinned, bald—was, like many *chaparritos*, *negritos*, and *peloncitos*, just as Mexican as any of his classmates—and his readers. This process of identification, then, had little to do with actual representations of Afro-Mexicans. Afro-Mexicans, in fact, continued to be invisible to many readers of *Memín*. But the particular experience of Memín as a symbol of difference in general made the particularities of his difference—his black skin, his shortness, his exaggerated features, his baldness—irrelevant. The reading of *Memín Pinguín* as racist, then, feels imposed on many Mexican readers, not because *Memín* does not portray Afro-Mexican characters in a derogatory way, but because his popularity is the result of an alternate reading that does indeed accept and even identify with his "defects," including his racial difference.

This would not be the reading of Afro-American critic bell hooks. She agrees that "In contemporary debates on race and difference, it is mass culture that publicly declares and perpetuates the idea that it can be pleasurable to recognize and enjoy racial differences" (17), but adds that, ""Real enjoyment" is attained upon bringing to the surface all the "annoying" fantasies and unconscious desires concerning contact with the Other, inserted in the profound secret (not so secret) structure of white supremacy" (17–18). But I will insist that *Memín*'s function has been double. On the one hand, the *historieta* reinforces Mexican nationalist propaganda that claims Mexico to be an antiracist society, while turning a blind eye to a notion of white supremacy that is deeply embedded in Mexican culture; on the other, *Memín* opposes racist thinking, marks overt racism as immoral and, using the sentimental hooks of melodrama, incorporates Afro-Mexican figures into the national imagination as beloved icons.

Whether or not it was ever Vargas Dulché or Valencia's intention to promulgate a negative image of Afro-Mexicans, *Memín Pinguín* surely did so

by employing tools of the trade and making him a comic hero, an object of laughter, by thoughtlessly repeating hurtful stereotypes. On the other hand, for those readers who embraced Memín, despite any perceived racial difference, he was naturalized as part of a national imaginary. Just as nineteenth century romantic novels incorporated difference into the notion of national community by making racially diverse characters' aims of integration into the mainstream of national culture sympathetic to readers (Sommer), comic book readers' sympathy for and identification with Memín's lot in life, his foibles, his endearing personality, his miserable physical environment and his sense of humor serve to bridge racial differences.

FINAL THOUGHTS

I will conclude by clouding the waters a bit further by recalling that *Memín Pinguín*, although written and illustrated by Mexicans about Mexicans and with an undoubtedly Mexican audience in mind, was not a mere national icon. Long after his conception and first decades of circulation among Mexican readers, *Memín* became an export of Mexico's enormous comic book industry. Just as many of Mexico's golden-age films were distributed widely outside of Mexico, *Memín* became a popular comic in many countries in Latin America and beyond. The shifts in significations of Mexican cultural production when they leave the confines of the nation remain relatively unexplored territory. How was Mexican golden-age cinema received in Cuba? What did Jorge Negrete's classic *ranchero* ballads mean to Venezuelan listeners? What did *niños ecuatorianos* make of *Memín* when the *historieta* became popular there? A tougher question might be what *Memín* meant to readers outside of Latin America, in Indonesia or the Philippines. The serious study of mass culture is relatively young, and so far has not gotten much beyond national contexts. A next step for critical inquiry will be to understand how cultural industries in major Latin American cultural centers such as Mexico have influenced notions of cultural identity in the places that consume their products. This will be a task for a new, "postnational" Mexican studies.

NOTES

I am indebted to Bettina Ng'weno and all those who gave me helpful feedback at the Africa and African Diaspora Studies brown bag seminar that Bettina organized in the fall of 2005 at UC Davis, at which I presented my preliminary research on *Memín*. I also thank Juan Poblete and Héctor Fernández L'Hoeste for their useful suggestions on a later draft of this chapter.

1 This and all subsequent translations from the Spanish are mine, unless otherwise indicated.

2 This group, of decidedly limited visibility within Mexico, represents the interests of the large Afro-Mexican community of the Costa Chica region of the states of Guerrero and Oaxaca.

3 Pieces of this episode are reprinted in Camacho Hurtado 119–121, 128, 133, 142, 153, 157–160.

Works Cited

Acuña, Rodolfo. "Memín Pinguín—Stupidity Is Stupidity." Hispanicvista. com. July 11, 2005. http://www.hispanicvista.com/HVC/Opinion/Guest_ Columns/071105Acuna.htm. Consulted October 1, 2005.

"Aparecerá *Memín Pinguín* en 750 mil sellos postales." *La Crónica* June 28, 2005. http://www.cronica.com.mx/nota.php?idc=18913. Consulted February 12, 2006.

Aurrecoechea, Juan Manuel. "Prólogo: y cuando despertó la historieta, ya no estaba ahí." *Catálogo de la historieta mexicana del siglo XX* (CD-ROM). México/ Colima: Instituto Nacional de Antropología e Historia/Universidad de Colima, 2001.

Aurrecoechea, Juan Manuel and Armando Bartra. *Puros cuentos III: historia de la historieta en México, 1934–1950.* México: Consejo Nacional para la Cultura y las Artes/Grijalbo, 1994.

Bartra, Armando. "Introducción: debut, beneficio y despedida de una narrativa amotinada." Juan Manuel Aurrecoechea. *Catálogo de la historieta mexicana del siglo XX* (CD-ROM). México/Colima: Instituto Nacional de Antropología e Historia/Universidad de Colima, 2001.

Brooks, Kenneth. "Memin Pinguin Comic Character is Offensive." Ethicalego. 7/11/2005. http://www.ethicalego.com/memin_pinguin.htm. Consulted October 1, 2005.

"Califica la Casa Blanca de racista estampilla de *Memín*." *El Universal Online* June 30, 2005. http://www2.eluniversal.com.mx/pls/impreso/noticia.html?id_nota= 291260&tabla=notas. Consulted February 12, 2006.

Callimachus. "Memin Pinguin." Done with Mirrors. http://vernondent.blogspot. com/2005/07/memin-pinguin.html. Consulted October 1, 2005.

Camacho Hurtado, Eusebio. *El negro en el contexto social.* Cali: Bejerano Impresores, 1999.

Campbell, Monica. "Cartoonist Defends Stereotypes Image on New Mexican Stamp." *San Francisco Chronicle* July 4, 2005. http://www.sfgate.com/cgi-bin/article. cgi?file=/c/a/2005/07/04/MNGDKIDSKS1.DTL. Consulted October 1, 2005.

Cavazos, Cristóbal. "Memin Pinguin and Mexico's National Myth." *People's Weekly World Newspaper* July 21, 2005. http://www.pww.org/article/ view/7437/1/279/. Consulted January 9, 2006.

Equal Justice Society. "Equal Justice Society Asks for Meeting with Mexico's Ambassador to U.S. to Discuss Memin Pinguin Stamps." http://www. equaljusticesociety.org/action_mexicanstamp.html. Consulted October 1, 2005.

Ferriss, Susan. "Blinded by Indignation, Mexicans Ignore Black Opinion at Home." Cox News Service August 29, 2005. http://www.coxwashington.com/ reporters/content/reporters/stories/MEXICO_JOURNAL28_COX.html. Consulted January 9, 2006.

Hernández Cuevas, Marco Polo. "*Memín Pinguín*: uno de los *cómics* mexicanos más populares como instrumento para codificar al negro." *Afro-Hispanic Review* 22:1, 2003: 52–59.

Hinds, Jr., Harold E. and Charles M. Tatum. *Not Just for Children: The Mexican Comic Book in the Late 1960s and 1970s.* Westport: Greenwood Press, 1992.

hooks, bell. "Devorar al otro: deseo y resistencia" [1992]. Mónica Mansour, Trans. *Debate Feminista* 7:13, 1996: 17–39.

Krauze, Enrique. "Los ancestors de Memín." *Reforma* July 3, 2005. Reprinted in SalvadorLeal.com. http://www.salvadorleal.com/piensa.htm. Consulted January 9, 2006.

Krauze, Enrique. "The Pride in Memin Pinguin." *Washington Post* July 12, 2005. http://www.washingtonpost.com/wp-dyn/content/article/2005/07/11/AR2005071101413.html. Consulted August 24, 2005.

Live U4. "Memín Pinguín Sí Vende." Briefblog: Publicidad y Marketing. September 18, 2005. http://www.briefblog.com.mx/archivos/2005/09/18/410.php. Consulted October 1, 2005.

Lomnitz, Claudio. "Mexico's Race Problem: And the Real Story Behind Fox's Faux Pas." *Boston Review.* November–December 2005. http://www.bostonreview.net/BR30.6/lomnitz.html. Consulted April 14, 2006.

Malkin, Michelle. "So…Mexican Racism Is OK?" michellemalkin.com. June 29, 2005. http://michellemalkin.com/archives/002886.htm. Consulted January 16, 2006.

Martínez, Elizabeth (Betita). "Looking at the Mexican Stamp and Beyond." Portside 7/19/2005. http://www.portside.org/showpost.php?postid=2361. Consulted October 1, 2005.

"*Memín*: un conflicto de historieta." *El Universal Online* July 2, 2005. http://www2.eluniversal.com.mx/pls/impreso/web_editoriales_new.detalle?var=29470. Consulted February 12, 2006.

Palapa, Fabiola, Ericka Montaño and Mónica Mateos. "Memín Pinguín 'no es el icono popular del racismo en México.'" *La Jornada* July 1. 2005. http://www.jornada.unam.mx/2005/jul05/050701/a04n1cul.php?partner=rss. Consulted August 24, 2005.

Peters, Troy. "Understanding Pickaninnies and Improving the Race." *The Black Commentator* 147, July 21, 2005. http://www.blackcommentator.com/147/147_guest_peters_pickaninnies.html. Consulted January 9, 2006.

Pitts, Leonard. "Again, Mexico Steps into Racial Quagmire." *Jewish World Review* July 6, 2005. http://www.jewishworldreview.com/0705/pitts070405.php3?printer_friendly. Consulted January 9, 2006.

Rubenstein, Anne. "Yolanda Vargas Dulché, A Great Mexican Author." Good Bye! The Journal of Contemporary Obituaries. September 1999. http://www.goodbyemag.com/sep99/dulce.html. Consulted April 14, 2006.

Siegel, Jules. "Understanding the Memín Pinguín Argument." The Narcosphere. July 11, 2005. http://narcosphere.narconews.com/story/2005/7/11/195836/388. Consulted October 1, 2005.

Sommer, Doris. *Foundational Fictions: The National Romances of Latin America* [1991]. Berkeley: University of California Press, 1993.

Vargas Dulché Yolanda (arguments) and Sixto Valencia Burgos (illustrations). *Memín Pinguín.* México: Vid, 1964–present (372 installments).

Vasconcelos, José. "José Vasconcelos." Emmanuel Carballo, Ed. *¿Qué país es éste?: Los Estados Unidos y los gringos vistos por escritores mexicanos de los siglos XIX y XX.* México: Consejo Nacional para la Cultura y las Artes, 1996: 223–237.

Vincent, Ted. "Why Memín Pinguín Is Accepted in Mexico." *Berkeley Daily Planet.* July 8, 2005. http://www.berkeleydailyplanet.com/article/cfm?archiveDate=07–08=05&storyID=21808. Consulted October 1, 2005.

CHAPTER 7

Acevedo and His Predecessors

Carla Sagástegui

Atender al pasado.
Vivir el presente.
Adelantarse al futuro.
A veces presiento una perspectiva desde la que se supera mi mirada lineal.

Juan Acevedo. Pobre diablo y otros cuentos

In Peru, most of the stereotypes and conventions in graphics were built in spaces set aside for humor. Inside these spaces, comics accomplished a fundamental role, since they gave shape to the narrative of three of the most important representations of the Peruvian way of thinking in the twentieth century: *criollismo* (advocacy of native character) or the ability to escape norms, the ridicule of the political system, and racial/cultural representations. Although the history of Peruvian comics has been discontinuous, it is clear that, until it managed to become professionalized, this medium grew hand in hand with three projects: a literature centered on regional manners and customs known as *costumbrismo* (1887–1890), the ensuing modernism (1907–1910), and a later stage of nationalism (1952–1975).

These three projects did not cancel or question each other. Instead, they highlighted a shared trait, which would distinguish and define them: like *criollismo, costumbrismo* gave more relevance to social practices; modernism emphasized the political situation; and nationalism gave more significance to racial and cultural representations of *peruanidad* (Peruvianness).

Likewise, three fundamental themes in the work of Juan Acevedo (1949), author of some of the most important contemporary comics, are social practices, politics, and *peruanidad*. The difference lies, though, in that his work deals with a true transformation in the history of Peruvian comics, given his integration of formal literary elements, through which he created a more complex and profound reading of the country, questioning old stereotypes

and proposing new representations. By way of a brief review of the history of graphic stereotypes in Peru, the aim of this chapter is to highlight the changes that Juan Acevedo's production embodies for each one of these three important aspects of Peruvian comics.

COSTUMBRISMO, THE BIRTH OF COMICS, AND SOCIAL PRACTICE

In point of fact, Peruvian comics were born from readings of everyday life translated into customs. In the middle of the nineteenth century, *costumbrismo* exploded as an aesthetic and cultured trend all over Latin America. *Costumbrismo* was characterized by its use of classicist arguments, from romantic perspectives to nationalist discourse. The outcome, for instance, was the Peruvian transformation of traditional plays like *El sí de las niñas* (An Innocent Girl's Consent) into a comedy with characters representing Lima's society, like *Ña Catita*, packed with octo-syllabic verses and a very amusing local slang. Such was the humoristic style of satirical *costumbrista* narrative. Yet, above all, we shouldn't forget that it dazzles journalism with its most famous creation: the *artículo de costumbres* (the article on manners and customs). As Jorge Cornejo Polar notes in *El costumbrismo en el Perú* (Costumbrismo in Peru), it's hard to recognize what came first: whether the articles motivated the creation of newspapers and magazines, or whether these publications and their mass communication appeal originated the others. Yet the phenomenon existed: dozens of publications surrounded readers on weekends, while they watched (in sheer astonishment) how swiftly some titles disappeared, to be replaced by others. There was plenty of choice and variety mattered a lot. It mattered because *costumbrismo* represented the search for a national identity through the satirization of our customs. A query persistently confused with *limeñismo*—What did it mean to be Peruvian?—was present in every line, every word: each one trying to be more Peruvian than the next.

Solemn and exaggerated illustrations proliferated on the pages of newspapers in those days, part of an old tradition that accompanied national publications since Peruvian independence. In this context of patriotic fervor and national identity, images played a very important role: our landscape, dress, and personalities emerged before the reader's eyes as a reflection of the country. However, the articles on customs were not only critical and descriptive, but favored anecdotes in the same manner as short stories (hence, they are considered the forebears of the Peruvian short story). When someone was lampooned in the images of *La Campana* (The Bell) or *El murciélago* (The Bat), depiction emphasized traits of characters that, to the eyes of cartoonists, graphic designers, and readers, were deeply reprehensible. And this was a radical attribute of *costumbrismo*, since it criticized things to improve them—*para hacer país* (to be patriotic), if you will. However, these illustrations carried no anecdote. It was imperative to situate characters in their context, showing a familiar behavior, easily recognizable to readers. In other words, it was crucial

to discover a way to imitate the approach in these articles to things Peruvian (after all, they were called *cuadros de costumbres* [pictures of customs]) for several reasons: the way people stole from beggars, the way girls were seduced in Lima, and even how some locals became fashion victims. For these reasons, not only in Lima, but also in most cities where a romantic reading of classicism shed light on *costumbrismo*, illustrations evolved into comics.

So, after the war against Chile (1879–1884), when realist literature could not yet dethrone *costumbrismo* from our narrative, it relied instead on the first lithographs of our journalistic history: *Perú ilustrado* (1887) introduced what, according to the wit of editors, was called drawing with an epigrammatic intention. From the weekly magazine's third issue on, at least two pages—though sometimes they became three or more—were devoted to this new genre. The editors swelled with pride: they called them epigrammatic illustrations because of the epigrams or texts associated with each vignette that completed the narration, and celebrated repeatedly the genre's innovative streak and humorous inventiveness.

The graphic project of *Perú ilustrado* used two types of illustrations: one filled with linear or colored strokes, related to caricatures and satirical themes, and another one based on outlines, with realist aesthetics and topics. However, despite the variety of results based on both types of illustrations, no specific style, not even that of a particular author, became established. From a more modern perspective, these comics still lacked an element that was customary in almost all other versions: the bubble containing the words of characters. Yet, if we review the history of comics around the world, we may see that cartoonists as renowned as Alex Raymond, author of *Flash Gordon*, decided to work without it and focused instead on *didascalias* (legends inside vignettes). Bubbles will appear in Peruvian drawings some years later, but in caricatures. It will take a couple of decades for them to make their way into comics.

All things considered, the result of *costumbrista* comics was the illustration of anecdotes that revealed *criollismo*, which evinced the ease with which Peruvians enjoyed the wit of their elusions—as in the series "La suegra" (The Mother-in-Law).

Modernism, Aestheticism, and Politics

In a certain way, comics were forced to be *costumbristas*, so readers could find them natural and easy to understand. According to Barthes, imagery operates in this manner. It habitually responds to the collective meaning that we hold in our imagination. Artists tend to use their own system of conventions, their personal language. This leads to the establishment of the artist's individual and generational relationship with history and politics, which apparently tends to be abrasive and critical. Although *costumbrismo* introduced conventions for the first comics, it wasn't able to establish a graphic style that made a distinction between characters and methodology. A few years later, modernism took this task heads on.

The modernist project was a generational movement that grew while surrounding criticism, with an emphasis on everyday politics. The magazines in which it became apparent were a privileged space for graphic experimentation and the establishment of fine conventions. Its best expression was the first version of *Monos y monadas* (Comics and Comicalities), under the direction of Leonidas Yerovi, a modernist artist, whose periodical lasted from 1905 to 1907. It emerged amid another national project: the failed civism gestated when the Peruvian upper class, as in other Latin American countries, decided to trigger development by modernizing Peru.

Civism embodied something like a republic for Lima and the owners of the country. For this reason, Jorge Basadre called it *"La República Aristocrática"* (The Aristocratic Republic), though it never even considered the middle-class population resulting from this very project. Accordingly, the oligarchic project by which Peru would become part of European civilization, idealized as a prosperous, organized, and cultured setting, experienced a crisis in the 1920s, due to the emergence of the urban middle class, which sought shelter in the public sector, the armed forces, trade, and intellectual labor, and the agricultural, mining, and urban working class, for which this project lacked proposals of incorporation or else did so at a desperately slow and truncated pace. At this time, the principal characters of comics and other caricatures were Nicolás de Piérola, the leader in charge of the reconstruction of the country after the war against Chile (1895–1899), whose image kept materializing distressingly within civism throughout the twentieth century, and President Leguía, a politician emerging from antimilitarism, who finally, after *Monos y monadas* had already disappeared, imposed an authoritarian development in name of the middle class, giving birth to the old tradition of forsaking Peruvian sovereignty in hands of the United States.

In 1905, the aesthetics of *Monos y monadas* can't be understood outside the cultural context that prevailed in those days: the milieu of modernism. As a cultural current, modernism was basically literary and graphic. French influence was welcome with great enthusiasm, as it was perceived as an alternative to Spanish tradition. On the other hand, art nouveau discovered Japanese drawing and, in terms of graphics, contours became priority. The master of the so-called "Belgian school" in Peru was the great draftsman Julio Málaga Grenet (1886–1963) (figure 7.1). Málaga Grenet not only immortalized the main politicians of the time in caricatures, but also, following a modernist aesthetic tradition, developed great experiments, one of which was *Metempsicosis* (Metamorphosis). Like poet and short-story author Abraham Valdelomar, Málaga based his style on the transformation of a person into an insect or animal (a change with a clear political motive).

Art critic Marta Barriga has pointed out that, generally speaking, during Mexican and Peruvian modernism, there was a very intimate connection between illustration and literature. This generational aesthetic proposal fostered the emergence of a first style for Peruvian comics, shared by magazines like *Fray Simplón* and *Fray K-bezón*, with an evident anticlerical bent. In this way, the emphasis on contours became a standard, which, with just a few

Figure 7.1 Julio Málaga Grenet's humor on a cover of the political weekly *Monos y monadas*.

strokes, engendered a caricature that, by way of convention, represented each Peruvian politician. Subsequently, by the late 1940s, graphic representation of politicians ceased exhibiting a natural size and became diminutive, pejoratively grotesque.

NATIONALISM, RACISM, AND *PERUANIDAD*

Once the modernist period concluded, Peruvian comics appeared sporadically in newspapers and magazines. The medium regained strength when graphic representations were envisioned as instruments that gave meaning to the country's transformation: the government became the protagonist of social development and integration, urban migration began having a massive character, and public education was expanded.

In Deborah Poole's book *Visión, raza y modernidad. Una economía visual del mundo andino de imágenes* (Vision, Race, and Modernity: A Visual Economy of The Andean Image World), we learn that Peruvian intellectuals and photographers only recreated the visual politics of race at the end of the nineteenth century and in the early twentieth century. Perhaps for this reason, unlike its politics, Peru's history took a while to define its iconography for texts for children. When illustrated magazines for children finally came out, they revealed a schoolbook aesthetics, which prevails to this day. They were not comics, but primitive *infographics*. This happened in the 1940s, while Peru was at war with Ecuador (1941), and the Axis powers battled the rest of the world. And this is how the subject of war landed in the first contemporary Peruvian comic (called *chiste* [joke] until twenty years ago), *Palomilla* (1940–1942). In Peru, *palomilla* (little dove) is an old word used to describe children who spend time in the streets playing pranks. It sounds funny when somebody says "¡*No seas palomilla*!" (Don't be a little dove!) to an adult who does something bad. This was the name of the first completely illustrated magazine with comics, literary adaptations, and historic illustrations. Most of its adventures seem to have been inspired by U.S. pulp fiction. Its main characters were not superheroes, but brave Caucasians who fought unusual battles in an ingenious manner, probably copied from characters that undoubtedly inspired the creation of Captain Sky. They were also children who, dressed as soldiers, fought in imaginary countries. Many authors have noted the impact of the war with Chile on Peruvians. The martial enthusiasm evident in *Palomilla* came not only from world militarism, but, above all, from the military victory of Peru over Ecuadorian troops. In turn, this was a political bonus for the national armed forces, contributing to social peace and the legitimacy of the existing Peruvian administration.

It is a cliché to emphasize that comics are a transcription of people's thought. They embody the different views of a particular society on how we express ourselves. The U.S. public, conscious that comics not only express ideas but transmit and publicize them as well, used this medium to incarnate ideas that were pleasing for its citizenry (comics on the conquest of the Far West are a paradigmatic example).

In Peru, the first ideological attempt involving comic strips was, regrettably, very basic. In 1952, General Odría's government, typified by its brutality and corruption in Mario Vargas Llosa's *Conversación en la catedral* (Conversation in The Cathedral, 1969), produced an odd nationalism that gave rise to the foundation of the daily *Última hora* (Current News). In this newspaper, there were comic strips that the U.S. government had designed specifically for the entertainment of its allies during World War II. These were in print until 1952, the year when, all of a sudden, it was decided that only national comic strips should be published. There is no concrete document to corroborate this, but, without a doubt, much consideration was given to the fact that "all" Peruvians should be represented in these texts (figure 7.2).

In this way, by 1952, there were characters like *Serrucho* (Mountain Hick), a farmer who had recently arrived to Lima and who, despite traditional outfits that made him look like a dim and unrefined fool, listened to mambo and went crazy for blondes; *Boquellanta* (Rubber Mouth), a blackface child also in love with a blonde, who lived with his mother, the repeated victim of his pranks and silliness; and *Sampietri*, which had been published as a comic strip for many years, with its reiterated depiction of the typically penniless pleasure-seeker, with a little Mexican-style moustache, chasing stunning, unreachable women like a madman. All these characters were described through degrading stereotypes. Nevertheless, two equally conventional heroes appeared during the same period, which at least transmitted a somewhat positive image: *Yasar del Amazonas*, by J. Vera Castillo, and Juan Santos, the leading character of *La cadena de oro* (The Golden Chain), by Rubén Osorio, considered the first Peruvian superhero. Using his golden chain as weapon and as a device to glide through Andean geography, Santos protected settlers and treasures from thieves. These characters suggested a starting point for the graphic representation of *peruanidad*. Despite the turmoil following Peru's first and only revolutionary attempt in 1968, their conventions prevailed.

For critical historians like Nelson Manrique, this was an unfinished revolution. As a consequence of the colonial hierarchical system, like other Andean countries, Peru is characterized by its exclusion of indigenous population, always exploited and abandoned in rural territories with little presence of the State. During the nineteenth century, the Amerindian question did not emerge until nationalist and positivist discourses were deeply rooted in educated groups (Denegri: 2004). Throughout the twentieth century, constant complaints about social inequalities consumed the attention of intellectuals and were portrayed as central issues for literature. However, those with political and economic power always assumed that this issue wasn't their problem—unless it could be used as fodder for electoral rhetoric. An agrarian reform, for example, was only imperative if the object was a modern country, without large landholders; however, the situation went unchanged for years. Finally, social pressure was channeled through military discourse. The military thought that, every so often, it was their duty to save Peru

Última hora. 1952.

nacional. Las tres fueron estructuradas con tres tiras divididas en dos o tres viñetas, con globos invasivos.

El espacio ganado en las revistas para la profesionalización de los dibujantes creó una oferta que pudo sustentar un trabajo diario, solo faltaba que algún periódico tomara la decisión. En 1952 en un "acto sin precedentes" como ha señalado Mario Lucioni, *Última hora* "despidió a todos los personajes de historietas extranjeras" (literalmente lo hizo jugando gráficamente a incluir personajes peruanos en ellas) y anunció el arribo de nuevas tiras cómicas, cada una a la búsqueda de una estética peruana proyectada hacia los diferentes integrantes de la familia: *Sampietri*, *Serrucho*, *Boquellanta*, *Cántate* algo, *Yasar del Amazonas* y *La cadena de oro*.

La inolvidable *Sampietri* de Julio Fairle utilizó casi siempre tres viñetas en una estructura reticular. Los dibujos estaban rellenos con tinta negra y acuarelada. Caricaturizó hombres y niños, mientras que las atractivas mujeres que Sampietri siempre intentó conquistar (pretensión trunca por el rechazo o la interrupción) tuvieron proporciones estilizadas, nunca jocosas. La "belleza" de Sampietri se debía a su pequeña nariz, contrapuesta a los gigantescos anexos que portaban sus congéneres, pero más importantes fueron aún su bigote y sus cejas (heredadas por su sobrino Puchito), dibujados con trazos de líneas exageradamente gruesas que de alguna forma expresaban su mentalidad: el pelo como signo masculino, que hizo de él un creyente de la estafa, seducción y abuso.

Serrucho de David Málaga estuvo dividida en cuatro viñetas, en las que su pequeñísimo protagonista, vestido siempre con poncho, chullo y ojotas, hacía alarde de su choledad: solo era indio típico para los turistas, prefería el mambo y a las mujeres blancas. Su ventaja, tener una velocidad inesperada para desplazarse digna de una cabra montes, o llama andina, escondida en

y así resaltar la importancia de la información por su invasivo tamaño. Similar estructura tuvo *Miguelito Campeón*, mientras que *Pepe Zeta* utilizó la estructura de las viñetas literarias. La caricaturización completa del personaje, de gran cabeza y cuerpo rechoncho, propia de *Moñito*, se presenta en las historietas que concluyen con mucho humor las travesuras de sus protagonistas en una sola página: *Guayacón*, un niño *blackface*, *El Canillita*, niño de tono picaresco, y el pobre *Tombo Camote*, quien nunca aprendió a comportarse como un policía peruano: ya se comportase honrado o corrupto, siempre perjudicaba al cuerpo

Figure 7.2 *Última hora* introduces an innovative project in the Peruvian comics industry: the graphic representation of difference.

from chaotic democracy. Nonetheless, they had been described regularly as leaders who supported the dominant sectors of society. This time around, that did not happen. In 1968, a social movement led by General Juan Velasco Alvarado organized a coup and the first thing that he did was to nationalize oil and implement land reform. It looked like a socialist reform, but its leaders did not consider themselves capitalists or communists. Eventually, government leadership imposed all sorts of transcendental changes, trying

to cover up the negative consequences of measures that, throughout their implementation, created substantial problems.

This was the first government to create an ideological campaign based on graphic material. Despite its good intentions, reforms were implemented through authoritarian means and therefore were very limited. Until the 1970s, while Velasco's military government (1968–1975) held control over the press, the specific graphic style sponsored by the State for the comic strips in newspapers was that of *Avanzada* (Vanguard). This particular style began in a magazine published by *Cruzada Eucarística Misional* (Eucharistic Missionary Crusade), a branch of the Catholic Church, and was the longest lasting *chiste* in Peru: since its cartoons were distributed directly in the class-rooms of religious and public schools, it ran for 15 years. This was a pub-lication with a highly polished style, though it never suggested alternatives to the aesthetics of Disney. Conventional cinema prevailed in its design of images and, considering the cautionary Catholic narratives that surfaced in its scripts, it represented a very traditional form of art.

Since the military government feared comics as a medium for capitalist ideological manipulation, this style was taken as safe and straightforward. On the other hand, given the years it had been used by Rubén Osorio and Hernán Bartra, it was recognized as a "national" style. Political propaganda in support of Velasco's government came out of the work of these two authors or the adoption of conventional realist aesthetics. Texts with potentially sub-liminal messages were not allowed, much less critical or subversive ones. *Peruanidad* continued being defined according to regional types, characters like a man from the coastal region named "Coco," in lieu of Jorge, a western name; "Vicuñín," a character from the mountains, basically a tribute to the mammal in the national coat of arms; and "Tacachito," named after *tacacho*, a traditional dish from the Peruvian Amazon.

It wasn't viable for these characters to hide the rivalry between political groups in a government that collapsed amid generalized disorder, caused by populist and liberal economic measures. In due course, Velasco turned ill and conflicts erupted. Eventually, led by Francisco Morales Bermúdez, the most conservative wing seized power. Bermúdez started a reversal of reforms and managed economic policy through a *paquetazo* (a reprehensible nick-name for the set of governmental measures that affected mostly the economy of popular sectors). Social pressure increased and historic nationwide strikes were organized, which even included the National Police. The result was a general call for a constitutional assembly. Bermúdez's government tried very hard to impose its liberal discourse and therefore pretended that it was promoting a democratic space. Taking advantage of the situation, *Monos y monadas* (1978) reappeared and devoted itself to criticizing the govern-ment with humor, embracing Bermúdez as one of its favorite characters. The magazine combined writers and cartoonists with the irreverence required to fight a government that, through a stern demeanor, tried to impress solemnity on its irresponsible political decisions. In addition, it revealed new political alliances popularized through the announcement of a return to

democracy, which, at the time, tried to delineate the rhetoric of new politi-
cal protagonists in Peru. Despite the failure of the *Gobierno Revolucionario
de las Fuerzas Armadas* (Revolutionary Government of the Armed Forces),
some relations of power managed to be redefined and some new spaces for
popular demands were generated.

JUAN ACEVEDO AND THE TRANSFORMATION
OF PERUVIAN COMICS

The context of reform and counterreformation, censorship, and apparent
freedom of speech seems to be an excellent breeding ground for political
humor. In all likelihood, it is a phenomenon of Western nature. As a matter
of fact, aside from personal disagreements, one of the reasons put forward as
the cause for the final crisis of *Monos y monadas* in 1980 was the return to
democracy.[1] In this magazine, Juan Acevedo found the necessary freedom
to draw. And his influences came from aesthetics emerging from a similar
context. As he points out, the authors who inspired his work were the car-
toonists from the Spanish publication *La Codorniz* (The Quail), famous for
its work during Franco's dictatorship. In other words, during these years
comics managed to break free from canonical U.S. conventions and real-
ist guidelines, which allowed them to explore a completely graphic kind of
humor. Though Peruvian comics follow an irregular tradition, the graphic
stereotypes enumerated thus far (*criollismo* or the ability to avoid norms, the
improvisation of political sectors, and racial/cultural representations) would
not be understood as defining elements of Peruvian comics were it not for
the fact that Acevedo used them as guiding principles for the break from and
creation of characters with an individual or universal nature—"typical ones,"
as Umberto Eco would call them.

Juan Acevedo was the first cartoonist to organize workshops on popular
comics in Ayacucho (1974) and Villa El Salvador (1975–1977). Ayacucho is the
poorest town in Peru, where the revolutionary group called *Sendero Luminoso*
(Shining Path), which sowed a tragic history of terror during its war against
the Peruvian State, emerged later on. Yet, before this happened, Ayacucho
was the focus of much intellectual interest, centered at the Universidad de
San Cristóbal de Huamanga and its Regional School of Fine Arts, directed
by Acevedo. Until this moment, there was no place to teach or popularize
the art of comics. In fact, illustrators who started producing comics profes-
sionally in the 1950s claimed that they had to abandon the School of Fine
Arts in Lima because they never found a space that allowed them to develop
their art. The case of Villa El Salvador is also very special. Since basic utili-
ties were precarious in nearly the entire country, a migration process started
in 1940, basically, from the *sierra* (the Andes) to Lima (Contreras y Cueto,
2000). Since they lacked any kind of support, these men and women invaded
the hills surrounding the city, and built small huts with mats and low-quality
materials. These settlements were called shantytowns till Velasco's govern-
ment labeled them *pueblos jóvenes* (young towns). This trend continues today;

huge numbers of people invade sandy areas in the middle of the desert and later struggle to receive basic utilities, like electricity and water. This is the way Villa El Salvador (1971) was born. However, in contrast to other young towns, in this place south of Lima, the population was willing to organize itself from the beginning and built an industrial park to develop microbusinesses. In the 1980s, this city received the Príncipe de Asturias Award as a model for development. This is where Acevedo starts the workshops that will later shape his book *Para hacer historietas* (To Make Comics, 1978)*:*

> Until that moment, some comics had already been created in centers that tried to increase access to knowledge on the inner workings of society, social issues, etc., which did not make good use of images, or used them improperly. They were bulky volumes, and access remained limited. In the workshops, we pondered images, worked with them, learned to love them, learned to use them, and, thanks to our experience, grew more convinced everyday that we would only gain complete access to criticism of established comics—through imagery—if we knew the language. In other words, it wasn't enough that some very intelligent men wrote books denouncing ideological propaganda through comics. People had to have access to this sort of knowledge to learn how ideological propaganda was disseminated and, what's even more important, to create their own comics. (Polar, 1988, p. 29)

This sort of support to blue-collar business is evident in *Luchín González*, a comic resulting from collaboration between CeaPaz, an institution that uses and promotes working-class comics, and organizations such as El Agustino and Villa El Salvador.

A critique of customs involves a point of view and a way of understanding what social aspects are reprehensible, which generates a feature representative of criticism through comics. But in Peruvian comics these critiques were limited to anecdotes, like the condemnation of middle-class vulgarity. *Costumbrismo* gave priority to the description of social practices, portrayed as negative as the result of its style of humor. In contrast, *Luchín Gonzalez* is a positive practice, in which the main character supports community mobilization. Luchín, its main character, is a high school senior who moonlights as journalist. He ignores what profession to follow, be it historian or artist, but his friends from the barrio, like Causita, the boy who washes cars for a living, connect him to stories from real Peru, in which people have to stick together to fight injustice caused by structural violence. For instance, its principal characters organize a march to get a tuberculosis patient admitted to the hospital. These are the spaces that give shape to Luchín's personality and turn him into a courageous and likeable character.

In *Luchín*, the attention to the representation of the street reveals an urban style of depiction, using signs, anonymous characters, and geometry. Colors (sepia, grey, white, and black) are reminiscent of the graphic scheme of classic Latin American comics. The dialogue between characters and abstract images allow Acevedo to omit legends and play with time, as in a single-day episode that ends months later, with extensive use of fables

and back-and-forth editing. Acevedo's aesthetics, also used in *Collera* (Chain Gang) and other texts, undoubtedly propose a reading of life in Peru, where children and teenagers learn in the street. His *costumbrismo* isn't just a positive vision of social habits, but, above all, in the replacement of gags with a literary plot: in this case, it's about narrating a learning experience, in which the adolescent hero discovers his place in social dynamics through witnessing or participating in one or more social practices. It's akin to a fortunate picaresque, conveying promise and possibility of a brighter future.

Acevedo's interpretation of daily routine allows him to incorporate new "Peruvian" characters into comics, given his total detachment from conventions typical of social homogenization. *Guachimán* (Guard) is a good example of a comic in which the styles of Eisner and Acevedo combine to offer a bungled narrative with a security guard as main character:

> The word *guachimán* is a Latin American version of the English word watchman (security guard). In the 1980s, Lima was full of *guachimanes*. They were seen not only at an exclusive club, a factory, or a mansion, but protecting every block of any middle-class neighborhood. Later, since there weren't enough guards, huge walls and fences with barbed wire were installed around every house in these neighborhoods. There was a generalized sense of danger. *Sendero Luminoso* would cut off electricity in the cities whenever it wanted, and bomb banks, police stations, and supermarkets. Police stations did not hire security guards (though I imagine they would have liked to), but they at least put speed bumps close by to guarantee cars would drive by slowly. Every day the newspapers announced tens of deaths, robberies, massacres, bombings, tortures, and kidnappings. Ironically, everyone accepted that democracy strengthened as time went by. *Guachimán* wasn't about this. The name just came from the label given to private policemen. (Acevedo, 1999, p. 184)

Acevedo uses monologues and bizarre imagery to describe the lonely night adventures of *Guachimán*. The blending of superhero antics (since he was able to fly) and the uncanny, proper of fantastic literature, pays special tribute to a new member of Lima's society.

Though Acevedo explores many intricate styles and topics to convey Peru's reality and history, like the rest of Peruvian comics, when it comes to politics, humor has been his most usual tool. In 1978, with the rebirth of *Monos y monadas*, politicians returned to comics. Acevedo surprised readers with *Love Story* (1978), one of the funniest accounts of national politics. In a way, the string of political alliances and breakups of the time replicated a soap opera perfectly. Thanks to a bit of drag, grotesque, and shadow play, Acevedo's version of national politics was a hilarious text. In a way, this mix, as eclectic as the Chinese cuisine in Lima, was an ideal match for Peruvian taste. On that same year, though, Acevedo's humor attained one of its most personal expressions with *Pobre Diablo* (1978), a comic in which he tried to defy stereotypes; perhaps it was for this very reason that, throughout its production, characters and styles changed from issue to issue, making it very hard to describe (figure 7.3).

Figure 7.3 Juan Acevedo experiments extensively with Peruvian comics in his project *Pobre Diablo*.

To understand the importance of the change signified by this work, we must remember another of Juan Acevedo's influences: the reflections of author José Carlos Mariátegui on human and Peruvian condition. In his essays on Peruvian reality, the insightful Mariátegui yearns for cosmopolitan influence in Peruvian literature, i.e., contact with discourses that went beyond empty nationalisms. Mariátegui's support to literary and graphic experimentation came together in the magazine *Amauta* (1926–1930). In this periodical, he published articles that later became part of *El alma matinal* (The Morning Soul) and *El artista y la época* (The Artist and His Times), two texts that are essential for the understanding of the relationship between art and ideology in Acevedo's work. Hence, *Pobre Diablo* embodies the thirst for a quest to avoid stereotypes of our habits and, at the same time, captures the existential feeling of a generation besieged by urban anxiety. At times, *Pobre Diablo* goes even further, since it abandons the narrative discourse of its images and instead favors a poetic anti-discourse.

> I first thought about it in 1977 and, a year later, it was published in *Monos y monadas*. Pobre Diablo wanted to be a hero from daily life, often mediocre, like the average guy. Once he realized the odds against him, Pobre Diablo emerged as a great super ego: like Marx, Superman, Jesus…The idea was appealing, but, as time went on, I dropped it. Other Pobre Diablos came into view, the social critics, the existential ones, the loving ones, etc. I had the dream of working without guidelines, according to however I felt at the end of the week…Many people would ask me what was it with Pobre Diablo. These are my most intimate comics. I trust the reader and do not hide a thing: I digress, celebrate, grumble, and turn foolish, brilliant, righteous, prejudiced. (Acevedo, 1999, p. 184)

In addition, the close relationship between literature and the manufacturing of characters with an individual and universal nature (like those Eco labels typical) is evident in the comic adaptation that Acevedo made of *Paco Yunque*, a 1931 short story by poet César Vallejo.

In 1978, when *Monos y monadas* brought together authors who began working in different media, the so-called *nueva historieta peruana* (new Peruvian comics) was born. It targeted adult readers with a critical vein, fans of high and pop culture with a playful and mischievous streak. Thanks to sponsors like Nicolás Yerovi, who gave a certain air of freedom to the movement, it explored many different forms of expression. Acevedo's main contribution to *nueva historieta* lies in his literary connections, such as his ties with the picaresque and the uncanny, his break from conventional characters, and his poetic anti-discourse. Yet, it was only after the dissolution of *Monos y monadas*, the founding group, when Juan worked as an editor for the magazine *No*, a humorous Sunday supplement for the magazine *Sí*, that he got involved in the publication of *Anotherman*. This

was a graphic novel that, upon considering literary traditions, should be regarded as an exceptional case, given its proposals for Peruvian literary topics:

> This is my longest *Pobre Diablo*. It was published in 1985 and 1986 in the magazine *El Idiota* (The Idiot). It is my first masked character. Although his facial features cannot be distinguished because his head is shaved and he is wearing dark glasses, he reminds us a bit of *Oratemán*. But *Anotherman* is quieter, almost mystical, and he is not looking for the great love of his life, but for justice, and, as a result, he descends to hell and confronts the Devil. (Acevedo, 1999, p. 185) (figure 7.4)

While *Anotherman* descends to hell, the Devil forces him to undergo a series of tests proper of archetypal superheroes. In this case, the idealized woman is also a trap, an Eve from hell, but she is also the woman with whom he starts a classic search for himself, in the context of justice emphasized by Acevedo. The awareness of an epic saga hints at many ways to understand the piece: Dante Alighieri's text, an evident source of intertextuality, suggests a reading allusive of a greater vision of hell, tinged by mystical details proper of *ayahuasca* rituals and spiritual searches. On the other hand, epic journeys like Odysseus's suggest a search for identity—by definition, a sort of Peruvian utopia.

A topic that pervades Peruvian literature is the portrayal of identity based on the father image. Since the times of the Inca Garcilaso de la Vega, architect of Peruvian literature, illegitimacy has been considered a literary topic. In his *Comentarios*, De la Vega, the son of a Spanish captain and a noble Inca, narrates how his father was forced to marry a Spanish woman and how conquistador Gonzalo Pizarro sought a kingdom in Peru. When De la Vega traveled to Spain, his claim to a share of his father's fortune was rejected, so he started writing and eventually became a distinguished author. Following this incident, the fact that he changed his given name, Gómez Suárez de Figueroa, to Inca Garcilaso, shows an effort to assimilate his dual roots. During the twentieth century, the topic of abandoned rural children fathered by white men who abused indigenous Peruvian women dominated *indigenista* texts. Within this context, this lack of fatherly recognition is just a minimal indication of a greater injustice: it shows how a small sector of Peru has turned its back on the vast majority of the population.

In the mid-twentieth century, renowned author José María Arguedas set out to end the lack of appreciation for indigenous Peruvians, not just in economic terms, but, above all, from a cultural perspective. Due to political reasons, Arguedas's father, a lawyer from the city of Cuzco, had to move constantly. As a result, he left the young boy with his stepmother in Apurímac. The stepmother, a woman with great power, sent the boy to live with Indians. They then raised Arguedas, inspiring a love so great that

Figure 7.4 *Anotherman* is the first graphic novel to take up the subject of Peruvian identity, a constant in Acevedo's work.

he suffered for not being one of them. In *Todas las sangres* (1964), perhaps Arguedas's most ambitious novel, the main character is a landowner who leaves his Indian lover and child—whom he has publicly declared his only heir—in the hands of his foreman, going to fight for the rights of Indians. This is a story that foretells change. In a later example, Zavalita, the main character of *Conversación en la catedral* discovers that his father is a repulsive and corrupt human being. However, he only discovers this later on in life. When *Anotherman* (1986–1999) arrives at the Devil's barracks, which resemble the ones used during the war between *Sendero Luminoso* and the Peruvian government, he discovers that the Devil is his father. At this point, it is the son who rejects the father.

This kind of fiction, in which main characters represent regions, races, and personal interests, allow the reader to view the bond with the father as a relationship with the homeland or State. In this case, we see how in Peru, following the democratization process that took place after Velasco's government, there was a conscious rejection of corrupt and speculative institutionalization. It is only through literary dialogue that we're able to understand narratives proposed by Acevedo to deal with the change in attitude originating from the country's secular split.

> At a first level, as creator, I also have a proposal with many sides; there is one that's closer to comics, which tries to rescue images in which the reader may recognize himself here in Peru, which has to do with our surroundings, with the events that took place, as much as with psychology, environment, ways of talking, etc., a series of images proposed so that we can recognize ourselves. There, the project is to look for images that allow us to accept our national identity, to search for a national comic. (Polar, 1988, p. 28)

Juan Acevedo's main contribution to Peruvian comics is his sensibility. Maybe it is the only reason for the big change that his work represents for the graphic representation of Peru. Throughout this article, I have stated that the formal presence of literature in Acevedo's work (narrative genres, diverse kinds of fiction, characterization of literary characters, and topics) gives comics a type of writing that transforms their space in a radical way. At the same time, it establishes dialogues that require more authorial conventions than stereotypes. However, it also embodies an admission that Acevedo is aware of the traits that have characterized Peruvian comics (social practices, politics, and identity) and redefines them in his search for national comics.

CODA

In 1999, Acevedo published an anthology titled *Pobre Diablo y otros cuentos* (Poor Devil and Other Stories). *La historia de Latinoamérica desde los niños*

(Latin America's History from The Children's Perspective) remains, until today, his biggest and most ambitious project. It seems like Acevedo, also renowned as author of the comic strip *El Cuy* (Guinea Pig), has returned to his old ways. (figure 7.5)

At this point in time, a publication titled *CRASHBOOMZAP* is one of the most obstinate countercultural projects in comics in Lima. Its twelfth issue pays homage to the various aesthetic influences in contemporary national comics. Within this selection, a key element is Acevedo's *Publicherry* (term used in Peru to designate a promotional plug), which evolved from a column into comics, with some of the advertising narrative illustrated with small iconography. CRASHBOOMZAP's director, simply known as Cherman, embraces this text's structure and, alluding to Acevedo, transforms it into an extensive, profound argument, attesting to the author's importance in the context of Peruvian comics. (figure 7.6)

Figure 7.5 Many Peruvians identify Acevedo as "the Cuy's author," given that the character reflects well his political opinions.

Figure 7.6 The underground comic rehashes national iconography through its critique of language.

NOTE

1 Nicolás Yerovi, the grandson of the founder of the 1905 version, continued publishing and distributing the magazine *Monos y monadas* until the end of the 1990s. It never reached the level attained by the original 1978 team in other magazines.

WORKS CITED

Acevedo, Juan. *Pobre Diablo y otros cuentos.* Lima: Francisco Campodónico Editor, 1999.

———. *Luchín González.* No. 2. Lima: Ceapaz, Julio, 1989.

———. *Paco Yunque. Historieta basada en el cuento de César Vallejo.* 6th edition. Lima: TAREA, 1988.

Antología. Humor gráfico español del siglo XX. Prólogo de Álvaro de Laiglesia. Madrid: Salvat, 1970.

Barriga, Martha. Ponencia presentada en *Espacios y discursos compartidos en la literatura de América Latina.* Actas del I Coloquio del Comité de Estudios Latinoamericanos. Asociación Internacional de Literatura Comparada, 2004.

Barthes, Roland. *La torre Eiffel: textos sobre la imagen.* Barcelona: Paidós, 2001.

Cherman. *CRASHBOOMZAP* No. 12. Lima: Tumay Komiks, 2003.

Cornejo Polar, Jorge. *El costumbrismo en el Perú: estudio y antología de cuadros de costumbres.* Lima: Copé, 2001.

Durand Flórez, Ricardo (director). *Avanzada.* Lima: Cruzada Eucarística Misional, 1961.

Mariátegui, José Carlos. *7 ensayos de interpretación de la realidad peruana.* 47 edition. Lima: Biblioteca Amauta, 1984.

Polar, Julio (director). *Búmm! Revista bimestral de historietas, humor y literatura.* Año 1, N° 2, april 1988.

Poole, Deborah. *Visión, raza y modernidad. Una economía visual del mundo andino de imágenes.* Lima: Sur, 2000.

Yerovi, Nicolás (director). Revista *Monos y monadas.* Lima, 1978–1979.

Brazilian Comics: Origin, Development, and Future Trends

Waldomiro Vergueiro

Brazilian comics have experienced a very idiosyncratic development. In the beginning, they received influences from different parts of the world: initially, from European humor and children's magazines, and later on, from U.S. comic books. More recently, the influence of Japanese *manga* on Brazilian comics has been strong. However, aside from any cultural influence, it is also important to consider the significance of international economic contingence when alluding to comics in Latin American countries. Besides being a graphic art, comics are a communicative medium, part of a huge mass market with ramifications all around the world and closely related to other media. To a considerable extent, the history of comics in Brazil is a permanent struggle between the cartoonists' needs to express themselves by means of the language of comics and the impositions of the modern entertainment industry, whose main object is the maximization of immediate profit.

This text proposes a brief review of the history of Brazilian comics. Though it is as exhaustive as possible—considering the brevity of these pages—it does not claim the exclusive authority to define the world of Brazilian comics, a field as large and complex as the nation in which it originates. This caveat, which defines the incomplete nature of any historical narrative, should be taken into account vigilantly.

THE BEGINNING OF COMICS IN BRAZIL, BY AN ITALIAN'S HANDS: ANGELO AGOSTINI AND *O TICO-TICO*, THE FIRST BRAZILIAN COMICS MAGAZINE

At the origins of Brazilian comics, one name cannot be forgotten: Angelo Agostini, an Italian who lived most of his life in Brazilian lands (Gaumer, 2002) (figure 8.1). He was the precursor of comic art in the country, and

Figure 8.1 Zé Caipora, illustrated by Angelo Agostini. *Zé Caipora* © Angelo Agostini.

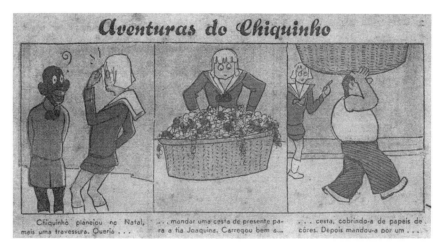

Figure 8.2 Chiquinho, illustrated by a Brazilian author, published in the comic book *OTico-Tico* in 1939.

his art is compared to his contemporaries Töpffer, Busch, Swinnerton, and Colomb. Although he did not use balloons, Agostini dominated superbly the technique of narrating a story with images. Many Brazilian comic scholars consider his graphic work *As Aventuras de Nhô Quim, ou Impressões de uma Viagem à Corte* (The adventures of Nhô Quim, or Impressions of A Journey to The Capital of The Empire), which was published in the newspaper *Vida Fluminense* (Fluminense Life) since 1869, to be the first comic story published in Brazil. Agostini produced many other graphic narratives during more than 30 years of work as cartoonist and was considered a model for all those who followed him (Cirne, 1990).

Angelo Agostini was also responsible for drawing the title design for the first Brazilian magazine to publish comics regularly in Brazil at the start of the twentieth century (Lago, 2001). This magazine, called *O Tico-Tico* (named both after a very common Brazilian bird and a Brazilian kindergarten school of the time, called the *Tico-Tico School*), was published from 1905 to 1960. Designed in the European style, it brought to Brazilian readers many of the U.S. comic characters of the early twentieth century.

Chiquinho was *O Tico-Tico*'s most famous character (figure 8.2). Although readers imagined that he was an originally Brazilian creation, in fact, the character was born in the United States. Few readers knew about this at that time, but Chiquinho's real name was Buster Brown, the mischievous boy created in 1902 by one of the pioneers of the ninth art, the North American Richard Felton Outcault. Curiously, Chiquinho, besides becoming a constant presence in the Brazilian magazine, was included in *O Tico-Tico*'s pages until the mid 1950s, decades after Buster Brown's disappearance from U.S. newspapers. Several local artists who created adventures and other companions for him, such as the Afro-Brazilian boy Benjamin, produced the Brazilian magazine *Chiquinho*. Some of the artists responsible for Chiquinho's adventures

in Brazil were Loureiro, A. Rocha, Alfredo Storni, Paulo Affonso, Osvaldo Storni, and Miguel Hochman.

Furthermore, the magazine *O Tico-Tico* made possible the dissemination of other comics stories in Brazil, many of them produced by native authors and published for years, representing an abundance of narratives of which Brazilians can be proud. Some of the characters created by Brazilian authors for *O Tico-Tico* are Luis Sá's Reco-Reco, Bolão, and Azeitona, three boys who were also used to advertise many products during the 1950s and 1960s; Bolinha and Bolonha, two fuzzy characters, probably based on artists like Stan Laurel and Oliver Hardy; Zé Macaco and Faustina, by Alfredo Storni, a hilarious married couple, similar to many others in comics of this period, and Kaximbown and Barão de Rapapé, by Max Yantok, another amusing comic strip.

In its 56 years of existence, *O Tico-Tico* introduced the work of many Brazilian authors, like Fragusto, Cícero Valladares, Heitor, Luís Gonzaga, Leopoldo, Therson Santos, Aloysio, Messias de Mello, Justinus, Regina, Darcy, Percy Deane, Joaquim Souza, and Daniel, among others (Moya, 1970:202). It was not the only comics publication created in the early twentieth century in Brazil, but its popularity and longevity surpassed all its contemporaries, like the magazines *Juquinha*, *Guri*, and *Cômico*, making it dearly remembered by all its readers.

The Arrival of U.S. Comics to Brazil: A Gazetinha and Suplemento Juvenil

Although *Chiquinho*'s popularity among Brazilians can be seen, from a certain perspective, as the introduction of U.S. comics characters into the country, it can also be considered a relatively isolated event: the mischievous boy was accompanied by few other foreign characters, also published in *O Tico-Tico*. In fact, the actual "invasion" from the United States happened in the first half of the 1930s, with two publications related to daily newspapers in São Paulo and Rio de Janeiro.

In São Paulo, the newspaper *A Gazeta* (The Gazette) started publishing a children's supplement in September 1929, soon called *A Gazetinha* (The Little Gazette), which was initially published once a week, and later on, twice and thrice a week. During its first period of publication, from 1929 to 1930, it showed a few U.S. comics, the most important certainly being *Little Nemo in Slumberland*, by Winsor McCay. However, in its second and most productive period, from 1933 to 1940, *A Gazetinha* published many foreign comic strips soon after their appearance in foreign newspapers or comic books. Aside from U.S. comics, *A Gazetinha* published many Brazilian authors, like Nino Borges, Zaé Jr., Sammarco, Messias de Melo, and Jayme Cortez. These last two authors were the most prominent Brazilian creators working for *A Gazetinha*.

Manoel Messias de Mello was a prolific artist, drawing comics in almost any style and on any subject. He produced a great variety of comics and

hundreds of illustrations for *A Gazetinha*, from 1934 to 1950. Many of his stories imitated foreign productions, but others had a distinctive appeal, dealing with facts of Brazilian history, like the series *Perdidos no Igapó* (Lost in The Igapó) and *História do Brazil* (Brazilian History). He was perhaps the most prolific Brazilian cartoonist in the first half of the twentieth century, authoring science fiction comics like *Audax, O Demolidor* (Audax, The Demolisher), humor series like *O Pão Duro* (The Miser), action series like *O Capitão Blood* (Captain Blood), *Sherlock Holmes e a Prisioneira do Subterrâneo* (Sherlock Holmes and The Prisoner in The Underground), and *Os Três Mosqueteiros* (The Three Musketeers), each based on characters from world literature, and *Dick Peter*, a private detective, originally created by Jerônimo Monteiro for a radio series.

Jayme Cortez was, in fact, born in Portugal. Still, his work influenced Brazilian comics greatly; several of his contributions will be listed later in this text. In 1948, shortly after his arrival in Brazil, he joined the team of *A Gazetinha*. Initially, he was responsible for a magnificent comic adaptation of a great classic of Brazilian romanticism, the novel *O Guarani* (The Guarani), by José de Alencar, published in the newspaper *Diário da Noite* (Nightly Newspaper). He also brought along some experience, having worked in the publication *O Mosquito* in his homeland. Soon after his arrival, he became the mentor for all cartoonists working at *A Gazetinha*, where he popularized the use of live models to draw comics.

Though these are only two authors among the many who contributed to this publication, which played an eminent role in the history of Brazilian comics, they certainly rank among its most noteworthy. Following a brief interruption during World War II, *A Gazetinha* returned to the newsstands. It was published until the 1950s, when it was discontinued. Its role as the predecessor of a trend, the arrival of U.S. comics to the country, hints at the early nature of international communication in the field of Brazilian comics.

In point of fact, if popular acceptance is the most important indication of the success of a comics publication, March 14, 1934 stands as the crucial moment for the popularization of U.S. comics in Brazil. On this date, a publication called *Suplemento Juvenil* was released in Rio de Janeiro, as part of a project by journalist Adolfo Aizen, who had spent some time in the United States. There, he became acquainted with the customary model of colored supplements (the "funnies") in many newspapers. Returning to Brazil, Aizen imagined that this model could be easily adapted to tropical lands and made a proposal to the directors of the newspaper *A Nação* (The Nation), regarding the publication of several supplements. The directors of the newspaper were sympathetic to his proposal and soon included several supplements with their newspaper. The supplement directed at children had the highest acceptance, quickly becoming an independent publication in itself.

Initially called *Suplemento Infantil* (The Children's Supplement), the publication's name changed swiftly to *Suplemento Juvenil* (The Young

Adult's Supplement), in a hurried effort to increase its market. From this early moment, it became evident that comics were not just for children. The publication included all the main U.S. comics characters of its time, such as *Mandrake, Flash Gordon, Tarzan, Dick Tracy, Prince Valiant, Secret Agent X-9, Jungle Jim*, and *Mickey Mouse*, and promptly became a great surprise in terms of circulation. Due to its national distribution—in contrast to *A Gazetinha*, which was distributed almost exclusively in São Paulo—this publication made possible the acquaintance of Brazilian readers with the most popular comics published at the time in the United States. In this sense, its national scope brought about an enormous shift in reading habits.

The success of *Suplemento Juvenil* was remarkable and immediate. It was soon published independently from the newspaper, at a rate of three times per week. Besides comics, *Suplemento Juvenil* also included educational or cultural articles, like the series *Aprender a aprender ou como estuda o Rabedéco* (Learning How to Learn or How Rabedéco Studies), in which a boy called Rabedéco shared practical advice on ways to study with his friends and told them about the things he learned during his classes at school (Silva, 2003). Hence, it is important to consider this publication's great contribution as a pedagogic tool for the Brazilian masses.

Another significant contribution of *Suplemento Juvenil* to the popularization of comics in Brazil was the possibility that it offered Brazilian authors. Adolfo Aizen, the editor of *Suplemento Juvenil*, was an entrepreneur like very few others in the Brazilian press. Showing an unusual degree of concern for local content, he was very conscious of granting an opportunity in his publication to many Brazilian artists. For example, J. Carlos, a very successful artist during the first half of the twentieth century in Brazil, who would later become a legend in newspapers, drew the first cover for *Suplemento Juvenil*. In fact, many local authors were able to publish their first major stories within its pages. Collaboration between native authors and *Suplemento* began from the very start of the publication. Its first issue, for example, included a story titled "*Os Exploradores da Atlântida ou As Aventuras de Roberto Sorocaba*" (The Explorers of Atlantis or The Adventures of Roberto Sorocaba), by Monteiro Filho, who emulated the comic strips distributed by U.S. syndicates. Other Brazilian titles published in *Suplemento* were Renato Silva's "*Nick Carter versus o Fantasma Negro*" (Nick Carter versus the Black Phantom); Carlos Arthur Thiré's "*Rafles*"; and Fernando Dias da Silva's "*O enigma das pedras vermelhas*" (The Mystery of The Red Stones), to mention just a few authors who benefited from this early opportunity for local content (Moya, 1970: 203–204; Silva, 2003: 43–44).

As a result of *Suplemento Juvenil*'s success, other comics for children were soon released into a developing national market, contributing to the steady popularization of U.S. comics among Brazilian readers. The most prominent of these publications was *O Globo Juvenil* (The Young Adult's Globe), published by the newspaper *O Globo* (The Globe), from Rio de Janeiro. Characters like *L'il Abner, Alley Oop, Abbie an'Slats, Don Dixon*, etc. were included in this publication.

The competition for the national comics market intensified. Each publication tried to present characters sympathetic to readers, creating very aggressive marketing campaigns. The market's competitive conditions also originated a great variety of publications. This was good for readers, as news from this period can attest: "*Suplemento* released another magazine published on Wednesdays, Fridays, and Sundays in a tabloid format, *Mirim*, soon imitated by Globo with *Gibi*, which later became *Gibi Mensal* with full-length stories" (Moya, 1970: 205). Created in 1939, the comic book *Gibi* became so popular in Brazil that the word became a synonym for comic books, a practice still used today.

In 1939, in a yet somewhat obscure commercial arrangement, most of the characters published by *Suplemento* were transferred to *O Globo Juvenil*. After this agreement, *Suplemento*'s roster of characters was weakened considerably, with few remaining staples, like *Tarzan, Terry and the Pirates*, and *Dick Tracy* (Silva, 2003: 29). As a result, it lost a great deal of its appeal to readers. This change brought along a crisis for *Suplemento*, from which it never recovered. It ceased publication around the end of World War II, in 1945.

With the closing of *Suplemento Juvenil*, one may say that a new period began in the Brazilian comics market, as the first publishing houses specializing in comics emerged soon after this failure. These publishing houses were located mainly in the most developed states of southeastern Brazil, a situation that prevails till today. However, through their work, they made comic books very popular among Brazilian kids and, in this way, little by little, a national comics industry became established. Although a great percentage of the production of comics by Brazilian publishing houses was restricted to foreign content, these publishers also introduced many national publications. Thus, they contributed to the discovery of many cartoonists who became masters for new generations of Brazilian comics authors. Along the way, they facilitated the appreciation of their main thematic lines.

The Development of Brazilian Comic Art: Brazilian Comics in the 1950s and 1960s

Following the previous review, it is easy to conclude that Brazil has a long tradition when it comes to the publishing and reading of comics. In 1951, a group of young and idealistic Brazilian authors organized the First International Comics Exposition in São Paulo, including original art from the most important names of the time (Moya, 1970, 2001). However, notwithstanding the popularity of the art of comics in this country, the predominance of U.S. comics products has, in many ways, embodied great obstacles for the survival of Brazilian comics authors and comics art itself. This has happened principally because most of the narratives of U.S. comics deal with global matters, with few cultural barriers for their acceptance and dissemination throughout other countries. Economic factors have also favored their predominance in Brazil, as they arrived here partially paid for in their

country of origin. Additionally, they frequently benefited from advertising and promotional schemes created and disseminated to popularize new characters among the Brazilian public, even before the arrival of actual comic books to the newsstands (Vergueiro, 1999b).

Although foreign production has enabled contact between a great number of Brazilians—from their early childhood—and comics, it also signified barriers for the establishment of local comics. Though many readers dreamed of becoming future producers of comics, the predominance of foreign characters in the market jeopardized the fulfillment of these dreams. Many young artists just gave up and directed their attention at other arts. On the other hand, the history of comics in Brazil also shows that many prospective authors have persisted in their objective and succeeded in writing and drawing comics, creating a unique variety of comic art. They can be found in any genre and directed at any segment of readers, from horror to underground comics, from children to adults.

After the establishment of the main publishing houses in Brazil, comics seemed to be a promising field for investment. Many small companies appeared, trying to find their place in a growing market. In São Paulo, during the 1950s and 1960s, several small publishers were responsible for a plethora of titles created mostly by Brazilian authors. Publishing houses like Editora Outubro, Editora Continental, Editora Triestre, Editora Edrel, Editora La Selva, and others were very important for the development of Brazilian comics, as they enabled many local artists to work in comics for a long time.

The biggest publishers were companies like EBAL and RGE, from Rio de Janeiro. While they concentrated their production on comics from other countries, principally U.S. superheroes, small publishing houses could publish almost any kind or genre of comic books. During the 1950s and 1960s, for example, small presses published many characters related to the world of entertainment in Brazil, all created by Brazilian artists. Most of their comic books were in black and white, with simple drawings and clear-cut adventures. Notwithstanding their naïveté, though, artists like João Batista Queiroz (*Oscarito e Grande Otelo*, *Cacareco*, etc.) and Gedeone Malagola (*Juju Faísca*) had the opportunity to develop their expertise by working in comics with subjects closer to their own social environment.

Horror comics were the most popular genre of comics in Brazil during the 1950s. To begin with, the popularity of horror comics in the country is connected with the publication of the comic book *Terror Negro* (Black Terror), by Editora La Selva, which began publishing the stories written by Jerry Robinson for his superhero character *Black Terror*. After the character was discontinued in its country of origin, the local publisher decided to change the subject of the comic book to original horror stories. As a result, U.S. horror stories—principally from publishers like EC and DC Comics—were published in *Terror Negro* and other titles of Editora La Selva, soon becoming favorites. Noting the success of *Terror Negro*, other publishers started launching their own titles, frequently resorting to Brazilian artists. In this way, a different kind of horror story was gradually established, focusing on

popular legends and narratives from Brazilian culture. Thus, Brazilian horror comics began representing folkloric characters like *Boitatá* (The Snake of Fire), *Negrinho do Pastoreio* (The Little Black Shepherd), *Cuca* (The Old Lady), *Curupira* (The Spirit of Wood) and *Iara* (The Mother of Water).

In general, due to a realistic drawing style and the clever, distinctive treatment of supernatural subjects, readers appreciated horror comic stories by Brazilian authors. From the beginning, Brazilian horror stories seemed very different from their U.S. counterparts. They did not rely on bloody representations or the reproduction of physically menacing situations, involving death or torture, to captivate readers. Brazilian horror stories explored a more psychological kind of terror, the ambivalence of the supernatural world, and the never-ending uncertainty present in relationship between human beings and unknown supernatural forces. Black and white publications were prevalent in Brazilian horror comics, contributing to the general atmosphere of existential doubt and obscure fear evident in such publications.

In a short period of time, due to their work in this genre and the quality of their art, several Brazilian authors became famous and admired by readers. Some of the most relevant names among them, which include the paramount representatives of the genre, are Júlio Shimamoto, Aylton Thomas, Getúlio Delphin, Flávio Colin, Lyrio Aragão, Nico Rosso, Luíz Saidenberg, Monteiro Filho, Mozart Couto, Rodolfo Zalla, Rodval Matias, and Jayme Cortez. As mentioned previously, the latter cartoonist can be considered the most important figure within the group. Aside from drawing, he has also worked as art director for Editora Outubro in São Paulo, coordinating the publication of several horror comic books.

When it comes to Brazilian horror comics, it is also important to emphasize the special contribution that many writers were able to bring to these stories. Unlike other Brazilian comics genres, in horror stories, it was much more common to have professional writers working exclusively in the elaboration of storylines, while others illustrated. Thanks to this practice, scriptwriters were able to achieve a thorough command over all the peculiarities of the genre. Thus, stories became more and more interesting as time went by. The names of Rubens Francisco Lucchetti and Gedeone Malagola, probably the two best and most prolific writers who ever worked on Brazilian comics, should not be forgotten in this instance. During their work with artist Nico Rosso, they were responsible for many of the best horror stories ever published in the country (figure 8.3).

Rubens Francisco Luccheti was a very active author, writing more than 3,000 comics stories during his professional life, in addition to short stories and pocket books (Lucchetti, 2001). In the two comic book series that he elaborated in collaboration with Nico Rosso—*Cripta* (Cript), published by Editora Taika in the late 1960s, and *O Estranho Mundo de Zé do Caixão* (The Strange World of Joe Coffin), published by Editora Prelúdio in the 1970s—he was able to introduce a new dimension to horror comics in Brazil, bringing social concerns that were a direct answer to the political panorama

Figure 8.3 Morgadinha dos Canaviais, illustrated by Nico Rosso in the comic book *Ediçao Maravilhosa*. *Morgandinha dos Canaviais* © Nico Rosso. Courtesy of the author's heirs.

of the period. Moreover, his work offered a broad view of Latin American society, marked by poverty, inequality, and degradation.

Another very prolific writer was Gedeone Malagola, having produced more than 1500 stories during his long career. Malagola was a follower of a classic approach to horror comics, favoring stories that presented characters from popular literature, like werewolves, mummies, vampires, and Frankenstein. His series on *Lobisomem* (Werewolf), illustrated by Nico Rosso and published during the 1960s by Editora Outubro, was very popular among readers. Rosso's drawings, with their tri-dimensional angles, perfect anatomic proportions, rigorous research of the European landscape, as well as his impeccable talent as an inker, transformed Malagola's *Lobisomem* into one of the masterpieces of Brazilian horror comics.

The golden age of Brazilian horror comic books is probably limited to the 1950s and 1960s. Unfortunately, with the growing popularity of U.S. superheroes, readers gradually abandoned the genre and all titles were discontinued. Editora D'Arte in São Paulo, directed by the artist Rodolfo Zalla, published the last regular horror comic books in the 1980s: the titles *Mestres do Terror* (Masters of Horror) and *Calafrio* (Fear). By the early 1990s, these publications had been discontinued.

On the other hand, though they may be blamed for endangering the publication of horror comics and other genres in Brazil, U.S. characters—for the most part, superheroes—can also be identified as directly responsible for the advent of another particular genre of comics, Brazilian superheroes, which for a time represented a profitable section of the market. As comics became popular in Brazil and readers became acquainted with the adventures of *Flash Gordon*, *Terry*, *Dick Tracy*, *Prince Valiant*, *Tarzan*, and so many others, it was natural for local publishers to look for characters similar to those already popularized by comics, which could resemble Brazilians and their culture more closely. In this way, they hoped that a more familiar environment would attract readers more effectively.

One of the first adventure comics produced by Brazilian authors was devoted to the character *Garra Cinzenta* (*Gray Claw*), created by Francisco Armond (text) and Renato Silva (drawings) for the previously mentioned *A Gazetinha* in São Paulo. A mix of horror and police comic, it introduced an evil character who announced the death of his enemies by sending them a card with the picture of a shriveled hand (*A Garra Cinzenta*, 2003). For the same publication, Messias de Mello illustrated *Audax, O Demolidor* (Audax, The Demolisher), about a gigantic robot, originally created abroad.

Another of the first adventure stories in Brazil was *Dick Peter*, a private detective, originally created by Jeronimo Monteiro for radio soap operas and transcribed to comics by Abilio Correa (in daily strips) and by Syllas Roberg and Jayme Cortez (in comic books). The character *O Anjo* (The Angel), another popular title of the 1950s, also came out of radio. It was the successful brainchild of Moyses Weltman; first illustrated by Flávio Colin, it was sketched later by Getulio Delphin. Colin was also the hand behind the comic adaptation of *O Vigilante Rodoviário* (The Road Cop), a very popular TV

series from the 1960s. He was a fine artist, with a distinctive line, who illustrated many horror stories and worked in comics for over 30 years. Likewise, Delphin worked in *Aba Larga* (Broad Brimmed), a comic book about a group of adventurers in southern Brazil.

Regional local identities also had implications for the design of comics and their narratives. Many adventure comics tried to situate heroes in rural environments, replicating the conditions of less developed Brazilian regions. The adventures of *Sérgio Amazonas*, by Jayme Cortez; *Jerônimo*, by Edmundo Rodrigues; and *Raimundo Cangaceiro*, by José Lanzelotti, correspondingly set in the Amazon, Minas Gerais, and northeastern Brazil, had this kind of regional appeal. In general, Brazilian adventure comics were very naïve in terms of their thematic proposal. Most of them tried to emulate foreign comics, reproducing their styles and *raison d'être* to empathize with readers and bring them the kind of comics they found familiar.

The same line of reasoning applied to superhero comics produced in Brazil during the 1960s. To them, U.S. superheroes were more than a mere inspiration: they were their main source of ideas and projects. Although some Brazilian superheroes originated in TV series and advertising—like *Capitão 7* (Captain 7), adapted to comics by Getulio Delphin and Oswaldo Talo, and *Capitão Estrela* (Captain Star), by Juarez Odilon—most of them emerged directly from U.S. production. Brazilian publishers would usually obtain comic books from the foreign market and ask artists to adapt them to a Brazilian setting, changing only minor details.

The 1960s were probably the most productive period for Brazilian superheroes. Many characters were created in those years. Unfortunately, although some of them could eventually exhibit a certain artistic quality, most of them were just "sad pastiches of foreign productions, copying motives, powers, subjects, garments, plots, etc." (Vergueiro, 2000). Some Brazilian superheroes are *Raio Negro* (Black Ray), by Gedeone Malagola, based on Green Lantern; *Escorpião* (Scorpion), by Rodolfo Zalla, based on *The Phantom*; *Hydroman*, also by Gedeone Malagola, following the steps of *Namor, The Submariner*; *Bola de Fogo, O Homem do Sol* (Ball of Fire, The Man from the Sun), by Wilson Fernandes, shamelessly copied from *The Human Torch*, and so on.

This trend did not last very long. The lack of depth from these characters led Brazilian superhero production to its demise in the early 1970s. During the 1980s and 1990s, some Brazilian artists began working for U.S. comics, mostly as part of outsourcing for the illustration of U.S. superheroes. At the same time, new characters came out in the Brazilian market, illustrated by some of these same artists, but were only able to hold public interest for a short time.

The 1950s and 1960s were also very conservative periods in Brazil, both in moral and political terms. The first of these decades was characterized as a time to preserve moral values. In general, gender values remained very traditional. During the second one, "Brazilian people had to deal with

the effects of a political coup d'état by the Armed Forces, which forced the country to enter the most conservative and reactionary period of its recent history" (Vergueiro, 2001:71). Thus, political change inhibited the development of progressive attitudes. For the comics industry, the two decades also represented difficult times regarding themes that could be freely addressed in its pages. Any transgressions concerning moral issues were regarded as a threat to the establishment. In this respect, the history of Brazilian comics during this period shows a distinctive production that, in a way, responded to the people's need of social liberation: erotic or pornographic comics.

There were literally hundreds of pornographic comic books produced in Brazil during the 1950s and 1960s. Generally speaking, they were produced, distributed, and sold in a clandestine fashion, as everyone involved could be targeted by police persecution. These comics were usually printed in a small format, always in black and white, and with nearly rudimentary editing. Their length usually varied between 24 and 32 pages, so they could be easily hidden inside a book or a notebook. Readers adopted the term *catechisms* to allude to these publications. Carlos Zéfiro—the *nom de plume* for civil servant Alcides Caminha—is the most representative author of this kind of comics, practically establishing the model for all authors of pornographic comics in Brazil. Though not a very talented artist, Carlos Zéfiro was a master storyteller, successfully captivating readers in the more than 150 stories produced throughout his career (Barros, 1987).

Zéfiro's *catechisms* are not very shocking or scandalous compared to other pornographic comics. Although there are hundreds of graphically detailed sexual situations in his stories, it's worth noting that its narratives flow in a natural way and sexual intercourse usually appears to be consensual. In general, his stories follow a very recognizable plan, portraying a solitary person—a single or a married man who is temporarily away from his wife—who "meets a woman, flirts with her during the first eight to ten pages of the story, takes her to an appropriate place, and has sex with her in a variety of manners" (Vergueiro, 2001:74). In Carlos Zéfiro's narratives, the male protagonist usually tells the story, adding to the (hypothetically male) reader's identification with the main character. Besides that, the secret of Zéfiro's success is that he seemed to be very attentive to Brazilian family values and encouraged a gentlemanly behavior towards women. As a rule, his characters avoided the use of any violence to obtain women's favors; instead, persuasion would come into play, convincing women about the good nature of male intentions. He never portrayed first relatives in sexual intercourse. Incest was clearly a taboo for him as well as for his public. In this sense, he seemed to be well aware of his readers' profile, since the situations he presented in his stories did not run against the social mores of his time. In all, Zéfiro's views of male homosexuality, lesbianism, the role of women in sex, etc. have a direct relationship with Brazilian culture and depict Brazilian eroticism quite accurately.

BRAZILIAN COMICS IN THE 1970S AND 1980S

Children's comics took a new direction in Brazil in 1970. In that year, the artist Maurício de Sousa succeeded in convincing one of the greatest publishers in the country to publish a comic book with his character Mônica, a little girl inspired by his own daughter. From then on, it is possible to argue that children comics are the field in which this medium has presented the greatest development in Brazil.

It is important to mention that children's comics were not any novelty for Brazilian readers when the Editora Abril of São Paulo released the comic book *Mônica*. Since the early twentieth century, when they were first published in *O Tico-Tico*, comics were very popular among children and many characters had been created for them.

At the beginning of the 1960s, there was very a popular comic book with stories created by the artist Ziraldo Alves Pinto for his character Pererê, published by Editora O Cruzeiro from Rio de Janeiro. The stories were closely related to Brazilian cultural heritage, reproducing local folk stories and valuing the idiosyncratic way of life of Brazilians. The stories dealt with a group of characters organized around Pererê, a folkloric character portrayed as a child by Alves Pinto. Although the title was published for 4 years only, being discontinued in March 1964, it can be considered one of the most important contributions to the building of a genuinely native production of comics in Brazil, since the subjects focused on Pererê's stories were regional and dealt with matters peculiar to Brazilian cultural heritage (Vergueiro, 1990).

In the late 1950s, Maurício de Sousa had tried producing children comics with one of his first characters—the small dog Bidu—published by Editora Continental, from São Paulo, for a short period. However, from 1970 on, with the publication of *Mônica*, his main comic book character, Sousa's creative production succeeded in developing a special appeal for Brazilian children. It is difficult to identify the reason for his success. Perhaps it was the distinct group of characters that he created around *Mônica* that made the difference, as they were designed after real children that the author knew personally. It could also have to do with the environment where he situated their adventures, which, although bearing universal characteristics, also had the flavor of local neighborhoods, with many activities typical of Brazilian children. Maybe it was the production model that he organized to create his characters' adventures, counting on the help of assistants and an ability to produce a regular number of stories for a long period of time. Ultimately, it could also have been a little bit of each of the above, in addition to the use of his characters in merchandising, including TV and outdoors advertising. In any case, a few years after the release of his first comic book by Editora Abril, his characters were surpassing the sales of Disney comic books, making him the most successful Brazilian comics artist in the world.

Overall, *Mônica*'s stories deal with universal themes and do not establish many relationships between the facts they present and the actual place/country where the readers live. On the other hand, Maurício de Sousa

cannot be accused of leaving Brazilian culture totally apart from his production. One of his most popular characters, the young peasant Chico Bento, may be considered a major representative of the Brazilian countryside, as the struggle between rural and urban life is at the center of his stories, with ecological concerns and messages that are peculiar to Brazilian society.

Many other Brazilian authors attempted to follow Sousa's footsteps towards success, but few of them have succeeded in getting close to his preponderance. Even those who tried to follow the model of a group of characters with universal features could not obtain the same acceptance and acclaim, giving it up after a few years. It is what happened, for example, with Daniel Azulay and his *A Turma do Lambe-Lambe* (Lick-Lick's Gang), Primaggio Mantovi and his clown *Sacarrolha* (Corkscrew), Ely Barbosa and his *A Turma da Fofura* (The Gang of Tenderness), and even with Ziraldo Alves Pinto, who tried to reproduce in comics the success of his children's book character *O Menino Maluquinho* (The Little Crazy Boy), but succeeded only partially.

Other Brazilian comic books for children produced in the last twenty years tried to explore the popularity of many show business personalities, like the title based on the group of comedians known as *Os Trapalhões* (The Blunderers), published by Editora Abril from 1988 to 1993. However, all these attempts were always related to the acceptance of the actual show business personality, decreasing in the same proportion as it decreased in "real" life (Vergueiro, 1999a).

In the 1970s, the military government was still very strong, affecting all aspects of social life. Comics and comic books were not strange to this influence. Many commercial publications had to be packaged in black plastic bags to prevent children from seeing their contents. On the other hand, the period also produced the advent of independent comics and fanzines, which tried to escape from official censorship and establish an informal system of production and distribution for comics.

It may be said that Brazil has a publishing tradition of independent comics, which, in most cases, are manually produced and distributed. Faced with the impossibility to publish in the mainstream comics market, many amateur cartoonists produce comic books and fanzines in small quantities, distributing them among their families, friends, and colleagues. *Ficção* (Fiction), by Edson Rontani, was the first fanzine published in Brazil, in 1965 (Magalhães, 1993). Other comic books collectors and amateur artists followed his footsteps and, in a short period of time, a wide range of publications about and with comics was circulating in Brazil, dealing with diverse subjects and representing a viable alternative for those who wanted to produce comics independently.

Unfortunately, most independent publications in Brazilian comics just manage to release a few issues before disappearing. Despite this, some of the people involved in fanzines or underground comics persevere and sometimes succeed in having their comics published by commercial companies

or newspapers. Several artists in Brazil followed this trend, later becoming acclaimed and respected authors.

The most famous artist in this category is certainly Henrique de Souza Filho, also known as Henfil, who had his works published in many newspapers during the 1960s and 1970s. Henfil became widely respected for his position against the military government and his strict defense of Brazilian comics. He worked for the newspaper *O Pasquim*, the most aggressive graphic publication against the military dictatorship. Henfil's characters were extremely popular among the young crowd, which reproduced their criticism against the status quo and the political situation. Readers recognized his characters *Graúna*, a native Brazilian bird; *Bode Orellana* (Orellana, the Goat); and *Zeferino*, an inhabitant of northeastern Brazil, as extremely important representatives of the Brazilian ethos. Created in a highly distinctive, underground style, the messages in his stories and comic strips were always extremely caustic to the establishment, providing readers with a kind of cathartic compensation.

His most popular characters were certainly a pair of monks, *Os Fradins* (Mad Monks), who explored malicious and sadistic situations, but in fact always presented a message of goodness and solidarity (Izidoro, 1999). His drawings were very basic, economic, almost dirty, sometimes even giving the impression that they were done in a hurry. His characters became more economic with time, going from a complete figure to the mere suggestion of an image, like his character Graúna, which, at the beginning, resembled an actual bird and, in his last period, was similar to an exclamation mark. Henfil was a model for all underground comics in Brazil and the artists who followed him in the establishment of a production directed at mature readers. After him, adult comics in Brazil maintained a close link to the alternative market. The underground lingo prevails in Henfil's production (as in other authors, like Caco Galhardo, Eloar Guazzelli, and Alan Sieber).

Aside from Henfil, it is also important to mention that *MAD* magazine, published in Brazil since the 1970s, was another very important model for Brazilian authors of adult comics. Under this model, caustic humorous cartoons were the common standard.

The most important comic books for adults in the country, published in São Paulo, took advantage of this trend and disseminated this model throughout Brazil. Published from the late 1980s on, they provided space for the graphic eccentricities of authors like Angeli (*Chiclete com Banana/* Bubble Gum with Banana), Laerte Coutinho (*Piratas do Tietê/*Pirates of The Tietê River) , Glauco (*Geraldão*), Newton Foot (*Animal*), and Fernando Gonzalez (*Níquel Náusea*). Most of these authors are still publishing comic strips in Brazilian newspapers.

Brazilian Comics since the 1990s

The last years have shown a sensible development of adult comics in Brazil. Several authors who produce for a more mature audience have succeeded in

having their work published by commercial companies, but they are normally edited as graphic novels or albums. This fact has both a positive and a negative side: on one hand, to be published as albums or graphic novels means to have better designs, good paper quality, and more attractive products; on the other hand, it limits the sale of their works to bookstores, at a much higher price than the average comic book in the market, and with small print volumes.

In the late 1990s, the choice to edit albums and graphic novels for a public with better financial conditions has become more frequent among publishers. Some of them, principally small publishers, focus on this kind of comics, leaving the great market—or rather, the one with comic books for the masses—to the great publishing houses. Likewise, some authors have chosen the graphic novel as the better format for their work. Lourenço Mutarelli, one of the most famous and acclaimed comic books artists in Brazil, is a good example of this trend.

Mutarelli, who appeared on the scene of Brazilian comics during the 1990s, is now a legend in the field. After giving the industry a shot, working for some time at Maurício de Sousa's studio, he decided to produce comics for the independent market. He sent stories to magazines like *Chiclete com Banana* and *Animal*, and scarcely succeeded in publishing a few stories. After that, he decided to publish his own comics, editing the fanzines *Over-12* and *Solúvel* for Pro-C, the most important publisher of underground comics in the 1980s.

The characteristics of his art became evident in these first publications. In *Over-12*, he presented *Soledad* (Solitude), surprising the audience with his expressionist drawings. The influence of literature is evident in his first work, principally from books by Borges, Dostoievsky, Kafka, Baudelaire, and Brazilian author Augusto dos Anjos, a master of symbolic poetry. The theme of loneliness will surface in many of his comics, always focusing on his own life and its difficulties. Producing comics became a kind of therapy for Mutarelli, as it took him almost two years to finish his first album, *Transubstanciação* (Transubstantiation), published by Editora Dealer from São Paulo in 1992. Among other prizes, it received the Best Comic Story of The Year Award at the First International Biennial of Comics in Rio de Janeiro, with a committee headed by acclaimed artist Will Eisner. The praise received for *Transubstanciação* led to his collaboration with the magazine *Mil Perigos* (One Thousand Dangers), also edited by Dealer, where he published the stories later compiled in the album *Desgraçados* (Damned), released in 1993. In the following years, he produced two additional albums, *Eu te amo, Lucimar* (I love you, Lucimar), in 1994, and *A confluência da forquilha* (The Junction of The Fork), in 1996, always exploring his personal dissatisfaction with human relations, the proximity of death, and the problematic situation of a poor graphic artist who was not able to provide for his family's needs (Vergueiro, Mutarelli, 2002).

Although the three titles were very successful, Mutarelli was excessively evident in the narrative, the plot, and even in the physical appearance of the

characters. In fact, his heroes mirrored his own anxieties, as if he were trying to find a way for his own life through his comics. Notwithstanding critical acclaim, he didn't make much money. He was forced to illustrate books, covers for compact discs, and other publications, things that were not very close to his heart.

In 1995, he decided to concentrate on graphic novels. Fortunately, an arrangement with Devir, a publishing house from São Paulo, came through. From then on, he wrote the first of several new graphic novels in a *noir* style featuring the detective Diomedes, in stories that received the same acclaim as his former works but were distinctive from the old, almost autobiographic model of underground comics. With *O dobro de cinco* (The Double of Five), published in 1999, he entered a new period in his cartoon production, authoring almost one graphic novel per year and new stories for the Internet. Since 2003, Devir started translating Mutarelli's graphic novels into Spanish, distributing them in Europe, and also prepared English versions.

Graphic novels by Lourenço Mutarelli have started a new trend in the Brazilian comics market, showing the way to other artists, like the twin brothers Fábio Moon and Gabriel Bá, with *10 pãezinhos: O girassol e a lua* (10 Small Breads: The Sunflower and The Moon), in 2000; Maurício Pestana, with *Violência histórica* (Historic Violence), in 2002; Luis Saidenberg, with *Na trilha de Masamune* (In The Track of Masamune), in 2003; and Marcelo Campos, with *Quebra-Queixo: Tecnorama* (Cheesebreaker: Technorama), in 2003, to mention just a few.

THE BRAZILIAN COMICS MARKET
IN THE NEW MILLENNIUM

When it comes to the Brazilian commercial comics market, one must clarify that it has experienced many changes in the last decade. At the end of 2000, Editora Abril abandoned the Marvel Superheroes, which were taken over by Panini, the Marvel Comics representative in the country. A few months later, Editora Abril also dropped DC characters, then published by Panini, which, in this way, has become the main comics publishing house in Brazil. Unfortunately, its regular production involves foreign comics, with a prevalence of U.S. superheroes.

Another contemporary phenomenon in the Brazilian comics market is the boom of Japanese comics, which, at present, are published in great quantity and variety. In this sense, the Brazilian market is not different from what is happening all over the world. However, in the case of Brazil, the popularity of *manga* seems to have increased much more easily. On one hand, this happens due to the great number of Japanese descendants living in the country, who are eager to have contact and become acquainted with cultural products related to ancestry and, on the other hand, due to the massive presence of Japanese items in the Brazilian entertainment industry, providing children with different and multiple cultural products.

Besides customary products, this Japanese "invasion" has also given birth to several titles that try locally to emulate the style and themes of *manga*. Most of them are just naïve, clumsy attempts at exploring the language of Japanese comics beyond its native context. However, perhaps due to the familiarity of many Brazilian authors with original products from Japan— since many of them are Japanese descendants and are quite used to them—a few comics modeled as *manga* do succeed in proposing a noteworthy comics product, like the stories presented in the album *Manga Tropical* (Tropical Manga), published in 2002, with authors like Alexandre Nagado, Marcelo Cassaro, Érica Awano, Fabio Yabu, Daniel HDR, Arthur Garcia, Silvio Spotti, Elza Keiko, Eduardo Müller, Rodrigo de Góes, and Denise Akemi. Besides this album, there are comic books conceived by Marcelo Cassaro, which have been very successful in Brazil and are now being published in the United States. Titles such as *Holy Avenger, Victory,* and *Dungeon Crawlers* (the names are originally in English), which include the work of different cartoonists, show the adventures of wizards, druids, and warriors in a traditional *sword and sorcery* world, exploring a mix of the *manga* style and RPG games.

CONCLUSION

The beginning of a new century poses the same questions to Brazilian comics and comics industries all over the world. How will they survive in the new virtual environment? How will comics maintain their popularity in a world dominated by such a diversified universe of offerings in entertainment and leisure? How will local producers of comics make a living in a world increasingly controlled by the Japanese comics industry? In spite of everything, there are no definitive answers for these questions. However, as Brazilian comic artists of the past have let us know through their not always conveniently rewarded struggle and persistence towards the progress of comic language, there is still much to be done. In due time, Brazilian comics will find a way to surpass all the barriers they face. And they will do it in a Brazilian way, relying on their creativity and their sense of opportunity.

WORKS CITED

"A Garra Cinzenta." *Catapôu! Onomatopéias Abrasileiradas* [site] Available at: http://garracinzenta.blogger.com.br/ Accessed on July 17, 2003.

Campos, Marcelo. *Quebra-Queixo*: technorama. São Paulo: Devir, 2003. V.1

Izidoro, Simone. "Os *Fradins* de Henfil." *Agaquê* [Electronic Journal] 2: 2 (July 2003) Available at: http://www.eca.usp.br/gibiusp/ Accessed on July 17, 2003.

Lago, Pedro Corrêa do. *Caricaturistas brasileiros*: 1836–2001. 2nd ed. Rio de Janeiro: Marca D'Água, 2001.

Lucchetti, Marco Aurélio, ed. *No reino do terror de R. F. Lucchetti*. São Paulo: Editoractiva Produções Artísticas, 2001.

Magalhães, Henrique. *O que é fanzine*. São Paulo : Brasiliense, 1993.

Moon, Fábio and Gabriel Bá. *10 pãezinhos*: o girassol e a lua. São Paulo: Via Lettera.

Moya, Álvaro de. 1970. *Shazam!* São Paulo : Perspectiva, 2000.

———. *Anos 50/50 anos. São Paulo 1951/2001, edição comemorativa da Primeira Exposição Internacional de Histórias em Quadrinhos.* São Paulo: Editora Opera Graphica, 2001.

Mutarelli, Lourenço. *Transubstanciação.* São Paulo: Dealer, 1992.

———. *O dobro de cinco.* São Paulo: Devir, 1999.

Nagado, Alexandre, ed. *Manga tropical.* São Paulo: Via Lettera, 2002.

Pestana, Maurício. *Violência histórica.* São Paulo: Opera Graphica, 2002.

Saidenberg, Luiz. *Na trilha de Masamune.* São Paulo: Opera Graphica, 2003.

Silva, Diamantino da. *Quadrinhos dourados*: a história dos suplementos no Brasil. São Paulo: Opera Graphica Editora, 2003.

Vergueiro, Waldomiro. "Histórias em quadrinhos e identidade nacional: o caso 'Pererê'." *Comunicações e Artes* 15.24 (1990): 21–26.

———. "Children's Comics in Brazil: From *Chiquinho* to *Monica*, a Difficult Journey." *International Journal of Comic Art.* 1.1 (Spring/Summer 1999a): 171–186.

———. *The Image of Brazilian Culture and Society in Brazilian Comics.* San Diego, CA, 1999b. Available at: http://home.earthlink.net/~comicsresearch/CAC/99-vergueiro.html. Accessed on July 16 2003. [Paper presented at the Popular Culture Association National Conference, San Diego, CA, March 31–April 3, 1999]

———. "Brazilian Superheroes in Search of Their Own Identities." *International Journal of Comic Art.* 2.2 (Fall 2000): 164–177.

———. "Brazilian Pornographic Comics: A View on the Eroticism of a Latin American Culture in the Work of Artist Carlos Zéfiro." *International Journal of Comic Art.* 3.2 (Fall 2001): 70–78.

Vergueiro, Waldomiro and Lucimar Ribeiro Mutarelli. "Forging a Sustainable Comics Industry: A Case Study on Graphic Novels as a Viable Format for Developing Countries, based on the Work of a Brazilian Artist." *International Journal of Comic Art.* 4.2 (Fall 2002): 157–167.

Pavane for a Deceased Comic: Decadence, Illusions, and Demise of an Exuberant Narrative

Armando Bartra

In the nineteenth century, Mexican entertainment was gregarious in nature. It included country fairs, carnivals, *palenques*, bull-fights, cockfights, dances, religious parades, masses, circuses, and theaters. In 1910, with the arrival of the Revolution, literacy increased and leisure time became more of a private matter. Mexicans did not enter the century of things massive as a physical body, but as a "virtual" crowd: throngs of listeners gathered next to the heat of bakelite radios and flocks of lonely readers were baffled by the hundreds of thousands of indistinguishable magazines. These mesmerizing publications, these low-cost dream machines, were the *historietas* (Aurrecoechea and Bartra, 1988: 179–277).

During the second decade of the twentieth century, the *historietas* sneaked into the Sunday supplements. However, comics have a bigger potential market than newspapers and, by 1934, they had secured an independent means of communication through the release of *Paquín*, soon followed by *Paquito, Chamaco, Pepín, Pinocho, Palomilla, Piocha, Periquín, Colorín, Chiquitín, Chapulín, San Dieguito*, and many more. These were *historietas* with childlike names, yet adults also procured them. In the 1940s, many of these *pepines*, as they were affectionately called, were published daily, and some even twice on Sundays. The leading ones reached a circulation of almost half a million copies, with four to five avid readers per issue. During the 1950s, when close to twenty million Mexicans were over six years of age, half of the population was literate, and half of this educated mass read *historietas* (Aurrecoechea, Bartra, 1993: 13–85).

The big wave of comics reached its climax in the 1970s, when weekly magazines such as *Lágrimas, risas y amor* ([Tears, Laughters, and Love], with Vargas Dulché as scriptwriter and Gutiérrez as illustrator) and *Kalimán*

(Fox, Velasco) sold well over one million copies. *Historietas* like *Chanoc* (Zapiain, Mora), *El Payo* (Vigil, Buendía), *Torbellino* (Ortiz, Cardoso), *Fantomas* (De la Torre, Lara), or *Aníbal cinco* (Jodorowzky, Moro) combined commercial success with a high level of inventiveness. New comics appeared, quickly becoming canonical, such as *Los Supermachos* and *Los Agachados*, by Eduardo del Río, "Rius," and there was even some experimentation in terms of graphic narratives, like *Historietas de animales* (Animal Stories), by Jorge Godet, *Comix arte*, by Salathiel Vargas, and the Beckettian *Hombre de negro* (Man in Black), by Helio Flores (Bartra. 2000: 103–121).

Beginning in the 1980s, editorial dullness coupled with the overwhelming presence of television discouraged readers and, by the end of the twentieth century, the popular commercial *historieta* with millions of copies in sales was in its death throes. In the 1990s, *auteur* comics enjoyed a moderate peak that, for a short while, was evident in fanzines, newspapers, magazines, and books. Nevertheless, without resources, regular publications, and commissioned work, the promising *neomoneros* (neocartoonists) felt discouraged. The most fortunate ones found work in the U.S. comics industry; others found shelter in graphic design, advertising, and illustration; most of them bid farewell to *historietas* and other youthful diversions.

During the first half of the twentieth century, radio, cinema, and *historietas* shared the leisure time or marginal attention of the public. Mexicans listened to radio powerhouses like XEQ or XEW, watched the movies of the *Charro Negro* (with Rodolfo de Anda in the leading role), and read *Chamaco* or *Pepín*, without experiencing hardly any incompatibility between these activities. Television, on the other hand, is a medium based on exclusionary tendencies, which, little by little, displace other communication media until—with the arrival of VCRs, DVDs, videogames, and the internet—the small screen consumes all spare time. Radio managed to survive by keeping us company in spaces unreachable by television, but the tube, with its hypnotic miniature screen, cornered film, more indicative of a shared experience for the masses, and the historieta, more symptomatic of an intimate pleasure.

The last few characters introduced by the local *historieta* and shared by most Mexicans were paper heroes like *Chanoc, El Payo, Fantomas*, or *Kalimán* (Bartra, 2000: 103–107), exotic vamps like *Yesenia, Oyuqui*, or *Rarotonga* (Vargas Dulché and De la Parra, Gutiérrez), and children like *Memín Pinguín* (Vargas Dulché, Valencia). They were all extremely popular in the 1960s, well before television and its suffocating repertoire of characters absorbed the entirety of our collective imaginations (Aurrecoechea y Bartra, 1994: 353–420). Without a doubt, these were our last, truly omnipresent paper celebrities. Very little is left of the cadence of post-revolutionary language, of the sentimental education of many grassroots Mexicans, of the great publishing machinery of the twentieth century that gave us an identity at an affordable price. The Mexican *historieta* for the masses has vanished. National comics are no longer the busy commodities that they were for well over half a century; they have ceased cramming newsstands, taking

a discrete second place next to the ancillary publications of the small screen, like *Teleguía*, *TV y Novelas*, and *TV notas*, which, these days, are the ones with sales of over a million copies.

The defeat of the *historieta* is the defeat of the reading habit. The *monitos* (cartoons) did not lose to books, magazines, or newspapers, but to the devastating path of media giants like Televisa and Televisión Azteca. While cultured reading pressed forward at a turtle's pace, the only form of massive reading that we ever enjoyed collapsed irreversibly. Though 20 years ago it was consumed by tens of millions of Mexicans, the *historieta* has currently lost up to nine out of ten readers. Its circulation of millions dwindled to somewhere between thirty and forty thousand issues and, while in the good days there were well over a hundred different monthly titles, today there is hardly a handful of them. Mexicans did not stop reading *historietas* to read something else; we simply stopped reading. The fall of *monitos* is the misfortune of our civilization. In Mexico, at the end of the millennium, the reader is an endangered species.

Auteur Comics: Where Do We Find New Mexican Cartoonists?

The decline of big-circulation Mexican *historietas* started in the 1980s. However, in the midst of opening markets and globalization, the interest in U.S. and Japanese comics grew markedly among middle-class children and youth. This came about, first, as the result of increased access to *historietas* in English, available through expanding comics-store chains, and second, due to the detailed superhero editions marketed by Editorial Vid, in addition to the introduction of valued series like the first *Dragon Ball*, by Akira Toriyama; *The Simpsons*, by Matt Groening; *Hellboy*, by Mike Mignola; *Hitman*, by Garth Ennis and John McCrea; or *Sin City*, by Frank Miller. Furthermore, there is the *manga* and superhero boom of the 1980s and 1990s, a consumerist phenomenon evident in the large number of collector's editions, pins, cards, posters, plastic models, baseball caps, and T-shirts available in the market. It belongs to a militant and swarming culture that congregates at big conventions, like *La Mole*, *Conque*, or *Mecycif*, and around world-class comics celebrities like Will Eisner, Stan Lee, or Todd McFarlane. Nevertheless, it is also an encouraging event, since it awakens a passion for illustrated narratives in new generations, placing them in contact with some of the best expressions.

In the course of fading years for the comics industry and, along with the increase in popularity of Anglophone comics, came the rise, growth, and increase in popularity of auteur comics, a veritable expansion of alternative comics, and the proliferation of inventive, sophisticated, and bold *monitos* (cartoons). By the end of the twentieth century, a new generation of *comiqueros* (cartoonists) emerged in Mexico that paid little attention to the industrial *historieta*, since it did not identify itself with the old school. Instead, it embraced *monitos* as means of personal expression and viewed comics as

part of the fine arts or, at the very least, as one of the fine media. This new group involved a big circle of *neomoneros*, whose works appeared regularly in newspapers and Sunday supplements, cultural magazines, humor publications, alternative comics, and fanzines; a creative wave of fans of the ninth art, who produced three to four specialized magazines, some with amazing perseverance; and a new batch of graphic narrators, willing to work hard in their projects. And they weren't just a few. In the 1990s, more than 100 different cartoonists contributed to the Sunday comic section of *La Jornada* (The Workday), directed by Bulmaro Castellanos, also known as "Magú," (author of *Histerietas*, and later on, *El Manojo* [The Handful]).

The crowded team of new cartoonists that makes up the alternative *historieta* movement practices the most efferent and postmodern plurality of styles (Bartra, 2000: 119–135; Bartra, 2001: 225–236). Many are openly anti-establishment, the children of "Rius" and heirs to the Mexican lithographic tradition, like the incisive Rafael Barajas Durán, "El Fisgón" (The Jester), author of *Mike Goodness y el cabo Chocorrol* (Mike Goodness and Corporal Chocorrol); Chilean José Palomo Fuentes, "Palomo," creator of the comic strip *El cuarto reich* (The Fourth Reich); Gonzalo Rocha, who introduced the *banda* babies, first, in *Los gachos* (The Ugly Ones), and later, in *El Evenflo*; Patricio Ortiz González, creator of *El Pulgas* (The Flea), sidekick of *Hombre Man*, and patron of *Los miserables* (The Wretched); Antonio Garci Nieto, member of *El licenciado* (The Bachelor) and a young master of gag, as evident in *Las gallinas quieren pollo* (Hens Love Chicken); Grandvillean Damián Ortega, author of *Excelentísimas personas* (Eminent People); José Luis Diego Hernández y Ocampo, "Trizas," creator of *Supersalario* (Supersalary); Antonio Helguera; José Hernández; Cintia Bolio; Ramón Garduño Hernández; Oscar Quezada Pablo, "Tacho"; Julio Iván López Valverde (*Rictus*), and many more.

In Guadalajara, a number of ink terrorists materialized, like Josel Reynals, Manuel Héctor Falcón Morales—author of *Güilson, rey de la güeva* (Wilson, King of Balls)—and, above all, José Ignacio Solórzano Pérez and José Trinidad Camacho Orozco, "Jis" and "Trino," who shared intimate digressions and silly humor to coin *El Santos y la Tetona Mendoza* (Santos and Big Tits Mendoza), the toughest pair of characters at the turn of the century, as well as *La Chora* (The Liar). As solo projects, they produced *Mátalas callando* (Kill Them Silently) and *Gato encerrado* (Locked Cat), by "Jis," and *Historias del Rey Chiquito* (Stories of The Little King), *Crónicas marcianas* (Martian Chronicles), and *Fábulas de policías y ladrones* (Fables of Cops and Thieves), by "Trino." The fact that Mexicans who are more or less well read have embraced El Santos and La Tetona enthusiastically shows that Guadalajara conservatives are the paradigm of national decorum. When it comes to moral values, we all come from Jalisco and are shockingly enlightened by the iconoclastic temperament of El Santos and his friends. However, Guadalajara's sense of rebelliousness is as provincial as Jalisco's sense of decorum: "Jis" and "Trino" are not ill-fated poets but foul-mouthed cartoonists who have a good time flaunting their characters' dirty clothes.

It is no small feat, given that, quite frequently, the most sophisticated liberalism conceals childish, judgmental chauvinism. Once on his own, "Jis" displayed the most intoxicating, self-absorbing humor, well assisted by his drawing style, a baroque exercise on free association, while "Trino" showed an excellent ear for vernacular language—worthy of Gabriel Vargas or Ricardo Garibay—and weakness for the humor of the countryside: plain but effective.

Following the steps of Moebius, Dionnet, Druillet, and Farkas, the *Humanoïdes Associés* who launched the cult magazine *Metal Hurlant* in 1974, in 1991, Edgar Clément, Ricardo Peláez, Luis Fernando Henríquez, Damián Ortega, and Abraham Cruz Villegas (Avrán)—led by Víctor del Real, the most tenacious publisher from Zacatecas—published *El Gallito Inglés* (The English Cock), which reached the sixtieth issue and disappeared with the turn of the century. By then, the most important alternative comics publication in Mexico was called *Gallito Cómics* (Little Cock Comics), and the team had also changed: Del Real, Clément, and Peláez carried on, and now shared work with Erick Proaño Muciño (Frik), José Quintero, Ricardo Camacho, Alejandro Gutiérrez Franco, Patricio Betteo, and others (figure 9.1). *El Gallito,* which also published Spanish and Latin American comics, popularized some of the best Mexican alternative comics during the late 1990s, like those by Edgar Clément, a self-absorbed demonologist and angel enthusiast who authored the saga *Operación Bolívar* (Operation Bolivar), an ornate and cultist work influenced by the collages of Dave McKean and, quite possibly, by the maps, calligraphies, and typographies of Pierre Alechinsky (figure 9.2). Clément's first epic combines pre-Columbian mythologies, revisionist accounts of the Spanish conquest, and anti-imperialist paranoia, with a grand finale set on an early October at Tlatelolco. His obsessions, which run rampant in his imagery, were developed further in the inscrutable *Incubus Sucubus.* Daily routine, easily recognizable *chilango* settings, and intimate experiences typify the bitter and poignant work of Ricardo Peláez, an author whose political sensibility tends to be intimate, rather than sensationalist, close in spirit to the work of Spaniard Carlos Giménez. Peláez welcomed the new century with a four-issue series from Editorial Vid, in which he teamed with Tijuana scriptwriter Luis Humberto Crosthwaite to adapt *El complot mongol* (The Mongolian Intrigue) by Rafael Bernal, a classic of the Mexican hard-boiled thriller. However, due to copyright issues, only one issue was published. In the case of José Quintero, the reality of planet *Buba*—his narrative shares the name of the female protagonist—is explicit on the page (figure 9.3). Yet this underground guru's emblematic characters, metaphysical subjects, and poetic language do not allude to real contexts, but to ink-stained worlds whose conventions come from the U.S. underground. A fitting descendant of Lewis Carroll's Alice, Quintero's little girl has many fans and has been published at length in *La mosca en la pared* (The Fly on The Wall), a rock magazine. In exchange for being lethargic and indecisive in his illustration, "Frik" is an excellent scriptwriter, who stages pointed family portraits in *Madre Santa* (Holy Mother) and *Caldito*

Figure 9.1 A page from the saga *Harum Scarum* by Pepeto (José Cárdenas), published in *Gallito Cómics.*

de pollo (Chicken Broth), while in *Krónicas Perras* (Dog Chronicles), whose graphics were shaped in collaboration with Quintero and Camacho, he gives life to an ironic and Corvenian canine superhero. Ricardo Camacho, creator of *Perrodehabas* (Sweetpeadog), is a fine cartoonist in search of scripts; and Alejandro Gutiérrez Franco endorses sexy cyber-fiction with effeminate expertise. *El Gallito*'s final surprise is José Cárdenas, "Pepeto," whose pure

Figure 9.2 A vignette from *Operación Bolívar* by Edgar Clément, first published in *Gallito Comics* and then as a book by Planeta.

lines and vertiginous blacks, sans texture or half-tones, create a universe populated by bizarre criminals and crazy superheroes, like Zodd and Max, who do not refer readers to his native Celaya or an adoptive Querétaro, but maybe to comics by Argentine Carlos Nine (figure 9.4).

Figure 9.3 *Buba*, a character by cartoonist José Quintero, first published in *Gallito Cómics*, then in *La mosca en la pared*, and later edited by Vid.

Born around the fateful 1968, the core of the *Gallitos*—who soon formed the *Taller del Perro* (The Dog's Workshop) and, later on, *La perrera* (The Doghouse)—does not belong to a generation with grand, thwarted expectations, or to one professing total disbelief. In them, there is irony, disillusionment, fading idealism, and an at times intimate—occasionally metaphysical, though seldom theatrical—critical spirit. They have little to do with the national comic tradition, nor with *manga* and conventional superheroes. The end of the century caught them between thirty to forty years of age and making *historietas*, so, to them, comics were not some adolescent hobby but a determined calling. They have influences: Carlos Giménez's testimonial stories, Crumb's iconoclastic punch, Corven's decadent superheroes, McKean's formal experimentation, Frank Miller's dark tendencies, and Muñoz's and Sampayo's new objectivity. However, they also show a penchant for narratives and art forms that have little to do with comics. They published in *Gallito Cómics* and, every now and then, in *La Jornada*, *MAD en español*, and the fanzines *Slam!* and *Limbo*. In addition, they authored *historieta* volumes like *Operación Bolívar* (Planeta, 1994), by Clément; *Fuego lento* (Slow Fire, self-published in 1998), by Peláez; *Buba* (Vid, 2000), by Quintero, and *Sensacional de Chilangos* (Gobierno de la Ciudad de México, 2000), a volume dedicated to Mexico City that includes, aside from the founders of the *Taller*, the young and brilliant Patricio Betteo; the ex-Molotov Sebastián

Figure 9.4 *Sensacional de chilangos*, an anthology of comics with urban themes published by the government of Mexico City in 2000.

Carrillo, "Bachan"; the émigré Humberto Ramos, and scriptwriters Alfonso Escudero, "Vera," and Rodrigo Ponce (figure 9.4).

Aside from the *Gallitos*, there were other small teams that struggled, like the Molotov collective, formed by the rebellious "Bachan" (Sebastián Carrillo), "BEF" (Bernardo Fernández), "Carcass" (Luis Javier García), and "Vera" (Alfonso Escudero), who brought to life an ephemeral cult magazine with exemplary antiheroes like *Fresa Asesina* (Killer Strawberry),

Figure 9.5 Cover of the fanzine *Molotov*, created by Bachan (Sebastián Carrillo) and Bef (Bernardo Fernández), among others.

Pipo el Payaso (Pipo The clown), and *Tiburón Travesti* (Transvestite Shark: figure 9.5). And, to cap it all, there were also dark groups, like *La Caneca* (The Trash Can), with shady characters like Octavio Romero, Martín and Ernesto Barragán, and Carlos Ostos Sabugal, creator of *El Hombre Tlacuache* (Tlacuache Man: figure 9.6). These illustrators of new hyperheroes are an Anglophone legion, which includes the mythical Francisco

Figure 9.6 Vignettes from *El hombre tlacuache* by Carlos Ostos Sabugal, member of the *La Caneca* collective.

Solís Méndez, source of alternative comics in Monterrey and author of *Criaturas de la Noche* (Creatures of The Night), with Edgar Delgado, Hugo Arámburo, and other cartoonists; Francisco Ruiz, the creator of *B-Squad*; Alfonso Ruiz, the older brother of *Psico Boy* (Psycho Boy) and patron of the *Lulú Cómics* issues; Manuel Martín, the author of *Fuerza Rem*; Rojas and Sánchez, perpetrators of *Mantis;* Raga and Puerta, co-authors of *Siamés* (Siamese); Humberto Ramos, head of *Némesis 2000*; alleged heirs of the great Walt-like Edgar Delgado with *Ultrapato* (Ultraduck), and his *Valiants*. There are also dark heroes like *Lugo*, by Carlos García Campillo, Salvador Vázquez, and Giovanni Barberi. Half way between alternative comics and the mainstream comics industry, there are cases like *Drucker!* and *Condonman* (Condomman) by "El bachiller" Rubén Lara. One of the superhero authors who managed to sneak into the newsstands was Bachan, the author of the short-lived *Chamán* (Shaman) and a more lasting series, *El Bulbo* (The Bulb), in which Molotov's founder developed his humorous and parodical bent thanks to improvisations by cartoonists as mixed as "Vera" and Garci. *El Bulbo* resulted from collaboration between this author and Shibalba Press, an alternative press that also edited *Tinieblas* (Darkness), an *historieta* with a wrestler as main character, written by Francisco Espinosa and illustrated by Arturo Anaya.

In the world of fanzines, there are gores and goths, like Casasola, of *Disinto*; Sergio Moreno, of *Necrocómic*; Raly, of *La Mordida* (The Bite); González Llarena and Salvador Montemayor, parents of *Dramatus*; Ricardo Gómez and Max, authors of *Ransom*. Satirists of the alternative comics scene, like the Barragán brothers, authors of *Hards' y Marión*, edited by *La Caneca*, Alberto Hinojosa with his *Amazonas*, and Polo Jasso, from Monterrey, creator of *El Cerdotado*, represent a breath of fresh air in the middle of so much heroism and darkness (figure 9.7). Amid the heat of the rising sun, some first-generation *otaku* blossomed, like Oscar González, father of *Karmatrón y los Transformables*. There were even second wave efforts like Gabriela Maya, scriptwriter for *Los Supercampeones del fútbol* (licensed Mexican version of Tahashi characters) and author, along with Adalisa Zárate, of the *I.doll* series, which appeared in the short-lived commercial publication *Toukán Manga*, together with *Las aventuras de Gurobarú* (The Adventures of Gurobaru), by "Oval" and Rodrigo Ramírez, and *Rokk*, by F. G. Hagenbeck and Salvatore

Figure 9.7 *Cerdotado*, a character by Polo Jasso, first published in an alternative comic in Monterrey and later as a comic strip in *Milenio*.

Lavattiada. True to form, Japanese influence knows no limits. In the same way that it promotes *neozapatista* comics like *A la sombra de la revolución* (Under The Revolution's Shadow), authored by Raúl González López and edited by Mangage, the *hentai* (erotic) *manga* multiply, bringing about pairs like *Chicas trabajadoras* (Working Girls) and *Sexis divertidas y abusadas* (Fun and Abused Sexy Ones), illustrated by Oscar Medina and Jorge A. Resendiz; *Meteorix 5.9 no aprobado*, written and illustrated by Jorge Break and published by Toukán; *Al borde de la fantasía y seducción 3x* (At The Edge of 3X Fantasy and Seduction), made, in some measure, by the *Lulú Cómics* rascal, fanzine author Alfonso Ruiz; and *Sex ch 69 l*, by Daniel García and Arturo Vázquez. The persistence of some of these titles, which in the beginning were marginal, demonstrates that Asian porn stole readers away from the local erotica of *sensacionales*. There is no shortage of "lone wolves" in the new *historieta*: Manuel Ahumada, guide of the Mexican night and author of *El cara de memorandúm* (The Memo Face, Penélope, 1983), with a script by Jaime López, and some languishing eroticism and street-alley and canteen fare in *La vida en el limbo* (Life in Limbo, Fonca, 1997); the lustfully archaizing Héctor de la Garza-Batorski, "Eko," author of *El libro de Denisse* (Denisse's Book, Grijalbo, 1990) and faithful devotee of Dürer; Luis Fernando Henríquez, re-creator of flamboyant deep Mexico, as evident in *La Blanda Patria* (The Soft Homeland, Praxis, 1988); and, finally, Sergio Arau, cartoonist (*El Capitán Pelotas*), rocker (Botellita de Jerez), performer, movie director (*Un día sin mexicanos* [A Day without Mexicans], 2004), and author of the illustrated volume *La netafísica* (Planeta, 1989). The alternative comics scene also includes prolific and obsessive authors like Agustín Aguilar, author of *El goloso de rorras* (The Babe Glutton); poetic ones, like Jorge Noé Lyn Almada, "Noé," and Carlos Mario de la Cruz Portillo; veiled and sultry ones, like "Javillo," "Tacho," and "Merlín," architects of the fanzine *Monorroides* and eventual contributors to *La Jornada*; proudly exportable ones, like Felipe Galindo González, "Feggo"; metaphysical ones like

Abraham Cruz Villegas, "Avrán"; and, ultimately, rodent-centric aficiona-
dos, like Enrique Martínez. There is also a pair of female neocartoonists who
are relentless, echoing the work of legendary comic authors like Delia Larios
(*Adelita y las guerrillas*), and more recent ones like Palmira Garza, who col-
laborated in the illustrations of *La familia Burrón*, by Vargas: they are Cintia
Bolio, who collaborated in *El Chamuco* (The Devil), and Cecilia Pego, who
published the series *Terrora y Taboo* in *La Jornada*.

When Mexican comics discovered their own means of circulation, they
left newspapers but made it back home. In the 1980s and 1990s, almost
every national newspaper combined political cartooning with some kind of
comic strip. *Milenio Diario*, born in the new millennium, publishes five: *El
Cerdotado*, by Monterrey native Polo Jasso; *Los Miserables*, by Veracruzan
Patricio; *Crónicas marcianas*, by Jalisco's Trino; *El Escribidor*, by "Teta"; and
some untitled, generic comics strips by Kabeza, aside from a cryptic cartoon
by "Jis," also from Jalisco. A sign of the times is the evident majority of pro-
vincial cartoonists in *Milenio* and the fact that at least four of them started
publishing fanzines.

In some cases, the Sunday supplements with Mexican comics have returned,
like the leading *Más o Menos* (More or Less), in *Uno más Uno*, and *Histerietas*,
in *La Jornada*, and, in the case of Jalisco, *Monobloc*, in *El Occidental; La
mama del Abulón* in *Siglo XXI*; and *Tu hermana la gordota* (Your Sister The
Fat One), in *Público*. The publication of formerly blue-collar comics in many
magazines and cultural supplements stands as proof that the Mexican *histo-
rieta* has gained cultural prestige. *Nexos* included Falcón; *Nitrato de Plata*
(Silver Nitrate) published "Trino"; *Biombo negro* (Black Screen), a series by
Jaime López and Felipe Ehrenberg, among others; *La regla rota* (The Broken
Rule) included Luis Fernando, Arau, Ahumada, "El Fisgón," "Eko," and
José Castro Leñero; *Lumpen ilustrado* (Learned Masses) included "Feggo,"
"Mongo," Vicente Vargas, and several others; *Zurda* (Left-Handed) included
"El Fisgón," Leticia Ocharán, and others; *Complot, revista para armar*
(Complot, A Magazine to Build), included Garci; *Topodrilo* published Oscar
Luis and Montes Solís; *Dos filos* (Double-Edged) included Damián Ortega;
Limbo included Daniel Ramírez and Vic Hernández; and *Pusmoderna* pub-
lished, among many others, Clément, Patricio, "Trino," "Jis," "Mongo,"
"Avrán," Cárdenas, Damián Ortega, and Luis Fernando.

The horrors of the Salinas administration, the mistakes of Ernesto
Zedillo's government, and the slow Mexican transition towards democracy
favored a new boom for political caricature, in cartoons and comic strips,
and the rebirth of satirical magazines like *El Chahuistle* (Corn Mold), *El
papá del Ahuizote* (The Father of The Pest), *El Guajolote* (The Turkey), and
El Chamuco. Some comics were also published in magazines of political or
colloquial humor like *Rino, Lapiztola, Rhumor,* and *Los Caricaturistas* in
Mexico City, and, in the provinces, *Galimatías* and *La Mama del Abulón*,
from Jalisco; *El Chicali Nius,* from Baja California; *Cacto*, from Coahuila;
El Monosapiens, from Quintana Roo; *La Iguana*, from León and *Asteroide*,
from Celaya, both in the state of Guanajuato, to mention just a few.

Illustrated in freehand style or with a Macintosh, circulating as photocopies or through cyberspace, alternative comics and fanzines were a fruitful group for quite a while. Some persevered like *El Gallito*, some hardly lasted like *Mono de Papel* (Paper Monkey), and others only flourished once a year right before big comics conventions. Some fanzines were dirty, like *Pelos-necios* (Foolish Hairs), and others were impeccable like *Animanga*; some were multinational, like *Slam!*, which published Latin American and local comics, like *La tía de Vladivostok* (The Aunt from Vladivostok), from Xalapa, Veracruz. Still others were countercultural, like the ones featuring *Superbarrio*, symbol of the popular urban fight, and others discouragingly *gringo*, like *Ranson, The Beginning of The End*, published by *The Cómic Group*. Although most of them were from the capital, there were many alternative *historietas* produced in other states. Thus, *Traumática popular* (Popular Traumatics) was illustrated in Veracruz and *Dramatus* was from Tamaulipas, but, indisputably, Monterrey was the second main thoroughfare for fanzines and alternative comics: *Criaturas de la noche, Mantis, B-Squad, Siamés, Psycomix, Subkomyx, Estigma cerebral* (Cerebral Stigma), and *El Cerdotado*, among others, appeared by the foothill of the Cerro de la Silla, Monterrey's landmark peak. In terms of ideology, there were all kinds of comics, from anarchist punks, in publications like *El Tirabuzón* (The Corkscrew), and feminist works, like *Esporádica* (Sporadic), to pro-Zapatistas like *A la sombra de la revolución*, aside from neo-Aztecs, like *Mix'q*, and even Mormons who engaged in illustration, as in *Aún estamos a tiempo* (There's Still Time).

A symptom of the cultural demand of comics has been the frequent publication of hardcover comics. Most of the more than one hundred graphic volumes edited by "Rius," which Grijalbo published during the last few years, were specifically designed for this type of format. The same applies to his disciples Javier Cavo Torres (*Los Mayas, Picasso en cubitos* [Picasso in Cubes], etc., by Editorial Dante) and Miguel Ángel Gallo (*Historia de México en historietas* [Mexican History in Comics], by Ediciones Quinto Sol, 1990). However, many of the hardcover volumes include works initially published in short-lived media. *Historietas* by many authors were published as part of hardcover compilations, as in the case of "Magú" (*Hidalgo y sus gritos* [Hidalgo and His Cries], with Enrique Krauze), Sergio Arau (*La netafísica*), "Palomo" (*El cuarto reich*), Ahumada (*La vida en el limbo*), "El Fisgón" (*Las aventuras de Mike Goodness y el cabo Chocorrol*), Garci (*Las gallinas quieren pollo*), Luis Fernando (*La blanda patria y otras historias*), "Jis" and "Trino" (*El Santos contra la Tetona Mendoza*), "Eko" (*El libro de Denisse*), Kemchs (*Los torcidos* [The Crooked Ones]), among others.

There are five recent collections—on a variety of topics, yet all released during this century—that figure within this type of publications. These collections, which group works of close to seventy different Mexican authors, attest to the existence of a large group of neocartoonists: "virtual" illustration in a country without comics. As mentioned earlier, the Mexico City administration published *Sensacional de Chilangos*, a splendid collection of urban comics, in 2000. The volume was developed by the *Taller del Perro*

with the help of "Bachan," "Vera," Ponce, Ramos, and Vlasco. Back then, the group included Edgar Clément, Ricardo Peláez, Eric Proaño, "Frik," and José Quintero, all ex-members of the mythical *El Gallito Inglés*, and rookie Patricio Betteo. The remaining members of this effort came from different backgrounds; it included *"Bachan"* and "Vera," who came from Molotov; Humberto Ramos, a young professional who works in the United States but keeps in touch with the alternative comics scene in Mexico; and scriptwriter Juan Vlasco. Except for young Betteo, who was 21 years of age when the book was published, the cartoonists of *Sensacional de Chilangos* are not early beginners. Most of them belong to a generation prior to Generation X: they don't bear wild libertarian hopes or total disbelief, perhaps a tad of utopian disenchantment. And just like their beloved capital city, their comic strips are rough, bitter, and intimate. In 2002, *B.D. Mex. Historieta mexicana de autor (Bande Desinée Mexicaine.* Mexican Auteur Comics) was published for an exhibit organized by the Mexican Cultural Center in Paris. It included requisite works by Peláez, Clément, Quintero, "Frik," Betteo, "Bachan," and "BEF," together with Sergio Flores, Francisco Blanco, Polo Jasso, and scriptwriters Juan M. Servín and Rodrigo Ponce. Most of the material included in this French collection had been published earlier. In 2003, *La perrera*, one of the remaining halves of *El Taller del Perro*, published *Zig Zag. Historietas de sabores para niños de colores* (Zig Zag. Flavorful Comics for Colorful Children), which, as usual, included works by Peláez, Betteo, "Frik," "Bachan," and "BEF," as well as pieces by Cintia Bolio, Oscar Carreño, Augusto Mora, Adrián Pérez, and painter Mauricio Gómez Morín. Its contents do not undervalue children or this line of work. On the contrary, most of the comics in *Zig Zag* are in color, an unusual feature in circles that hardly have the means to publish in black and white. In 2003, there's a new exhibition volume produced in Madrid: *Consecuencias. Historieta mexicana* (Consequences. Mexican Comics). It includes work by the usual suspects, as well as pieces by "Pepeto," Cecilia Pego, Ricardo Camacho, Roberto Carlos Gómez, Carlos Ostos, Ricardo Sandoval, Tony Sandoval, Roberto Cavazos, Luis Sopelana, Jimena Padilla, Rogelio Bobadilla, Rodrigo Ponce, Raúl Treviño, Esteban Saldaña, Nuria Chapa, Jorge Flores, Juan Carlos Silva, Anabell Chino, Rocío Pérez, Héctor Germán, Javier Puyou, Jorge Ignacio Zúñiga, and Marco Aníbal Negrete. The fact that there are 39 authors in this collection adds to the volume's overall sense of unevenness. However, the group's level of professionalism is striking, particularly if we consider that Mexican comics authors enjoy few venues where they can get this kind of experience. Finally, thanks to the support of the Consejo Nacional para la Cultura y las Artes (National Council for Culture and Arts, Conaculta), a sci-fi volume titled *Pulpo Cómics* (Octopus Comics) is published in 2004, with almost 130 pages of Mexican comics and close to 40 cartoonists as participants. Bernardo Fernández, "BEF," the erstwhile member of the Molotov collective, was the editor and driving force behind this project. It is particularly striking that young cartoonists who were born after the 1950s—when Germán Butze's *Los Supersabios* was first

published in the weekend supplement of *Novedades*, and even a while later, when new issues were released—dedicated this book to Butze. One of our few comic classics, Butze is a cartoonist and a brilliant scriptwriter, the father of humorous Mexican science fiction, and, undoubtedly, the most effective narrator in Mexican comics (Aurrecoechea and Bartra, 1993: 271–296). The volume's introduction notes how resolute Mexican comic authors from the 1970s strived "to escape the ghetto of fans during the darkest hour." Its combination of an undervalued language—comics—and a marginal narrative genre—science fiction—provides a clear portrayal of contemporary Mexican comics. In all sincerity, given that Mexican comics have practically disappeared, what the book truly documents is the presence of a significant group of talented neocartoonists bent on the idea of auteur comics. Some of the authors in this volume who have not published work in any of the four former collections are: Jorge Alderete, Martín Arceo, Gabriel Benítez, Luis Javier García, Alberto Chimal, Osvaldo Cortés, Alberto Dagón, Cesar Evangelista, "Kone," Sergio Flores, Ricardo García, Oscar González Loyo, Francisco Haghenbeck, Vic Fernández, Miguel Ángel Hernández, Jimena Padilla, David Kimura, R. G. Llarena, Rafael Rodríguez, Carolina Shantal Parra, Julio Iván López, Eugenia Robleda, Pepe Rojo, Javier Saurio, Gerardo Sifuentes, Raúl Treviño, Javier Trujillo, and Cynthia Yee. The authors in *Pulpo Cómics,* whose average age is close to 30 years of age, belong to a sort of baguette generation—they are too young to be a BLT and too old to be a Big Mac—that does not share the moderate left-wing politics of the 1970s nor the laid back cynicism of the younger crowd. They shift easily from nostalgia—usually, someone else's—to post-apocalyptic pessimism. Hence, the spirit of their production lays somewhere between utopia and blunder.

Two of the five comics anthologies published in the last years are exhibition catalogues from Paris and Madrid. This would be encouraging were it not for the fact that, currently, there is no plausible production and publication of comics in Mexico. Given the constricting conditions of production that we presently endure, it certainly isn't a matter of comfort that works that are practically unknown in Mexico are being exhibited at venues in France and Spain. There certainly isn't any comfort in that four years ago, when an exhibit at Mexico City's Casa Frissac included works by much-admired Eduardo del Río, the already classic Ángel Mora, Antonio Cardoso, and Sixto Valencia, and the talented and young Rafael Gallur, the primary motivation was the display of original pieces by Spaniard Carlos Giménez. Or in the fact that a specialized magazine such as *Curare: Espacio crítico para las artes* (Curare: A Critical Space for The Arts) published an essay on Mexican comics during the latter half of the twentieth century in the July-December 2000 issue in its usual *Revisiones de la historia del arte* (Reviews of the History of Art) (Armando Bartra, "Fin de fiesta: gloria y declive de una historieta tumultuaria"). There was coverage even in academic periodicals like the *Revista Latinoamericana de Estudios sobre la Historieta*, published in Cuba, which included Ana Merino's essay *Fantomas contra Disney* in the December

2001 issue, and my text *Debut, beneficio y despedida de una narrativa tumul-tuaria* (Unveiling, Benefaction, and Farewell of A Mass Narrative) in the June, September, and December 2001 issues, all focused on Mexican comics. Two years later, a chapter on cartoons was included in *Hacia otra historia del arte en México. La fabricación del arte nacional a debate (1920–1950)* (Towards Another History of Art in Mexico. A Debate on the Manufacturing of National Art). Shortly after, my article "Piel de papel. Los "pepines" en la educación sentimental del mexicano" appeared in a volume compiled by art historian Esther Acevedo. And, in 2004, the Fondo de Cultura Económica translated and published *Del Pepín a* Los Agachados. *Cómic y censura en el México posrrevolucionario* (Bad Language, Naked Ladies, and Other Threats to The Nation), by Anne Rubenstein. That recent Mexican comics partici-pate occasionally in other media certainly does not compensate for an overall absence and lack of access. There are also, for instance, regular television broadcasts of *Monos y monitos* (Cartoons and 'Toons), a series coordinated by Juan Manuel Aurrecoechea and Leopoldo Best, and produced in 2000 by the Universidad Nacional Autónoma de México (UNAM, the National Autonomous University of Mexico). In another case in point, Conaculta edited a CD called *Catálogo de historieta mexicana del siglo XX* (A Catalog of Mexican Comics in The Twentieth Century), which I co-authored with Juan Manuel Aurrecoechea and Jacinto Barrera. To come to the point, when a friendly, affordable, mass-oriented, and humble form of cultural produc-tion like the *historieta* becomes "art," an elite fashion item, the object of historical rescue, museum collection, and television nostalgia, something is definitely wrong with the down-to-earth world of comics.

WHEN CARTOONISTS LEAVE: SCENES FROM AN EXODUS

On a regular day, about 1,400 Mexicans escape to the United States, that is, at a rate of about one per minute. In the last decade, almost five million fellow countrymen have crossed the border following a dream. Some of them were cartoonists. Since the 1940s, there are comics published in the United States with main characters who are categorically Mexicans, such as *Gordo*, by Californian Gustavo Montaño Arriola, and *Pancho,* created by De la Torre in Arizona. These cartoonists are Mexican-Americans, born on the other side of the border. There are others, though, who came from Mexico. Manuel Morán Granados, who worked with comics author Rafael Araiza and published some comic strips on his own—like the evocative *Bracerías,* set north of the border—migrated to the U.S. east coast in the 1940s. His latest production came to México from New York (Aurrecoechea and Bartra, 1993: 133, 143, 161, 211, 335, 444). We may have lost track of "Many" Morán, but Sergio Aragonés, who left Mexico in the 1960s dreaming to work for *MAD* magazine and achieved his goal, is an example of the successfully transplanted cartoonist. However, Aragonés' decision was personal, not generational. Others like him appeared in the 1950s and

decided to stay in México, where they were able to produce abundant and valuable work, and, in some instances, were even acknowledged. This is the case of Ángel Mora (*Torbellino*), Sixto Valencia (*Memín Pinguín*), Antonio Cardoso (*Torbellino*) and, in terms of humorists, "Rius" (*Los agachados* and *Los Supermachos*), and Helio Flores (*El hombre de negro*), to name a few. The thing is, forty to fifty years ago, no one had to migrate in order to draw comics and publish.

In contrast—given the lack of interest from dull Mexican editors—by the late twentieth century, the exodus of local talent is a well-accepted fact. In 1983, Felipe Galindo González, "Feggo," left to New York, where he managed to get some work published in the *New York Times*, *Wall Street Journal*, and *The New Yorker*, and also published several books. But "Feggo" has a very personal style, quite apart from the Mexican comics industry, and his departure had no immediate followers. In the 1990s, though, the numbers were higher. Humberto Ramos and Juan Vlasco worked for Marvel Comics; Francisco Haghenbeck and Ricardo García Fuentes, for DC Comics; Edgar Clément made contacts with Marvel Comics; Sebastián Carrillo, "Bachan," with DC Comics and Humanoïdes Associés; Oscar González Loyo has been working for a while in Groening's *The Simpsons*. In some cases, comics collectives managed to make it across, like Studio F, established in Monterrey in 1999, which groups Edgar Delgado, Raúl Treviño, Francisco Ruiz Velasco, Marco Antonio Fabela, and Oscar Carreño, who have worked for DC Comics and Dark Horse Comics. Other talented Mexicans involved in Anglo comics include Omar Ladronn, Paco Medina, and Carlo Barberi. Those in the Mexican comics industry who did not manage—or want—to work for the U.S. comics industry lived from something else; proverbially, from illustration, design, and advertising. Cartoonists like Peláez, "Frik," Betteo, "Kone," "Carcass," Kimura, "Vic," and Ponce, who proved their talent, earn their living through these activities. Others abandoned their unruly cartoons for more generous artistic activities: Manuel Ahumada and Cecilia Pego are devoted to painting; Bernardo Fernández, "BEF," published novellas and science fiction stories; Damián Ortega and Abraham Cruz Villegas, "Avrán," are successful conceptual artists.

Once the century of comics is over, the vast venture of commercial comics is fading rapidly in Mexico. The butler didn't kill our comics; the tube poisoned them. First came the idiotic box, then video, DVD, and video games; then, finally, the Internet and its smart box put an end to paper narratives. For a while, crude fanzine comics prevailed, though next, given tribal propensity, Mexican youth drifted towards graffiti, tattoos, and piercing. These are valid communal expressions, powerful and creative, but they are less effective when it comes to narrating collective experiences. Today's generations are simply not very interested in narration. What a pity. Alternative comics have always been tribal. Like graffiti, body paint, and tattoos, they respond more to symbolic, convening, and cathartic impulses than to aesthetic prerogatives. Comics are like totems: they confer clannish identities. And the

resourcefulness of neocartoonists is almost always intermittent, syncopated; it embodies an energetic but dispersed slam-draw, resulting from the precariousness of fanzines and the lack of decently paying, regular publications that might propitiate professionalism. Be it through calling or failure, alternative *historietas* are amateur in nature. Once the fever is over, very few neocartoonists persevere in their effort to draw. And those who persevere, the stubborn and obstinate ones, those who have to write or draw comics because, if they don't, they will fall apart, those can seldom find a place to publish or distribute their work. The challenge, then, is to create the medium, the framework, a vehicle. Whatever it is, it is clear that, in this new millennium, Mexican comics will be geared toward minorities, toward segments of the cultural market that are fragmented beyond repair. The times when *pepines* evened out the weaknesses of an entire nation are a thing of the past. Today, all that's left is specific identities that congregate around totems: wall graffiti, skin tattoos, cyberpunk webpages, and neocartoonists, worshiping a drawing table or a Mac. Fortunately, the times of harmony are history. The massive illustrated endeavors will not return, but their eradication could open the way to smaller and more agile beasts. I truly hope that is what will happen. Quite sadly, I am aware that this text has become a register of "virtual" comic authors. It involves a long list of cartoonists who could become memorable authors, but who will probably fail in the attempt; not because they lack a will, but because comics are an industrial art that cannot flourish without means. For this reason, I try, at the very least, to have the decency of noting their contribution.[1]

Note

1 Particularly in the first sections of this article, I have reproduced information covered at length in some of my other essays on this topic, especially "Piel de papel. Los 'pepines' en la educación sentimental del mexicano" (Paper Skin. Pepines in the Sentimental Education of Mexicans) and "Fin de fiesta: Gloria y declive de una historieta tumultuaria" (The End of the Party: Glory and Decline of a Massive Comic). In this case, though, I made changes and added information. The last part of this chapter includes more recent material, yet unpublished in any other source.

Works Cited

Aurrecoechea, Juan Manuel and Armando Bartra. *Puros cuentos. La historia de la historieta en México, T. I, 1874–1934*. México: Consejo Nacional para la Cultura y las Artes, Museo nacional de las Culturas Populares, Grijalbo, 1988.

———. *Puros cuentos. La historia de la historieta en México, T. II, 1934–1950*. México: Consejo Nacional para la Cultura y las Artes, Museo nacional de las Culturas Populares, Grijalbo, 1993.

———. *Puros cuentos. La historia de la historieta en México, T. III, 1934–1950*. México: Consejo Nacional para la Cultura y las Artes, Museo nacional de las Culturas Populares, Grijalbo, 1994.

Bartra, Armando. "Debut, beneficio y despedida de una historieta tumultuaria." In *Revista latinoamericana de estudios sobre la historieta*. Vols. 2, 3, and 4. June, September, and December. Cuba, 2001.

———. "Fin de fiesta: gloria y declive de una historieta tumultuaria." In *Curare. Espacio crítico para las artes*, no. 16, July–December, México, 2000.

———. "Piel de papel. Los "pepines" en la educación sentimental del mexicano." In Esther Acevedo (editor). *Hacia otra historia del arte en México T. III. La fabricación del arte nacional a debate (1920–1950)*. México: Consejo Nacional para la Cultura y las Artes, 2002.

The *Fierro* Years: An Exercise in Melancholy

Pablo de Santis

Comics have always had a complex relationship with literature. While the American humor-based comic strip was capable of acquiring an immediate autonomy—and along the way gave the genre its universal name, comics—the adventure comic strip always resorted to art or literature in an effort to find not just sources of images or storylines, but also legitimation. In Argentine comics, this dependency had a double nature, which corresponded to a dual inferiority complex: on one hand, it was a "minor genre," a detour of written culture; on the other hand, it was an unoriginal product, inherited from U.S. mass culture. Conventional scriptwriters basically had a literary formation and, in their work, they developed connections with the literary texts they read as children. They may have also read contemporary literature, but, at least in their work, it was all about Poe, Salgari, or Verne. Those in charge of adapting the literary texts worked mostly from a "frozen culture," trapped in the web of childhood and adolescence.

In literary adaptations, which today are rare, but were abundant in the 1930s and 1940s, the dialogue between comics and literature is revealed. There, one can see clearly how comics favor a particular region of the world of letters to create its models; how they think of themselves as a narrative; what is the kind of writing comics tolerate in the restricted territory assigned to words; and, above all, how they have sought their own legitimacy in literature.

In the following pages, I will trace some of the moments of this Argentine dialogue between comic strips and literature from the 1930s to the 1980s. I will consider the adaptation of literary texts to comics less as an object of study than as a prism allowing a better understanding of these two modes of writing. Toward the end, I will include some general notes on adaptations, beyond the specificity of the Argentine case.

LITERATURE IN ARGENTINE COMICS: FROM A CHILDHOOD IMAGINARY TO LEGITIMATION

In the 1930s and 1940s, and even in 1950s, literary adaptations in comics were abundant in Argentina. Today they are rare. What is it that literature and comics had to share and what separates them today?

They had the sea, jungles, mysterious islands, the center of earth, the Moon and Mars, i.e. a common imaginary. Comics were the graphic form of adventure and anything else was unthinkable. In the works of Emilio Salgari, Jules Verne, and Edgar Rice Burroughs, comics had learned to escape the biggest danger: everyday life. This strong tie allowed comics to be an entry door for literary reading—an entry point, by the way, which formal education did not favor and, even more, forbade. The worlds of each genre were contiguous. Today, it would be difficult to imagine that literature could be compatible with the most extreme adventures of superheroes or Japanese *manga*. The latter have their own scenario, their own laws, and they lead us into a world of pure image: words are just the shadow of drawings. Yet comics did not dialogue with contemporary literature, but with literatures from the past. They chose texts considered "classics" for young adults; these were texts that were classics due to their persistent popularity and not because they had been canonized by formal critics or higher education. Comics shared their popular nature and intense relationship with readers with those classics, without any additionally consecrating cultural mediation. They were cultural fields far removed from what ought to be taught in the schools or college. Nobody would have included Verne in a French literature class or Salgari in an Italian one.

In Argentina, there was a strong tradition in the field of adaptations. Versions of the classics proliferated in popular magazines emerging in the 1930s and 1940s, such as *El Tony, Patoruzú, Patoruzito, Intervalo* (Interval), or *Aventuras* (Adventures), and even in serials with more general interests, such as *El Hogar* (Home). The most daring of these magazines was *Aventuras*, which included adaptations of the U.S. hard-boiled and noir novels, although often times derived from their screen adaptations. The drawings of Alberto Breccia—one of the key artists—took the darkness of the stories to a corresponding graphic level of anguish; Breccia—to whom I will return later—drew, for example, *The Informer* (1925), the famous novel by Liam O'Flaherty. But this literary text made it to comics through its film version by John Ford. Movies were the first translators for comics. In the 1930s, one of the pioneers of adaptation from one genre to the other was Raúl Roux, who started to draw in *El Tony* versions of classics such as *Hansel and Gretel* (1928), *Robinson Crusoe* (1929), *Treasure Island* (1929), and *Sinbad The Sailor* (1929), along with texts coming from the mythology of westerns and dime novels like *Buffalo Bill* (1930) and *Nick Carter* (1930). Although *Hansel and Gretel* is often referred to as the first non-humorous comic in Argentina, it is not yet the case of a true comic. All of these are still illustrated versions of literary works. Below each vignette, there is an

extensive written text summarizing the original work. We are not faced with a new language, but confronted with a condensed version of a previous language. Later, Roux made a comic about the so-called *conquest of the desert* (the conquest of Argentine wilderness), which is his most celebrated work. It was called *Lanza seca*, and for it, he did significant research. At this point, it is worth mentioning that comics with a *gauchesca* topic that became very popular, did so only after literature had completely abandoned the gaucho as a key figure.

The adaptation of the adventure novel found its great drawing artist in José Luis Salinas (1908–1985), who made the connections between literature and comics the central axis of his oeuvre. Salinas became one of the key figures in the history of most Argentine comics, since he started working in the 1930s and kept doing so until his death in 1985. In 1936, he published *Hernán El Corsario* (Hernán the Pirate), his first comic, with a self-authored script in the popular magazine *Patoruzú*. He also adapted to comics novels by Salgari, Alexandre Dumas, James Fenimore Cooper, and Rudyard Kipling. Anticipating the route of many other artists, Salinas left the country in 1949 in order to do syndicated work with King Features for *Cisco Kid* (with a Rod Reed script based on an original idea by O.Henry). This series continued until 1968.

From his youth, Salinas was a fervent admirer of Harold Foster, the author of *Prince Valiant*, and he was always faithful to that early illuminating influence. In his adaptations of H. Rider Haggard, Salgari, or Kipling, the texts are juxtaposed to the illustrations without any infectivity. Salinas decided to ignore the bubbles for dialogue, which seem so essential to comics, in favor of selecting fragments of the text, to be accompanied by drawings of the adventure's key moments. Thus, he allowed the narratives to explore highly detailed jungles, inhabited by equally well-defined animals. In this work, encyclopedias and proper epochal documentation collaborated with imagination.

In his collection *El domicilio de la aventura* (The Place of Adventure), Juan Sasturain highlights the fact that, when Salinas published his first comic, *Hernán El Corsario*, he was already fully formed as an artist. And his long career—he did not stop publishing until his death in 1985—was nothing but a way of perfecting his art without any consideration for innovation. According to Sasturain, "For Salinas, the adventure was always already written—before, far away, and forever—and all that was left to do was to narrate it again. His drawings are an act of fidelity to the world that writing had revealed for a child's imagination." In a way, this is a perfect way to define one of the forms of conceiving adaptations: fidelity to childhood.

During the 1930s and 1940s, Argentine comics thought of literature not just as an archive of scenarios and adventures, but also as a form of cultural legitimation. Comics presented themselves as a form of transition, a useful aid in the initiation to reading, a threshold leading to a superior form of art, though not in itself an art. Jorge Rivera, a literary critic who devoted a great deal of his work to the study of popular culture genres, wrote in his

book *Panorama de la historieta en la Argentina* (An Overview of Comics in Argentina): "The dominant tendency was to promote comics as a road leading to reading, when in fact comics themselves, with their pros and cons, *were a form of reading* located right at the center of the new civilization of images and visual discourse (...) By choosing the road of adapting great literary models, comics did nothing but repeat a path (an ambiguous, and for many, an equivocal route) already well trodden by film in its very beginnings, with its so-called art-films and its displays of divas, heartthrobs, period costumes, and gigantic and overtly operatic scenarios."

Nevertheless, and despite their efforts to be culturally accepted, comics did not attain their desired legitimacy. In schools, comics were not considered a respectable path to reading, but instead were disloyal adversaries for any form of education. By the 1950s, comic adaptations of literary works had lost all their will to become part of normative culture through this indirect path, and the few remaining adaptations produced later were nothing but isolated phenomena.

A history of fictional reading in Argentina that would consider not only literary texts but also comics and *fotonovelas*, a history that would be able to show the importance of these texts in daily-life conversations, public transportation, school or college-based environments, is yet to be written. The history of texts is also the history of how they have been read, deployed, and, sometimes, concealed.

Between Semiotics and Darkness

From 1965 on, there are multiple elements indicating the normative culture's acceptance of comics. In that year, the Italian magazine *Linus* makes its debut and Umberto Eco publishes his book *Apocalypse Postponed*. Comics lose all their innocence and are now read, on one hand, as a system of signs (semiotics, which found in comics a particularly appropriate object of study, had just been born); on the other, they are seen as a space of unlimited suspicion. Particular attention was paid to those comics that played openly with the genre's language: *The Spirit*, by Will Eisner; *Krazy Kat*, by George Herriman; and *Peanuts*, by Charles Schulz. Then again, suspicion arose from the presumed tranquil ingenuity of numerous superhero comics, such as *Superman*, by Jerry Siegel and Joe Shuster; war-based comics, such as Milton Caniff's *Steve Canyon*; or children's comics, like *Donald Duck*. Where before there were only drawings and words, now the intellectuals discovered signs and ideologies. In the 1960s, comics made it to art galleries and museums, but in an ironic way. Pop artists such as Roy Lichtenstein and Andy Warhol gave much bigger dimensions to the little vignettes of *Dick Tracy*, *Sweethearts*, or *War Stories*. What they rescued, though, was not what was alive in the language of comics, but all that made them stereotypical and rigid.

This new form of reading, sparked by Eco and *Linus*, found one of its sharpest followers in Argentine author Oscar Masotta. Born in 1930, Masotta added two features that rarely go together: depth and a certain

enthusiasm with the products of cultural fashions bordering on snobbery. To read the span of his work now is tantamount to reading a 1960s encyclopedia: he dealt with comics, Merleau Ponty, Sartre, Lacanian psychoanalysis, pop art, etc. This penchant for the new did not prevent him from engaging all topics with a clear and distinctive intelligence. His notes on comics, which he compiled in his book *La historieta en el mundo moderno* (Comics in The Modern World), are among the best of his output. They both extend and challenge Umberto Eco's insights. Masotta was one of the organizers of the International Comics Biennale, which took place in 1969 at the Instituto Di Tella in Buenos Aires. He also edited the journal *LD* (*literatura dibujada*, graphic literature), which only published three issues. They included a worldwide selection of comics, and articles by Masotta, Eco, and Oscar Steinberg, another pioneer of semiotics in Argentina.

This incorporation of comics to the cultural field coincided with a similar incorporation of other genres to literature and the arts (journalism, photography, kitsch), and with a certain disregard for "pure" disciplines that lacked an interest in work with popular genres. If comics had sought prestige in the past by approaching literature, now they attained such prestige through the opposite route: being acknowledged as a language of its own and as part of mass culture. Yet this recognition arrived just when comics were running out of readers in Argentina. It was an archaeological rescue. In Carlos Trillo's words: "The 1970s arrive as a sumptuous funeral. The best Argentine works featured in the grand exhibition of comics organized by the Instituto Di Tella were all at least five years old."

Not long after the Di Tella's exhibition and its "sumptuous funeral," Alberto Breccia (the only Argentine artist featured in the pages of *LD*) attempted some rapprochement with literature. He engaged literary adaptations in a way that was completely opposite to Salinas's method. He conceived adaptation as the invention of a device capable of providing an account of the same story through different means. Breccia, who claimed to be relatively uninterested in comics, nevertheless paid particular attention to the work of French artist Jacques Tardi, who was deeply involved in reconstructing literary works through comics. With his versions of H. P. Lovecraft's *The Call of Cthulhu* (in collaboration with Norberto Buscaglia, 1973), Breccia took comics to the frontiers of the genre. There, figuration is threatened and narrative values give way to the needs of expression. To start, Breccia chose an author who seemed particularly difficult to adapt, since his descriptions were mostly reiterations on the unsayability of horror. Later on, in his more famous adaptations, such as "The Tell-Tale Heart," by Edgar Allan Poe (which he made for the Italian magazine *Alter Linus* in 1975) and *La gallina degollada* (The Decapitated Hen), by Horacio Quiroga (published for the first time in *Breccia negro*, 1978), Breccia, along with scriptwriter Carlos Trillo, represented horror through darkness and repetition. In the first case, what is repeated monotonously is the beating of the heart hidden under the floor; in the second, it's the images of the mentally challenged siblings culminating in tragedy. Thus, Breccia drew attention to something

that was hidden in each narrative. Yet another collaboration between Breccia and Trillo was *Donde suben y bajan las mareas* (Where Tides Ebb and Flow) (*Breccia negro*, 1978), a subtle rendering of Lord Dunsany's fantastic world.

Breccia's last adaptation was *Informe sobre ciegos* (Report on The Blind, published as a book in 1993, and based on the central chapter of Ernesto Sábato's novel *Sobre héroes y tumbas* [On Heroes and Tombs], 1962). In it, Breccia returned to a balance between expression and the demands of a clear narrative. It was in fact an old project, which Breccia had started with Norberto Buscaglia in the early 1970s and then abandoned. Also among Breccia's plans was an adaptation of *One Hundred Years of Solitude* by Gabriel García Márquez, which he then switched to *Chronicle of a Death Foretold*, left unfinished at the time of his death.

A relationship with literature is also prominent in another of Breccia's great works, *Perramus* (1984), although in this case it's not a literary adaptation, but an original script by Juan Sasturain. Published as a series during the first period of the magazine *Fierro* (Iron) in the mid 1980s, it became one of the best comics of the decade. At a time of many films, comics, literary, and journalistic texts on the military dictatorship, *Perramus* belongs to the small group of truly significant works produced. Juan Sasturain (one of the best noir and detective novel writers in Argentina) was at the time director of *Fierro* and an influential supporter of the hybridization of genres that defined the magazine.

Perramus tells the story of a stranger who, having lost his memory, arrives at a city called Santa María, governed by a group of sinister military men who throw the bodies of their enemies into the river. Perramus—who, lacking a name, picks his moniker from the label of his jacket—becomes a member of the resistance movement. One of its members is Jorge Luis Borges, who in this world is not apolitical or conservative, but instead favors the revolutionary forces. In a conference on Quevedo, Borges secretly communicates key information for the revolutionary cause. Here, the comics do not repeat literature, but turn it into the very subject of their fiction; fragments from "true" essays by Borges, when translated into comics writing, are turned into fictional texts.

In *Perramus*—developed in a number of different magazines and even including García Márquez at one point—Breccia worked with a collage of materials and also a mixed set of historical moments. In those collages, the glued papers seem to reproduce layers of different cities, sometimes from the 1930s, sometimes from the 1960s, but also different times of Breccia's life. The album—specifically, its first prize-winning volume, the best-known example of this production—was in many ways a summa of Breccia's art.

Breccia has had a central role in the history of Argentine comics. In his work, there is everything: the will to narrate from comics in the 1930s and 1940s; the expressionism that characterizes the best of 1950s; the expressive attempts of the 1960s, when comics change their status and are recognized as a form of art; and, finally, the will for perpetual renovation.

CRITICISM, FICTION, AND HORROR

In 1984, along with a newly recovered democracy, the magazine *Fierro* was born in Buenos Aires. It set out to divulge the work of many comic artists who had published their works abroad during the preceding decade (above all in Italy, but also in France and Spain). The first issue included the section *La Argentina en pedazos* (Argentina in Pieces), explicitly created to hybridize comics and literature. In its pages, a fragment or short story from Argentine literature was adapted to comic form. Ricardo Piglia, a well-known Argentine writer and critic, introduced the corresponding comic. Thus, Enrique Breccia drew Esteban Echeverría's *El matadero* (The Slaughterhouse), Francisco Solano López tackled Germán Rozenmacher's *Cabecita negra* (Little Blackhead) and Rodolfo Walsh's *Operación masacre* (Operation Massacre), and José Muñoz adapted a fragment from Roberto Arlt's *Los siete locos (The Seven Madmen)*. The lucidity and effectiveness of Piglia, along with the graphic quality of the narratives, ended up comprising one of the exemplary books in the history of Argentine criticism and comics. Here, the presence of literature had no legitimizing role; instead, it worked as a stranger that needed careful accommodation within the space of a comics magazine. Such a section within a comic magazine, which was in itself a commercial product that sold well, is unthinkable today. *Fierro* was born at a special moment, in the midst of the cultural effervescence of the mid 1980s. With the recently restored democracy, new or forgotten books began circulating again, and journalism, film, and literature began exploring the recent tragedy of the military years. The pages of *Fierro* mixed articles on art movies, detective and noir literature, science fiction, and the history of comics. The non-academic criticism that circulated through Ediciones La Urraca's magazines such as *Fierro, Superhumor*, or *El péndulo* (The Pendulum, a magazine devoted to science-fiction literature) reached high levels of brains and precision. In their pages, Juan Sasturain, Elvio Gandolfo, Rodrigo Tarruella, Angel Faretta, Daniel Croci, Marcelo Figueras, or Pablo Capanna investigated popular genres such as comics, science fiction, fantastic literature, detective and noir stories, both in film and literature. These genres would never again receive comparable journalistic attention.

The pieces first published in *La Argentina en pedazos* were then collected in a homonymous book. Its pages are not just vignettes of a dialogue between comics and literature, but also a way of iconographically searching the Argentine past. Comics do not simply create from literature; they also find elements that, as a result of the impression left in the writer, were already present in the literary text. For instance, when Enrique Breccia works on Esteban Echeverría's *El matadero*—the first fictional text of Argentine literature, written in 1838 but published only in 1871, 20 years after the death of its author—he highlights and recuperates Bacle's engravings; when he illustrates a tango, Crist evokes the advertisements published in magazines and newspapers at the time when the musical genre was born. This is

another meaning of adaptation: the re-discovery of iconographic aspects that were already present in the literary texts, hidden as they were behind words.

Starting in 1990, when publication of the *La Argentina en pedazos* section had long ceased, a new section appeared in *Fierro*. It was called *Alucinaciones latinoamericanas* (Latin American hallucinations), and included adaptations of literary texts by well-known Latin American writers, such as Felisberto Hernández, Augusto Roa Bastos, Álvaro Mutis, and José Eustasio Rivera. Pez (Alberto Quiroga), an artist defined by his personal, baroque art, who later devoted himself to children's literature and film work (he did the storyboard for several films, including *Highlander III*, filmed in Buenos Aires), illustrated it. Also, during the early 1990s, Alberto Breccia and Juan Sasturain developed versions of literary works by some Latin American authors, including Onetti, Borges, and Guimarães Rosa, in the political and literary magazine *Crisis.*

Other than the occasional work in *Fierro*, contemporary Argentine literature was rarely explored in comics. Evidently, there were some exceptions: in the early 1980s, there was a version of Osvaldo Soriano's *Triste, solitario y final* (Sad, Lonely, and Final) by Sanyú in the magazine *Superhumor*, and Luis Scafati produced a version of Ricardo Piglia's *La ciudad ausente* (The Absent City), published as a book in 2001. Indeed, Scafati's work has been always connected to literature, not only through comics, but also through his emblematic illustrations for magazines such as *El péndulo*, *Humor*, and *Fierro*, including an illustrated version of Kafka's *Metamorphosis.*

La ciudad ausente, first published in 1992, is the only case of a contemporary Argentine novel adapted to comics. Luis Scafati worked with few captions and big frameworks, sometimes using the entire page. Working against the computerized writing prevalent in today's comics, Scafati used his stylized calligraphy, full of violent letters splashed with ink. Here, letters want to become drawings, while the latter attempt to become letters. Instead of downplaying the conflict between graphics and texts, like most adaptations, Scafati's art stages the confrontation willingly.

In 2003, a curious graphic experiment was published: *Las aventuras de Recontrapoder*, by Luis Felipe Noé and Nahuel Rando. Noé—one of the greatest Argentine artists and a member of the legendary group Nueva Figuración in the 1970s—had written an experimental narrative titled *Códice rompecabezas sobre Recontrapoder en cajón desastre* (A Puzzle Codex on Recontrapoder in a Taylor/Disaster Chest) in 1970. Almost thirty years later, he adapted it as a comic with the help of the young artist Nahuel Randó. A mix of political allegory and poetic art, *Las aventuras de Recontrapoder* has very little to do with traditional comics, but is nevertheless one of those works that allow themselves to cross freely the borders separating literature, comics, and art.

Horror comics have always had a closer relationship with literature than other genres. Science-fiction, detective, and western comics have always had their sights on film, often attempting to capture its atmosphere on the illustrated page. Instead, horror comics have been very attentive to literary horror,

from which they have taken several formal mechanisms, such as authenticating devices, growing suspense, and the unavoidable final revelation.

Horacio Lalia's work reflects well this double passion for literature and comics. He is a specialist in producing versions of literary classics, including Poe, Bierce, and Stevenson, which he collected in a comic book called *La mano del muerto* (The Corpse's Hand, published by Colihue in 2001). He also devoted two complete albums, published in France, to the works of H.P. Lovecraft. Lalia works in an opposite direction from Breccia: he is always concerned with recreating the gothic settings, their castles, basements, and crypts. In him, horror has found an exemplary craftsman, one for whom the adaptation means recovering the absolute and passionate way of childhood reading. Among his early works is the gothic story *Nekrodamus*, published in 1975 with a script by Oesterheld.

At the beginning of the 1990s, the main magazines, *Fierro* and *Skorpio*, went out of business. The closing of *Fierro* was particularly hard for those beginning their careers, since each issue included the *Subtemento Óxido* section, a few pages devoted to the work of new authors. There was also plenty of information about the work of fanzines. Upon the demise of *Fierro*, many artists began their own publications. However, lacking the support of a big publishing company, these efforts often ended after a few issues, given financial and distribution difficulties. One of these publications was *Gritos de ultratumba* (Cries beyond The Grave), which attempted to revitalize the tradition of horror comics. Lovecraft and Henry Kuttner are among the writers adapted in the pages of this magazine, bringing to mind some legendary early-1970s publications of mysterious origins circulating in Argentina, such *Dr. Tetrik* and *Dr. Mortis*.

Today, anyone perusing magazine kiosks in Buenos Aires will find no comic magazines published by a big or well-established publishing company, other than imported material. Nevertheless, there is a small-format magazine called *Bastión* (Bastion). In it, from time to time, there is the occasional adaptation of a master of literary horror. On the other hand, big albums with classics of the genre, published by Colihue and Doeyo Editores, enjoy broader circulation.

The Place of the Scriptwriter

Adaptations are not the only way in which literature and comics can meet. In recent years, the growth in fame and relevance of scriptwriters such as Neil Gaiman, Alan Moore, or Frank Miller (also an artist) and their "graphic novels"—which conclude the story in each volume, protecting it from the dispersion of serialized publication, thus highlighting unity and coherence as a single piece of work—are all signs of the pertinence of certain comics in the world of letters. A similar impression is drawn from the cross between comics and some other genres, such as memoirs and personal journals, in the works of Art Spiegelman or Will Eisner, which could be initially interpreted as the antipodes of comics.

This other possibility of dialogue, which does not forget literature, but does not simply adapt it either, had one key figure in Argentina: Héctor Germán Oesterheld (1919-¿1977?). While the work of other authors remained hidden behind characters or magazines in which they published, Oesterheld's production positions him as a distinctive author in a difficult terrain, more predisposed to anonymity than to singularity. Like his four daughters, Oesterheld was kidnapped and *disappeared* by the military dictatorship that ruled Argentina between 1976 and 1984.

In part, Oesterheld's place in Argentine culture is due to the incorporation of his work *El Eternauta* (with drawings by Francisco Solano López) to the canon of Argentine narratives. Published in serialized form in 1958 and republished multiple times since then, *El Eternauta* has been included in many collections of "literary" classics. Oesterheld's figure has been the object of multiple critical overviews, essays, and commentaries, well beyond the type of attention normally garnered by comics. *El Eternauta* narrates the story of an alien invasion of Buenos Aires. First, there is a deadly snowfall, and then, the occupying troops of "*gurbos y cascarudos*" ("gurbs" and beetles) appear, as well as intelligent "hands" (aliens are called *manos* in the original text), whose mission is the extermination of any survivors. However, there are groups of humans who actively resist with improvised weapons. The great accomplishments of this comic are its use of a familiar space as the terrain for a science-fiction narrative—something Oesterheld had already tried with *Rolo, el marciano adoptivo* (Rolo, The Adoptive Martian)—and the transformation of regular women and men into heroes.

Héctor Germán Oesterheld is the most important scriptwriter in the history of Argentine comics. Before writing scripts, he studied geology and published generally oriented scientific texts and children's books. In 1950, he began writing scripts for Editorial Abril. During those years, comics were such an excellent business that Césare Civita, the owner of Abril, had brought the Italians Alberto Ongaro, Mario Faustinelli, and Hugo Pratt to Argentina. With the latter, Oesterheld produced the memorable series *Sargento Kirk*, *Ernie Pike,* and *Ticonderoga*. From 1957 on, Oesterheld started Frontera (Frontier), his own publishing company. Oesterheld was practically the only scriptwriter for its two magazines: *Hora cero* (Zero Hour) and *Frontera*. In their pages, he published *Sherlock Time* (1958, with drawings by Breccia), and the long story of *El Eternauta* (1958, with drawings by Solano López). This moment has been considered the golden age of Argentine comics. All the elements are there: scripts are imaginative and original, attempting a new way of narrating; drawings begin to indicate a tradition of their own; and comics become a sophisticated product, simultaneously capable of artistic expression and wide popularity.

But success was not longlasting. The 1960s were a very punishing time for the Argentine comics market. It is not an exaggeration to think that decline in readership is linked to the arrival of television and Mexican publications by Editorial Novaro. With the help of Mexican artists and scriptwriters, the latter developed characters stemming from U.S. comics and television shows.

Oesterheld continued to write comics, but lacked the will to provide them with a material venue. His interest in politics deepened and was manifest, for example, in his writing of a comics biography of Ernesto Che Guevara (1969, illustrated by Alberto y Enrique Breccia). He also carried forward the curious exercise of adapting his own work, when he wrote a new version of *El Eternauta*. In 1969, he prepared a new updated and ideologized version, illustrated by Alberto Breccia for the Argentine weekly *Gente* (People). Here, he underplayed most human aspects of his story in order to highlight the ideological elements and the condemnation of capitalism. The readers' negative reaction prompted Oesterheld to turn the final pages of the publication into a tight summary of the original story. This new version of *El Eternauta* failed, but left behind some admirable images of nightmare.

Next, *La guerra de los Antartes* (The War of The Antartes) was Oesterheld's new way of approaching politics with a science-fiction script. The action takes place in a future Argentina, in which a triumphant socialist revolution is threatened by an alien invasion. With drawings by Gustavo Trigo, *La guerra de los Antartes* was published in 1974 in serialized form in the daily *Noticias*, linked to the political guerrilla group Montoneros. In August 1974, the newspaper was closed by presidential decree.

While living clandestinely—he was a militant *montonero*, in charge of some aspects of the organization's press—Oesterheld wrote a second part to the first version of *El Eternauta*, also illustrated by Solano López. During these times, Oesterheld would meet his artistic collaborators in different bars or talk to them over the phone. In 1977, he disappeared.

Oesterheld's work renews the relationship between literature and comics. If, within the context of literature, he is the most recognizable script-writer, he is so on the strength of his refusal to adapt literary works and on his insistence that comics are an absolutely autonomous creative space. Curiously, however, Oesterheld did visit the opposite route: he wrote literary versions of his comics, including *El Eternauta, Bull Rockett,* and *Ernie Pike,* but did so, not in an effort to "elevate" comics to a different cultural standing, but simply as part of disreputable collections sold at magazine stands. He placed the "written" versions of his comics among cowboy novels and pulp fictions by romance author Corín Tellado. In talking about the relation between Oesterheld and literature, in the epilogue to *El Eternauta y otros cuentos de ciencia ficción* (which collects Oesterheld's stories sans "images"), Juan Sasturain states that in 1965 Oesterheld founded the magazine *Galaxy*, devoted to science fiction, where he published stories related to this genre. Some of Oesterheld's short stories, Sasturain continues, were published in one of the first literary anthologies devoted to the genre: *Los argentinos en la Luna* (Argentines on The Moon, published by Ediciones de la Flor in 1968).

While the history of Argentine comics begins with some graphic versions of literary classics, its golden age ends with the publication of these written versions of comic classics. These inexpensive novels signal, on one hand, the possibility that comics may generate their own sub-products; on the other

hand, they also indicate that the many readers devoted to the genre had begun looking in a different direction, and that they demanded new ways of engagement.

NOTES ON GRAPHIC LITERATURE: GOALS, FAITHFULNESS, RIGHTS

Comics are a genre pulled by a double nostalgia: the call from movies and the memory of literature. Film represents nostalgia for the future, a desire for that which may or may not come, but is floating around as an always-latent possibility. Comics have ceded full sections of their mythologies to films, but have also received countless formal contributions from them. Film is always within the horizon of comics. The storyboard, turned into a regular tool in the production of movies, is a metaphor for the secret aspirations of most comics. The absence of a single or dominant author, the serialized publication that demands more a collector than a reader, are all defining traits of the genre, but they also threaten the status of comics as unitary works. For comics, the aspiration to become film is also the search for a lost unity.

Literature, on the other hand, is the nostalgia for the past, for the written origin of any story. As if comics suspected the danger of an imminent transformation, a becoming images without written words on one hand, and turning into pure words, a renunciation of drawings, on the other. Literary adaptations in comics have always reaffirmed this second form of nostalgia. They have reactivated the link of comics with literature. If comics are, by definition, a hybrid genre, literary adaptation makes that trait, that construction of a sphinx, even more marked.

The adaptation of a literary work to comics is a summary and interpretation. Although it may be similar to the task of illustrating a book, in a certain sense, adaptation ends up being its opposite since, once the boundaries of the genre have been crossed, drawings occupy center stage and texts simply become a form of additional guidance. The original text functions less as an origin than as a destiny. It is not something that is increasingly out of sight, but rather a goal being pursued.

As is the case with all mixtures of languages—the transition from literature to film, from theatre to television, from one language to another—there is an obsession at stake. It is the specter of faithfulness. This phantom speaks on behalf of the text being transposed, it brings to memory the old right of written works to be preserved without variation; it wants to repeat an old story, as in Borges' "Pierre Menard," making it look new. But the good adapter knows you mustn't respond to the demands of such a ghost, because rather than paying homage to the original, repetition erases it. In a good adaptation, only that which lends itself to transformation can remain. An adapter, like a translator, may not know the source language perfectly, but must know well the targeted one. Faithfulness always signifies fidelity set in the future: the hope that, in a future reading, both the original and its adaptation may reach a point of coincidence. Adaptation is a very special

way of reading. Like all interpretations, it aspires to overcome all previously existing versions and to leave its mark on the original text.

For a long time in Argentina, novels and films were adapted without requesting authorization or paying copyrights of any kind. Comics represented a sort of underworld. It was only in the 1990s, with the mass availability of internet and the more visible presence of literary agents, that the question of rights for the adaptation of any material became a mandatory issue. The topic of rights raises interesting issues on the concept of adaptation from a literary work. A few years ago, a publishing company wanted to buy the rights to a collection of Argentine short stories from a Spanish agent. There were no problems with the money, but the duration of the contract was a different issue. While the agent was proposing a seven-year term, as it is customary in the case of rights from books, the publishing company wanted an undetermined, open duration. The publisher's argument was that when a movie is made from a book, a new cultural text is produced and there is no built-in limitation to its circulation. After seven years, the movie is not recalled or prevented from circulating. The agent, however, insisted on her position, as though this was the case of a regular book, as though the comic were an illustrated book. The deal never materialized. This example shows how difficult it is to define the real nature of comic adaptations of literary works, pulled as they are by their dual condition of written work, depending on the book, and their search for autonomy.

Works Cited

De Santis, Pablo. *Historieta y política en los 80. La Argentina dibujada*. Buenos Aires: Letrabuena, 1992.

———. *La historieta en la edad de la razón*. Buenos Aires: Paidós, 1998.

Eco, Umberto. *Apocalípticos e integrados*. Barcelona: Lumen, 1988.

Gociol, Judith and Diego Rosemberg. *Historieta Argentina: una historia*. Buenos Aires: Ediciones de la Flor, 2001.

Masotta, Oscar. *La historieta en el mundo moderno*. Buenos Aires: Paidós, 1982.

Sasturain, Juan: *El domicilio de la aventura*. Buenos Aires: Colihue, 1995.

Mexican Comics: A Bastion
of Imperfection

Ricardo Peláez

It is paradoxical that Mexico hasn't been studied through its comics, since this is one of the more eloquent languages speaking for the country. The overwhelming number of comics and photo-novels produced monthly attests to this fact, particularly if compared to the limited number of books published. On the other hand, the reading rates of comics in Mexico and Japan are among the highest in the world (or at least, they were until recently). If cultural products shape a country's identity, then one may state emphatically that current Mexican culture is built on television, movies, radio, and comics. However, unlike films, radio, and television, no one pays attention to Mexican comics. It is a forceful reality that is purposely ignored. Not only is it disturbing that we study very little of Mexico through its comics, but also that comics are generally disregarded as an object of study in Mexico. The relevance of this situation transcends comics circles, because no serious study of national culture—past, present, or future—can be founded on such an omission.

Let's establish a minimal context for our reflections with some data: in Mexico, 99 out of 100 people can read and write, but 57 out of 100 do not use these skills; that is, they are functional illiterates. There is one book store per 85 thousand people. Income inequality ranks among the highest in the world. Ten percent of the richest population earns almost 40% of the national income while ten percent of the poorest makes only 1.5%. Finally, 44 out of every 100 Mexicans live from the informal sector; that is, they lack stable jobs (Aguayo Quezada, 2002). Taking in consideration these superficial but eloquent data, the dynamics of Mexican cultural consumption are understandable. Our penchant for cheap goods and the precariousness of our quality of life correlate well to the devaluing of cultural goods. A clear sign of this tendency is the growing consumption of music and movies in the black market. However, a study of the history of Mexican comics, particularly—as

in this case—from the perspective of identity, allows us to reveal cultural aspects that would be impossible to understand through more traditional means (art, literature, architecture, or handicrafts).

This text is divided into three sections. The first one provides a general review of the history of Mexican comics, focusing on matters of national identity. The second section involves a detailed description of the current situation of comics, willing to draw a clear distinction between local and foreign production. Based on my personal experience, the third and final section hopes to expound on a connection between collective and individual identity.

A Brief History of Mexican Comics

In *Puros Cuentos. La historia de la historieta en México* (Just Stories. The History of Comics in Mexico, 1993), research by Juan Manuel Aurrecoechea and Armando Bartra delineates the history of Mexican comics. In these texts, the authors identify four main periods: a first one, covering the end of the nineteenth century and the Mexican revolution, from 1874 to 1919; a second one, from 1919 to 1934; the third one, from 1934 to 1950; and a final one, covering from 1950 until today.

The origin of Mexican graphic narratives can be traced to pre-Hispanic times. Ancient codices may be considered the earliest relevant representation of picture reading in this area, even though, back in the early days, it was restricted to particularly privileged groups of Mesoamerican culture. All the same, only after the Spanish conquest can we really talk about a true popularization of the printed image, always linked to the evangelizing purposes of the Catholic Church. Those first prints combined "saints, apostles, martyrs of Christianity, and other virtuous images, with those of ghosts, devils, Grim Reapers, and other demons" (14) equally. Two features characteristic of the Mexican press, including comics, emerge from these printings, lasting until today: its religious and moral conservatism, and its sensationalism.

Another element that defined the local editorial tradition was a noteworthy bent for humor, irreverence, and the picaresque. For Aurrecoechea and Bartra, the first book to incorporate this trait, which remains a part of comics until today, was Fray Joaquín Bolaños' *La portentosa vida de la muerte* (The Portentous Life of Death), illustrated by Francisco Agüeros and published in 1792, though forbidden by the Inquisition. In this sense, it is enlightening to discover that one of the more solid symbols of *mexicanidad* (Mexicanness), the adoration of the Virgin of Guadalupe (Guadalupanismo), of colonial vintage, emerges precisely in printed form: from the image of the Virgin on the clothes of the Indian Juan Diego.

Independence brings along the explicit hope to define Mexican identity, and politicians, writers, journalists, and illustrators, of course, dedicated themselves to this task. In 1826, lithography "revolutionizes the publishing landscape of the time, since it allowed the development of fully illustrated

publications that were difficult to make with wood, copper, or steel engravings" (25). Many works of this period foreshadow the language of comics, through the breakdown of scenes into vignettes, and the combination of words and images into a well-integrated narrative.

Just as there was an interest to forge a motherland with the many languages available, there was an increase in popular demand of entertainment periodicals, such as romance serials, lurid news bulletins, *corridos*, songbooks, catechisms, children's stories, lithographs, etc. Then came the *papeleros,* the street vendors for these products, who became everyday urban characters. According to Aurrecoechea and Bartra, "While an artistic and invigorating Mexican lithography paints an idyllic picture of a society under construction, lacking the ability or desire to rid itself of a picturesque and rhetorical vision of national character, graphic arts shops spread throughout the country and popular demand for less pretentious publications grows" (33).

However, popular journalistic graphics weren't the only ones playing an important role in nation-building. A number of publications dedicated to social and political satire also made significant contributions. During the mid-nineteenth century, in the heat of battles between liberals and conservatives, a vital and combative journalism developed and flourished, establishing a solid school of cartoonists with a critical spirit. During the late nineteenth century, that is, with Porfirio Díaz as dictator, from 1880 to 1910, this combative journalism began to dissipate. The consolidation of a modernizing capitalist project contributed to the development of journalism, which compensated the government with obedience and support. In the meantime, inequality and repression intensified. Job opportunities for illustrators and cartoonists were abundant, generating production with a high technical quality, yet dull in content. An important milestone of this period takes place in 1880: Antonio Vanegas Arroyo, the most distinctive popular publisher, opens a press, editing all sorts of printed matter for mass consumption. Some early evidence on comics results from this experience, from collaboration between Vanegas Arroyo and famous engraver José Guadalupe Posada. Bartra and Aurrecoechea point out the importance of this work for the birth of Mexican comics. According to them, "It can be argued that this workshop's entire production foretells the world and themes of future comics. In a time when the language of comics was still in diapers, these publications satisfy a popular demand that comics will cover many years later with similar content" (35).

Until the early twentieth century, the Mexican press was heavily influenced by Europe, source of many imported products. Though local publishing was varied, it couldn't satisfy the enormous demand from rising urban centers. Since then, illustrated readings covered all social strata and contributed to national identity. The 1910 revolt politicized journalistic entrepreneurs, who employed cartoons for reactionary and conservative crusades in favor of the regime, showing little mercy for revolutionary leaders. The period between 1919 (publishing date of the first Sunday magazine with local cartoon content) and 1934 is strongly influenced by early

U.S. comics, which impose their canon on modern Mexican comics and relegate European production. During this period, Mexico goes from the nationalist, post-revolutionary comics of the 1920s, with a strong but well assimilated Yankee influence, to the overwhelming takeover of journalistic spaces by U.S. press syndicates during the 1930s.

Between 1934 and 1950, the works of national authors recapture the interest of the public. The quest for the independence of comics from newspapers and supplements—in which they appeared until then—promoted the proliferation of publications of many trends and styles, from the official ones (*Palomilla* [Little Pigeon] and *Piocha* [Cute]), to those with a clear evangelical purpose (*La Cruzada* [The Crusade] and *Juan Dieguito* [Little Juan Diego]). This is the time of massive literacy campaigns for millions of Mexicans, particularly through what were then called *pepines* (comics). During this period, "the passion for comics grows and stabilizes throughout the 1940s. Several titles become part of daily life, circulation grows enormously, and the consumption of publications becomes a national habit" (Aurrecochea and Bartra, 1994: 15). This is also the time for the consolidation of three large commercial cartels formed with the introduction of comics: one led by Colonel José García Valseca, who published the magazine *Pepín* (naming the genre); another one headed by Francisco Sayrols, with *Paquín*; and a third one by Ignacio Herrerías, with *Chamaco*. But back then, like today, real power remained in the distribution of published products. This monopoly combined the delivery—managed by Everardo Flores—and sale of comics by the Union of Street Vendors, founded in 1923 and controlled by Manuel Corchado. Though many big publishers from this period eventually collapsed, control of distribution remains an almost Mob-oriented structure till today.

To understand the future of Mexican comics, one must take a close look at the typical comics author from this period:

> Overwhelmingly young, of provincial origin or spirit, willing but inexperienced, dazzled by the illusion of success, they seem willing to sacrifice everything for their careers (...) They do not have anything else to sell except their talent and an enormous capacity for physical endurance that leads them to work in the industry without the acknowledgment of authorship or working rights. Businessmen soon learn to exploit them in exchange for bread crumbs and a pat on the back, or threats and kidnapping if necessary. (87)

Despite exploitation, there was no misery, since the frenetic rhythm of work and the enormous circulation of magazines elevated cartoonists and scriptwriters to the level of stardom. On the other hand, with editorial mobsters as bosses, cartoonists and scriptwriters were seldom conscious of a change in status. In terms of form, this is also a period in which the topics, styles, and formats of the modern Mexican comic are established, though always influenced by U.S. innovations.

The fourth and final period, which starts in the mid-twentieth century, is characterized by the disappearance of magazines and the rise of individual

issues with two to three hundred pages. These first graphic novels, predecessors of today's *sensacionales*, emerged through the introduction of informally bound versions of the most successful serials, developed by salespeople willing to rent them, and industrial publishers, seeking an outlet for their surplus production. This period also marks the comeback, published by Novaro and La Prensa, of U.S. comics, previously eclipsed by the enormous local production. With them as models, the local *historieta* (comics) embraces new formats and color in its publications, as, until then, it was strictly in black and white, or sepia. In turn, admiration for the *American way of life* spreads through the country, due for the most part to the growth of electronic media and the advent of industrialization/urbanization.

Within local comics, thematic focus suffers the least during the U.S. onslaught. The public's preferences include melodrama, festive humor, horror, bizarre adventures of wrestling heroes, biographies of famous locals, and, of course, varied kinds of eroticism. The work of cartoonist, photo editor, and writer José G. Cruz, author of the photo-comic strip *Santo, An Atomic Magazine*, based on the famous wrestler, is particularly noteworthy. According to Bartra, at its peak, it was the most popular *historieta* in the world, "with three weekly issues of thirty-one pages, that is, thirteen pages daily, more than two vignettes per hour" (Bartra, 2000: 95).

The 1960s arrive with important world events: Vietnam, the Civil Rights movement, the Cuban Revolution, and the prominent role of a rebellious youth, articulated through music, drugs, and sexual freedom. They impact Mexico heavily, where an enlightened middle class was emerging thanks to increased access to higher education. At high schools and universities, left-wing movements caught fire, confronting right-wing conservatism, which prevailed in the two previous decades with relative success. However, as the political movement began to incorporate other social groups, the government cut it short, with a massacre on October 2, 1968 and the assassination or imprisonment of student leaders, just in time to inaugurate the Olympic Games two weeks later, like a peaceful and civilized country.

In the 1960s, the Mexican *historieta* peaked in popularity, just as signs of decline also became noticeable. This resulted from a combination of circumstances and elements: the previously mentioned sociopolitical context, favorable for critical and creative initiatives; the influence of the U.S. underground and the European adult comic; a local intelligentsia that embraced pop cultural expressions shamelessly, and even explored its languages (Alejandro Jodorowsky worked in Mexican comics in these years); an increased proximity between political cartoonists and comics; and the growing educational level of *historieta* readers. Compared to earlier years, the number of publications dropped, but overall circulation was huge, with more than a million weekly issues for the most successful titles (*Kalimán*, *El libro vaquero* [The Cowboy Book], and *Lágrimas, risas y amor* [Tears, Laughter, and Love]).

In the mid 1960s, *Cuba para principiantes* (Cuba for Beginners), by Eduardo del Río, "Rius," was published, marking the beginning of

book-length chronicles in Mexican comics. A bit later, *Los supermachos* appeared, and shortly afterwards, *Los agachados,* which went from being a socially critical, amusing comic to becoming the most important educational *historieta* in the country, selling up to 300 thousand copies. Rius' case is illustrative because his invention of the educational *historieta* not only took root in our country, contributing decisively to the materialization of an identity for Mexican comics from that moment on, but also because it allowed the world to use a Mexican comic as national reference and embrace it for its own ends.

Always influential, political cartoons existed in Mexico since the early days of the press. There was constant generational change and, though at times they aligned with power, they usually fulfilled a critical purpose from an independent position. Nevertheless, there was little communication between *historietas* and political cartoons. Little or nothing could be found about political conflict in comics and few comics authors made political cartoons. It is not until the 1960s that this is done openly in the magazine *La Garrapata* (The Tick), where, in addition to Rius, the best cartoonists of the period participated in the creation of comics with political content.

The massacre of October 1968 and the ensuing years of repression were a blow to the country's political development. Generally speaking, it brought an abrupt interruption to the maturing process of culture—and comics, in particular. The state machinery established a more or less explicit, mutually beneficial alliance with cultural monopolies (television, press, radio, and film), according to which they received government support and assistance with commercial hegemony in exchange for mass entertainment and complicity with power. Personally, I believe that, if there ever was a favorable moment for the development of Mexican comics, this was it. I understand subsequent decline as the logical consequence of cancellation of social spaces due to repression and the advancement of a political system that appropriated—to its own benefit, obviously—the immense power of the cultural industry.

In the late 1970s and early 1980s, there were some studies, probably supportive of Dorfman and Mattelart, that *revealed* the possibilities of comics "as a vehicle for progressive ideas, contributing to greater awareness, and even for aesthetic forms of experimentation and expression" as a counterbalance to the "alienating" intent of this "product of industrial society." Comics were the sheepskin of an imperial wolf that had to be "expelled" in order to appropriate its language and make the most of its "great possibilities" (Gallo, 1980–1987?). In 1980, the future hard-boiled master Paco Ignacio Taibo II, intellectual son of the 1968 student movement, undertook the ambitious project of rescuing comics from publishing monopolies while working as General Director of Publications of the Department of Education. In his project, which defended them as a reading resource for most of the population, comics fulfilled a social purpose. The project had various objectives; the institutional one was the teaching of Mexican history through comics, but there were also other less explicit and perhaps more important ones, with

long-term consequences: to revert the alienating role of cultural monopolies by attacking the most vulnerable one, the publishing industry (television and radio were strategic government means and much more solid); to break the *maquila* (sweatshop) system prevalent in the production of comics; to encourage the development of auteur comics; and to promote an evolution of language in a fashion akin to Europe.

The initiative involved a number of assorted publications, all with high circulations, starting at 50,000 issues and targeting specific sectors of the reading public. The *Novelas mexicanas* (Mexican Novels) collection sought readers of short genres by adapting classic works and contemporary Mexican literature to comics in a small, inexpensive format (10 X 14 cm, B&W, and 160 pages long). The *Episodios mexicanos* (Mexican Episodes) series attracted the young and adult public, hooked on series, through dramatic fictions based on Mexican history, from the pre-Hispanic period to the mid-twentieth century, with a larger, brief format (14 × 21 cm, B&W, and 32 pages long). These first two publications were aimed at low-income readers, traditional newsstand consumers. The *Mexico, historia de un pueblo* (Mexico, History of A Nation) collection targeted better educated middle-class readers, with more purchasing power, willing to add comics to the family collection. It was co-published with Editorial Nueva Imagen and involved twenty volumes in an unusual comic-book format (15 × 23 cm, color, 88 pages long), very similar to adult graphic novels in the United States. Finally, there was a magazine called *Sniff,* published by the DOE and Editorial Penélope. Akin to *Metal Hurlant* (21 × 28 cm, B&W, 88 pages long), it included the work of Europeans, Cubans, Argentines, and some Mexicans. This publication, the most expensive, was aimed at the educated middle class, convinced beforehand of the aesthetic integrity of comics and up-to-date in fashionable cultural trends. These latter titles were sold only at bookstores. Publishing companies were involved to create a movement that could, in the short term, survive without government mentoring and stand on its own.

In addition to editorial projects, a conference and contest were organized with top-level international authors, like Carlos Giménez, Alfonso Font, Luis García, Antonio Hernández Palacios, Roberto Fontanarrosa, Alberto Breccia, José Muñoz, Carlos Sampayo, Leopoldo Durañona, and Sergio Aragonés. In terms of authors, the object was to provide access to the industry, to back working conditions incorporating copyright regulations, and to foster an awareness of authorial and working rights, thus leading to internationalization. The project also involved scriptwriting; to provide advice, aside from cartoonists, an important team of experts was invited. In 1982, Taibo II described the situation: "In the case of scriptwriters, the ones working in this industry are those who have been unable to do anything in other fields: the leftovers of the huge web of journalism, literature, and movie or television scripts have filtered into the underworld of darkness" (Monsiváis et al., 1982). After the fleeting experiment, none of the invited writers remained in the ranks of the comics industry.

Regrettably, neither work in the DOE titles nor contact between locals and foreign authors had any major consequence. There was no time to see the project's first results because, since it depended directly on government, it ended along with the presidential term and management change at the DOE. Publishers and distributors didn't even require an intimidation campaign to stifle competition from official publications.

In the 1980s, the reason for the rapid decline in sales of comics was unclear: whether it was television's omnipresence, the way that publishers became bogged down in their own formulas, or a combination of both. Most sales went to ancillary publications of the TV industry, such as *Teleguía*, *TV y Novelas*, or *TV notas*, which then exceeded more than a million copies. For Mexican comics, the last two decades of the past century were a period of collapse. Characters disappeared almost completely, granting hegemony to the graphic novel with a 12×14 cm format: the *sensacionales* published by EJEA and the large comic books by Novedades. Likewise, Grupo Editorial Vid gradually eliminated national content and focused on the translation and publishing of U.S. superheroes and Japanese *manga*. Amid this debacle, the age of Mexican comics reached its end. The 1990s brought the rise of auteur comics, the proliferation of specialized bookstores and comic events, and the increase of *manga* and superhero publications.

Contemporary Mexican Comics: Amid Global Schizophrenia

What kind of *historietas* are there today in Mexico? If we classify them according to topics, manufacture, and consumers, we can identify four large groups: *sensacionales*, superheroes, *manga*, and alternative comics. At the newsstands, the blatantly obvious ones are the *sensacionales*, although, in truth, they don't even carry that name any longer, nor does their subject matter share much with early versions. Their diminutive and brash appearance is unmistakable. Most of them have sex and some risqué title on the cover, with a warning stating, "For adults only. Sale of this product to minors is a crime. Contents may be offensive for some people." Sure enough, if these comics hold onto anything, it's their public: mostly adult, low-income workers. The number of titles is still large, but the fact that only few survive for long periods of time hints at the chronic deterioration of product. In general, since they're pornographic, they only vary in terms of narrative. We call them *sensacionales*, mainly, for the way they are produced. It has to do with a refinement of the popular, massive *historieta* system from the 1940s that progressively suffered a process of *maquilización*. The trend brought about the decline of these comics.

In the past, comics focused on characters created by authors, who provided them with a body and soul, and a distinct narrative and graphic personality. In many cases, someone took care of scriptwriting and somebody

else drew, though, quite frequently, one person would do both. In addition, there were assistants, as the trade evolved in a quasi-feudal style. Even so, in most cases, authorship involved no more than two people. Little by little, extreme division of labor ended this working style; authors became an assembly army with a formula to optimize mass production and depersonalize publication. Characters disappeared, making way for generic titles illustrated and written by anyone minimally capable of doing the job. Stories started and finished in the same issue, bringing an end to the notion of *continuará* (to be continued). This process directly threatened the rapport between reader and text: it's impossible to miss characters without a future. In this sense, *sensacionales* are totally disposable.

In France and the United States, though the labor division process exists, laudable characters not only survive, they are worshipped, recreated, and re-edited, and appear permanently fresh. In the United States, there are many comics made to order, but the industry requires authors to nourish, revitalize, and even recreate the genre. In France, it's unthinkable to conceive of a *bande dessinée* (French comics) without characters or authors, in the most revered sense of the term. In Mexico, prior to the printing stage, the production of a comic may involve up to ten persons: the editor establishes the structure of the script, a scriptwriter makes it to order, a letterer inscribes the dialogue, a tracer outlines the characters, a second tracer sketches the backgrounds, an inker shapes the imagery, an assistant (often, a family member) fills in spaces with black ink, delineates the boundaries of vignettes, and erases the pencil strokes, a colorist sets a guide for the printer on a translucent frame, and, in the meantime, two other cartoonists prepare the cover: one draws while the other one colors. Quite obviously, none ends up becoming an *author*. The process resembles Chaplin's assembly line in *Modern Times* more than the idyllic image of a lonely artist working on his drawing board. One could blame the greed of publishers for the introduction of this form of production. Nevertheless, authors contributed decisively to this "perfectionism." The rationale is simple: they discovered they could earn more money through specialization.

Exploited ad nauseam, the formula deteriorates swiftly. Publishers are unable to come up with alternatives other than more explicit sex; the greater the drop in sales, the less clothing there is on the female protagonist. Today, a measure of scriptwriters' talent is the narrative created to promote unrelenting sex marathons. The future is even darker for cartoonists, since porno *fotonovelas* leave them jobless. Most unemployed cartoonists migrate toward activities that have little to do with illustration. Given the scant demand for their skills, only those with a high rate of performance survive in the publishing industry.

Businessmen unaware of the cultural phenomenon that engendered Mexican comics manage today's publishers. They've inherited the wealth but have been unable to cultivate it. Used to old formulas with quick, fat profits, they are unwilling to risk innovation, unless it implies some other sort

of business. Still, a few owners who are aware of the artist's labor endure. In Vid (formerly known as Argumentos), the authors themselves became entrepreneurs, and the working conditions for cartoonists and scriptwriters did not vary significantly. However, general business, which yields millions of dollars in profits, is carried out without monitoring of any kind, to quantify the number of issues published. The National Chamber of the Mexican Publishing Industry, which should carry out this activity, neglects the situation.

At the newsstands, we find U.S. comics, read by many young, mostly middle-class Mexicans. Then again, the few that are available are based on superheroes. Vid translates these comics, which it sells through its chain of stores and distributes in some South American countries. Their content has little to do with national reality, so readers in different places may relate to it in identical fashion. Comics consumed by Mexicans are edited in this country but, needless to say, this does not mean these comics are very Mexican in nature. However, a relationship does exist between superheroes and Mexican cartoonists. In the past few years, small group of cartoonists have been working for the U.S. industry, under particular guidelines, of course. They are paid in dollars, but work and pay taxes in Mexico. Their work could hardly be considered as Mexican comics, especially if we consider the titles they produce are not even published in Mexico. They work for the United States because, in Mexico, there is neither an opportunity for professional growth nor a market for their line of work. Mexican publishers once rejected well-established contemporary authors—like Humberto Ramos—greatly valued in the U.S. market.

In contrast, Japanese comics (or comics drawn in Japanese style) have conquered a bigger presence, with two kinds of *manga*: the Japanese one, though printed in Mexico (mainly by Vid), and the local, which looks Japanese but is drawn in Mexico. In the latter one, the reader may perceive local influence, be it in language or drawings. Among adults, erotic and pornographic content sells well; and, among teenagers, science fiction and robots are quite popular. These comics have had, at the very least, the virtue of bringing back a female audience, a segment habitually extraneous to graphic narratives. Women mainly consume romance *manga*. In addition, as many publications indoctrinate young fans through their content—listing lessons to master the drawing style—the Japanese approach is not only consumed, but is also taught. In most magazines, *manga* represent only a fraction of the vast assortment of hobbies of Japanese origin that complement content, like anime, videogames, cards, toys, etc. Production quality among these cartoonists and scriptwriters is disparate, and the variety of Japanese titles edited in Mexico is poor compared to the quality and variety of the Japanese industry. An apprehensive spirit influences publishing, limiting licensing to stories with TV series (Dragon Ball, Ranma, etc.), or to commonplace topics assuring good sales. Generally speaking, Mexican comics are regarded as a mediocre medium for reading; in the case of *manga* and anime, there is the additional association with sex and violence. Regretfully, Japanese-style

comics at newsstands only corroborate this impression. Some *Manga*-Mex creators understand well that their work is crafted in and for Mexico, despite the Japanese-inspired style. There is also a more radical following, which, along with some young audience, shares its interest in an almost fundamentalist fashion, mastering Japanese to consume original issues and debating related topics with a quasi-religious verve.

Authors unrelated to these previous categories form the alternative comics scene. They may share points, since some went through the mainstream industry or were strongly influenced by *manga* and the U.S. comic, yet their distinctiveness remains in their assimilation of many influences and, consequently, in the production of stylistically eclectic material. These authors live mainly from work as illustrators or designers, and only tangentially from the manufacture of comics. As a result, the production of alternative comics, though irregular, is marked by a definitely experimental streak and themes reveal many kinds of personal concerns. They enjoy greater creative freedom and, for this reason, their production has also been labeled auteur comics. Their production is not consumed massively and is difficult to locate at newsstands, as they only appear in various magazines in which they collaborate sporadically, every so often gaining readers who value them and follow their production. They meet in groups to publish their own magazines or fanzines, which they later sell themselves at comic events, schools, or specialized bookstores. Since issues are almost always self-financed, they're also known as independents. Notwithstanding occasional government grants and the fact that sometimes even well established publishers edit and distribute this work, production focuses on the kind of comics that authors want.

Despite little possibilities of growth for the alternative scene, it manages to survive. This is an example of a cultural practice built from the ground up, against official policy; for this reason, it is considered an act of cultural resistance, though it lacks the coordination or agenda to be described in such gallant terms. It is also called underground comics, more for its marginal and low-scale publication than for its clear relationship with the themes and circumstances linked to the U.S. phenomenon of the 1960s. It does not support official constructs of *mexicanidad* and, nevertheless, its members thrive across the country. Undoubtedly, alternative production contains great insight and clarity with respect to the role of comics in the context of Mexican culture, as well as their possibilities of development, but the little affinity evident between its creators and the demands of a paying job, as opposed to voluntary positions, prevents a better articulation of efforts.

At this moment, from my perspective, the future is not promising. In general, there isn't a government project that goes beyond mere rhetoric. On paper, the Fox administration was ambitious about reading; then again, it is well known that President Fox isn't an avid reader. Besides, comics are absent in any effort to promote reading, in a country that, as mentioned earlier, has basically been a reader of comics. Nevertheless, both the Fox administration

and the leftist government of López Obrador in Mexico City used comics for propaganda purposes. In both cases, the result was deplorable and government understanding of the language didn't evolve. To them, comics remain a vehicle for easy access to the masses, which, through cartoons, understand messages better.

A critique of our demand for state support might suggest that cultural initiatives need to rise from the bottom up; that these are times for action and that paternalism and welfare belong to the past; that, for better or worse, such projects are in the hands of the private sector and the fortune or failure of efforts will be dictated by the market and the degree of acceptance granted the product. Well, aside from the fact that the minimal conditions and fair play necessary to make proposals work have been missing, existing rules make it difficult to undertake initiatives without substantial economic support. I am not talking about marginal publication of fanzines, but about people who, even with economic resources, had their projects fail. While many have been so poor that they almost deserved to disappear, some exhibited good quality and were even welcome enthusiastically by the public. The lack of conditions to publish has even upset foreign publishers, baffled by the Kafkian labyrinths of the Mexican market.

Personal Account of a Mexican Cartoonist

The comics scene is made up of whatever is published, whatever is physically registered. Through this experience, representative of a collective body, one may study and determine identity. Yet, this collective identity is made, in turn, of individual identities, of authors. And, how does this authorial identity, this personal creativity, come to be? As a cartoonist and comics author, I think it is enlightening to review the way in which this happens, by way of looking at my personal trajectory, and along the way, describe the circumstances of my generation. Heterogeneity may be key to our identity, but, in the end, we share a context and history.

I was born in 1968, five days before the massacre at the Plaza de las Tres Culturas in Tlatelolco, Mexico. This event marked the ensuing years of the nation and my life in particular, since my older brothers, who had lived closely the effervescence of the student movement, transmitted their political ideals and concerns to their younger siblings. As a result, there were always magazines, books, and newspapers at home, which, given the repressive environment prevailing in the 1970s, could have been labeled subversive. Among these publications, my favorites were the illustrated ones, and particularly, the only comic that my father used to buy: *Los agachados*, by Rius, which combined cartoons with politics and ideology.

It was this very ideological filter that prevented other comics from entering home. The other ones, the alienating, popular ones, were read in the streets. And, though I think the reasons to not buy these other titles—*Lágrimas y risas, Kalimán, Memín Pinguín, Chanoc,* or *Rarotonga*—were never stated

in radical terms, they were definitely at hand. However, there was also the matter of taste, the quality of the content. The middle class consumed its own products and had its own idea about what was acceptable and necessary for its youth. Therefore, a child had to read literature, not comics: in my case, novels by Salgari, Verne, or Twain. My daily visual quota involved—aside from TV, certainly—newspaper "funnies" (the only Mexican cartoonists I knew) and superhero comics that, in defiance of my elders, I purchased on my own. I recall a special enthusiasm for Superman, Green Lantern, Captain Marvel, and issues with joint appearances.

No one ever explained convincingly why I shouldn't read these comics since, paradoxically, there were some valued comics, like *Mafalda* and *Peanuts*, in addition to the ones by Rius. I'm now aware of a common misconception of the time: graphic narratives allegedly degenerated comprehension skills, as people became accustomed to *easy* reading. My mother, a schoolteacher, used to argue that spelling was learned and mastered through reading, and that there was little grammatical challenge in comics, cheap reading material aimed at idle minds. My siblings, on the other hand, censored them as tools of ideology (quite obviously, they were haunted by Dorfman and Mattelart). So they discarded all my comics and forbade me from buying any more. Yet one fine day, during a secret visit to a newsstand, I found a magazine called *The Spirit*, edited by La Prensa, a publisher that even today practices the most entrenched yellow journalism in Mexico. It was issue number 24, so, from then on, I collected it and, though it concluded by number 28, I searched for old issues till I had most of the set. As a comics reader, I think that I went through puberty with Will Eisner.

Nonetheless, the defining moment for my vocation as cartoonist was the appearance of *Snif* in 1980, with its many authors: Carlos Giménez, Hugo Pratt, José Muñoz, Alfonso Font, and Luis García, among others. About the same time, Breccia published *The Call of Cthulhu*, a comic book I deemed ugly and whose real value I only appreciated many years later. In those years, I bought almost everything published by the DOE, as, by chance, Taibo gave me the perfect excuse to legitimate my interest in comics and read them unabashedly in front of family and teachers. (Titles with the DOE logo could not be discarded easily.) Taibo's work ended as abruptly as it started, but the damage (at least in my case) was already done. I lost interest in superheroes (to which I returned years later) and started buying European comics compulsively.

In the late 1980s, many important events happened: the celebration of a broad historic exhibit of Mexican comics, introducing the winners of the first (and only) comics contest at the Museum of Popular Cultures; the release of the first volume of the history of Mexican comics by Aurrecoechea and Bartra; and the publishing of *Bronca* (Ruckus), another of Taibo's attempts towards auteur comics. After participating and earning an honorable mention in the competition, my perspectives in the field of comics became fairly clear. This event soon influenced my parents' response to my inclination for

comics. On the other hand, since I attended a graphic design program, my parents couldn't object my enrollment in college.

In those days, there were no specialized comics stores, never mind large comics conventions. Finding someone with common interests was next to impossible. This reveals a generational gap among Mexican cartoonists, since it attest to little expansion in the field of comics, in contrast with other countries. At the time, young illustrators lacked resources and there were no available schools to learn the trade. The existing studios mainly trained production teams for big publishing companies and were handled by old veterans of the *sensacionales* trade (some of whom were superb illustrators but languished and wasted in the *maquila*). Young cartoonists who lingered not only failed to rejuvenate the industry, but also aged rapidly thanks to the industry's demands.

Those of us who chose separate paths had to invent ourselves. We lacked mentors or publishers for our product, and above all, had no audience, or even a potential public, to offer new alternatives and have them considered. We learned what we could, intuitively, from editorial cartoonists, who published some comics in *La Garrapata*. In those years, Rius published *La vida de cuadritos* (Life in Vignettes), a book on the history of comics, in which some well established cartoonists offered professional advice. He concentrated on the production of books that resembled manuals of ideological indoctrination, rather than conventional comics. None of these cartoonists were ever instructors, nor did they lecture at schools. I bring this to light because, in contrast, those were the years of the Pan-American School of Argentine Comics, where, among many others, Pratt, Breccia, and sometimes, even Borges lectured.

In those days, through sporadic encounters with magazines, we learned of places where the kinds of comics we cherished were possible and successful. Europe, the United States, and Argentina were places we observed and sources for many influences. Part of my generation favored more commercial U.S. comics, like superheroes; some were more excited about the underground; others were interested in young, experimental Anglo comics (McKean, Williams, Muth); and, finally, there were people like me, more identified with European and Argentine authors. Quite obviously, I simplify a bit when I pigeonhole my generation in this way, as our allegiances chose us rather than the other way around; i.e., we were influenced by what was handy, and not by free selection from a variety of possibilities.

What kind of identity could be expected from such a disorganized and eclectic group of aficionados? Little by little, we met each other, only to discover that, in many cases, there were more differences than similarities. We did not follow tradition; on the contrary, if we had anything in common, it was our desire to not resemble our predecessors, the cartoonists of big publishing companies, who belonged to the *historieta mexicana* and incarnated the end of a golden age and the consolidation of a product industrialized to the point of shame. Had we met them face to face, we

could have learned a lot; however, by then, they had either passed away or become a fleeting memory. In the best of cases, those I befriended conserved their skills intact; their spirit, however, had withered. They remembered the DOE period sadly because, had it continued, something could have been achieved; now, all they harbored was resignation. My proximity to the publishing industry allowed me to understand one of the reasons why Mexico, despite commonalities with places like Argentina and Spain, did not experience the growth and maturity that took place elsewhere: neither scriptwriters nor cartoonists understood the role of authors. There was no contemplation, no awareness of a historic role, much less a working or social consciousness.

In 1992, the first issue of *El Gallito Inglés* (The English Cock) appeared, edited by Víctor del Real, who articulated the efforts of various, previously unsuccessful cartoonists, befriended during his years as independent publisher. Del Real tried to establish a tradition with an explicit purpose: to support a comic conscious of its context, with a language open to reality, contributing to the formation of an author in charge of his destiny; in sum, an author with a clear object and devotion to a role as creator. Despite Del Real's record as a Trotskyite expelled from many political organizations for his unconventional approach, he became responsible for the most important Mexican comics magazine in recent years. Quite sadly, he planted ideas in poor soil, downright unresponsive to this seed. Certainly, the group that remained in the magazine till the end understood and identified with his goals. However, we also had limitations (e.g., passivity) and, as today, the times did not favor ideological commitments in the creative field; ethical postures were generally viewed as useless.

When continuity between generations of authors is broken, patience and persistence are necessary to create an identity. If disasters take time (it took at least two decades to mechanize the production of comics), it takes at least the equivalent to fix anything, i.e., supposing there is a will to do so. Absent in most Mexican comics, this object was vaguely present in *El Gallito*, with some fully committed members. Then again, the magazine never represented financial gains for contributors or the director, who, despite his management skills, I doubt ever contemplated profits or a motivation other than philanthropy. Given earlier experiences, he knew perfectly well about its futility, in light of unfavorable conditions for distribution and advertising, or direct opposition to independent publishing. Previously, he had witnessed "very ambitious projects go down." Ironically, *El Gallito* twice obtained official support for independent publishing, through an annual call that today excludes comics publications. Such was the magazine's general context, rich in blunders and handicaps.

Nevertheless, it also had good aspects. First, there was a conscious posture towards production, addressing authorship without conditions or censure, as well as the opportunity to create anything you wanted. In a context defining success or failure exclusively in terms of sales, this

outlook seemed praiseworthy. Also, it formed a new generation of cartoonists. The Gallito experience lasted 60 issues, almost 10 years, a long time for an independent, self-sufficient project. In Mexico, few comics of this kind last over a year or even reach five issues (*Snif* lasted five, while *Bronca* made it to six). This circumstance allowed the eventual integration of cartoonists who consumed the magazine as children, establishing a budding continuity between generations. Throughout the magazine's lifetime, there were workshops for young cartoonists, who later contributed as authors and currently work as professional cartoonists. Unlike us, these new generations already have local references, Mexican cartoonists whom they follow, meet face to face, and learn from, to question and even confront their work. This not only happened with *El Gallito* readers; it also happened with cartoonists who never sought a following and nonetheless gained fans. In particular, this is the case of Humberto Ramos and Francisco Ruiz Velasco, who both work for the U.S. market. Another welcome development was the evolution of an audience. Thanks to *El Gallito*, we discovered people interested in our work, offsetting recurring arguments by publishers, who justified sweatshops with hypothetical demands. With this attitude, they not only undermined a potentially diverse market, but also irritated and overwhelmed the public. In addition, the flow of international comics increased. After issue number nine, Del Real became aware that the magazine couldn't survive exclusively on Mexican cartoonists, so he turned to *Fierro* (Iron) and *Puertitas* (Little Doors), two contemporary Argentine magazines, and received a steady output from them, free of charge. In this way, the array of influences for Mexican readers and comics buffs increased notably. In terms of identity, the temperament of a generation of creators isn't formed just by the way it assimilates the past, foreign or national, but also in relation to its contemporaries. In this sense, *El Gallito* fulfilled an essential task. A final contribution was the embryonic level of decentralization attained. Despite its small print run and clumsy distribution, *El Gallito* circulated nationwide, motivating interested cartoonists from other states. Some of their work was published, favoring local efforts.

The magazine ended when an overworked Del Real succumbed to exhaustion, though the scarce response from public and collaborators was disappointing. In 1999, a small group of authors (Clément, Quintero, "Frik," Camacho, and I) formed *El Taller del Perro* (The Dog's Workshop), a collective that, for five years, defined its purposes and strategies practically. We hoped to live on what we knew and enjoyed, and realized that, to be successful, we had to sell our work and preserve our independent nature. Since we couldn't delegate responsibilities, we soon discovered that we had to fulfill all duties (planning, financing, production, management, distribution, advertising, sales, and manufacture). Since we all lived and worked independently (I already had a family), we persevered and supported these activities to dissimilar degrees. In this way, we published

on our own, co-edited titles with Vid and the local government, marketed products related to our cartoons, and even taught workshops. The result was paradoxical, successful to some extent yet a failure in others. For instance, we managed to sell and distribute our products, but charged a low margin, neglected management, and, for the most part, exemplified how hard it was, in a small startup, to share work, much less with just four to five people.

Anyone might wonder whether we requested loans, or advice or support for small businesses. Absolutely, though not frequently, since what we found was rather discouraging. We were able to learn from similar experiences elsewhere, specifically, from *L'Association* in France. There, we learned the difference between startups in the rich and poor world. The problem was not lack of initiative, or the unwillingness to sacrifice or invest in a long-term effort; we had loads of it. The problem was the inexistence of conditions necessary to guarantee success of our efforts—so they could eventually bear fruit. Adversity may be an ingredient, a factor in the gestation of a group's identity, and may even become its engine and test for growth, yet it may never be a foundational and systemic condition. After the collective's disintegration, together with Patricio Betteo and Cintia Bolio, "Frik" and I formed *La Perrera* (The Doghouse), in essence, a venture like the *Taller* but sans workplace or action program. The only publication we've edited is *Zig Zag*, a children's magazine for the occasional comics workshops we teach.

Epilogue

I see Mexican culture as an uneven fabric, with brightly colored, thickly interwoven parts, where nothing may rip, even if it's still being knit. On the other hand, there are areas that are fragile, with few threads, almost translucent. In between, there are varieties of any kind. I would place Mexican comics in the middle. Today, there is a fabric, but it is disorganized, with loose ends, with isolated knots with little relationship in between. There's one group for *sensacionales*, one for superheroes, another one for *manga*, and a final one for alternative comics, each one with its own thing.

Throughout time, there were periods when this tapestry was uniform and colorful, but the fabric wasn't strengthened, things were done in an abusive way, sacrificing creativity and inventiveness. From my perspective, the most important issue is that many portions weren't connected. In large part, Mexican comics were dissociated from the rest of the tapestry by its own stars, but also by the strong official distinction between high and lowbrow culture. It is a serious mistake to study Mexican comics as a fact and accept their atomization into myriad groups, each one with specific and exclusive identities, despite a common context of inequality and an adverse sociopolitical background. In the end, it contributes to overall extinction.

Figure 11.1 A vignette from *El antojo*, a short story by Juan Manuel Servín, adapted to comics by Ricardo Peláez.

Cada día, se decían que ese sería
el último de la era de la ignominia.
y salían a la calle con el propósito firme
de no volver iguales...
de rescatar su entusiasmo extraviado
y la alegría secuestrada.

Y con el frío, la noche los traía de vuelta
 mas golpeados,
 cansados,
 derrotados
con la muerte y la desesperanza
pesando otro poco sobre sus hombros.

Se tenían tan solo a ellos mismos,
a sus debilitados cuerpos
a sus manos temblorosas
y a su fé menguante
 ...

tenían —finalmente— para luchar
contra la amante insomne
de sus propias muertes,
Un minúsculo retoño de amor
todos los días...

terco, irremediable ...

 y efímero.

Figure 11.2 Final image of *Los días de la ignominia*, by Ricardo Peláez.

Figure 11.3 A fragment of *La intensísima pasión del artista*, a comic strip by Ricardo Peláez.

Figure 11.4 A fragment of *Lacanción Lacandona*, a comic strip by Ricardo Peláez.

Works Cited

Aguayo Quezada, Sergio. *México en cifras.* Mexico: Editorial Hechos confiables—Grijalbo, 2002.

Alfie, David. *El cómic es algo serio.* Mexico: Ediciones Eufesa, Colección Comunicación, 1982.

Aurrecoechea, Juan Manuel and Armando Bartra. *Puros cuentos I, II, III; La historia de la historieta en México 1874–1950.* Mexico: Grijalbo-CNCA-Museo Nacional de Culturas Populares, 1998, 1992, 1994.

Bartra, Armando. "Fin de fiesta: gloria y declive de una historieta tumultuaria." *Curare. Espacio crítico para las artes.* No. 16, July–December 2000.

Gallo, Miguel Ángel. *Los cómics: un enfoque sociológico.* Mexico: Ediciones Quinto sol. 1980–1987?

Ilan Stavans's *Latino USA: A Cartoon History* (of a Cosmopolitan Intellectual)

Paul Allatson

Launched with considerable media coverage in 2000, Ilan Stavans's *Latino USA: A Cartoon History*, with illustrations by comic-artist Lalo Alcaraz, aimed to render accessible the history of the United States' heterogeneous Latino sectors.[1] In the Foreword, Stavans justifies the book's comic format by distancing it from Ariel Dorfman and Armand Mattelart's *Para leer al Pato Donald*, which in English translation became *How to Read Donald Duck: Imperialist Ideology in the Disney Comic*.[2] That 1971 study targeted the Disney comic as paradigmatic of U.S. cultural imperialism, a mass-cultural form capable of corrupting Third World youth with nefarious "American" capitalist and bourgeois individualist values. Stavans dismisses this argument as simplistic, tired, and tied to a bygone era of left-right Latin American antagonisms. Rather, Stavans insists, the worldwide popularity of the comic medium confirms that "Our global culture is not about exclusion and isolation, but about cosmopolitanism, which, etymologically derives from the Greek terms *cosmos* and *polis*, a planetary city" (xi). This appeal to an all-inclusive cosmopolitanism underwrites Stavans's desire for his cartoon history "to represent Hispanic civilization as a fiesta of types, archetypes, and stereotypes," and thus to avoid "an official, impartial tone, embracing instead the rhythms of carnival" (xv).

Concomitant with Stavans's ambitions to generate a highly playful historical text, *Latino USA* is also committed to elucidating the author's own personal history. As Stavans puts it, "History, of course, is a kaleidoscope where nothing is absolute. The human past and present are far more malleable than the future. This, in short, is my own account, a pastiche of angles I have made my own" (xv). Indeed, Mexican-born and raised Stavans consistently describes the genesis and final form of *Latino USA* in autobiographical terms: "The opportunity had arrived to become, finally, a manufacturer of kitsch, while paying tribute to a core aspect of my upbringing that I had

cast aside when I focused my professional career on the muses of literature and academia" (xiv). This mix of avowed professional academic status and nostalgically qualified autobiographical desire has a direct authorial effect on the narrative's capacity both as history and as a contribution to Latino Studies. Not only is *Latino USA* filled with references to and endorsements of Stavans's own publishing backlist in Latino literature and culture, but the self-avowed cosmopolitan Stavans himself appears in the text as its dominant icon, at once the governing narrator, a sideline commentator on the narrative, and an active participant in Latino history.

With its ambitions stated, and the author's centrality in the text established, *Latino USA* is emblematic of the process by which Stavans has positioned himself at the forefront of U.S. Latino Studies. This status is exemplified by Stavans's stewardship of the first course in Spanglish offered by a U.S. university, and by a prolific publishing record that has helped to establish Latino Studies in the academy, and to spread the word about the Latinization of the United States outside that country's campuses. Accordingly my interest here lies in tracing the impact of Stavans' cosmopolitan view of Latino history, and his self-conscious insertion of himself into that history, on both *Latino USA* itself and the wider terrains of Latino Studies. Despite its popular cultural comic form, *Latino USA* helps to disseminate what I regard as an exclusive conception of *latinidad*. The fluidity and accessibility of Stavans's choice of medium for *Latino USA* is intended to parallel the boundary-crossing ease that the book—and other works by Stavans—celebrates as the basis of a cosmopolitan and intellectual-centered trans-American notion of *latinidad*. This exclusive intellectual modality informs one of the selling-point laudations on the book's back cover, from Richard Rodriguez: "Not since Octavio Paz has Mexico given us an intellectual so able to violate borders with learning and grace." Overlooked in this rhetorical violation of borders, of course, are those Latinos who lack the requisite credentials of transnational and transcultural mobility reified in *Latino USA* and other texts authored by Stavans. Related to the border-violating credentials of its author, *Latino USA* contains a cluster of historiographical, taxonomic, geopolitical, and personal interests that also invite scrutiny. In focusing on these interests I have two concerns. First, to determine the extent to which *Latino USA* consolidates the figuration of Latino discourse as a "planetary" realm of and for one cosmopolitan subject. Second, to explore how *Latino USA* typifies Stavans's appropriation of Latino history and discourse so there can be no "Latino" without Stavans as and at its authorizing center.

My reading of *Latino USA*, then, emphasizes the impossibility of disentangling the text's author from its "author-function." This is the French philosopher's Michel Foucault's term for the author's appearance and function in discourse. For Foucault discourse refers to a body of related statements and utterances that combine to generate, normalize, and institutionalize a narrative of reality and associated claims to truth and knowledge, and that to some degree detach texts from the real world subjects responsible for the writing.[3] Four qualities characterize the author-function. It is

inseparable from the discursive productions of various (state) apparatuses (legal, educational, publishing, and so on). It is mutable and multifaceted, as befits its appearances in a range of intersecting historical and sociocultural contexts. The author-function is dependent on the processes by which a writing subject is discursively framed and produced as an "author." In turn, this framing may produce an author with "a variety of egos" and "subjective positions," irrespective of the writing subject's class origins (130–131). Foucault, moreover, also identifies authors who occupy a "'transdiscursive' position" (131). Such authors—Marx and Freud are his examples—are "initiators of discursive practices" in that their texts became the basis of theories, traditions and disciplines, or bodies of knowledge (131). Foucault nonetheless cautions that the change of emphasis from author to author-function does not quite entail the death, absence, or irrelevance of a living-breathing author or a writing subject. As he says, "it would be false to consider the function of the author as a pure and simple reconstruction after the fact of a text given as passive material, since a text always bears a number of signs that refer to the author."[4]

Accepting that the real-world author shadows the author-function, my contention with regard to *Latino USA: A Cartoon History* is that it does matter "who's speaking," to cite Foucault.[5] There is a tension inherent to this text between the discursive author-function and what Edward Said would call the text's discursive situation or worldliness, the web of "historical, ideological, and formal circumstances" in which a text enters the world as a product and symptom of power contests.[6] Certain discursive and material power struggles are occluded by Stavans's investment in presenting Latino history in a comic format, one that he insists attends to historical contradictions while promoting discursive innocence and eschewing "high" for "low" cultural (comic-kitsch-fiesta-carnival) qualities. The viability of *Latino USA* as history pivots on two related dynamics: first, the discursive role played by the author-function in the text; and second, the impact of the writing-subject Stavans himself on the comic's specific take on Latino history. As a consequence of these dynamics, the comic's playful coordinates and its foregrounding of historical contradictions paradoxically permit Stavans, the writing subject, to overdetermine and distort the history and civil rights struggles that are his ostensible topic.

The approach outlined here suggests the need for a clarifying statement on terminology. Although Stavans calls his narrative a "Cartoon History," I regard it as a comic that falls into the genre of history. I borrow this approach from Scott McCloud's *Understanding Comics*, a didactic comic about the comic medium, in which he distinguishes between a cartoon (a single panel) and a comic ("juxtaposed pictorial and other images in deliberate sequence," presented on the page in panels).[7] I also follow his lead in separating pictorial from written text or script. In my reading, nonetheless, I leave uninterrogated the issue of the cartoonist Lalo Alcaraz's possible inputs to the narrative's governing protocols. The Foreword leaves little doubt that narrative responsibility is claimed by Stavans alone; accordingly I cannot speculate

on Alcaraz's role in *Latino USA* beyond the level of his aesthetic and visual contribution, and his panel appearances as a character. This proviso accords with Martin Barker's argument that the comic's "meaning" is not determined by its formal qualities alone, but also by "the kind of relationship into which the reader is invited."[8] My analysis, then, is concerned with the impact of Stavans, as biological subject and author-function, on the ways by which *Latino USA* invites interpretation as a comic-framed historical narrative within Latino discourse.

THE LOGICS OF HISTORICAL INTEGRITY

Since the late 1970s the notion that the United States is undergoing an inexorable process of Latinization has gained wide currency. But rather than simply chronicle this process, many Latino cultural producers and critics have been concerned to debate how, if at all, the process is enabling a broad identification or affiliation, *latinidad*, under which people from diverse sectors may assert, and insert, their aspirations in U.S. political structures and modes of representation, as well as in transnational and continental imaginaries. As Chon Noriega describes it, the strategic use of Latino arose "because—in the popular imagination, governmental classification, and mass media distribution—specific Latino groups are not understood in national terms."[9] For Noriega, Latino does not signify an ethnic identity that overrides specific national or minority identities—Chicano, Mexican, Puerto Rican, Cuban, and so on—in the U.S. context. Rather, Latino connotes "the hilo/thread for a social movement to remap 'America,' and—in a more immediate sense—for negotiating the representation of specific histories/ identities as part of the national culture" (46). To some extent, these prospects and ambitions remain undefined, for as Frances Aparicio argues, the movement's critical practitioners operate within an "academic imaginary." That is, Latino Studies is "a potential rather than fact, a field very much in its initial makings despite the three decades of scholarly production in Chicano Studies, Puerto Rican Studies, and the emerging Cuban-American, Central American and Dominican scholarship."[10]

Given that the debates around *latinidad* emanate from a dynamic field-in-the-making based on diverse bodies of sophisticated scholarship, and characterized by institutional heterogeneity and multi-disciplinarity, the role of a text such as *Latino USA* is particularly timely. Not simply a popularizing and accessible account, *Latino USA*'s significance would thus seem to rest or fall on its ability to synthesize previous criticism, and to connect the historical experiences of the United States' Latino sectors to broader historical currents in the Americas. As a historical narrative emerging from and circulating within Latino discourse, *Latino USA* takes a playful approach to its governing brief, one that nonetheless impels its author to take certain ideological and aesthetic stands on the problem of how to manage the task of historical construction. "Nonsense," says Stavans in the book's Foreword, in reaction to the line taken by Dorfman and Mattelart that "Walt Disney's

characters, so the litany goes, are hardly about innocence" (xi). This reaction does not simply confirm Stavans's opposition to certain strands of 1960s and 1970s Latin American Marxism. It also places him at loggerheads with Foucault and Said, both of whom strenuously discredit the alibi of textuality's discursive innocence. To complicate matters, Stavans regards the comic medium as somehow immune to discourse, and thus able to control it, even to the point of disarming its disciplinarian potential. The comic's formal "unofficialness," he says, provides *Latino USA* with "a less Europeanized, more democratic viewpoint" (xv). Moreover, Stavans also sees in the comic format a manifestation of the carnival and its purportedly subversive qualities. While the Russian theorist Mikhail Bakhtin regarded the carnival as a social venue in which "low" democratic impulses could and did irrupt into social prominence, he also saw in it an ambivalent because short-lived and ultimately unthreatening response to prevailing political agents and institutions.[11] Stavans, on the other hand, asserts that his carnivalesque approach confirms the "historical integrity" and democratic credentials of his text. His democratic reading of Latino history, he claims, thus derives from and survives intact the cartoon's "mischief and caprice," its "purposeful imitation" and anarchy, its "inherently theatrical and humorous nature," and its "freshness, imagination, caricatures, and fantastical and delightfully irreverent overtones" (xiv-xv).

This commitment to "historical integrity" is tempered further by other factors, including Stavans's own biography and textual appearances, which challenge faith in the discourse of historical transparency that purportedly moderates *Latino USA*. According to its table of contents, *Latino USA* is divided into the already noted Foreword (the only part of the book not in comic form), an introduction, four main historical parts, a bipartite Epilogue—"Meet the Author, Then Run!" and "Welcome to the Future, Señor!"—an acknowledgements section, and an index. As the Epilogue's titles reveal, an icon of the Author figures prominently in his comic history. Readers encounter this Author throughout the narrative that follows and he is introduced, along with a "festive" cast of players, on the page facing the Introduction. Easily recognizable with his trademark spectacles and foppish, left-parted fringe, the Author provides commentary on the historical narrative and features in many panels as an active historical agent. He is joined and supported in this interventionist endeavor by a Toucan, included as the book's magical realist signifier, a female school teacher (la Maestra) whose presence confirms the comic's didactic ambitions, and a Calavera, a skeleton based on the engravings by the Mexican artist José Guadalupe Posada. Lesser cast players are also introduced: the Mexican film star Cantinflas; the Mexican wrestler-cum-social-activist El Santo; the latter's Anglo "nemesis," Captain America; the Chicano Cartoonist Lalo Alcaraz ("Este vato loco") responsible for the comic's black and white images; and finally, The Publisher, "the guy who counts the pennies," represented a la George Grosz from the shoulders up as a solid block of blackness with hat and smoking cigar (figure 12.1). These are not the only regular actors. Other Latin American

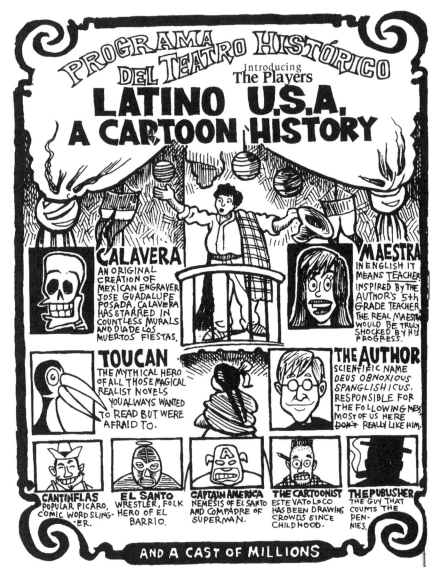

Figure 12.1 Programa del teatro histórico (from *Latino USA: A Cartoon History*, n.p.).

figures, including Che Guevara and Frida Kahlo, make repeat appearances in *Latino USA*, but unlike the four main players, they (and the lesser cast players, bar the Cartoonist) are not permitted to clarify, comment on, or dispute the historical narrative containing them.

The theatrical allusions by which these characters are introduced to the sequential format of the comic support Stavans's plan for *Latino USA* to present an irreverent historical entertainment; it is to be enjoyed, not deeply

assessed, by its readers. As the comic's recurrent icons, the regular players also facilitate the transitions from panel to panel, and contribute to a sense of continuity as the diegesis, or the comic's in-built commentary on its own historical narrative, sweeps over, and shifts between, distinct historical eras and geopolities. Yet these "naturally thespian" players (xiv) are also the main devices by which the comic diegesis purports to present and yet to toy with narrative cohesion, to transmit complicating nuances, and to generate (panel by panel, and within each panel) argument and differences in position. The approach recalls the Brechtian strategy of estranging audience expectations of witnessing the represented "real," and of recognizing themselves in that representation, through a rigorous unsettling of the (dramatic) work of art's formal conventions, a laying bare of its artifice and constructedness. Indeed, as if anticipating and abetting reader alienation from his rhetorical asides and running commentary, and the historical trajectory he directs, the Author is defined in self-deprecating terms: "Scientific name *Deus obnoxious spanglishicus.* Responsible for the following mess. Most of us here don't really like him" (xvi). As the sardonic putting under erasure of "don't" here suggests, the obnoxious Spanglish-speaking God-Author is shown reveling in his role as popularity contest contender, and yet making provision for popularity failure.

This deistic Author, of course, is not the same as the subject who goes by the name of Ilan Stavans. Rather, he is the narrative presence that, according to Foucault, operates as a textual stand-in for the real-world writer, and thus "as a complex variable function of discourse."[12] To Stavans, the supreme arbiter in *Latino USA*, are owed the titles of the four key sections, and the teleological logic they obey and convey: "Conquest and Exploration: 1492–1890"; "Into the Cauldron: 1891–1957"; "Upheaval: 1958–1977"; and, "In Search of a Mainstream: 1978-Mañana." Even before readers get to the first section, then, the comic's temporal organization pushes history in one discursively laden direction. Latino history, indeed American history in its broadest topographical sense, is inaugurated in 1492 with Columbus's first voyage. "He was the one," says la Maestra while pointing at a map of the Atlantic, "to unite the old and the new continents" (13) (figure 12.2). In the narrative that unfolds, this choice of historical origin effectively discounts all claims to modern-world status of indigenous Americans. The continent's Native peoples are swallowed up in the saga of European expansion and imperial success. They become the recipients of the Eurocentric viewpoint that the defeat and demise of Native peoples can be attributed to the inherent (socio-cultural, textual, technological, human) lacks of conquered indigenous peoples when compared to purportedly more "civilized" European cultures and peoples. Despite solid attentions to the fate of Meso-Americans after the Spanish conquest, the sidelining of pre-Columbian cultures goes unremarked, even when the Calavera asks pointed questions—"Whose big idea is that?" (12)—about the decision to opt for the Columbian genesis: "Every history starts with this poor misunderstood Italian. Couldn't we begin elsewhere?" (13). Later, in a discussion of the Chicano Movimiento in the 1960s

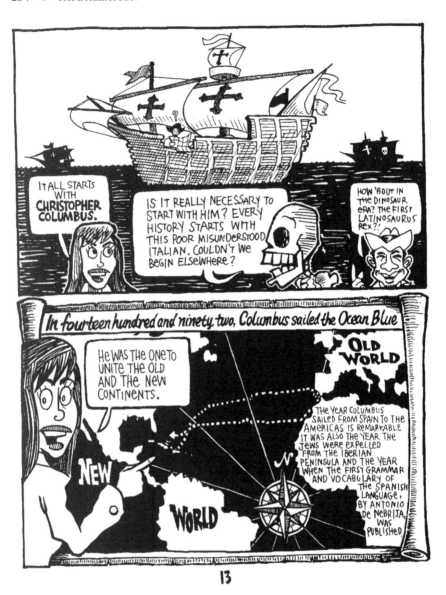

Figure 12.2 It all starts with Christopher Columbus (from *Latino USA: A Cartoon History*, p. 13).

and 1970s, the inclusion of a statement from activist and journalist Rubén Salazar suggests that the comic history has not been swayed by Chicano critiques of the Columbian-genesis thesis: "He [a Chicano] resents being told Columbus 'discovered' America when the Chicano's ancestors, the Mayans and the Aztecs, founded highly sophisticated civilizations centuries before Spain financed the Italian explorer's trip to the 'New World'" (130).

Nonetheless, the historiographical problem of ascertaining a beginning and a viable structure for *Latino USA* does affect the Author, whose anxiety on this score is rendered as two drops of sweat flying from his forehead: "How would you divide history? By definition, history has neither beginning nor end, but it is a neverending flux. It's the historians who are setting the limits" (12). Having set the beginning limits of *Latino USA*, the Author will later conclude "that history is a theater of possibilities" (166). In the intervening narrative, however, constraints on the theatrical possibilities celebrated at the comic's opening and close are evident. Responding to the Author's "what if?" scenarios about the Aztec colonization of Europe—a rhetorical inversion of the Euro-narrative of discovery, a favored trope of possibility in much Chicano cultural production—the Cartoonist asks, "The winner sets the rules, no?" (20). The drawing of attention to the proliferation of victors' narratives in the post-1492 epoch is alluded to later in a discussion of the Civil Rights era, and the Author's own question: "What is it that one wins in history?" (134). This, perhaps, is the central question posed by *Latino USA*; the comic's players constantly seek answers to it, including "better conditions, equal opportunities," and consciousness-raising "of the plight of Mexican-Americans and other Latinos," even if their overall assessment of such gains is pessimistic: "Not much has changed as a result" (134).

And yet this historiographical debate is not solely concerned with chronicling wins and losses. In a debate about historical exclusion and inclusion, ostensibly spinning off the importance to Latinos of 1848 (the end of the Mexican-American War) and 1898 (the Spanish-American War) as temporal "milestones," the Toucan, the Calavera, and the Author argue over the role of *Latino USA* as history. The Calavera reassures the Toucan, worried about its place in the sequential narrative, and by the comic's originality: "Well, originality is a tough term. See that library? How many books in it do you think are truly original? Besides, history has a set, predictable plot, but there's little room for creativity" (59) (figure 12.3). The Toucan, he adds, should be "thankful" that the Author "created us, we're figments of his imagination." Moreover, the Calavera posits that the Author—shown reading *Don Quijote* in a library whose shelves include Stavans's own *The Hispanic Condition*—has been an exemplary historian, not "miss[ing] any major event in history so far" (59). In this discussion, history is implied to be a dry catalogue of verifiable dates and facts. It is not deemed to share fiction's inventive imperatives, and its selective, exclusionary, and arbitrary ordering principles. However, the message to readers on this score is ambivalent, for the comic's function as historical record appears to collapse in the contradictory shifts between, on the one hand, self-conscious recognition of historical artifice, and on the other, anxious appeals to historical verisimilitude. *Latino USA* is arraigned against the fixed predictability or eventuality of history because of the Author's "unofficial" ambitions (xv), here codified in comic format. And yet the narrative's "unoriginality" and playfulness are also claimed by the Author to respect "major [historical] events." It is thus

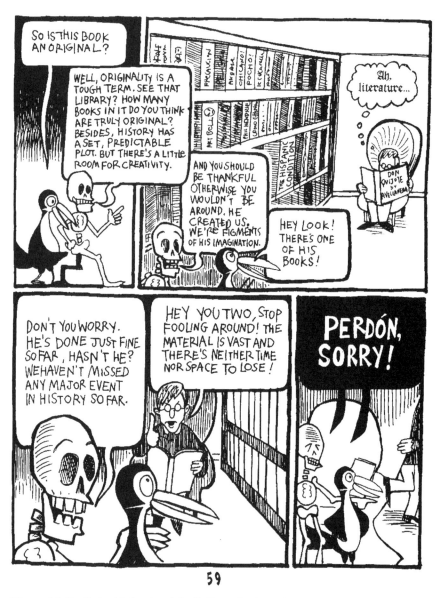

Figure 12.3 So is this book original? (from *Latino USA: A Cartoon History*, p. 59).

never clear whether *Latino USA* approaches history as a narrative construct open to myriad interpretations and manipulations, or as an empirically substantiated and finite list of occurrences.

It could be argued that this diegetic slipperiness does not matter within the governing "festive" logics of the narrative. History provides the Author with an appropriate generic vehicle for indulging his sense of play while claiming to respect historical truth. Nonetheless, it is also possible

to recognize that this Author-directed play generates a see-sawing dynamic between opposed notions of history—rather than an acceptance that in historical discourse, truth (events) and fiction (historians' subjectivity; narrative construction) defy disentanglement—thereby marooning the players in a script of constant contradiction, equivocation, and generalization. Within the comic's overarching teleology, these effects are fixed by the four historical divisions, the first being "Conquest and Exploration: 1492–1890." The dating here suggests a neat continuum from Spanish imperial to later U.S. national expansions, although the section bypasses Spanish colonization in the Caribbean and covers only those territories now subsumed into Mexico and the U.S. southwest. From this initial stage the narrative moves to "Into the Cauldron: 1891–1957," presented as the era of hemispherical events responsible for the first significant mass migrations from Latin America to the United States. This is followed by "Upheaval: 1958–1977," which describes the Cuban Revolution and the rise of various Latino protest movements, and finally, "In Search of a Mainstream: 1978-Mañana," whose title and content propose that Latinos, like *Latino USA*, are about to reach the desired teleological endpoint of social respectability and national significance, if not political power.

Stavans's speculative vision of Latino history as the movement of Latinos toward inevitable mainstream success and influence informs much of his writing. Similar speculations on Latino history, for example, are evident in his *The Hispanic Condition*: "Ours is Montezuma's revenge. We shall infiltrate the enemy, we shall populate its urban centers, marry its daughters, and re-establish the kingdom of Aztlán. We are here to reclaim what we were deprived of, to take revenge. This isn't a political battle, a combat often stimulating to the liberal imagination, but a cosmic enterprise to set things right."[13] Aside from the masculinist, heteronormative desire at work here—Stavans's "we" excludes women and queers—the rhetoric, like that in *Latino USA*, exemplifies what Chon Noriega has targeted as the "Sleeping Giant" allegory. This refers to the process by which "Latinos are imagined or represented as 'potential citizens' rather than as actual ones. The struggle over civil rights, political representation and cultural pluralism, then, becomes an agenda for some future date, with the onus placed upon a hypothetical image for the Latino community. And while the giant sleeps, it has no past and no present."[14] Noriega is especially critical of Latino intellectuals who have popularized the Sleeping Giant thesis and "undertaken a leveraged buyout of *Latinidad* based on its future performance (in consumption, reproduction, electoral politics)" (47). This is precisely the message transmitted by the Author's concluding line in *Latino USA* that "history is a theater of possibilities" (166). Under the Stavans author-function, which is driven by the thesis that "The sleeping giant can (and will soon) awaken," Latino social struggles of past and future become play, the matter of allusion and illusion, not historical-material action and hard-fought achievement.[15]

These speculative concerns for the Latino future aside, the comic's linear approach to the Latino historical record is under internal pressure in

other ways. Little assistance is given to readers to ascertain the precise rea-soning behind the comic's arbitrary temporal divisions or their historical content, and at times, historical events are discussed in apparent disregard of the comic's temporal dynamic. For instance, to mention three oddly posi-tioned examples, the "1891–1957" section includes the sixteenth-century discourse of the Black Legend (a demonization both of the Spanish character and the Spanish imperial project that arose among Spain's rivals in largely Protestant northern Europe), the "appearance" of la Virgen de Guadalupe to Juan Diego, and the emergence of Latin American states, Mexico excepted, since its national genesis is noted earlier. Another oddity occurs in the panel that details the coming to independence of Spain's Latin American colonies. Here, the Maestra recalls that Puerto Rico achieved its independence from Spain in 1897, a claim that would surprise residents of the island, then and now (49). The Author, however, has a comment on the narrative's "play-ful" approach to historical content that provides him with an explanation of sorts, an appeal to the systematic biases inherent to all historical endeavor: "History is nothing but the attempt to systematize human memory. And memory is so fragile, so subjective. Each historian ends up writing an account that is suitable, convenient to him [sic], that justifies the past in his [sic] eyes" (98). Disguised by this admission is the link between the Stavans author-function's ability to center a discourse in specific institutional contexts, and the process by which those discursive and institutional sites direct substan-tial benefits to Stavans, the writer subject.

DISCURSIVE INNOCENCE OR INTEREST?

As the Author admits, it is impossible to avoid constructing his, indeed any, historical narrative without recourse to such criteria as suitability, con-venience, and self-justification. Yet this explanation also implies that the scripted approach to the complex processes of U.S. Latinization adopted in *Latino USA* cannot be anything but discursively weighted, despite the Author's claims about the comic's ideological innocence. Symptomatic of this discursive weight are the many appeals to lowest-common denominator ethnic clichés, as exemplified by the Author's intervention, delivered from the panel sidelines, that "Pan y circo, tacos and soccer, is what Latino cul-ture is all about" (9). Indeed, when the Toucan says that "Latino history is like a crowded fiesta: masks, music, and endless energy!," the Author's response—"What a cliché!" (11)—confirms his functional inconsistency, since throughout *Latino USA* he is often the device responsible for similar typecasting. Even in moments when the stereotyping urge is parodied, it is clear that the Author's rhetorical flourishes amount to a relentless tropical-ization of Latin(o) peoples and cultures. According to Aparicio and Chávez-Silverman, tropicalization refers to a "system of ideological fictions [by] which the dominant (Anglo and European) cultures trope Latin American and U.S. Latino identities and cultures."[16] Two simultaneous trajectories are evident in this system. First, tropicalizations of Latinos—the production of

tropes characterized by references, among others, to an erotic-exotic, dark and sinuous "Latin" sensibility, to superstitious-cum-magical Catholicism, to heat, spice, emotionality, musicality, and barely repressed violence—are "distributed among official texts, history, literature, and the media" and disseminated throughout U.S. society (8). Second, and in dialectical tension with official tropicalizations, Latinos may attempt to appropriate such "ideological fictions" in their own cultural-political productions, the aim being to divest them of their negative connotations, to resemanticize and politicize them, and to recirculate them as Latino friendly images (12). That said, Aparicio and Chávez-Silverman warn, this counter-hegemonic struggle at the level of representation can and does not preclude Latinos from tropicalizing themselves. Latinos, too, may produce and distribute damaging tropes of latinidad in ways that replicate and mirror dominant-cultural protocols (11).

Latino USA is filled with examples of damaging tropes of latinidad as its ethnicized tropicalizations merge with gendered ones, thus undermining the Author's claim to construct what Barker calls "an authentic collective representation."[17] In one of the Author's what-if speculations, he asks, "What if our [an undefined possessive in the script] view of beauty had Indian women, bronze, svelte, stunning, as its ideal, and not its Iberian counterparts?" (20), thereby betraying his heteronormative eroticization of Native ethnicity, and reiterating the point he makes in the Foreword that a "beautiful señorita" (another recurring icon in *Latino USA*) encapsulates "the exuberant sexuality I grew up with" (xv). Later, when discussing the representation of Puerto Ricans in *West Side Story*, the Calavera mocks a prevailing cultural assumption that "all Latina girls [are] named María" (99). But the critique appears to be forgotten a few pages later when the setting shifts to Dade County, Florida, and a Spanish-language teacher and her student parrot the line, "Yo me llamo María" [My name is María] (106). These "Marías" may well be intentionally named. But they also support a more literal counter reading. Despite the Author's argument with "the recurrence of stereotypes," that critical stance is invariably followed, in the same or following panel, by enthusiastic endorsements of a Latin(o) "tropical spirit" (44–45).

Aside from establishing the tropicalizing contours of the Author's script, the Introduction also attempts to define "Latino" peoples and to explain why they are of narrative interest in the comic's four historical sections. The Introduction emphasizes the profound sociocultural and political changes brought about by the numerical increase in Latino populations in such areas as cuisine, language use, sport (the rise of soccer), electoral power ("We will be able to decide who the next President is" [9]), and racial/ethnic make-up. The entire narrative, in effect, works toward validating the Author's take on the historical inexorability of U.S. Latinization. Confirming his reading of U.S.-Latin American relations as the temporal lead up to a preordained Latino order, the projected statistics on the demographic break-up of U.S. sectors in 2025 are rendered in

an "enchilada"—another tropicalizing sign—superimposed on mainland United States, with Latinos (23%) shown to be more numerous than Blacks (17%) and Asians (21%), but not yet as numerous as Whites (29%) (8). The U.S. future portrayed in *Latino USA* will soon be seamlessly Latino. But that speculative drive is nonetheless preordained by the comic's representation of the "American" past as U.S. "Latino" history. Anything and everything, it seems, can be appropriated into that history, from Spanish colonization and Catholic evangelization to the Monroe Doctrine, from Cabeza de Vaca's chronicle of shipwreck and survival and Stephen Crane's writings on Cuba to magical realism, from slavery and Latin American nation-building to *West Side Story*, from *I Love Lucy* and Cantinflas to the Mariel boatlift, from Pablo Neruda's poetry and Diego Rivera's murals to barrio graffiti, and, from *Time* cover images and U.S. space exploration to Stavans's own published backlist.

While the playful provisions of data and topics of coverage in *Latino USA* do convey some sense of the far-reaching demographic impact on U.S. society generated by U.S. expansion and hemispherical power, and of ongoing mass migration from Latin America, that playfulness also impacts on the way those populations are conceived and identified in the comic. The text foregrounds the term Latino, but grudgingly, as attested by the Author's description of it as an "in-vogue" term, and his prediction that by the time readers get to the text, another term will have replaced it (7). The Author, in fact, prefers the term's rival—"I like 'Hispanic' the best" (7)—thereby dispensing with the longstanding Latino critical debate over terminology, much of it generated in angry response to successive U.S. government usages of Hispanic, that has dominated Latino discourse since the late 1980s. The Author's preference for Hispanic is balanced, at least in the panel in which it appears, by the Cartoonist's reaction, "His Panic makes me panic!" (7), but the comic glosses over the political tensions alluded to in this contrast in opinion. In the enchilada-chart, moreover, "Latino" is conceived as a "minority group" of the same conceptual order as "white," "black" or "Asian," that is, a racialized category. "Spanish" is often used in the comic, although the script does not clarify if this designation refers to a national, linguistic, or culturally determined collective: "In 1776, when the declaration of independence was announced there was no Spanish presence in the new United States of America. That wouldn't happen until the first Puerto Ricans and Cubans arrived in 1853" (25). The Author also expands Hispanic/Latino so that either term can encompass Spaniards; thus, Felipe Alfau becomes a "Latino" writer, not a Spanish-migrant writer (60). The inclusion of "Spain" under the Latino rubric also leads to identificatory anachronisms, exemplified by the panels in which the Calavera describes the Conquistador and writer, Cabeza de Vaca, as the "first Latino to be lost," an ironic reference to the many years spent by the shipwrecked Spaniard among Native Americans in what is now U.S. territory in the sixteenth century (16). Elsewhere, the Movimiento is referred to as a Latino phenomenon, rather than a Chicano civil rights enterprise (109).

At the very least, the many identificatory options on view in *Latino USA* reveal confusion over what and who precisely is being discussed. While this does perhaps reflect the innate instability and contestability of the identity terms themselves, the presentation of taxonomic uncertainty in the comic tends to flatten the demographic and aspirational complexities and conflicts (most obviously racial, but also class and gender/sexual) between and within what the text calls Latino "subgroups" (8), collectively the most racially mixed of U.S. populations. The proliferation of options thus echoes the homogenizing aims of the U.S. Census, which in 2000 provided three terms of purported equivalence—Spanish, Hispanic, Latino—by which respondents could self-identify. The Census Bureau's conflation of Latino, Hispanic and Spanish suggests that this particular U.S. state apparatus regards identifications based on linguistic (Spanish, Hispanic), national (Spanish), and ethno-cultural (Spanish, Hispanic, Latino) factors as synonymous. By also regarding the three terms as interchangeable, *Latino USA* perpetuates a similar logic.

These signifying moves link *Latino USA* to other texts in which the Stavans author-function is at work. In an interview posted in the Spanish e-journal *Cuadernos Cervantes*, Stavans rejects the term minority to designate U.S. Hispanics, and proposes that they comprise a set of national groups united by a common language and historical heritage.[18] Hispanics as defined here must speak Spanish, thus disenfranchising millions who speak English only. And by assuming that "historical heritage" is shared, and provides a coherent vector of communal identification, Stavans overrides the disparate and often conflict-ridden historical experiences of U.S. residency, and of Spanish colonialism, between and within Latino groups. The taxonomic conundrum continues in one of Stavans's more detailed comments on the Hispanic versus Latino debate:

> Hispanic, generally preferred by conservatives, is commonly used when discussing demographics, education, urban development, or health policy. Latino is generally preferred by liberals and is more often than not applied to artists, musicians, and movie stars. The government uses Hispanic to describe the heterogeneous ethnic and cultural minority with ancestors across the Rio Grande and in the Caribbean archipelago. But the majority of citizens of that region acknowledge Latin America as the correct English designation.[19]

But later in the same article he opts for Hispanic—"a more accurate and convincing term and thus I'll stick with it" (3)—unabashed by the fact that this choice allows him to be identified, according to his own wording, as a conservative. As with *Latino USA*, however, the Stavans author-function also at times uses Hispanic as a linguistic signifier only, "because language is the main factor here, a vehicle of one's thoughts."[20] Finally, yet another take on terminology is proposed in *The Hispanic Condition*. Faced by the rise of Latino, a term he has always distrusted, Stavans feels authorized to pronounce: "I herewith suggest using *Latinos* to refer to those citizens from

the Spanish-speaking world living *in* the United States and *Hispanics* to refer to those living elsewhere. Which means that, by any account, a Latino is also an Hispanic, but not necessarily vice versa."[21] Here, the relocation of Hispanics to an undefined but clearly non-U.S. elsewhere begs the question why Stavans prefers Hispanic when dealing with U.S. cultural terrains, yet settles for Latino when providing his comic with its title.

One explanation for these apparently shifting and contradictory preferences lies in a fundamental aspect of the Stavans author-function's discursive power: its assumption of authority-figure status. Stavans's arbitration of the Latino/Hispanic debate can only be made because everything he says on the matter—in university classrooms, electronic media sound bites, press interviews, essays, books, anthology introductions, a comic—is predetermined by the author-function in expert mode and designed to perpetuate that function. This functional success depends on two factors. First, the expert position implicitly carries the authorizing imprimatur of the author-function's institutional (academic, publishing, media) connections, which in no small part support the production and frame the worldly receptions of the author's texts. Second, expert status is based on the naturalizing premise that the worldly authority it signals will be accepted and respected, not scrutinized.

As it pans out in *Latino USA*, this usurpation of the expert position also locates the Stavans author-function on one discursive side of the debates over identity terminology. Noriega provides a useful sense of these debates as a struggle between dominant and counter-discursive interests. Discussing the contradictions and tensions accruing to two terms that ostensibly designate the same populations, he says: "The fact that 'Hispanic' emerges as a U.S. census category suggests the difficult play between race and ethnicity, as the government seeks institutional control through homogenization ('Hispanic'), and social movements undertake radical social change through the formation of a collective identity ('Latino')."[22] Notwithstanding a title that bears the term favored by liberals and radicals, social activists, and many cultural producers and commentators, *Latino USA* consistently betrays its Author's distance from the counter-discursive option. Latino, and not Hispanic, is preferred by many Latino critics because it avoids the Spanish (Europeanizing) shadow that makes Hispanic the attractive option for community conservatives, U.S. government apparatuses, and the Stavans author-function alike.

The Stavans author-function's stance on the identity question in part supports Noriega and López's argument that since Hispanic and Latino refer to the same sectors, the key issue lies in the different political motivations for their deployment.[23] Yet, as those critics also recognize, all identity categories, including Latino and Hispanic, are subject to epistemological slippage and obfuscate differences. Thus, notwithstanding the issue of political usage, the Latino versus Hispanic conflict is always in danger of being locked into an either/or argument, thus ignoring other axes of dispute and action. Questions arise, then, about Stavans author-function's indefatigable

intervention into what Suzanne Oboler calls a "false debate—insofar as, like the label Hispanic, the term Latino or Latina, or even Latin American, does not solve the problems raised by existing national and linguistic, class and racial differences in the U.S. context."[24] Throughout *Latino USA* those differences are sidelined if not ignored because of the narrative's insistence on deploying potentially antagonistic or inappropriate identificatory options. Latino does not only grate against Hispanic in the narrative; the comic also perpetuates a notion of Latino/Hispanic as by turns a racialized designation, a multinationally vast entity, one that includes Spain among its component parts, and an equally vast linguistic space, *el mundo hispanoparlante*, in which U.S. Latino specificities may not even count. It is perhaps not unco-incidental that the only historical presence in *Latino USA* to figure in all of these options is the Author himself, a figuration that again raises the issue of what the Stavans author-function and its worldly referent (the author) might gain from arbitrating Latino and Hispanic in the expansive way it/he does.

The Alibi of Intellectual Cosmopolitanism

Stavans has characterized his popularizing mission in these terms: "I write in English for Americans about topics they know little about, and I write in Spanish for Mexicans about topics they are unacquainted with. I act as a bridge, I symbolize dialogue…I am the owner of a divided self and am sure that my circumstances come as a result of exile and, also, of a polyglot existence."[25] Left undefined in this confession of altruism, and in the Author's comments about his hopes for his comic as well, is the make-up of his intended audience. In the case of *Latino USA*, a U.S. readership is perhaps the comic history's obvious beneficiary; but this audience could mean, variously, school-children, Latinos of all ages, Anglo-Americans of all ages, Latinos and Anglos alike, other academics, or perhaps an imagined coterie of regular readers in thrall to the Author's penchant for littering his texts with self-referential clues. That said, the comic's hard-cover presentation and cost, US$20, as well as its decidedly high-cultural internal references that require a certain level of reader familiarity, suggest a highly educated and economically privileged readership, one that cannot be aligned with the ranks of comic consumers in both the United States and Latin America, where comics are mass-produced and affordable. Yet with no clear parameters for identifying precisely its audience, the impression arises that *Latino USA* was conceived, produced, and sent out into the world as if its lot were transcendental homelessness, to borrow Heidegger's formulation. Perhaps the comic was intended for all readers, for all inhabitants of Stavans's "planetary city," in keeping with the author's didactic bridging aspirations.

Stavans's self-anointed bridging function is presented as if no other Mexican or "American," Latino or otherwise, has ever attempted a dialogue, or indeed attempted to do the comic work that *Latino USA* purports to do. A case in point, and a highly apposite one given that it was the first comic-book account of Chicanos, is *The Chicanos*, a text dating from 1973 by

the Mexican cartoonist Rius.[26] Produced by the North American Congress on Latin America (NACLA), *The Chicanos* is an updated translation into English of the original Spanish-language comic in Rius' "Los Agachados" series, from Editorial Posada. As with much of Rius' work, and as its foreword indicates, *The Chicanos* is informed by a leftist political agenda that targets the U.S. "government and its imperialist policies." Interestingly, it also advocates a trans-border alliance between Mexican workers and intellectuals and the Chicano workers in the north. *The Chicanos* is self-consciously didactic and, like *Latino USA*, utilizes recurring characters and icons to construct its historical narrative of gringo exploitation and Chicano victimization at the hands of bosses and state agents alike. Although Stavans refers to Rius in the foreword to *Latino USA* as an important forerunner of his own comic history, he does not mention *The Chicanos* as either a significant antecedent or influence.

One possible explanation for this oversight, and for Stavans' self-conscious assumption of a pan-American bridging role that overlooks prior dialogues and cultural productions, might lie in the author's figuration of himself, using V.S. Naipaul's terminology, as an exile, a "man of no tribe."[27] This variant of transcendental homelessness provides the Author with an ambivalent, yet productive, location: "it [exile] can give you freedom; you don't have to be loyal to a set of symbols, to patriotic concepts. On the other hand, you will retain a sense of loss: everyone else belongs somewhere."[28] But the logic here is disingenuous. Casting himself, and his texts, into that amorphous place of potential and pain called exile, Stavans glosses over his unequivocal homeliness in U.S. academic and publishing apparatuses, the bases from which he projects his writings into the wider "Hispanic" world, and inserts himself into the terrains of U.S. Latino culture as its chief advocate. The Stavans author-function thus resonates from textual into material-world terrains, with Stavans himself emerging, to cite Caren Kaplan, as an exemplary "cosmopolitan intellectual or writer...proclaiming liberation politics from the safety zone of privilege, traveling to accrue and control knowledge in the name of [Hispanic] multiculturalism."[29] As if to underscore the uncontroversial, comfortable, and state-friendly coordinates of his "exile" in the United States, the Author appears in the Epilogue to *Latino USA* waving Mexican and U.S. flags, while a conversation balloon proclaims, "America, America sweet land of liberty!" (159). It is a heavily ironic scene, but perhaps not in the way the Author imagined.

The discursive situation by which the Stavans author-function appears as "el zar" [the tsar] of Latino culture, to use a description from the Spanish newspaper *El País*,[30] reflects, in the Foucauldian sense, a will to appropriate a "transdiscursive" role as the "initiator" of Latino discursive practices.[31] This move to founding-father status clearly surpasses the author-function's more modest brief "to characterize the existence, circulation, and operation of certain discourses within a society."[32] In *Latino USA* and other Stavans-penned texts, the omnipresent Stavans author-function dispenses a self-legitimating version of both the Latino identification he occupies despite exile, and the

field of Latino Studies he popularizes and centers. Stavans, in effect, subsumes *lo latino* into the cosmopolitan romance of a *pax latinoamericana*, with its origins and dominant logics anchored in a Spanish (national, literary, linguistic, gendered) patrimony. In this romance, geopolitical borders, and class, racial, and gender/sexual divides, offer few obstacles. His discursive situation so sanctioned, the Stavans author-function finds its modus operandi and authorial alibi. Since his true discursive home is intellectual cosmopolitanism-cum-exile, Stavans never need explain his post-European, post-Mexican residency as the endgame result of a move by a Mexican-trained critic to a more lucrative and institutionally powerful seat in the U.S. academy. Lost in this dissembling approach to his personal trajectory are the historical-material benefits that derive from the Author's interventions in the highly charged terrains of Latino cultural politics. Stavans generates his texts as if his physical, institutional and discursive mobility does not confirm the separation of his cosmopolitan world from that of the Latino millions who have yet to find solace, safety, or security in the romance he popularizes. Stavans never admits that in order to pronounce authoritatively on a broad Latino habitus he must expand the conceptual edges of "Latino," or better Hispanic, into exclusive cosmopolitan territory so that his migrating-academic self can slip unquestioned into it.

Latino USA's back cover suggests, in principle, that these matters do preoccupy the Author: "Will all taco lovers please stand up? There's no doubt about it, Latinos are a social force rapidly revolutionizing the texture of America, but who are they? A single homogenized group or a sum of minorities? Are they all linked through a common language and ancestry?" But *Latino USA* sidesteps answering these fundamental questions. The comic confirms the Author's failure to sustain a desimplified transnational and transcultural understanding of "Latino" even as he expands that designation into planetary terrain. And the narrative takes up the tropicalizing spirit of the "taco lover" reference to perpetuate a consistently clichéd reading of *lo latino*. More to the Stavansian point, the back-cover questions are framed by sound bites of "Praise for Ilan Stavans," which laud him as the trailblazer of Latino Studies (figure 12.4). Readers encounter renowned García Márquez translator, Gregory Rabassa, holding a tome entitled "100 years of Ilan Stavans" while approving Stavans's "grip" on "Spanish America." Readers perceive an endorsement of Stavans's "opening [of] the door" on "Hispanic culture" from the Spanish newspaper *El País*. They are met by Chicana Kathleen Alcalá's claims that *Latino USA* might even provide the antidote to a century-and-a-half of Anglo-U.S. accounts of the Alamo, and similar claims about Stavans's "giant leap forward in setting the record straight" from Colombian-born Jaime Manrique. And readers are presented with the fulsome commendation of Stavans's friend and "Hispanic" ally, Richard Rodriguez, for whom Stavans is the border-violating intellectual par excellence, the heir to Octavio Paz, despite that particular intellectual's concerned dismissal of Mexican-Americans as irredeemably abject. Forgotten in this catalogue of praise are the many Latino cultural producers and critics

Figure 12.4 Praise for Ilan Stavans" (from *Latino USA: A Cartoon History*, back cover).

who, over many decades, have labored to set the Latino historical "record straight." This figuration of Stavans as the inventor of a "new," never before countenanced, Latino purview has obvious implications for the selected Latino cultural producers and critics whose viewpoints he mediates and samples in *Latino USA*.

The defining characteristic of the Stavans author-function would seem to be an indifference to its inhabitation of an epoch that has come to distrust, in

Foucauldian terms, the intellectual who "place[s] himself 'somewhat ahead and to the side' in order to express the stifled truth of the collectivity,'" in this case the stifled imagined Latino collectivity.[33] In the conversation with Gilles Deleuze in which Foucault's stand against this breed of intellectual appears, Foucault offers some suggestions for a critical project that not only refuses to regard the intellectual as self-designated arbiter of truth, but heeds Deleuze's warning about "the indignity of speaking for others" (209). The only viable critical agenda is to "struggle against the forms of power that transform him [the intellectual] into its object and instrument in the sphere of 'knowledge,' 'truth,' 'consciousness,' and 'discourse'" (208). The critic's task is to identify and thus begin to sabotage—by "denouncing and speaking out"—the myriad ways by which intellectuals may come to dominate speech and benefit from exclusive discursive positions. The intellectual author-function thus requires careful scrutiny precisely because of its often unremarked and unremarkable power-generating capacities. Indeed, to cite Edward Said here, such scrutiny of the author-function and its writing-subject shadow must accredit "the self-confirming will to power from which many texts can spring."[34] This, then, might be the appropriate response when readers of *Latino USA* confront the Stavans author-function as it violates borders, moves in cosmopolitan mode in safe U.S. "exile," presumes to speak regardless for all Latinos, and takes refuge in "innocent" comic play. These discursive sleights of hand invite "all taco lovers" (and critical allies) to take the first step in reversing the power that has named them as such, and then inscribed them into the comic "fiesta of types, archetypes, and stereotypes" that is Stavans-centered Latino history.

<div align="center">Notes</div>

I would like to thank Lyn Shoemark, Trish Hill, Murray Pratt, and Diana Palaversich, as well as the other participants in the Workshop on "The Death of the Concerned Intellectual," celebrated at the Institute for International Studies, University of Technology, Sydney, Australia, in December 2002, for their comments during the writing of this chapter.

Exact material to be reproduced: Ilan Stavans, /*Latino USA: A Cartoon History*/, Basic Books, 2000, ISBN: 0465082211. PAGES: programa del teatro histórico (after foreword, no page), 13, 59, 127, 138, backcover.

1 Ilan Stavans, *Latino USA: A Cartoon History*, with illustrations by Lalo Alcaraz (New York: Basic Books, 2000). Further references to this text are indicated in parentheses.

2 Ariel Dorfman and Armand Mattelart, *How to Read Donald Duck: Imperialist Ideology in the Disney Comic*, trans. David Kunzle (New York: International General, 1991).

3 Michel Foucault, "What Is an Author?," in *Language, Counter-Memory, Practice: Selected Essays and Interviews*, ed.. Donald F. Bouchard, trans. Donald F. Bouchard and Sherry Simon (Ithaca, NY: Cornell University Press, 1977): 124.

4 Foucault, "What Is an Author?" 129.

5 Foucault, "What Is an Author?" 138.

6 Edward Said, "The World, the Text, and the Critic," in *The World, the Text, and the Critic* (London: Vintage, 1991 [1983]), 50.

7 Scott McCloud, *Understanding Comics: The Invisible Art* (Northhampton, MA: Kitchen Sink Press, 1993), 9.

8 Martin Barker, *Comics: Ideology, Power and the Critics* (Manchester and New York: Manchester University Press, 1989), 133.

9 Chon A. Noriega, "*El hilo latino*: Representation, Identity and National Culture," *Jump Cut* 38 (1993): 46.

10 Frances R. Aparicio, "Reading the 'Latino' in Latino Studies: Toward Re-imagining Our Academic Location," *Discourse* 21 (Fall 1999): 4.

11 Mikhail Bakhtin, *The Dialogic Imagination: Four Essays*, trans. Caryl Emerson and Michael Holquist (Austin: University of Texas Press, 1981).

12 Foucault, "What Is an Author?" 137.

13 Ilan Stavans, *The Hispanic Condition: Reflections on Culture and Identity in America* (New York: HarperCollins Publishers), 1995.

14 Noriega, "*El hilo latino*," 47.

15 Stavans' use of the "sleeping giant" metaphor comes from his essay "Hispanic USA," *The American Prospect* 4 (September 21, 1993), accessed 19 April 2002, www.prospect.org/print-friendly/V4/15/stavans-i.html.

16 Frances R. Aparicio and Susana Chávez-Silverman, "Introduction," in *Tropicalizations: Transcultural Representations of Latinidad*, eds. Frances R. Aparicio and Susana Chávez-Silverman (Hanover, NH: University Press of New England, 1997), 1.

17 Barker, *Comics*, 131.

18 "Entrevista con Ilán Stavans," in *Cuadernos Cervantes* (N.d.), Archivo CC 31, accessed April 19, 2002, www.cuadernoscervantes.com/entrevilanstavans.html.

19 Stavans, "Hispanic USA," 3.

20 Ilan Stavans, "The Writer in Exile: Interview," *Web del Sol* (N.d.), accessed 19 April 19 2001, www.webdelsol.com/istavans/is-in.html.

21 Stavans, *The Hispanic Condition*, 27.

22 Noriega, "*El hilo latino*," 46.

23 Chon A. Noriega, and Ana M. López, "Introduction," in *The Ethnic Eye: Latino Media Arts*, eds. Chon A. Noriega and Ana M. López (Minneapolis: University of Minnesota Press, 1996), xi.

24 Suzanne Oboler, *Ethnic Labels, Latino Lives: Identity and the Politics of (Re) Presentation in the United States* (Minneapolis and London: University of Minnesota Press, 1995), 165.

25 Stavans, "The Writer in Exile."

26 Rius, *The Chicanos* (Berkeley: NACLA, 1973). My thanks to Diana Palaversich for bringing this comic to my attention. In his Preface, Stavans provides a possible explanation for not mentioning this particular text when he states: "I stopped reading Rius one specific day, when a most anti-Semitic installment of *Los agachados*, endorsing Hitler, reached my hand" (xii).

27 Stavans, "The Writer in Exile." Also informing this claim to exile status is Stavans's Jewish background, and his family's displacement from Europe to the Jewish quarter of Mexico City where Stavans was born ("The Writer in Exile").

28 Stavans, "The Writer in Exile."

29 Caren Kaplan, *Questions of Travel: Postmodern Discourses of Displacement* (Durham and London: Duke University Press, 1996), 126.

30 Juan A. Carbajo, "El mundo hispánico hablaré Spanglish," *El País*, (2 enero 2000): 34 (sección cultura).

31 Foucault, "What Is an Author?" 131.

32 Foucault, "What Is an Author?" 124.

33 Michel Foucault, "Intellectuals and Power: A Conversation between Michael Foucault and Gilles Deleuze," in *Language, Counter-Memory, Practice: Selected Essays and Interviews*, ed. Donald F. Bouchard, trans. Donald F. Bouchard and Sherry Simon (Ithaca: Cornell University Press, 1977), 208.

34 Said, "The World, the Text, and the Critic," 50.

WORKS CITED

Alfau, Felipe. *Sentimental Songs: La Poesia Cursi*. Translated by Ilan Stavans. McLean, IL: Dalkey Archive Press, 1992.

Aparicio, Frances R. "Reading the 'Latino' in Latino Studies: Toward Re-imagining Our Academic Location." *Discourse* 21.3 (Fall 1999): 3–18.

Aparicio, Frances R. and Susana Chávez-Silverman, eds. *Tropicalizations: Transcultural Representations of Latinidad*. Hanover, NH: University Press of New England, 1997.

Bakhtin, Mikhail. *The Dialogic Imagination: Four Essays*. Translated by Caryl Emerson and Michael Holquist. Austin: University of Texas Press, 1981.

Barker, Martin. *Comics: Ideology, Power and the Critics*. Manchester and New York: Manchester University Press, 1989.

Cabeza de Vaca, Alvar Núñez. *Chronicle of the Narvaez Expedition*. Rev. Harold Augenbraum. Intro. Ilan Stavans. New York: Penguin Classics, 2002.

Carbajo, Juan A. "El mundo hispánico hablaré spanglish." *El País* (sección cultura) (January 2, 2000): 34.

Dorfman, Ariel and Armand Mattelart. *How to Read Donald Duck: Imperialist Ideology in the Disney Comic*. Translated by David Kunzle. New York: International General, 1991 [1971].

Foucault, Michel. "Intellectuals and Power: A Conversation Between Michael Foucault and Gilles Deleuze." In *Language, Counter-Memory, Practice: Selected Essays and Interviews*, ed. Donald F. Bouchard. Translated by Donald F. Bouchard and Sherry Simon, 204–217. Ithaca: Cornell University Press, 1977.

——— "What Is an Author?" In *Language, Counter-Memory, Practice: Selected Essays and Interviews*, ed. Donald F. Bouchard, trans. Donald F. Bouchard and Sherry Simon, 113–138. Ithaca: Cornell University Press, 1977.

Grieco, Elizabeth M. and Rachel C. Cassidy. "Overview of Race and Hispanic Origin: Census 2000 Brief." U.S. Census Bureau, Washington, March 1–11, 2001.

Kaplan, Caren. *Questions of Travel: Postmodern Discourses of Displacement*. Durham and London: Duke University Press, 1996.

McCloud, Scott. *Understanding Comics: The Invisible Art*. Northhampton, MA: Kitchen Sink Press, 1993.

"Meet Lalo Alcaraz." N.d. Biographical page. *Ucomics.com*. Accessed May 16, 2002. www//ucomics.com/laloalcaraz/bio.phtml.

Noriega, Chon A. "*El hilo latino*: Representation, Identity and National Culture." *Jump Cut*. 38 (1993): 45–50.

Noriega, Chon A. and Ana M. López, eds. *The Ethnic Eye: Latino Media Arts.* Minneapolis: University of Minnesota Press, 1996.

Oboler, Suzanne. *Ethnic Labels, Latino Lives: Identity and the Politics of (Re) Presentation in the United States.* Minneapolis and London: University of Minnesota Press, 1995.

Paz, Octavio. *El laberinto de la soledad. Postdata. Vuelta a El laberinto de la soledad,* 3a ed. México: Fondo de Cultura Económica, 1999 [1950].

Rius. *The Chicanos.* Berkeley: NACLA, 1973.

Rodríguez, Clara E. *Changing Race: Latinos, the Census, and the History of Ethnicity in the United States.* New York: New York University Press, 2000.

Rodriguez, Richard. *Hunger of Memory: The Education of Richard Rodriguez, An Autobiography.* New York: David R. Godine, 1982.

Said, Edward. *Orientalism.* London: Routledge & Kegan Paul, 1978.

————. *The World, the Text, and the Critic.* 1984. London: Vintage, 1991 [1984].

Stavans, Ilan. N.d. "Entrevista con Ilan Stavans." *Cuadernos Cervantes*, Archivo CC 31. Accessed April 19, 2002. www.cuadernoscervantes.com/entrevilanstavans. html.

————. N.d. "The Writer in Exile: Interview." *Web del Sol.* Accessed April 19, 2002. www.webdelsol.com/istavans/is-in.html.

————. "Hispanic USA." *The American Prospect* 4.5 (September 21, 1993). Accessed 19 April 2002. www.prospect.org/print-friendly/V4/15/stavans-i.html.

————, ed. *Tropical Synagogues: Short Stories by Jewish-Latin American Writers.* New York: Holmes and Meier, 1994.

————. *Bandido: Oscar "Zeta" Acosta and the Chicano Experience.* Boulder: Westview Press, 1995.

————. *The Hispanic Condition: Reflections on Culture and Identity in America.* New York: Harper, 1995.

————. *The One-Handed Pianist.* Albuquerque: University of New Mexico Press, 1996.

————. *The Essential Ilan Stavans.* New York and London: Routledge, 2000.

————. "The Gravitas of Spanglish." *Chronicle of Higher Education* 47.7 (October 13, 2000): B7–10. Accessed April 19, 2002. chronicle.com/free/v47/i07/07b00701. html/.

————. *Latino USA: A Cartoon History.* Illustrated by Lalo Alcaraz. New York: Basic Books, 2000.

————, ed. "The Quest for a Latino Literary Tradition." *Chronicle of Higher Education* 47.14 (December 1, 2000): B13–15. Accessed January 16, 2001. chronicle.com/free/v47/i14/14b01301.htm/.

————. "Spanglish: Tickling the Tongue." *World Literature Today* 74 (2000): 555–558.

————. *The Inveterate Dreamer: Essays and Conversations on Jewish Culture.* Lincoln: University of Nebraska Press, 2001.

————. ed. *The Cross and the Scroll: A Jewish-Hispanic Reader.* New York: Routledge, 2002.

————. Spanglish: The Making of a New American Language. Rayo: New York, 2003.

The Bros. Hernandez: A Latin Presence in Alternative U.S. Comics

Ana Merino

Within the U.S. comic scene, Latino identity has emerged in multiple ways. On one hand, there is the comic strip production for the traditional "funnies" in daily and Sunday editions of newspapers and, on the other, there is the notebook-like comic book with dense narrative constructions, such as anthologies or graphic novels. Within the first kind, among comic strips or syndicated pages, there is the example of "Gordo," created by Gus Arriola, who illustrated some stereotypes associated with Mexican and Mexican-American identities in the context of the printed media from 1941 to 1985. In the same setting, there is the more recent work of Lalo Alcaraz with his comic strip "La Cucaracha" (which appeared independently in the early 1990s and was syndicated in 2002), with a humorous and critical vein that questions the society in which Latinos live. "Baldo," by Héctor Cantú and Carlos Castellanos, with its familiar depiction of manners and customs, is also quite popular.

In the context of the notebook-style graphic novel, starting in the 1980s, the work of the Brothers Hernandez marks the beginning of a new era. Their production introduced new aesthetic and narrative guidelines for the adult alternative comic, and new peripheral subjects with Chicano, Latino, and Latin American characters who allude to a common cultural experience. This chapter discusses the graphic work of both brothers and the form in which they articulate Latino and Latin American multiculturalism in the world of comics. Their work poses a Latin multiculturalism that crosses border geographies and that is problematized within an aesthetic fiction in which the language of vignettes is able to reach innovative points for the medium. Their comics are stories that question race, gender, and ideology, and look for ends within these discourses to address readers and force them to acknowledge spaces with contradictory realities, which, in many cases, have previously stood ignored. Through their comics, the Bros. Hernandez

redefine the locus of creative expression, committing it ideologically to Latino and Latin American identity, and try to break the stereotypes that assume that comics are mere objects for mass entertainment.

FROM THE UNDERGROUND TO THE ALTERNATIVE: THE REVOLUTION OF THE BROS. HERNANDEZ

In the 1960s and 1970s, the elaborate voice of adult comics emerged from the countercultural Comix Underground, with Robert Crumb as one of its leading exponents. The comics by Crumb and some of the members of his generation, like Justin Green, Gilbert Shelton, Robert Williams, Spain Rodríguez, or Kim Deitch, distanced themselves radically from the customary dialectics of teenage superhero comics and created a radical subaltern voice for adults, bent on attacking even the most remote corners of the establishment. These anti-system Comix are narrated sarcastic stories filled with sex, drugs, and violence, usually linked to the cultural and aesthetic ideology of hippie culture. Art Spiegelman, who had also grown amid the Comix Underground, evolves towards other more avant-garde aesthetic and narrative trends within comics. In 1980 in New York, together with his French wife, Françoise Mouly, he created the magazine *RAW*, which published the work of numerous young artists, like Kaz Prapuolenis, Josh Alan, Joost Swarte, Jacques Tardi, or Mariscal, of U.S. and European origin. As part of a series, *RAW* also publishes the episodes of "MAUS," which would become one of the most important graphic novels of the twentieth century. In this way, the intellectual and aesthetic project that is *RAW* abandons the underground to venture into an avant-garde experimentation influenced by European sources.

In California, parallel to *RAW*, the Bros. Hernandez unknowingly established new coordinates for the world of the alternative comic. In 1981, encouraged by Mario, their older brother, and with a loan from their younger brother Ismael, Jaime and Gilbert Hernandez self-published the first issue of what would become the *Love and Rockets* series. In this first issue, some of the key traits of their characters and subjects, which will gradually consolidate and gain strength as the series matures, are already in evidence. While Gilbert's creative world centered on life in a Latin American town called Palomar, Jaime's portrayed a group of Latina adolescents from the outskirts of Los Angeles, who lived the punk-rock experience with a great deal of intensity.

By the early 1980s, *The Comics Journal* magazine (founded in 1976) was already one of the most solid publications of the comics scene. Its appraisal of comics was renowned for its outspoken and sharp critical streak. Gilbert and Jaime decided to send a copy of the first issue of *Love and Rockets* to Gary Groth, the editor and founder of the *Journal*, fearing the worst of reviews. Both authors were in dire need of some sort of recognition and were willing to try luck with their comic, regardless of the potentially negative assessment

of their work. Nevertheless, the first issue fascinated Gary Groth, to the extent that, together with Kim Thompson, his partner from Fantagraphics, the alternative comics press, they offered publication of the entire series to the Bros. Hernandez. In the fall of 1982, Fantagraphics Books released the first number of *Love and Rockets*. In a way, the event marks a symbolic beginning for Fantagraphics as the comics press that will revolutionize the alternative market. Gary Groth and Kim Thompson knew well that the two brothers would spark a new era in the world of illustration. Gary Groth explains in detail the philosophy of these two artists, who lived a multicultural, punk, Californian adolescence in the late 1960s:

> They didn't take their cue from other work being published. They had an I-don't-give-a-shit attitude, as in, they didn't give a shit what any other artists were doing at the time, they were going to do their work their way and if it was un-commercial, so be it. And to hell with anyone who didn't like it.[1]

From its inception, *Love and Rockets* was a shared notebook with many stories, with many key female characters facing a complex and trans-cultural reality, and in constant search of different ways to define their own existential identities.[2] These storylines impressed Gary Groth because, above all, they were "liberating." Both brothers had a healthy attitude towards sex: "It was the first comic that I remember seeing that didn't view sex as a taboo to be smashed, but as a natural part of life."[3] In the 1960s, the world of the Undergound Comix had used sex as a graphic tool for provocation, whereas, in the work of the Bros. Hernandez, sex represented an intimate space within the expressive milieu of its characters. Trina Robbins, one of the representatives of the female Comix Underground, who has criticized sharply the misogynous-sexist approach of many of her colleagues from the Underground, emphasizes how important and healthy the influence of the Bros. Hernandez was for the female audience:

> While their books have always had a large male readership, they also have a uniquely female appeal [...] *Love and Rockets* is a Riot Grrrl comic, created before the term was invented.[4]

In her introduction to the book by Trina Robbins on the history of women comics, Carla Sinclair also underlines the importance of the work of the Bros. Hernandez and recalls the moment when she discovered them, while she was shopping for comics with a boyfriend:

> *Love and Rockets* n.11.[5] What was this? As I flipped through the fictional pages of grrrl rock musicians, a female champion wrestler, and young women with realistic post-adolescent lives, I realized there was more to comic life than violent one-dimensional superhero stories [...] I could relate to characters who were drawn as spunky as the girls in *Archie* (in an updated, eighties, goth-punk style), but were engaged in much deeper, truer-to-life situations (the

cover said "Recommended for Mature Readers"). I became instantly hooked in *L&R*, and desperately wondered: Were there other engaging comix about women? If so, how long has this type of graphic novel been around? Is there a subculture of females comic readers that I don't know about?[6]

What Trina Robbins and Carla Sinclair point out about *Love and Rockets* is a new way of including the feminine as an aesthetic narrative construct that interpolates both male and female audiences. In addition, it creates new models of graphic representation for women that, curiously, will later serve as models for the new generation of female authors. With the work of the Bros. Hernandez, the adult comics created by men, which seem limited by the provoking phallo-centric language of the male, countercultural Underground, suddenly evolved towards the construction of intense fictitious plots with complex characters who dwelled on new realities. What were the reasons for this change? What peculiarities surrounded these two brothers that motivated these differences? Did coming from a minority with its own set of distinct cultural codes prompt such a difference?

For Gary Groth, their editor, the representation of sex in a natural form through the eyes and voices of female character was what made the stories of the Bros. Hernandez so revolutionary in both their visual as well as narrative dimensions. It hinted at a form to approach sexuality without making readers uncomfortable, and which allowed for a new understanding of female identity in a predominantly male field. Still, there are other characteristics that distinguish this pair of creators. The work of Gilbert and Jaime Hernandez reflects their own mixed cultural heritage in a deep way, their Chicano, Latino, and Latin American reality as the expressive and intellectual engine of a graphic world. They also draw the Anglo reader closer to a new space within their own culture, the reality of Latino migration, illegal immigration, and the cultural and musical expression of barrio youth in the United States. Lastly, it also contemplates the great effort towards recognition and political commitment of a Latin American reality struggling to break free from the picturesque stereotypes of Latin American alterity sponsored by the North American gaze.

In a 1989 interview for *The Comics Journal*, Gilbert Hernandez summarized candidly many of these aspects before Gary Groth, highlighting their importance from the beginning and his expectations from comics:

> I just wanted to bring us closer together. I though it was something that was good, my childhood, my heritage, I though it was just as interesting as anybody else's [...] I wanted something that was worth lasting. And the story had never been told. I could go to the movies and I could not see—unless it was a Mexican movie made in the '50s by Buñuel or somebody, which nobody goes to anyway—you just weren't going to see it in popular entertainment [...] It's almost impossible to get something truthful on television. I thought, if this comic book simply exists, hopefully it means something [...] I wanted something that would last, and something that was original. (*TCJ*, #126, January 1989, p. 97)

The Latin Verve in the Biographic Dimensions of the Bros. Hernandez

The Bros. Hernandez were born in California in the late 1950s. Gilbert was born on February 1, 1957 at the Ventura Hospital, next to Oxnard, and his brother Jaime was born on October 10, 1959 in Oxnard, the town where they spent their childhood. Their father was a Mexican from Chihuahua who migrated to the United States in search of work. Their mother was from Texas, but came from a Tejano lineage that celebrated and vindicated its Mexican past. When prompted about his *raíces mexicanas*, Gilbert answers that the majority of relatives came from Mexico and that they (Jaime and him) belong to the generation born in the United States. They grew in Oxnard, California and, unfortunately, had to give up on bilingualism to integrate themselves to society in the 1960s and 1970s. Nevertheless, they understand Spanish and were raised with the Latin American imaginary that their mother transmitted through stories and oral accounts. In a 1989 interview for the *Journal*, Gilbert explains how many old traditions and superstitions survived in his family, many simple but passionate things, including the old ways of cooking, and many anecdotes and descriptions of Mexico. This allows him to feel bi-cultural at all times:

> I always felt that I was living in two worlds. One was the little Mexican world, because nearly everybody I knew, relatives and cousins and even kids in the neighborhood, were Mexican. The school was a different world. It was pretty ethnically mixed; I had a lot of black, white, Japanese friends. One thing I can remember all the way back is that I never noticed the difference between races except skin color. That's just something I learned. (*TCJ*, #126, Jan. 1989, p. 62)

The Bros. Hernandez were revolutionary because, influenced by their life experiences, they offered new subjects in their comics, portraying situations linked to a society that changed with each minority that arrived and tried to integrate itself to the new space it occupied.

The world of Gilbert spoke with an almost literary passion of some characters who lived in a Latin American town, while Jaime depicted the Latino and Chicano adolescents of Los Angeles. They narrated stories concocted with ardent and intricate vignettes that shied away from the established rules of superheroes. Their serialized notebooks were able to attract a new public, and forced the average comics reader—usually, a white Anglo adolescent—to mature faster.

In a 1995 interview with Neil Gaiman, Gilbert expands on appealing aspects related to the Latino way of being and proposes new lines of questioning for a readership that is extensively white. In turn, Neil Gaiman himself mentions that he never thought of them as "Latino creators" but as "Americans." Gilbert retorts that the United States is beginning to note its own racial and cultural multiplicity. While African-Americans have already

conquered spaces in the media, he argues, the acceptance of things Latino and Asian will come with time:

> Right now in America, it's a black and white country. Everybody else is in the middle and has to wait their turn. It's great that the blacks have made such powerful inroads into film in the last 10 years, because they made a big stink about it. They insisted on being there. Well right now the Asians and Latino are gearing up in the wings, and we hope to be involved in making more of a dent in a near future as far as that goes. (*TCJ*, #178, July 1995, p. 98)

On the other hand, Jaime Hernandez explained to Neil Gaiman that, though he saw them simply as a pair of American comic authors and never considered their racial reality and its differences, things were usually different, especially if one was white in the United States, "race has been an issue with us since we were born. That's just a thing that's in you if you are not white here" (*TCJ*, # 178, July 1995, p. 98). Gilbert Hernandez underscored this perception by maintaining that all media and public facets of U.S. society reminded him constantly about not being white, because being white seemed to be the norm: "You are constantly reminded that you are not white in this country—by the system or whatever. I'm not saying by individuals, but in television and advertising, that sort of thing. Whites are normal and then there is everybody else" (*TCJ*, # 178, July 1995, p. 98).

These declarations of the Bros. Hernandez in the interview with Gaiman opened the eyes of an audience of readers that was not accustomed to heroes and creators who weren't white and, on top of that, expressed their views clearly and criticized the limitations of a prejudiced society.

Crossing Boundaries, Identities, Races, and Realities in *Love and Rockets X*

The volume titled *Love and Rockets X* groups several stories of the universe of Gilbert Hernandez in which multiple realities intersect in spaces impregnated by the peripheral marginality of Los Angeles. It includes migratory tensions, many examples of the exploitation of illegal workers, raced-based conflicts, and violent, racist hostility. Moreover, television invades this universe of fiction occasionally with newscasts from Latin America. Gilbert Hernandez recreates a world based in encounters and mis-encounters between groups marked by prejudice and segregation. Cultures and ideologies merge and intersect just as they become polarized, thanks to rejection. The main characters have no other option than to learn to live with surrounding disappointments, intolerance, and violence. Furthermore, by naming the volume "X," Gilbert Hernandez toys with the idea of a crossing, not only of boundaries, but also of racial, gender, or class identities. The alternative voice tries to mix the subversive with a true commitment. The author displays an evident intent to endure through the expressive and ideological dimension of his vignettes.

In his interview, Neil Gaiman points out that this volume X by Gilbert Hernandez had called his attention strongly. He was mainly interested in characters that had crossed the border to work illegally in the United States. In this episode, Maricela, the daughter of Luba (the great matriarch of the Latin American town of Palomar), had escaped to the States with her best friend and lover, Riri. They both tried to search for a place where they could enjoy their love freely. Both women leave Palomar because they know that the strict moral of their culture and families will never approve their relation. Curiously, what Neil Gaiman finds surprising is to discover that Maricela and Riri talk in a different way in the United States because they are learning English and that, as an author, Gilbert Hernandez is concerned about representing these linguistics details:

> In *Love and Rockets X*, the moment I really found that went into my head and changed something [...], was running into Riri and Maricela in L.A., and watching them speak very, very bad English [...] That was a fascinating little moment for me [...] They're in the same position I would be if I were in a foreign country and did not speak, picking up the language desperately as I went along. (*TCJ*, # 178, July 1995, p. 98)

As pointed out previously, Gilbert Hernandez's main universe takes place in a Latin American town called Palomar. Palomar is located amid some isolated and ambiguous geography to the south of the U.S. border and next to the Pacific Ocean. The town of Palomar faces the islands of the Pitoio Indians in the Pacific. To the east, there are the mountains of the Ciencia Indians and, between the mountains and Palomar, there's the La Balada desert. Most of the stories take place within this area, though there usually is some direct or indirect relation with the United States, as in the case of Maricela and Riri.

Though they are written in English, Gilbert Hernandez's comics are inserted symbolically in a Spanish-speaking context, which the author routinely highlights with footnotes that state "In glorious *español* unless otherwise noted." That is, unless he states otherwise, his characters speak in Spanish. Never mind that the words in the bubbles from the vignettes appear in English, because, as author, what Gilbert Hernandez wants is to recuperate the lost mother tongue through fiction. This is what he explained in the interview with Neil Gaiman: "...the Heartbreak Soup stories where everybody is speaking Spanish. I have to remind my readers now and again that they're speaking Spanish entirely in Palomar, and sometimes the reader forgets" (*TCJ*, #178, July 1995, p. 98).

Likewise, Gilbert Hernandez tried to have readers understand his culture and to identify with it to some extent: "With Heartbreak Soup, I had an agenda of shorts. I'm trying to get non-Latinos, for lack of a better word, to identity with Latinos as human beings. Simple as that. I think I've felt that since I was a kid" (*TCJ*, #178, July 1995, p. 97). This attempt to have non-Latinos understand the complex reality of Latinos is well articulated in volume X of the series, dedicated to the adventures of Riri and Maricela

while working illegally in the States. Steve, a young, white surfer who has sometimes visited beaches close to Palomar, meets Riri in Los Angeles casually, while she works as maid in the house of the mother of his friend Rex. Steve stares at Riri; her face looks familiar but he doesn't recognize her. The conversation reflects Riri's reality in the United States, as well as her precarious knowledge of English. Therefore, the representation of orality in the globes shows the different dialects of the characters, or their limitations in the knowledge of language. This technique makes the reflection of orality in the vignettes more natural and the characters more credible. Steve and his friends talk with the slang typical of their age, with words like "babe," "chick," "dude," and sometimes abbreviate words, as in "ol'" instead of "old," "workin'" instead of "working," and "ain't" instead of "it is not." Since she is learning English, Riri makes many grammar and pronunciation mistakes. Amid the conversation, Riri vindicates the United States as her new home. Steve gives her some advice to endure possible abuse because he discerns the precariousness of her situation as an illegal worker:

> *Steve*: Uh…um so you're the cleaning woman? What happened to ol' Carmelita?
> *Riri*: I tink she go back to her family to Mexico…but I here for good. My home United States now.
> *Steve*: Oh…well, that's cool. I guess. Well…don't let Rex's folks rip you off, huh?
> *Riri*: Ha, ha…no, I not let them. Thenk [*sic*] you…
>
> (*L&R*, vol. 10, p. 6)

Then again, the viewpoint of Steve, who feels strongly attracted to Riri, contrasts with the racist and classist attitude of his friend Rex. To Rex, all maids are identical; they're illegal women who have crossed the border, "wetbacks" who are disposable because there will always be one willing to replace the other:

> *Steve*: Hey Rex! How long has that new cleaning babe been workin' here?
> *Rex*: Oh…that wetback chick? I don't know…two weeks…a month…they look all the same to me…
>
> (*L&R*, vol. 10, p. 6)

In another revealing moment in this same page we see how Steve, when he sees Riri waiting for a bus, convinces his friend Gerry to take her home. While they're in Gerry's car, they listen to Led Zeppelin's "Immigration Song": "We come from the land of the ice and snow…" Gerry will grant his friend the favor despite his doubts, fearing some possible incident in the neighborhood that Riri calls "el pueblo de los cholos." Gerry also points out the racial differences between Riri and them: "Aw dude, she probable lives way out in Cholotown! Ain't no place for couple of white boys like us, dude" (*L&R*, vol. 10, p. 6). When Riri gets home and meets Maricela, the conversation is fluent, with the usual slang and brackets (< >) that indicate they're

speaking in Spanish. Maricela, who works selling flowers, will tell her lover Riri about her problems with the "migra" (U.S. immigration): "<Today was a little jumpy, Riri. **La Migra** came and got ol' Joe Piña down the street. I don't know…things are getting>" (*L&R*, vol. 10, p. 7).

Aside from portraying the conflicts and predicaments of illegal Mexican immigrants in Los Angeles, Gilbert Hernandez also depicts the problems of Chicano and black minorities. Moreover, the conflicts between neighborhoods and the different groups or leading urban tribes, from radical neo-nazis to skinheads to punks, are also evident. At the same time, he introduces information through television newscasts. The news will impact characters in different ways. Gilbert Hernandez started writing the stories for this volume in late 1989, the same year of the massacre of six Jesuits and two workers in the campus of the Universidad Centroamericana de El Salvador at the hands of a death squad sponsored by the Salvadoran state. In a certain way, he pays homage to the eight victims, documenting the massacre and bringing awareness to his readers. For the author, it was important to demonstrate that comics also had voice to denounce injustices. Comics are no longer just a means of entertainment. Gilbert Hernandez forces the reader to get involved emotionally with the sordid reality of a repressive and politicized violence.

In this episode, television plays a key role, mediating between characters. In their work on audiovisual experiences and television fiction, Barbero and Rey point out the strategic location of television in the dynamics of the daily culture of the masses, and how they transform their sensibilities, affecting their way of building imaginaries and identities. Television is represented as a sophisticated means for the configuration and formation of the daily life and tastes of popular sectors.[7] In this episode, we see how characters perceive the actual news of the Salvadoran massacre in many different ways:

> …six Jesuit priests, a housekeeper and her daughter were murdered…tortured and mutilated […] <leftists are claiming it was the work of the right-wing death squads…> (*L&R*, vol. 10, pp. 8–9)

Ben and Charlie, the clueless, snobbish pair that usually stands next to Carl, the neo-Nazi K.K.K. member, have no interest in the news. They scorn it, suggesting a change to a channel with cartoons. These violent and racist youth are more attracted to childish fiction and they want to neutralize news they deem as "boring" with entertaining caricatures: "Aw, it's that same ol' boring El Salvador bullshit! Put on the cartoons, man!" (*L&R*, vol. 10, p. 8). In turn, Carl's naive girlfriend, Bambi, who ignores her friends' more sinister facet as followers of the K.K.K.'s rabidly racist philosophy, is touched by the crime: "GOD…Who'd do that to a PRIEST?" (p. 8). In a nutshell, Bambi is unable to fathom the existence of a repressive Latin American reality responsible for crimes against the religious workforce. In an opposite corner of town, Riri feels desolate looking at the news in television and wonders

anxiously what might be happening in Palomar. Rumor has it that the military have been in nearby towns abusing the civil population.

In these comics, Igor, the son of a black woman and a Mexican man, is another character who offers enlightening multicultural insight (figure 13.1). When he gets home, he finds his father watching the news of the massacre in El Salvador in the television. Still, his father is confused and perceives the event as a trick by the rebels. Igor tries to explain the situation to him:

> *Father*: Hello, mi hijo. Did you hear this shit now?
> *Igor*: About these people murdered in San Salvador? Yeah…pretty awful…I guess the one difference between our government and theirs is that theirs doesn't hide its crimes HALF as well as we hide ours…
> *Father*: The GOVERNMENT? It was those goddamn REBELS disguised as government soldiers who did it…!
> *Igor*: REBELS? Pop, WHY would the leftist want to kill the guys who backed 'em up?
>
> (*L&R*, vol. 10, p. 13)

Igor displays deeper knowledge of the Salvadoran case and tries to have him understand that the efforts of the priests in search of a peaceful dialogue have resulted in their death at the hands of the government's military. The Jesuits had offered themselves as mediators in the armed conflict, and denounced government corruption and the oppression of peasants. From his viewpoint, this crime is intended to bring any peace-seeking effort to an end.

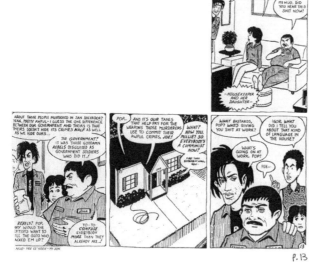

Figure 13.1 Pages 13 and 14 of *Love and Rockets X* by Gilbert Hernandez © 1999. Courtesy of Gilbert Hernandez.

But Igor's father confuses everything, trying to equate the anxieties of his daily life with Central American conflicts. He does not distinguish between ideologies and thinks it's all a communist conspiracy. In contrast, his wife shares her son's viewpoint and tries to clarify some points on the actions of military governments in Latin American countries. She also complains bitterly about why these military actions are many times supported by the U.S. government's policies and funding:

> *Father*: To...to CONFUSE everybody MORE than they already are...!
> *Igor*: Pop...
> *Mother*: And it's OUR taxes that help pay for the weapons those murderers use to commit their awful crimes, JOE!
> *Father*: WHAT? NOW YOU, MILLIE? SO EVERYBODY'S A COMMUNIST NOW? ...first those bastards at work; now...
> <div align="right">(L&R, vol. 10, p. 13)</div>

Igor then discovers that his dad is having problems at the Exxon gas station where he works and tries to comfort him:

> *Igor*: WHAT bastards, Pop? WHO'S giving you shit at work? What's going on at work, Pop?
> *Father*: They come into the station with their VALDEEZ jokes, and I tell 'em 'What's with this VALDEEZ shit; my name is JOSE VALDEZ and I had nothing to do with that goddamn oil spill [...][8]
> *Igor*: They're JERKS, Pop, that's all...
> <div align="right">(L&R, vol. 10, p. 14)</div>

It seems that someone is using the similarity of the surname to make fun of Igor's father. Then again, the Valdez oil spill certainly energized environmental activism. Quite appropriately, Gilbert Hernandez reflects on José Valdez's conflicting situation, as Exxon employee and Latino.

Eventually, while at work, where he sells hubcaps, Igor will have to deal with the nature of his multiracial heritage (figure 13.2). He will be harassed by Bobby, a Chicano gang member, and forced to articulate his identity explicitly:

> *Bobby*: You didn't answer me, ese. Are you RAZA or are you BLACK?
> *Igor*: I'm Mexican and I'm black AND I'm Chinese and Indian and Aborigine and Inuit and Jewish and MARTIAN...so you gonna buy a hubcap or what?
> <div align="right">(L&R, vol. 10, p. 19)</div>

Bobby is unfazed by Igor's neutral and conciliatory response; he wants Igor to define his cultural identity and take sides:

> *Bobby*: So are you a CHICANO or are you a NIGGER?
> *Igor*: And WHAT the FUCK are YOU? Man, the white European hold on the Third World is FINALLY losing its grip and here YOU are just ITCHING to build your own wall to replace THEIRS! WAKE UP!

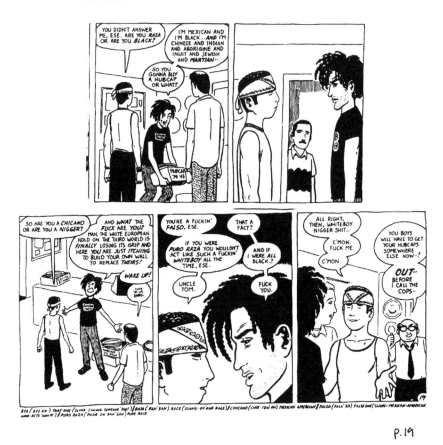

P.19

Figure 13.2 Page 19 of *Love and Rockets X* by Gilbert Hernandez © 1999. Courtesy of Gilbert Hernandez.

For Bobby, it is important that Igor chooses a racial space, whether he's Chicano or black. Though he engages Igor, he despises the blackness that makes part of Igor's bi-cultural roots. In return, Igor tries to have Bobby understand that such mindset, bent on territorial power, only reproduces the hegemonic, repressive white model that prevails in the Third World. After he listens to Igor's argument, Bobby accuses him of being a *falso*, of acting like a whitey and not being *pura raza*. Igor asks what would happen if he were completely black. Bobby then calls him an Uncle Tom, alluding to the slave who has been domesticated and seduced by white power. Igor loses patience. Bobby continues attacking, relying on a mixed (black and white), racially offensive discourse that distances Igor from a Chicano identity, from being true *raza*.

> *Bobby*: You're a fuckin' FALSO, ese.
> *Igor*: That a fact?
> *Bobby*: If you were PURA RAZA you wouldn't act like such a fuckin' WHITEBOY all the time, ese.

Igor: And if I were ALL black...?
Bobby: Uncle Tom.
Igor: Fuck you.
Bobby: All right, then, whiteboy nigger shit...

(*L&R*, vol. 10, p. 19)

Bobby needs to impose his racial pride on Igor, whom he disdains and rejects. By calling him *falso*, he accuses him of being a Mexican-American who acts white. But Bobby also despises blacks and feels superior to Igor. Gilbert Hernandez depicts the multiracial tensions of barrio life and the workings of bands that fight for racially-based social spaces. People like Igor try to dialogue and have gang members understand the meaninglessness of disputes that vindicate racial superiority. The idea of recognition as a space that articulates identity fragments in multiple fictitious evocations. Igor is unwilling to identify himself; he does not wish to define himself with a specific race. Rather than deal with the racial possibilities imposed on him by the alien gaze, he prefers to remain indefinite. Igor devalues identity because it is built through violent and racist discourses that he refuses to accept.

JAIME HERNANDEZ'S LOST WOMEN AT THE POINT OF AWARENESS

In the stories by Jaime Hernandez his characters also reflect on their identity. Initially, his comics are set in Hoppers, a Mexican neighborhood in Huerta, California, a place that mildly resembles Oxnard, his childhood town. The main characters are Isabel María, Penny Century, Hopey, and Maggie.

Isabel María Ortiz Ruebens was born in 1958. In 1970 she starts a female gang called "Las Widows." By the age of eighteen, Isabel already has problems with the law, but she manages to finish school and become a teacher. One of the most intimate and intense stories reflecting this character's complexity is "Flies on The Ceiling: The Story of Isabel in Mexico," created between 1988–1989, and set chronologically in 1981. Escaping from personal ghosts, Isabel travels to Mexico and tries a new life with a Mexican man and his son Beto. Nevertheless, her anxieties and the painful guilt resulting from several abortions get in the way of her happiness. Another appealing character is Beatriz García, a.k.a. Penny Century, who, according to the comics' internal chronology, was born in 1961. Still, the two most popular characters are Hopey and Maggie. Hopey's real name is Esperanza Leticia Glass. She was born in Downey, California and is the daughter of divorced parents. Her mother is Colombian and her father is of Scottish descent. Hopey is a punk rocker and she belongs to a punk rock band. On the other hand, Maggie's real name is Margarita Luisa Chascarrillo; as a child, her nickname was Perlita. She's a great mechanic, but can almost never show it, since the men in garages are too macho and never want to hire her. For a while, after her parents divorced, she lived with her aunt Vicky; later on, she lives alone in Los Angeles. In addition, she is the character with which most readers

identify because she has a tendency to get fat, gaining between twenty to thirty pounds, and gets frustrated when her clothing don't fit.

The presence of music in comics by both brothers is evident, becoming a constant in Jaime Hernandez's case.[9] Punk marked the expressive dynamics of characters by Jaime Hernandez because this movement heavily influenced Los Angeles's Latino and Chicano daily life. In her study on punk in Los Angeles, Michelle Habell-Pallán tries to vindicate her own Chicano identity and clarify how she "was rescued from the suburbs of Los Angeles by the Ramones" (p. 160). Besides, in her text, when she analyzes *Pretty Vacant* (1996), the short by Jim Mendiola, it is evident that she can't help but think of the work of the Bros. Hernandez:

> It turns out that the main protagonist of *Pretty Vacant*, Molly Vasquez, the fierce Latina characters of the Hernandez Brothers' *Love and Rockets* comic book series, and most importantly, the real-life Los Angeleno Chicana punk musicians all live at that particular intersection (p. 161).

As an artistic panorama of the 1990s, *Pretty Vacant* offers an acute reflection on punk's significance for the articulation of Chicano identity, a reading recreated by Jaime Hernandez in his comics of the previous decade. Habell-Pallán highlights this aspect:

> Like the Latina punks Hopey and Maggie, whose lesbian relationship Jaime Hernandez despicts with great sensibility in the *Love and Rockets* series, Mendiola's Molly represents a grassroots feminist punk—still in formation— that draws inspiration from the signs of British punk, the *Love and Rockets* series itself, Tejano culture in general, and *rock en español* to construct an "alternative" location away from patriarchal Aztlán, yet still oppositional to the racism of the dominant culture, a place from which to imagine new ways of being in the world, ways that speak to similar but structurally different conditions of working-class feminists, both straight and queer (pp. 177–178).

In "Wigwam Bam," Jaime Hernandez shows the cultural tensions affecting his characters, and how, in response, they establish codes for recognition and self-recognition. For example, in 1990 (according to the comic's chronology), Maggie and Hopey go to party at the house of a friend in Badgeport. Maggie gets upset when she listens to two gay-looking, white "mods" laughing at her because she's Mexican: "French? Italian? Persian? Indian...? Brazilian? Cuban? Puerto Rican...? MEX-I-CAN! Ha, Ha, Ha" (*LOCAS*, p. 439) (figure 13.3). Maggie feels frustrated and Hopey tries to ignore the comments, which makes Maggie even more upset:

> *Maggie*: Just when you think a city is full of wanna-be assholes, out come the real assholes the racists...
> *Hopey*: You mean this two art jerks? I hear them. And as stupid as they were I don't believe they were trying to be Nazis [...] I'm betting in their "hip fashion" world, to be Mexican just isn't in vogue at the moment...

Figure 13.3 Pages 439 and 440 of *LOCAS: The Maggie and Hopey Stories: A Love and Rockets Book* by Jaime Hernandez © 2004. Courtesy of Jaime Hernandez.

> *Maggie*: So, what's the fucking difference between that and Nazism? It's still
> a good reason to get as far away from here as possible.
> *Hopey*: So, where are we gonna go that's better? It's the same shit all over…
>
> *(LOCAS*, p. 440)

At that moment, Maggie draws a difference between them two and reproaches Hopey: "O.K, then don't go back to California! Shit, just 'cause you can

turn off your "ethnic" half whenever it's goddamn convenient!" (*LOCAS*, p. 440). Hopey belongs to both cultures and her physical ambiguity allows her to pass as white whenever she feels like it.

Jaime Hernandez encourages the reader to discover the complexities of multiculturalism and its interaction with daily apprehensions. His characters are ground-breaking because they depict accurately bisexual punk Latinas who face a prejudiced society. However, within them, there is also anxiety and narrowmindedness. They are contradictory heroines caught up within their culture. To be a Latino/a in the United States involves a mixed reality, where everyone assumes him or herself in a different fashion. Hopey is hurt by the exchange with Maggie and then tells everything to her friend Maya, who's Anglo. In the middle of the conversation, she uncovers a series of reservations that make her doubt about Maggie's way of thinking. She doesn't know whether Maggie is accusing her of being ashamed of her Latin roots, or whether she is jealous that her Scottish descent allows her to blend in. Nevertheless, it is Maya who suggests the possibility that Maggie is jealous about Hopey's "whiteness." Thus, it seems that it is Maya, who is white, who assumes automatically that Maggie isn't pleased with her Mexican roots (figure 13.4).

> *Hopey*: For some unknown reason, they thought it was funny that she's Mexican and she got mad at me because she thought I was defending them as racists...
>
> *Maya*: And that's when she said "Just because you can turn off your ethnic half whenever its convenient for you", right?
>
> *Hopey*: Right.
>
> *Maya*: Ok. But did she mean that you're ashamed of your ethnic roots or that you're fortunate to be able to hide your ethnicity and she's not?
>
> *Hopey*: I don't know...

Along with her explanation to Maya, Hopey also expresses prejudiced views towards the guys who have laughed at her. She calls them "fags," which

Figure 13.4 Page 454 of *LOCAS: The Maggie and Hopey Stories: A Love and Rockets Book* by Jaime

weakens her argument about the lack of sensitivity they've exhibited by laughing at her Mexican identity.

> *Maya*: By the way, what are you? I mean...
> *Hopey*: My dad is Scottish-American and my mom is Colombian. And if you make a crack about a drug dealer then you're just as bad as those two art fags...
> *Maya*: I see, as if "fags" never have anything to worry about.
>
> (*LOCAS*, p. 440)

Consequently, it is clear that Hopey is also prejudiced. Despite the character's lesbian nature, there's a clear degree of internalized homophobia, given she disapprovingly labels the men who laughed at Maggie as "fags." Still, a more thorough reading allows the reader to note that what really sparks her antagonism is the class difference between them and Maggie and her. These guys are "art," or in other words, they're modern and fashionable, and belong to an opinionated upper middle-class, willing to judge other groups as they please. The resulting tension is the product of a change in the perception of these men. Mexican identity is no longer exotic; the growing presence of Mexicans among the working class has brought about a shift in the dynamics of the relationship. The white upper and upper middle class, it turns out, perceive Latino identity as a category for second-class individuals.

CONCLUSION

There is an erroneous tendency to associate the work of Gilbert and Jaime Hernandez with the simple fiction of a "soap opera" in storyboard, produced for the entertainment industry. This perspective is usually assumed because most of the main characters are women. Besides, almost all of the plots take place in an apparently exotic Latin American town or in the California of rebel women that grew with punk. This vision ignores the true nature of voices extremely committed to Latin America's present and Latino reality in the United States.

What is undeniable is that, in the stories by both brothers, the setting for the characters sets off a harmonic quality that fits perfectly well with the idea of melodrama as a totalizing performance put forward by Barbero:

> The idea of a "totalizing performance" remains in melodrama not just as mise en scène, but also as part of the dramatic structure. Let's consider four types of particular situations—fear, enthusiasm, pity, and laughter—which, at the same time, also represent sentiments—horror, excitement, tenderness, and mockery—personified and experienced by four characters—the traitor, the avenger, the victim, and the fool—who, combined, embody the mix of four genres: noir, epic, tragedy, and comedy.[10]

The work of the Bros. Hernandez is made up of illustrated characters that talk to us from the depth of vignettes and want each reader to question him

or herself on the subject of cultural identities and learn to value them. These comics revitalize melodrama as a space of mestizo and timeless expression, in harmony with a real commitment. In their stories, a mixture of genres, sentiments, and situations seeks to express the zeitgeist of an era marked by self-recognition. More to the point, in many cases, the main characters conjugate transgressive features that outline them in different ways, giving the plots a "completely multi-generic" quality.

Love and Rockets revolutionized the alternative graphic novel genre because it was able to enhance the possibilities of fiction. It constructed a new world in which other identities narrated their stories from the setting of a concrete and painful imaginary. Ultimately, the Bros. Hernandez established a very strong bond with readers who discovered an innovative spatial aesthetic that facilitated the incorporation of Latino memories, insights, and desires into their imaginations.

NOTES

1 Ana Merino. "Conversation with Gary Groth, San Diego 2002." *The Creative Multiplicity of Comics*, 67.

2 The issues of *Love & Rockets* are compiled in numerous anthologies and, quite recently, two volumes compile Jaime's work (*Locas*) and Gilbert's production (*Palomar*).

3 Merino. "Conversation with Gary Groth." 65.

4 Trina Robbins. *From Girls to Grrrlz: A History of Women's Comics from Teens to Zines* (San Francisco: Chronicle Books, 1999), 107–109.

5 Issue 11 of *Love & Rockets* is titled *Wigwam Bam* and it narrates the adventures of Maggie and Hopey, two key characters in the universe of Jaime Hernandez.

6 Robbins, "Introduction." *From Girls to Grrrlz*, 4.

7 J. Martín-Barbero y Germán Rey. *Los ejercicios del ver: hegemonía audiovisual y ficción televisiva*, 18.

8 The Exxon Valdez oil spill happened on March 24, 1989 in the waters of Prince William Sound, a nature reserve in Alaska. Almost eleven million gallons of crude oil were spilled.

9 *Love and Rockets X* by Gilbert Hernandez started with an image dated 1989, a flyer announcing the concert of the band "Love and Rockets." Curiously, the band in Gilbert's comic vindicated its authenticity before the real British band that took its name from the comic. The sketched singer left no doubt about any difference between the groups: "WE had it FIRST! A couple of Mexican guys turned us on to the name" (L&R, vol. 10, 6). With this ironic allusion to the conflict generating tension between the real band and the illustrated one, Hernandez introduced parameters of reality acknowledged by many fans, well versed in the contemporary music scene.

10 *De los medios a las mediaciones,* 157.

Works Cited

Alcaraz, Lalo. *La Cucaracha*. Kansas City: Andrews McMeel, 2004.

———. *Migra Mouse: Political Cartoons on Immigration*. New York: RDV Books/ Akashic Books, 2004.

Gaiman, Neil. "Jaime and Gilbert Hernandez Interview". *The Cómics Journal* #178 (July 1995): 91–123.

Groth, Gary, Robert Fiore, and Tom Powers. "The Hernandez Bros. Interview". *The Comics Journal* #126 (January 1989): 61–113.

Habell-Pallán, Michelle. " 'Soy punkera, ¿y qué?': Sexuality, Translocality, and Punk in Los Angeles and Beyond." *Rockin' Las Américas: The Global Politics of Rock in Latin/o América* (2004): 160–178.

Harvey, Robert C. and Gus Arriola. *Accidental Ambassador Gordo: The Comic Strip Art of Gus Arriola*. Jackson: University Press of Mississippi, 2000.

Hernandez, Gilbert. *Palomar: The Heartbreak Soup Stories: A Love and Rockets Book*. Seattle: Fantagraphics, 2003.

———. *Love and Rockets X*. Seattle: Fantagraphics Books, 1999.

Hernandez, Jaime. *LOCAS: The Maggie and Hopey Stories: A Love and Rockets Book*. Seattle: Fantagraphics Books, 2004.

Martín-Barbero, Jesús. *De los medios a las mediaciones*. Santafé de Bogotá: Convenio Andrés Bello, 1998.

Martín- Barbero, Jesús/Rey, Germán. *Los ejercicios del ver: Hegemonía audiovisual y ficción televisiva*. Barcelona: Gedisa Editorial, 1999.

Merino, Ana. "The Creative Multiplicity of Comics." *Comic Release!: Negotiating Identity for a New Generation*. New York: D.A.P., 2003.

———. "Amor y Cohetes". *Leer* (Junio 2001): 96–97.

Robbins, Trina. *From Girls to Grrrlz: A History of Women's Comics from Teens to Zines*. San Francisco: Chronicle Books, 1999.

Contributors

Paul Allatson is senior lecturer in Spanish studies and U.S. Latino Studies at the Institute for International Studies, University of Technology Sydney.

Armando Bartra, a social analyst and cultural critic, is an expert on comics and the author (together with J.M. Aurrecoechea) of *Puros Cuentos*, the authoritative anthology on Mexican comics.

Eva Paulino Bueno is associate professor of Languages at St. Mary's University in San Antonio, TX.

Terry Caesar, an independent scholar, has written or co-edited seven books with Eva Bueno.

Robert McKee Irwin is professor of Spanish at the University of California, Davis.

Héctor Fernández L'Hoeste is associate professor of Latin American Culture at Georgia State University in Atlanta, GA.

John A. Lent is professor of Communications at Temple University in Philadelphia, PA.

Ana Merino is assistant professor of Latin American and Spanish Literature and Culture at Dartmouth College in Hanover, NH.

Ricardo Peláez, an ex-member of the El Taller del Perro collective, is an independent comics author and cartoonist in Mexico City, Mexico.

Juan Poblete is associate professor of Latin American and Latino Literature and Cultural Studies at the University of California, Santa Cruz.

Fernando Reati is professor of Latin American Literature at Georgia State University in Atlanta, GA.

Carla Sagástegui, a young novelist and comics expert, teaches literature at the Pontificia Universidad Católica del Perú in Lima, Peru.

Pablo de Santis, a renowned novelist and journalist, lives in Buenos Aires, Argentina. In the 1980s, he was editor-in-chief of *Fierro*, an alternative comics publication.

Waldomiro Vergueiro is associate professor of Communications at the School of Communications and Arts of the University of São Paulo in São Paulo, Brazil.

Index

A Gazetinha, 154–157, 161
Acevedo, Juan, 131–132, 140–150
Acuña, Rodolfo, 113, 129
Agostini, Angelo, 5, 20, 33, 151–153
Alberto, 13, 106, 192, 195–196,
 198–201, 211, 217–218
Allende, Salvador, 12–13. 16, 44
Alucinaciones latinoamericanas, 198
Álvarez, Santiago, 88
Amauta, 144
Aparicio, Frances, 6, 16, 230,
 238–239, 248–249
Appadurai, Arjun, 38
Arguedas, José María, 40–41, 145, 147
Arriola, Gus, 187, 251, 269
Augé, Marc, 41
author-function, 228–230, 237,
 241–247

Bakhtin, Mikhail, 231, 248–249
Baldo, 251
Barajas, Rafael (El Fisgón), 174
Barbero, Jesús Martín, 2–3, 38, 41–42,
 52–53, 259, 268–269
Barker, Martin, 230, 239, 248–249
Barthes, Roland, 133, 150
Baudrillard, Jean, 30, 32
Billiken, 8, 99
Brazilian superheroes, 161–162, 170
Breccia
 Enrique, 197, 201
 Patricia, 11
Burton, Julianne, 37, 53
Buster Brown, 5, 153

Caloi (Carlos Loiseau), 100–101
Camote, 104–108
cannibalism (cultural), 6, 27
Cantinflas, 231, 240
Cantú, Héctor, 251

Carpani, Ricardo, 105, 110
Castellanos, Carlos, 251
Chicano, 113, 230–231, 233–235,
 240, 243–244, 248, 250–251,
 254–255, 259, 261, 262, 264
Cirne, Moacir, 19–20, 23, 33, 153
Clemente, 100–104
comics conventions, 184, 218
Comix Underground, 252–253
Condorito, 6–8, 13, 35–53
Coné, 37, 45
Cornejo Polar, Jorge, 41, 132, 150
Cortez, Jayme, 154–155, 159, 161–162
cosmopolitanism, 227, 245
costumbrismo, 131–133, 141–142, 150
Couperie, Pierre, 18, 33
criollismo, 131, 133, 140
cuadros de costumbres, 133, 150

de la Vega, Inca Garcilaso, 145
Dedeté, 82, 84, 86, 89
didascalias, 133
Dirty War, 97
Disney, 6, 8, 11, 17–21, 24, 27–30,
 32–34, 37–38, 51–53, 67, 80, 139,
 164, 186, 227, 230, 247, 249
Disneyland, 17, 30
Donald Duck, 3, 13, 18, 33, 37, 42, 52,
 80, 194, 227, 247, 249
Dorfman, Ariel, 3, 13, 33, 42, 53, 67,
 80, 210, 217, 227, 230, 247, 249

EBAL, 158
Eco, Umberto, 140, 194–195
Editorial Pablo de la Torriente, 82, 86
Eisner, Will, 142, 167, 173, 194,
 199, 217
El Cartún, 87, 90
El Eternauta, 10, 67, 100, 106–107,
 110, 200–201

El Gallito Inglés, 175, 185, 219
El Santo, 57, 64, 68, 70, 80, 231
Evita Montonera, 98, 104–105,
 107–109

fanzines, 89, 165, 167, 172, 174,
 178–180, 183–184, 189, 199,
 215–216
Felton Outcault, Richard, 153
Ficção, 165
Fierro, 191, 196–199, 201, 203, 220
Fiske, John, 20, 33
Folha da Manhã, 20, 24
Fontanarrosa, Roberto, 42, 100, 211
Forgacs, David, 22, 33
Foucault, Michel, 228–229, 231,
 233, 247–249
Frei, Eduardo, 43

Gaiman, Neil, 199, 255–257, 269
Gallito Cómics, 9, 175, 177–178, 180
gauchito, 104
Gibi, 18, 157
Giroux, Robert, 18–19, 32–33, 110
Good Neighbor Policy, 6, 37
Gordo, 187, 251, 269
Groth, Gary, 252–254, 268–269
Guerrero, Vicente, 113

Habell–Pallán, Michelle, 264, 269
Hardt, Michael, 19, 34
Henfil (Henrique de Sousa Filho),
 9, 166, 169
hentai, 181
Hernandez
 Gilbert, 12, 252, 254–257,
 259–263, 267–269
 Jaime, 12, 252, 254–256, 263–269
heterogeneity, 4, 41, 60, 62,
 216, 230
historietas, 2–3, 10, 29, 124, 141,
 150, 171–173, 178, 184–185,
 189, 210, 212
hooks, bell, 127
horror comics, 158–159, 161, 198–199
hybridity, 41

independent comics, 165
Instituto Cubano de Radio y
 Televisión, 82

Instituto Cubano del Arte e Industria
 Cinematográficas, 82

Jameson, Frederic, 31–32, 34
Jis, 174–175, 183–184
Juárez, Benito, 113

Kalimán, 7–8, 13, 55–71, 78–80, 118,
 124, 171–172, 209, 216
Krauze, Enrique, 113, 129–130, 184

La Argentina en pedazos, 197–198
La Caneca, 178, 181
La Codorniz, 140
La Cucaracha, 15, 251, 269
La Familia Burrón, 12, 50, 120, 183
Laboriel, Johnny, 115
Lafourcade, Enrique, 36
latinidad, 16, 228, 230, 237, 239,
 248–249
Latino Studies, 228, 230, 245,
 248–249
Leguía, Augusto, 134
limeñismo, 132
Limoeiro, 21–26, 30,
Los Supermachos, 2, 8, 50, 172,
 188, 210
Love and Rockets, 12, 15, 252–254,
 256–257, 260, 262, 264–266,
 268–269

Macfarlane, Kenneth, 36
Mafalda, 2, 10–11, 13, 21–24, 33–34,
 50, 90, 101–104, 110, 217
Málaga Grenet, Julio, 134–135
Malagola, Gedeone, 158–159, 161–162
manga, 1, 9, 140, 151, 168–170,
 173, 178, 181, 184, 192, 212,
 214–215, 221
Mariátegui, José Carlos, 144, 150
Mariel boatlift, 81, 84, 240
Martín Fierro (Hernández), 101
Martín Rivas (Blest Gana), 48
Masotta, Oscar, 194–195, 203
Mattelart, Armand, 3, 13, 33, 42,
 51–52, 67, 80, 210, 217, 227,
 230, 247, 249
Maurício de Sousa, 8, 11, 13, 17–22,
 24–26, 29–30, 32–34, 164, 167
McCloud, Scott, 229, 248–249

mediation, 2–3, 35–36, 40, 42, 44–45, 49, 53, 192

Memín Pinguín, 14, 111–115, 118, 121–122, 125–130, 172, 188, 216

Mendiola, Jim, 264

Messias de Mello, Manoel, 154, 161

mexicanidad, 5, 206, 215

México Negro, 115

Mickey Mouse, 18, 156

Molotov, 178–179, 185

Mônica, 8, 11, 13–14, 17–34, 129–130, 164, 170

Monos y monadas, 134–135, 139–140, 142, 144, 150

Monsiváis, Carlos, 3, 5, 14, 16, 38, 70, 124–125, 211

Montealegre, Jorge, 36, 50, 52–53

Montoneros, 7, 97–101, 103–105, 107–110, 201

MSP, 17–20, 22, 26–28, 30–33, 65

Mutarelli, Lourenço, 13, 167–168, 170

Naipaul, V.S., 244

Negrete, Jorge, 128

Negri, Antonio, 19, 34

Nhô Quim, 20, 153

Noé, Luis Felipe, 198

Noriega, Chon, 230, 237, 242, 248–250

Oboler, Suzanne, 243, 248, 250

Odría, Manuel, 137

Oesterheld, Héctor Germán, 10, 13, 67, 100, 106–107, 110, 199–201

Okey, 36, 38–39, 52

Orientalism, 55, 63, 66, 71, 80, 250

Padrón, Juan, 88, 90, 92, 94

Palante, 82, 86, 89, 91

Palomar, 12, 252, 257–258, 260, 268–269

Palomilla, 14, 136, 171, 208

paquetazo, 139

Patoruzú, 5, 8, 99, 192–193

Pelé, 19, 23, 25, 38

Pelotillehue, 35, 38, 41–43, 51

pepines, 3, 171, 187, 189–190, 208

Pepo, 36–38, 50

Pereyra, Inodoro, 42, 50, 100

Período Especial, 81, 86–90

Periquillo Sarniento (Fernández de Lizardi), 126

Perón
Isabel, 10, 97, 100
Juan Domingo, 97–100, 105, 107, 110

Perú ilustrado, 133

peruanidad, 131, 136–137, 139

Piglia, Ricardo, 197–198

Pobre Diablo, 131, 142–145, 147, 150

Poniatowska, Elena, 114

Poole, Deborah, 136, 150

pornographic comics, 8, 163, 170

Pretty Vacant, 264

Prohías, Antonio, 83–84, 91, 93–95

Quino (Joaquín Salvador Lavado), 10–11, 21, 90, 103

Rabassa, Gregory, 245

racism, 19, 23, 63, 112–115, 121, 124, 127, 130, 264

RAW, 252

RGE, 158

Ríos Boettiger, René, 36

Robbins, Trina, 253–254, 268–269

Rodriguez, Richard, 228, 245, 250

Rosso, Nico, 159–161

Roux, Raúl, 192–193

Rubenstein, Anne, 9, 29, 34, 64, 80, 118, 130, 187

Sábato, Ernesto, 196

Said, Edward, 55, 60, 63, 71, 80, 229, 231, 247–248

Salinas, José Luis, 193, 195

Sasturain, Juan, 106, 193, 196–198, 201, 203

Scafati, Luis, 198

Schwarz, Roberto, 29, 34

Sinclair, Carla, 253–254

Snow White, 24, 28

Spiegelman, Art, 199, 252

Stavans, Ilan, 227–233, 235, 237–250

Sunkel, Osvaldo, 38, 53

superhero, 3, 7–8, 56–57, 59–60, 65, 67, 70, 118, 136–137, 142, 145, 158, 161–162, 168, 170, 173, 176–179, 192, 194, 212, 214, 217–218, 221, 252, 253, 255

Suplemento Juvenil, 155–157

Teitelboim, Volodia, 36
Terror Negro, 158
The Comics Journal, 94, 95, 252, 254, 269
Thompson
 E.P., 53
 John B., 41, 53
 Kim, 253
transculturation, 5, 41, 70
Trino, 174–175, 183–184
tropicalization, 6, 16, 238–239, 248–249
Turma da Mônica, 17–18, 24, 26–30, 33–34

Última hora, 137–138

Valdez oil spill, 261, 268
Valencia, Sixto, 111, 114–117, 119–123, 126–127, 130, 172, 186, 188

Vallejo, César, 144, 150
Vargas Dulché, Yolanda, 8, 13–14, 111, 114–124, 126–127, 130, 171–172
Vargas Llosa, Mario, 137
Vasconcelos, José, 56, 60, 80, 112, 130
Velasco Alvarado, Juan, 138
Villa El Salvador, 140–141
Villaurrutia, Xavier, 126

war
 with Chile, 136
 with Ecuador, 136

Yellow Kid, 99
Yerovi, Leonidas, 134

Zéfiro, Carlos, 8, 163, 170
Zipes, Jack, 24, 34
Zunzún, 82, 86